TWENTIETH CENTURY WILDLIFE ARTISTS

TWENTIETH CENTURY WILDLIFE ARTISTS

Nicholas Hammond

CROOM HELM

London

© 1986 Nicholas Hammond
Croom Helm Ltd, Provident House, Burrell Row,
Beckenham, Kent BR3 1AT

British Library Cataloguing in Publication Data

Hammond, Nicholas
Twentieth-century wildlife artists.
1. Wildlife painting 2. Painting,
Modern—20th century
I. Title
758′.3 ND1380

ISBN 0-7099-1266-8

Typeset by Ace Filmsetting Ltd, Frome, Somerset
Colour origination by Alpha Reprographics, Middlesex
Printed and bound in the Netherlands
by Royal Smeets Offset b.v., Weert

Contents

Acknowledgements 7
Preface 9

Part One
Introduction to Wildlife Art

Part Two
The Artists

For Antonia and Claudia

ACKNOWLEDGEMENTS

Many people have helped me with this book. To all of them I am most grateful, but there are some to whom particular thanks are due. Obviously without the artists there would have been no book, but particular thanks go to Robert Gillmor, who initially brought the publishers and me together, then generously helped me with suggestions, information and contacts. Don Eckelberry, Al Gilbert and Arthur Singer were three artists I met and talked with in the United States: as well as showing me typical American hospitality they were generous in the help that they gave me.

Enthusiasts for wildlife art seem to be very ready to share their enthusiasm. There are, therefore, several whom I would particularly like to thank: Crispin Fisher of William Collins, Martha Hill, picture editor of *Audubon*, David Lank of Toronto, Lars Svensson of Bonnier Forlag, Mark Wexler and Stephen Freligh of *National Wildlife*. Then, there were those who have lent transparencies: David Bingham of Tryon and Morland Gallery in London, Ian Fleming of the Brotherton Gallery in London, Peter Howarth of Cumbrian Fine Art Galleries, Fred King of Sportsman's Edge in New York, Robert Lewin of Mill Pond Press of Venice, Florida and William Marler of the William Marler Gallery in Cirencester. Don Luce of the University of Minnesota, Robert McCracken Peck of the Academy of Natural Sciences, Philadelphia and Ülla Lundgren of the Thielska Gallery in Sweden all helped me find transparencies.

The Royal Society for the Protection of Birds has allowed me to use some of the paintings and prints that it owns and several of my colleagues have been extremely helpful, particularly Chris Harbard, Patsy Hinchliffe, Rob Hume, Sylvia Sullivan and Mike Town; but special thanks go to Ian Dawson, the Society's librarian, who as well as tracing almost every reference for which I asked also managed to find some that I had not requested. Another invaluable source of information and books was the Bedfordshire County Library Service, whose staff at Sandy and Bedford Central Libraries were unfailingly helpful.

Some of the research was undertaken by Carole and Chris Stewart, to whom I am very grateful and of whose multi-lingual ability I am most envious. I would also like to thank Antonia Hammond for help with translation and Claudia Hammond for arranging the bibliography and sorting out typescripts.

At Croom Helm the enthusiasm, patience and encouragement of the natural history editor, Jo Hemmings, and other members of the staff, particularly Melanie Crook and Ann Doolan, made this a very enjoyable book to write.

Finally, my great thanks to Yvonne Hammond for typing and improving the manuscript, keeping a check on material as it arrived and for producing the index. I know that without her help there would have been no book.

PREFACE

This book cannot pretend to be a comprehensive survey of twentieth-century painting of wildlife, not least because the century has not yet finished. It is, however, an exploration into the painting of wildlife during a period when the human response to wild animals has changed radically. Painting has both helped that change and reflected it, although, admittedly, there are some painters who cling to the nineteenth-century romanticised studies of stuffed animals.

As an enthusiast for wildlife and for painting it would also be foolish for me not to admit that my view of pictures of wildlife is subjective. My first awareness of bird illustrations were the pictures in *The Observer's Book of British Birds*, bought for me by my father when I was very young. These pictures by Archibald Thorburn and J.G. Keulemans had a romanticism that fired my imagination as I grew up. They had a quality that took me from the mundane England of the 1950s back to an idealised epoch before the First World War. When my family realised my passion for birds, I was given every encouragement and soon began to realise how greatly wildlife illustrations varied. Bird books headed my list of presents, birthday and Christmas cards depicted birds and my subscription to the Royal Society for the Protection of Birds was readily paid by my parents. The work of Peter Scott and Maurice

Wilson featured strongly in the greetings cards I was sent and among the books I was given was Henry Williamson's *Tarka the Otter*, with wood engravings by Charles Tunnicliffe. My junior membership of the RSPB brought with it the quarterly magazine, *Bird Notes*, each copy of which then had a cover from a Tunnicliffe watercolour. Through a copy of *The Field Guide to the Birds of Britain and Europe* I came into contact with the bright, clean almost schematic illustrations of Roger Tory Peterson, which really did make it easier for me to identify birds.

My personal excitement at illustrations of wildlife accelerated when I began to work for the RSPB as an editor in the 1960s. This was a period during which the Society was growing fast as well as making real efforts to encourage artists. Inevitably my view of any wildlife painting then became affected by its possibility in print.

Choosing the artists to be included in this book has not been easy. I have tried to be as objective as possible, but I have no doubt that perhaps no one will agree totally with my choice, which tries to demonstrate the variety of approaches to the subject. There are no doubt several artists whose omission will be deprecated by readers and the artists themselves. I can only offer them and the enthusiasts for their work the consolation that I am not always right.

Part One
Introduction to Wildlife Art

CHAPTER 1
Wildlife and Art

Volcanic eruptions, landslides and earthquakes apart, landscapes have a stationary quality. Still life, by definition, does not move. The subjects of portraits and nude models do not move because they are told to be still. Horses and dogs, too, if moderately trained, can be made to stand still. But unless they are dead, wild animals have a habit of moving – usually quickly and frequently unpredictably. To paint a convincing picture of a live pheasant requires patience and knowledge of how the animal behaves and where it lives, but such knowledge would be immaterial to a painting of a dead pheasant. Ironically, though, it is the dead pheasant that would be considered as art.

Despite the difficulties facing an artist who decides to tackle a wildlife subject, the finished picture will probably be dismissed as 'genre painting'. Perhaps it is this very difficulty that requires a specialist knowledge that takes wildlife painting out of the realms of art, but the artists themselves must take some of the blame. It is they who claim, with justification, the need for specialist knowledge and it is they who form societies of animal painters and of wildlife artists. I sympathise with the attitude of Robert Verity Clem, who illustrated superbly a book on North American shorebirds. In a letter in which he declined to be featured in this book he wrote, '. . . I have been increasingly put off at the extent to which the creation of works involving natural history subject matter are relentlessly categorised as "wildlife art", in such contrast to *everything* else which seemingly qualifies as, simply "art".

'A number of years ago it seemed, briefly, that the restrictions on pictures with creatures in them being allowed in the realm of fine-art were easing, but it was probably just an illusion . . . a momentary aberration. By now the polarisation has solidified and bias against such subjects as "art" has increased greatly.' Books such as this and exhibitions of wildlife art are to blame for this, he continued. He might fairly have added that much of the work masquerading as wildlife art is adequate neither in artistic terms nor as representations of wildlife.

Perhaps it was Sir Edwin Landseer (1802–73) who started the rot. He began his life as an artist much influenced by Stubbs and was a fine illustrator of animals, until he realised that the Victorian public really wanted to see animals with humanised expressions. In addition to sentimental drawings of dogs, he added expressions of nobility to stags, which must have been comforting to hunters who wanted to be convinced that they were chasing a quarry worthy of themselves. Such artistic flattery of the buyers of paintings persists today with birds of prey and gamebirds given an exaggeratedly noble air. For example, cock pheasants, despite the splendour of their plumage, are faintly absurd, noisy, flapping creatures, but this is not an aspect on which artists dwell, knowing that the marketable pheasant painting shows a noble, upstanding, larger-than-life creature that is a fit quarry for the guns.

Quarry species, particularly gamebirds and deer in Europe and wildfowl in the United States, are very popular subjects among hunters, perhaps as some form of sympathetic magic to bring successful hunting. There is little doubt that among sportsmen are some of the most discerning buyers of paintings of animals. They have spent hours in blinds waiting for flighting canvasbacks or have watched along gun barrels the geese flying down to feed. They know their subjects well. Likewise, some of the best painters of wildlife have been hunters. Bruno Liljefors (1860–1939), the great Swedish artist who took the painting of wildlife from the nineteenth century into the twentieth, was a keen hunter. Sir Peter Scott (1909–), was once an avid wildfowler. Others, of course, have never felt the need to kill their subjects and find it difficult to understand the paradox of people killing the creatures they love.

Naturalists, for all their knowledge, are not necessarily the best judges of painting of wildlife. I have heard an ornithologist dismiss a wash drawing by John Busby (1928–) with the words, 'Whoever saw a goldfinch with a metatarsus like that?' Ornithologists will often buy studies of rare birds,

perhaps another example of sympathetic magic or maybe merely just a remembrance of birds past. Some painters are clearly birdwatchers' painters, uncompromising in their enthusiasm for birds. Several young illustrators of birds have this commitment to their subject, but sometimes so strong is their enthusiasm for birds that they fail to spend as much time as they should learning about, and painting, the landscapes in which the birds are found.

Possibly such specialisation is the reason for wildlife painting not being considered as real art. It is significant that the exhibition in London to celebrate the bicentenary of the birth of John James Audubon (1785–1851) should have been held in the Natural History Museum rather than in an art gallery. The specialist painter is just not taken seriously by the art world. Wildlife artists frequently bemoan this fact, but they continue to specialise, exhibiting in specialist exhibitions and specialist galleries. If only more would also paint subjects other than wildlife, their work might become more acceptable.

In the past artists were less specialist. The work of Albrecht Dürer (1471–1528) at the beginning of the sixteenth century included many animal subjects. He was, it appears, something of a naturalist, keeping animals as pets. His hare, painted in 1502, is one of the most enduring of animal images. He also painted squirrels, owls, tortoises and his drawings included a walrus, from a carcass washed up on the Dutch coast, and a rhinoceros, based on a description and someone else's rough sketch. The difference between Dürer's representations of the pet animals with which he was so familiar and the exotic subjects he did not know is that of life and death. Rembrandt's star pupil, Carel Fabritius (1622–54), painted a brilliant study of a goldfinch tethered to a perch, which shows how an artist with no specialised knowledge can paint a convincing picture of a bird. Later both Claude Monet and Pablo Picasso showed that artists who could observe accurately could paint animals. Picasso's drawings of doves and bulls, despite abstraction, were extremely well observed. Monet's 'The Magpie', painted in 1869 shows a snow-covered landscape in which one's eye is drawn to the magpie perched on a gate. He seemed to have none of the problems that some modern artists experience in trying to find the correct scale for a bird in a landscape, but that was no doubt because his view of the magpie and the landscape were complementary with neither dominating.

These, of course, were pictures as opposed to illustrations. It has to be admitted that much of what passes as wildlife 'art' is really 'illustration'. This is not to undervalue it. Illustrations of wildlife subjects have done much to encourage interest in natural history. The didactic illustration of birds began in the fifteenth century with the German invention of printing from movable type, but did not really gather momentum until the eighteenth century with the work of Buffon, Albin and Bewick. The grand aquatints of John James Audubon and the lithographs of John Gould made the study of natural history both exciting and acceptable. At the turn of this century Louis Agassiz Fuertes, Archibald Thorburn and J.G. Keulemans were painting illustrations aimed at helping people identify birds. Their illustrations enabled people to identify birds without having to shoot them first. An even greater step forward came when a young American teacher and naturalist, Roger Tory Peterson (1908–), introduced schematic drawings of birds with arrows pointing to the diagnostic characteristics. The Peterson method of identification, first applied in 1933 in *A Field Guide to the Birds*, was subsequently applied to mammals, reptiles, butterflies and other forms of natural history in North America. The idea of books showing several similar species on one page has since spread throughout the world. This concept must have been an important factor in the interest in birds and other animals which has increased so markedly, particularly in the English-speaking countries and Europe, since the end of the Second World War.

Naturally, an interest in natural history has led to an interest in conservation. We must remember, however, that an interest in natural history once meant an interest in collecting and killing. All the nineteenth-century illustrations of animals were based on dead specimens. Audubon and Gould with his team of artists relied on skins. Audubon was a hunter, who killed the birds he needed to paint. He must in the course of his career have killed many birds, but paradoxically his name has become the symbol of conservation in the United States through the National Audubon Society and individual state Audubon societies. This gives some idea of the amount of publicity and interest he generated in the last century, towards the end of which the Audubon Society was founded. John Gould (1804–81) was an English artist who was somewhat in the shadow of his older American counterpart but he is commemorated in Australia in much the same way as Audubon was in the United States. The Gould League is the main popular ornithological and conservation society in Australia.

The works of both have been used commercially for years, frequently inappropriately badly cropped and reproduced on table mats, firescreens or porcelain. The incomparable wood engravings of Thomas Bewick (1753–1828) have suffered a similar, ghastly fate: Ian Bain, an authority on Bewick, has a bizarre collection of artefacts on which the great man's work has been used, the nadir being a three-quarter-size chamberpot. Nevertheless, however tasteless some of these items are, they do help to create a public interest in wildlife.

A similar excuse might be made for the sentimental, badly observed studies that pass for wildlife art in commercial use today. Perhaps it is these, above all, that argue for the destruction of the label 'wildlife art' or at least the transfer of the 'wildlife' tag from art to illustration. It is legitimate for illustrators to specialise – medical subjects, horses, trains, cars, aeroplanes, all need specialised knowledge, as do birds, mammals, butterflies or plants. But when it comes to art, the danger of specialised knowledge is that it dominates colour and composition to too great a degree.

To me the wildlife pictures that approach art are the ones that make me want to share the artist's experience of seeing a particular animal in a particular place. The pictures that merely evoke a response related to an interest in a particular animal are illustrations. There are both types of picture in this book.

CHAPTER 2
The Background to Today's Wildlife Art

Cro-Magnon man had no inhibitions about the portrayal of wildlife not being art. On the walls of his caves he painted representations of the important elements in his life – himself and the animals he hunted. For about a hundred years, since the discovery of paintings on the walls of caves in south-western France and northern Spain, anthropologists have been trying to discover why these pictures were drawn. They knew when they were drawn, because among the animals depicted were woolly rhinoceros and mammoth, both of which became extinct towards the end of the Pleistocene Ice Age 15,000 years ago during the Würm and Wisconsin glaciation.

Today it is recognised that the most successful hunters are those who have come to understand and even identify with their quarry. It is scarcely surprising, therefore, that the caveman-artists, who were hunters, managed to capture the essence or, in birdwatchers' parlance, the 'jizz' of the animals. Why they should have come to decorate the walls of their caves is the fundamental question, which has yet to be answered. There is no doubt that in some cases the formation of the rocks has been used by the artist to help realise the animal. Did the shadows from a fire play on the walls of a cave to suggest the shape of one of the animals with which the hunter was so familiar? Or was it one of the scratches made in the cave by a bear sharpening its claws that suggested an animal shape that could easily be confirmed by the addition of a few man-made scratches?

From such accidental beginnings a mystic quality may have become attached to artists and their paintings. The Cro-Magnon men appear not to have lived in the caves that they decorated: difficult to enter, with many deep, dark passages and chambers, these caves would have been unsuitable for permanent habitation. For some reason there are no paintings near the cave entrances where available light would have made it possible for people to see them. It seems, therefore, that there must have been some element of mystery about the caves. One theory is that the cave paintings were a form of sympathetic magic and that they were drawn in 'sacred' places or where ceremonies were held to ensure either good hunting or the restitution of the animals killed in previous hunts. In some of the paintings there are men dressed in animal skins: perhaps they were magicians performing rites.

If, however, the reason for the paintings had been sympathetic magic, one might have expected that more species of animals would have been included. However, as André Leroi-Gourhan, director of the Musée de l'Homme in Paris, has pointed out, very few species are depicted in the cave paintings. Moreover, he discovered that there was a pattern of distribution of species within each cave: horses tended to be at the cave entrance or the deep and narrow parts of the cave, while the bison and cattle were usually in the more open parts. He also looked at the distribution of the abstract symbols in the paintings. The male symbols were always found with horses and the female symbols with cattle. This suggests that the paintings did have a religious meaning in which female and male had great significance.

Whatever the reason for the paintings, they must have been of considerable importance, because it appears that there was even a Cro-Magnon art school at Limeuil in south-west France, where 137 'sketch-sheets' were discovered. Similar sketch-sheets, which appear to be trial workings for the wall-pictures, have been found at several other sites. At Limeuil the standard of the sketches varies: some are good, some are bad and many have corrections on them, possibly the work of an art-teacher.

Cave paintings have been discovered beyond France and Spain in other parts of Europe as far east as the Urals. They appear to date from the same period and depict similar subjects such as horses, cattle, mammoth and rhinoceros with abstract symbols.

In other parts of the world the cave paintings do not appear to be as old as those in Europe. In Mexico as recently as the 1960s paintings were discovered by the American thriller writer, Erle Stanley Gardener. Although they are the oldest paintings yet to be discovered in North America, they are no more than

3,000 years old and were probably the work of the Olmecs, who lived in Mexico before the Mayas and the Aztecs. In common with the European cave paintings they are deep in the interior of the caves and they feature men and animals. However, the animals are much less easy to identify.

The rock paintings of Australia and Africa are less ancient than European cave paintings. None, it seems, is more than 10,500 years old and often they are drawn or engraved on exposed rock faces. African rock art frequently features hunting scenes – huge herds of eland and antelope, giraffes, ostriches, springboks and lions. Some are remarkably accurate in both shape and colouring.

Some of these so-called primitive paintings were being executed at the same time as the rather more sophisticated paintings of the Ancient Egyptians. Living in the fertile valley of the Nile, the Egyptians were close to nature being hunters, fishermen and farmers. There were many ways in which animals were a hazard to them: Nile crocodiles have always been quick to snatch any unwary human being who ventures within reach of their jaws; the wallowing hippopotamus could easily tip fishermen from their shallow-draught boats or wander from the river to trample and eat crops; and then there were lions, perhaps looking more fierce than they really are, but nevertheless prepared to devour anyone at a disadvantage. It is small wonder that these three animals became amalgamated into the Devourer, a fabulous monster that consumed the hearts of liars in the afterlife. Although other animals may not have been so feared, they too became symbols of the gods. Thoth, the god of wisdom, was symbolised by the sacred ibis, whose stooping demeanour and curved bill suggests an air of thoughtfulness. The flying falcon came to represent all-powerful royalty and the god Horus.

The low reliefs and frescoes of the Ancient Egyptians show us that, beyond the symbolic, wild animals played an important part in their lives – as food. The artists were aware of different species and their inter-relationships. While the species are clearly shown, accuracy of representation was not always paramount. In his book, *Bird Life and the Painter* (1955), the artist R.B. Talbot Kelly (1896–1974), describes how the weakness of the thin legs of a bird, supporting a relatively large body, can appear very unbalanced. 'If you look at these carefully posed Egyptian birds' he wrote, 'you will find that their choice of position is one that links the bird with the ground in a satisfactory visual manner, the arrangement of the two legs and the bird's tail being such that the design has a solid foundation on which to stand . . . At other times the Egyptian artist was quite happy to sacrifice the factual truth so long as he achieved structural soundness in his design.' Talbot Kelly felt that modern artists could learn something from the Egyptians and he drew attention to the rightness of their huge stone statues of falcons to which some of the giant eagles on modern war memorials can be unfavourably compared. Perhaps twentieth-century artists and sculptors have lost their ability to look at animals without the preconceptions of five thousand years of other people's views.

The palette available to the Egyptians was less restricted than that of the Cro-Magnon artists, who were limited to browns, red ochre and yellow ochre. During the 3,000 years of Ancient Egyptian civilisation the palette varied, but it was never wide. Usually the colours were symbolic and sometimes they were used quite arbitrarily: the shapes of the animals might be totally naturalistic but the colours quite wrong. Sometimes the colours were mixed to produce tones and greys and the birds were totally recognisable, despite the few colours available. An excellent example is the fresco on the tomb of Ne-Few-Maat at Medum in which red-breasted, bean and white-fronted geese are accurately represented. These species must have been winter visitors and because the hunters made a practice of catching wildfowl and keeping them in captivity to be fattened for the table, the artist would have had plenty of time to examine the birds.

Other ancient civilisations had bird artists but none seems to have had as many as the Egyptians. In most cases these pictures had religious significance or were related to hunting and fishing. There are excellent Assyrian reliefs of lions being hunted and Minoan frescoes that portray dolphins plunging around fishing boats. By the time the Romans ruled the known world their sophisticated mosaic illustrations lacked the freshness of their predecessors. Symbolism remained the main reason for illustrations: in the Roman Empire the popular Herculean ideal of the heroic hunter was manifested in pictures of hunters and their quarry. By the third century, however, the Christian ethic began to show itself in private art. As Christianity began to take hold the idea of Man the shepherd, caring for animals, began to replace that of Man the hunter. Both hunters and farmers appear in the mosaics on the floor of the Imperial Palace in Constantinople. Dating from the sixth and seventh centuries these images have great liveliness: the animals are not simple profiles and the artist has attempted and succeeded in catching the animals in awkward postures, such as a goat scratching itself with a hind leg.

Men living in largely rural communities are familiar with birds and other animals with which they live so closely. They are convenient foci for ideas and the religious were quick to use them for symbolism. The Christians were no exception. Both saints and religious events were symbolised by animals in the decorations of monastic manuscripts. One of the earliest was the *Lindisfarne Gospels*, written in the sixth century, and possibly illustrated by Eadfrith, who later became Bishop of Lindisfarne. In the beginning of the Gospel according to St John there is the Apostle's symbol, a flying eagle; and although there are some inaccuracies the arrangement of the feathers suggests that the artist had before him either a living bird or a skin. As Brunsdon Yapp remarks in his *Birds and Medieval Manuscripts* (1981), this flying eagle is barely less awkward than many representations of flying birds a thousand years later.

Generally, the representation of animals in manuscripts was very different from the attempts at accuracy that became popular in the late nineteenth and twentieth centuries. Many, Yapp suggests, were copied from other illustrations, but he points out that new figures were introduced as the artist had the opportunity to look closely at a species not previously illustrated. Copying is always a problem, because there is a tendency for each copyist to magnify the errors of his predecessors. This was not just a medieval problem; it still occurs today in the commercial illustrations of animals on greeting cards and other gift items. For example, there is an illustration of a kingfisher in the *Book of British Birds* (1969) showing a bird whose feathers are presumably being blown by a breeze into a crest: this unusual image has been copied and exaggerated on numerous occasions since.

The facility to multiply mistakes was, according to

Decoration from the early fourteenth-century Holkham Bible Picture Book

Yapp, particularly prevalent among the illustrators of bestiaries during the Middle Ages. There were undoubtedly model-books used by the illuminators but few seem to have survived. One of the most well known is the sketch-book in the Pepysian Library at Magdalene College, Cambridge, known as 'The Monk's Drawbook'. This dates from the fourteenth century and Yapp suggests that it is either French or Italian, because the 27 identifiable species have a Continental bias and include water rail which seems to be a much less secretive bird on the Continent than in England. European manuscripts have many animal illustrations, perhaps most famous of which are the marginal decorations to *De Arte Venandi cum Avibus* by the Emperor Frederick II. This was a manual on falconry and consequently contains a large number of birds of prey and their prey.

Undoubtedly some of the manuscript artists must have been familiar with the birds and other animals they drew. In some pictures the 'jizz' is captured well and the artist must have watched the birds at least in captivity, if not in the wild. One such was the artist of the Sherborne Missal, made for Sherborne Priory in Dorset about 1400. The chief illustrator was John Syfervas, who probably came from Hampshire, but Yapp thinks that he was not responsible for the 170 birds which decorate the manuscript, largely because the way in which the captions are written suggests a northern dialect and many of the birds illustrated were more likely to be seen in the north of England than the south.

At the time that the Sherborne Missal was being drawn, a recent German invention was about to change the communication of knowledge and ideas, which was in turn to change perceptions of the natural world. As the fourteenth century gave way to the fifteenth, Gutenberg's newly invented technique of printing from movable type began to change the face of Europe. Knowledge was no longer to be the privilege of the Church and the aristocracy. The earliest known printed book to contain nature illustrations was *Das Buch der Natur*, published in Augsburg in 1475. *Hortus Sanitatii*, printed by Jacob Meydenbach at Mainz in 1491, contained 103 illustrations of birds. The first English printed book with illustrations of wildlife was *De Proprietatibus Rerum* by Bartholomaeus Anglicus. Printed in about 1495 by Wynkyn de Worde, it was written in Latin and

the illustrations were simple woodcuts.

Specialised interest in particular groups of wildlife was almost unknown, but in 1555 Pierre Belon published a book confined to birds, *Histoire de la Nature des Oyseaux*. The author described his 160 woodcuts as 'simple portraits of birds, the nature of which no one else has illustrated before'. Ten years later Conrad Gesner's *Historia Animalium* was published in Zurich with woodcuts by Lukas Schan of Strasbourg that were accurate and rather more sophisticated than their predecessors; it appears that Schan was an expert fowler.

During the thirteenth and fourteenth century birds appeared symbolically in major religious paintings. Among the most frequent was the goldfinch, which had been adopted because of its preference for thistle-seeds, to symbolise the Passion of Christ. From the artist's point of view this species had the advantage of familiarity, because it was a popular cagebird. Hieronymus Bosch (c. 1450–1516), celebrated for his fantastic paintings of the torment of souls, was an excellent draughtsman as is shown by his very well observed depiction of a goldfinch in 'The Garden of Earthly Delights'.

Increasingly secular subjects began to take over from the religious. One artist who reflected both subjects was Dürer. As we have seen, he kept animals as pets and frequently used them as models. Such was his interest in wildlife that his death resulted from a fever contracted in the marshes of Zeeland when he went there to see a stranded whale. His enormous output included woodcuts, engravings, paintings, drawings and treatises on a number of subjects.

The sixteenth-century voyages of discovery opened huge new subjects of enquiry. One member of Sir Walter Raleigh's Roanoke expedition of 1586 was an artist, John White, who included birds among his subjects. His drawings of birds in Virginia were pirated and copied without credit by de Bry in *America*, published in 1590. White's work seems to have disappeared from public view for more than a hundred years until Sir Hans Sloane (1660–1753) discovered a folio of his watercolour drawings, some of which were used by Catesby in *The Natural History of Carolina, Florida and the Bahama Islands*. White's drawings of birds showed no landscape, but the seventeenth-century Englishman, Francis Barlow, put his birds into landscapes and thus helped to

develop the concept of showing animals as part of the environment. His accuracy left a little to be desired, but this may have been because he was often working from no more than written descriptions.

During the seventeenth century it was Dutch painters who painted animals that looked as if they might be alive. Carel Fabritius who, it is said, was the link between Rembrandt and Vermeer, produced one of the finest paintings of a goldfinch. Even though it is a captive bird tethered to a perch it has a liveliness that has rarely been matched. Fabritius's career was ended abruptly when he was killed in the Great Delft explosion of 1654. His countryman, Jan Asseljin (1610–52), painted 'The Angry Swan', a huge canvas showing a full frontal view of a male mute swan charging an intruder. Apparently this swan was a symbol of the Netherlands defending itself against aggression. The artist must have used a dead specimen that had been handled frequently enough for its feathers to have become disarrayed in a way that no living bird would tolerate. More than three hundred years later there are still paintings in which unpreened plumage gives away the artist who has used a dead bird as a model.

A family of seventeenth-century Dutch painters produced two members who were excellent portrayers of nature subjects: Jan Baptist Weenix (1621–63) and his nephew and pupil Melchior Hondecoeter (1636–95). They specialised in still life paintings, often enlivening vases of flowers with butterflies, moths and other insects. Hondecoeter also specialised in bird paintings, often bringing together a number of different species in a courtyard. Again, he must have relied on dead specimens because his birds have an unkempt look and the muscles of the mammals have atrophied in death.

Communication between England and the Continent, particularly the Netherlands, was extremely good in the sixteenth century. Illustrations to books, therefore, crossed national borders. In *Ornithologiae Libri Tres* by John Ray and Francis Willughby, the first bird book written in English and published in 1676, the illustrations come from various sources including some Dutch artists. Some of the pictures are very poor and without captions would be unidentifiable.

Engraving on metal was developed at the end of the sixteenth century, enabling more detailed line work. This process heralded two centuries of high quality illustrated books about birds and other animals. One of the first of these was *The History of Insects* by Eleazer Albin (?–1759), published in 1720. Little is known about Albin, but he appears to have been a professional artist, who took a particular interest in all aspects of natural history. In *A Natural History of Spiders* (1735) he included a chapter on feather-lice, a topic that even today might be regarded as somewhat esoteric. His approach, it has been suggested, was somewhat unscientific. In the first of the two volumes of his *A Natural History of British Birds* Albin included a plea for 'any curious birds' to be sent to him 'near the Dog and Duck in Tottenham Court Road' in London. Some of his illustrations were odd, but at his best, for example his plate of an African grey parrot, he was able to breathe life into his subjects. Albin's *A Natural History of British Birds* was published in 1731, the same year as the first volume of *The Natural History of Carolina, Florida and the Bahama Islands*, by Mark Catesby (1682–1749).

Born in Essex Catesby went to America in 1712 and set out to build up a comprehensive collection of North American birds. It could be argued that he has a better claim to the title 'Father of American Ornithology' than either Wilson or Audubon. His illustrations were lively and he was meticulous in attempting to show his birds with the correct plants and insects. A third naturalist-artist working at this time was George Edwards (1694–1773), who learned the technique of engraving from Catesby. With the encouragement and patronage of Sir Hans Sloane, Edwards was appointed librarian of the Royal College of Physicians, which allowed him both a salary and time to draw birds, fish and animals. His *Natural History of Uncommon Birds* was published from 1743 to 1751 and his *Gleanings of Natural History* was complete in 1758.

The study of natural history became widespread in Britain and Ireland in the eighteenth century. One of the reasons for this may have been the general interest aroused by the exploration of the southern hemisphere. Expeditions often contained at least one artist, much of whose work was expected to be of natural history subjects. One of the best known was Sydney Parkinson, chief natural history painter on Captain Cook's 1766 expedition on HMS *Endeavour*. Parkinson also worked for Thomas Pennant, one of the correspondents to whom Gilbert White wrote *The Natural History of Selborne* (1789), as well as for Joseph Banks, the botanist. Sometimes drawings were made by serving naval officers, who learned to draw in order to undertake cartographical and survey work. One such was George Raper (1768–98), who made a series of watercolour drawings seen on the voyages of HMS *Sirius* in Australasia. Although never published as a set, these drawings are in the collections of the British Museum (Natural History), the Mitchell Library in Sydney and the Alexander Turnbull Library in Wellington.

In the second half of the eighteenth century in France the Revolution was followed by another, far less violent revolution of scientific interest. Georges Louis Leclerc, Comte de Buffon, and Marthurin Jacques Brisson both made considerable contributions to zoology. Each used the same artist, F.N. Martinet, to illustrate their books, but despite their elegance his plates do not approach the standard of Marechal in *Le Menagerie du Museum National d'Histoire Naturelle* (1801), by Lacépède and Cuvier. Marechal clearly had imagination and was not content to present his birds in profile. Instead he presented his birds obliquely; one plate shows a view of an ostrich as it walks away. The period of Napoleonic Empire produced some lavishly illustrated ornithological works such as *L'Histoire Naturelle des Perroquets* (1801–5) by F. Levaillant with illustrations by J. Barraband, and A.G. Demarest's *L'Histoire Naturelle de Tangaras* (1805–7) with plates by Pauline de Courcelles, a pupil of Barraband.

Animal subjects were still not popular among professional artists. An exception was George Stubbs (1724–1806). Mainly renowned for his horses, he painted other animals in the menageries of aristocratic patrons. His 'Lion devouring a Horse', painted in 1769, shows a male lion clawing at the back of an agonised horse. There is no evidence that this referred to an actual incident, but Stubbs did paint both animals from life, albeit not simultaneously. The theme was taken up by Eugène Delacroix (1798–1863) with a painting of a tiger attacking a horse. Delacroix plainly enjoyed painting animal subjects and gave his paintings a romanticism that make them some of the most dramatic of all animal paintings. Delacroix's contemporary, Antoine-Louis Barye (1796–1875) is less well known, perhaps because he never managed to paint human figures as romantically as he painted

animals. As a teacher of zoological drawing at the Musée d'Histoire Naturelle he was in a good position to study animals. Although he was one of the major nineteenth-century Romantics, his work is much more realistic than Delacroix's, representing a move towards realism in wildlife painting.

At the end of the eighteenth century, during which fine line engraving had improved book illustration, one engraver in particular rediscovered wood engraving. Although trained as an engraver on metal, Thomas Bewick revived white line engraving in wood. By cutting into the grain and by lowering the level of the cutting of parts of the block he achieved a remarkable softness to the backgrounds and the textures of fur and feathers. This degree of delicacy had previously only been approached by copperplate engraving. Bewick also introduced to his illustrations an indication of an animal's habitat. His wood engravings in *The History of Quadrupeds* (1790) and the *History of British Birds* (1797) must be among the most famous of all images of wildlife, as immediately recognisable as the work of Audubon or Gould. Nevertheless, among the most delightful of his engravings were those for *The Fables of Aesop* (1818), which showed Aesop's animal heroes in a setting of the Northumbrian countryside. Born and bred a countryman, Bewick delighted in rural incident and decorated his books with narrative tail-pieces, showing the bucolic aspects of seventeenth-century Northumbria. In addition to his engravings Bewick watercolours and drawings still survive in the collections of the British Museum, the Natural History Society of Northumberland and the Pease Collection in Newcastle's Central Library.

Bewick's books brought him celebrity towards the end of his life and a year before his death he was visited by John James Audubon who was on a trip to Europe in search of subscriptions for his classic, *The Birds of America* (1827–38). Audubon was a Frenchman who sought his fortune in North America, but returned across the Atlantic to have his book published, because he was unable to find an American publisher. One of the reasons for his failure was the existence of a rival project by another artist-ornithologist, Alexander Wilson (1766–1813).

Wilson's reputation has been overshadowed by Audubon's paintings and romantic lifestyle, but Wilson's own life was far from mundane. He was born in Scotland and became a weaver, but he also was educated and could write verse. One of his poems, which satirised a local manufacturer, resulted in a libel suit, imprisonment on remand for three months and his being sentenced to burn his poem publicly on the prison steps. So embittered was he by his treatment that, in 1794, once he had saved enough for his passage, he sailed for the United States. Eventually he found work as a teacher and later he became assistant editor of an encyclopedia. Wilson decided to produce a book on American birds and began to seek subscriptions towards its publication in 1807. By September 1808 the first volume was published. To find further subscribers Wilson travelled throughout the United States where he was to meet, in Louisville, Kentucky, a storekeeper who showed great interest in the venture and almost took a subscription to the book. The storekeeper was John James Audubon and he would have subscribed if his partner had not persuaded him that Audubon's own paintings were superior to Wilson's. He was right: Wilson's illustrations were of a very high standard, but beside Audubon's they pale.

Wilson is the man who is generally credited with being the first real ornithologist in the United States, but perhaps he would have achieved greater fame had he not been a contemporary of the colourful Audubon. Not the least colourful aspect of Audubon's life was his birth in Haiti in 1785, the bastard of a French sea-captain turned merchant and his French Creole mistress. She already had a daughter by the Frenchman and when she died little more than six months after Audubon was born Audubon's father took both son and daughter back to France. His wife accepted, and later adopted, the children. John James was educated in France, but at the age of 18 he was sent to the United States to look after his father's interests in Philadelphia. He was not a successful businessman, spending too much time either hunting or drawing and too little in the counting-house. Nevertheless he did not lack ambition: his was to paint all the species of bird known in the United States. While he proudly claimed to paint birds from 'life', he actually painted dead birds. He first hunted and killed them and then he arranged the bodies in life-like poses, using wires and pins. When he had finished with them as models he would eat them.

When Audubon was seeking potential sponsors for his book in New York and Philadelphia his unsuccessful business career did not fill them with great confidence. This, together with the competition from Wilson's *Ornithology*, already partly published, made publication in the United States impossible. Audubon, therefore, had to cross the Atlantic for subscribers. Having saved money by painting portraits and from his wife's earnings as a teacher, he set sail in 1826 for Europe. During his three years in London, Edinburgh and Paris the American was acclaimed by fashionable society, fascinated by the rough-hewn frontiersman, an image which Audubon enjoyed and encouraged. The first volume was published in 1827 and towards the end of 1828 he had managed to acquire more than 140 subscribers. After an unsuccessful arrangement with an Edinburgh engraver, he found Robert Havell in London to make the copperplate engravings from the aquatints of his paintings. In Havell he had discovered a particularly skilful and creative craftsman, who managed to reproduce all the verve of the original watercolours, some of which are on public display at the New York Historical Society.

The double elephant plates in *The Birds of America* were quite different from any of their predecessors. Audubon introduced a strong compositional element into the plates and made great efforts to show aspects of the birds' behaviour. Several times he used his knowledge of snakes to paint a plate in which a snake is threatening a nest and the parent birds are displaying aggressively at the intruder. His blue jays, one of the most frequently reproduced of all Audubon plates, have robbed a nest of its eggs. Having several members of the same species in the same plate was an innovation that helped its composition: his plate of Carolina parakeets shows seven birds. Ironically, within a hundred years of the publication of the plate this species had been shot to extinction. In common with his contemporaries Audubon was working when information about birds was sparse, particularly in the New World and new species were being discovered continuously. At one point, however, he found that many of the birds which he had drawn in the supposition that they were new species from the western United States were in reality immature members of known species, which meant alterations to several plates.

The success of his bird book encouraged Audubon

Peace and war. Joseph Wolf. (William Marler Gallery)

to prepare in the 1840s drawings for *The Viviparous Quadrupeds of North America*. He was helped by his sons, John W. and Victor, and the plates, unlike the copperplate engravings in his *Birds*, were lithographed. Despite his age and failing eyesight, the drawings show his skill, but the final plates lack the compositional drama of the bird plates. In many ways they are more similar to the plates in the books of John Gould.

The invention of lithographic printing allowed much more subtle gradation of tone than copperplate engraving. Lithography also accelerated the publication of lavishly illustrated books. These books concentrated on families of colourful or dramatic species, such as pheasants or parrots, or birds of a particular region. A pioneer of this technique among bird illustrators was John Gould, who started his working life as an under-gardener at Windsor Castle. However, his skill as a taxidermist, which he exploited by stuffing specimens for the boys of nearby Eton College, was to lead to his appointment, at the early age of 23, as curator of birds and chief taxidermist to the Zoological Society of London. He had the honour of stuffing the first giraffe ever to be seen in England. Five years after his appointment to the post at London Zoo his first book, *A Century of Birds from the Himalayas* (1931–2), was published. In the next 50 years Gould published thirty more major works and over 300 smaller works in the form of papers and notes. Gould's output was 2,999 folio illustrations, but he did not draw all these. Instead he employed a stable of illustrators, some of the best in Europe. His role was as an entrepreneur but he often produced sketches from which the illustrators would work.

Gould's plates set a style that lasted well into the twentieth century: they usually showed an adult, or, if the species was sexually dimorphic, two, gave an indication of the habitat in the background and sometimes the scene would be enlivened by an interesting aspect of behaviour. Gould's own wife, Elizabeth, was among the artists who worked for him and helped particularly with the plates of Australian birds. Other Gould artists included Edward Lear (1812–81), better known for his *Nonsense Songs* than for his 42 splendid plates of parrots for *The Family Psittacidae* (1832); a German, H.C. Richter (1821–1902) amongst whose best 'Gould' work were plates for the three-volume *The Mammals of Australia* (1845–63); Willam Hart (*fl.* 1850–80), who later worked with Richard Bowdler Sharpe (1847–1909); and two Dutch artists, Joseph Smit (1836–1929) and J.G. Keulemans (1842–1912). Some of the best 'Gould' plates too were drawn by Joseph Wolf (1820–99), who came from Germany to work as an artist in London. Wolf is best known for his plates of birds of prey and certainly the work he did for Gould on this group is among the best of the 2,999 plates produced. His gallery paintings were painted on an heroic scale, showing predators engaged in the death-throes of their prey. The Victorians enjoyed the macabre and seemed almost obsessive about death, which reflected itself in their wildlife paintings.

Dead and dying animals certainly appealed to the buyers of oil paintings. They had an apparently insatiable desire for large oils of moribund red stags. Most famous (or infamous) of all Victorian stag paintings is 'The Monarch of the Glen' by Sir Edwin Landseer. He made a name and knighthood for himself with anthropomorphic paintings of animals: one can almost see the crown on the head of the 'Monarch'. However, Landseer's early work included some superb drawings of animals unalloyed by his later sentimentality. Other fashionable British painters were less successful in their representations of animals. Sir John Millais (1829–96), despite spending much time in the Highlands, had not observed birds closely enough to draw them convincingly. Above one of his Scottish landscapes there flies what might equally be a bird, a fruit-bat or a witch on a broomstick. His fourth son, however, took rather more interest in birds and John Guille Millais (1865–1931) did some paintings very much in the manner of his friend, Archibald Thorburn.

The young Millais was typical of many Victorian gentlemen in that he served both as a sailor and a soldier, was British vice-consul in Norway, a zoologist, author, and landscape gardener as well as an artist. During the reign of Victoria, men such as he served throughout the Empire as soldiers, sailors, administrators and medical officers. Many became deeply involved in the places where they served and often it was they who set the foundations of the study of natural history in those countries. The watercolours of Major Henry James (1838–1921), now in the possession of the Zoological Society of London, are examples of how skilled as artists these men could be. Others could not themselves draw, but they did organise those who could. One such was Brian Houghton Hodgson (1800–94), who worked for the East India Company in India. He employed three Indian artists to draw Indian birds, some of whose watercolour and pencil drawings have a liveliness that few, if any, of their contemporaries in Europe could match.

The most original paintings of wildlife in the second half of the nineteenth century were being produced in the United States. A painter of portraits and genre paintings, Martin Johnson Heade (1819–1904) became fascinated by humming-birds and began a series of oil

Ptarmigan. Joseph Wolf. (William Marler Gallery)

paintings of humming-birds and flowers in tropical rain-forests. Another painter who sometimes chose wildlife subjects was Winslow Homer (1836–1910), perhaps the most influential American painter of his period. His 'Jumping Trout' showed that he spent a great deal of time sitting beside the river and it was there on one occasion that he saw a black bear floating past on an upturned canoe. He painted this bizarre episode in a watercolour which had a Japanese quality of simplicity, in contrast to much of the fussiness of the contemporary Western painting. Another portrait painter, Abbot Thayer (1849–1921), became interested in the protective coloration of animals. He proved that colouring alone was not enough for successful concealment: he proposed that concealment depended on the distribution of light and dark on a bird's body. He showed by illustrations how the basis of concealment is that a bird is darkest where it is most exposed to sunlight and palest where it is least exposed. Thayer had a great influence on Louis Agassiz Fuertes (1874–1927), but he never managed to persuade his protégé not to play down the effects of concealment. There would still seem to be room for an artist specialising in wildlife subjects to experiment further with Thayer's ideas.

Chromolithography was a late nineteenth-century invention that helped to spread further the distribution of illustrated natural history books. The process enabled colour printing to be undertaken more cheaply and so provided illustrators with greater opportunities for work. Among them were the Dutchman, J.G. Keulemans, who had been lured to England by John Gould and his friend, Richard Bowdler Sharpe, and the Dane, Henrik Grönvold (1858–1940). One of the first bird books to be printed by chromolithography was Lord Lilford's *Coloured Figures of the Birds of the British Islands* (1898) which had illustrations by Keulemans and a promising artist called Archibald Thorburn (1860–1935), an almost exact contemporary of the greatest Swedish artist, Bruno Liljefors.

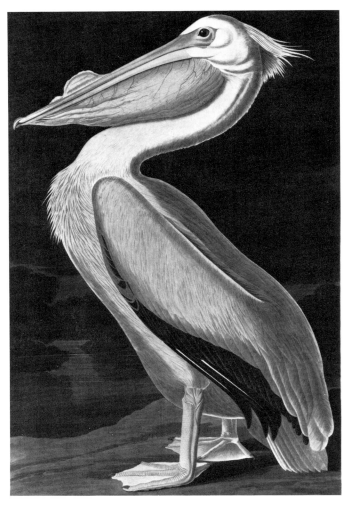

American white pelican. John James Audubon.

Improved techniques for colour printing in the twentieth century was to take natural history illustrations to a far greater market and make a huge contribution to public interest in wildlife and its conservation.

CHAPTER 3
Wildlife Painting in the Twentieth Century

By the end of the nineteenth century clearly recognisable ornithological establishments existed in both the United Kingdom and the United States. The British Ornithologists' Union had been founded in 1858, while in the United States there were three learned societies – the American Ornithologist's Society, founded in 1883, the Cooper Ornithological Society in the west, founded in 1893 and the Wilson Ornithological Society in the east, founded in 1885. These societies were based on the academic study of birds, their members coming mainly from universities and museums. Although today all these bodies are involved in fieldwork, at the turn of the century they were definitely museum-based and of the 'what's hit's history, what's missed's mystery' school. The gun was still mightier than the binocular.

Inevitably this led to an emphasis on representational, feather-sharp bird art. Many of the leading ornithologists were museum-orientated men to whom birds were specimen skins stuffed with tow in a grotesque exaggeration of *rigor mortis*. Very often they had no idea of how birds looked in their natural habitat. Collingwood Ingram (1880–1981) related how some of the leading bird experts in Britain were incapable of identifying birds in the field.

The most popular illustrators in the United Kingdom during the years leading up to the First World War were the expatriate Dane, Henrik Gronvöld and the Dutchman, J.G. Keulemans. Some of the Keulemans illustrations were still being published in the 1970s in *The Observer's Book of British Birds* (1937). They show a romanticised version of birds with exaggerated colour and shade that must have sparked off an interest in many young people; indeed my own copy of this book has a tattered binding through long usage and my image of certain bird species is still as they were drawn by Keulemans and Thorburn, rather than as I know they really are.

Archibald Thorburn represented the bridge between the feather-sharp studies and birds in their environment. It was his large watercolours of gamebirds, ducks and other sporting quarry that set a style imitated by several of his contemporaries and, even today, Thorburnesque originals find a ready sale in sporting galleries. Prominent among the school of Thorburn were Philip Rickman (1891–1982), J.C. Harrison (1898–1985) and George E. Lodge (1860–1954). All had a similar facility with watercolour. Rickman was particularly skilful with the iridescence of plumage, particularly in his paintings of pheasants and ducks. His paintings of small birds were not a patch on his watercolours of gamebirds or wildfowl, but at his best he was certainly better than the much more consistent Thorburn at his worst.

The school of Thorburn undoubtedly appealed to the sportsman. Looking at these paintings of birds in crisp landscapes full of sunlight it is easy to understand why. George Lodge was a keen falconer and his favourite subjects were unsurprisingly birds of prey. His illustrations of raptors in Witherby's *Handbook of British Birds* (1938–41) are, with the exception of Peter Scott's geese, the best in the book. His last major illustrative work was David Bannerman's *Birds of the British Isles* (1953–63), a rather eccentric twelve-volume epic. For Bannerman, Lodge painted birds with plenty of habitat visible, but, while these were often memorable images, it is the illustrations of the birds with which the reader is not familiar that are the most striking. Lodge was an artist who went into the field and understood well the relationship between birds and the landscape. His field sketches were very good and it is instructive to compare these with the finished paintings. There are excellent examples of the loss of spontaneity in the recently published *George Lodge: Artist/Naturalist* (1986) showing how vibrant sketches have been rendered lifeless in some of the finished illustrations, perhaps because he has painted what he knew was there instead of what he saw. In his eighties he wrote *Memoirs of an Artist Naturalist* (1946), in which he admitted to making mistakes and cites preoccupation with scientific book illustration as a big handicap. 'One tends to aim simply at producing nothing but a feather map of a bird's plumage', he

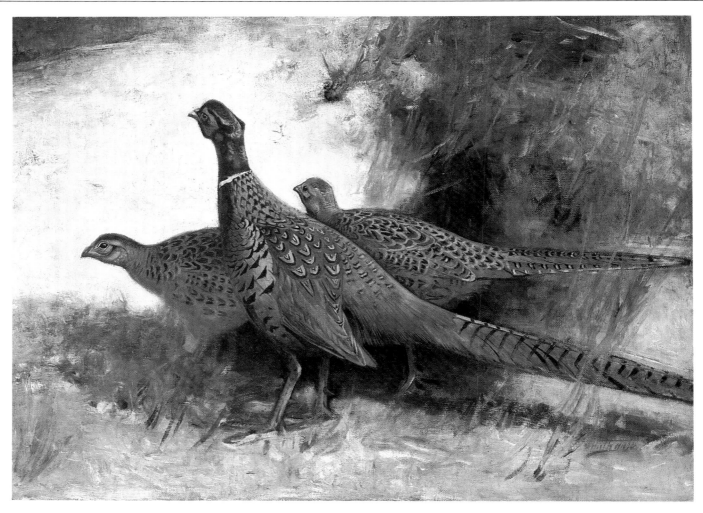

Pheasants. Frank Southgate. (William Marler Gallery)

wrote and added disarmingly, 'I feel that my own pictures have suffered by this.' Even if he did not always succeed, he knew how to draw and how to make pictures. He really did understand the relationship between a bird and its environment. 'Let it be remembered,' he wrote, 'that a blade of grass may be as tall as a snipe; and that one frond of bracken may be as large as a pheasant.' Landscapes, he claimed, should be painted as they are, not from memory, and landscapes should be completed in one day, because light conditions can change very much over 24 hours. He warned particularly about using photographs: 'The difference between a photographic record and an exact impression of rapid movement is erroneous. Rapid actions of birds should be ordered as they appear to the trained eye.' This warning is even more relevant today, when bird photography is much more widely practised and has the added dimension of colour. Whether they admire his work or not, all postulant bird artists should read the chapter of Lodge's *Memoirs* entitled 'Some observations on painting birds'. It is still pertinent some 40 years on, which may be as much a reflection on the small progress made by bird artists as on Lodge's percipience.

In days when it was still widely acceptable to shoot rare and interesting species, a high proportion of artists were also sportsmen. In some this led to their painting the birds they shot, but in the case of Frank Southgate (1872–1916) it was time spent in the field that was transferred to canvas. He was a passionate sportsman, a wildfowler, whose knowledge of birds and the seascapes and landscapes of Norfolk were committed to his watercolour and oil painting, which varied from the detailed to the impressionistic. He died on active service in France in February 1916.

Like Bruno Liljefors, Southgate and Lodge were deeply involved in the countryside. Their paintings sprang from an empathy with their subjects and

they did not seem to be too troubled by the demands of scientists, although Lodge did write of the 'antagonism between science and arts in the minds of people who wrote books about birds'. In the United States at the beginning of the century there seems to have been a much greater appreciation of art and illustration among the scientific establishment. The young Louis Fuertes was perhaps fortunate in being born the son of an academic at Cornell University, then the heart of American ornithology.

Fuertes did, however, face a conflict between the aesthetic and the scientific. His artistic mentor Abbot Thayer, who was successful as a portrait painter and keen amateur ornithologist, had, as we have seen, put forward the theory of countershading in the coloration of birds. Thayer wanted Fuertes to paint birds as they were, camouflaged and merging into their background. On the other hand, Fuertes's ornithological mentor, Dr Elliott Coues, the leading American ornithologist of his day, wanted his protégé to paint birds distinct from their local environment.

There is no doubt that Fuertes was painting birds and other animals in a very original way. While his paintings lacked the atmosphere of Liljefors or the skilful landscape painting of Thorburn, as representations of animals they were hard to fault. There was no doubt that here was a man whose deep knowledge of his subjects, acquired during field experience and in handling stuffed specimens (he was an excellent shot and taxidermist) led to his becoming an inspiration to several generations of American artists. Sadly, Fuertes never had the opportunity to develop as a painter rather than as an illustrator. The financial need to accept commissions for illustrations left him little time to concentrate on producing gallery paintings. In his late forties he had reached a position where at last he could begin to paint some gallery paintings and had begun to produce some exciting

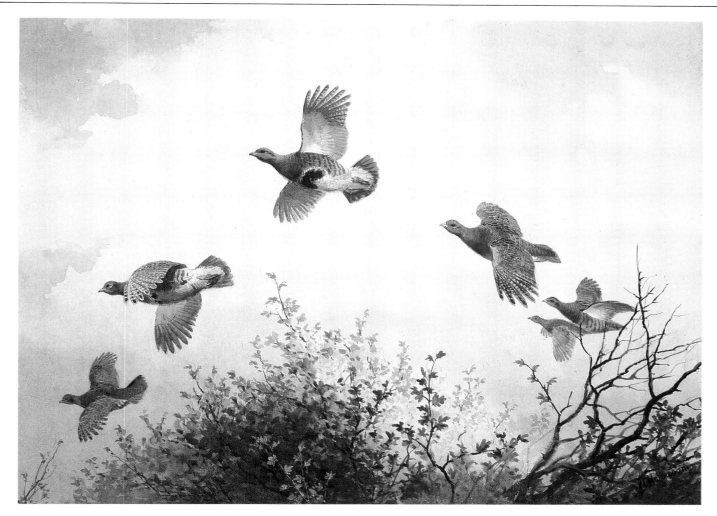

Partridges. J.C. Harrison. (William Marler Gallery)

large oils. But at the age of 53 he was killed when his car was struck by a goods train on a railroad crossing in upstate New York.

His death was truly untimely, because it may have had a long-term affect on North American bird painting. In a paper in *The Living Bird* (1979) Robert Mengel suggested that imitation of Fuertes fossilised American bird painting for many years. It is ironic that this should have been the case, because in the first part of the century North American artists were much more innovative than their European contemporaries. As well as the more formal illustrations of Fuertes and Major Allan Brooks, a Canadian, there were artists like Frank W. Hennessy, Francis Lee Jaques and Bruce Horsfall, all producing interesting painting; and the scientific establishment in the United States seemed much more encouraging to artists than were British counterparts. At their meetings both the American Ornithologists' Union and the Cooper Ornithological Society held exhibitions of paintings. The work of Fuertes had first received ornithological approval at an AOU Congress in Washington, D.C. in 1895. It was the same congress 30 years later that saw the debut of the man who through his illustrations was to revolutionise birding, Roger Tory Peterson, then a shy 17-year-old. He met Fuertes, who was kind and encouraging about the two paintings Peterson was exhibiting. The next year there was a large exhibition of paintings at the Cooper Ornithological Society meeting in Los Angeles. Almost all the leading American bird artists were represented and again Peterson was among the exhibitors.

The popularity of magazines in North America during those years provided illustrators with a market that barely existed in the Old World. In addition to Fuertes and Brooks, there was Charles Livingston Bull, a leading magazine artist, who specialised in wildlife subjects. As late as the 1950s and 1960s natural history illustrations were in demand from both general and specialised magazines. Among today's wildlife artists both Arthur Singer and Bob Kuhn began their careers as magazine illustrators.

In addition to magazines, museums were another source of illustrations in America and, again, one that barely existed in Europe. Perhaps because museums in North America have tended to be creations of the twentieth century, the approach to them in the United States has been more exciting. Dioramas have long been used to give additional information about the way in which the animals lived. The exhibits in the American Museum of Natural History in New York thrust themselves on the attention of the visitor, but they are not all new: some are over 50 years old. Artists such as Fuertes, Francis Lee Jaques, Carl Rungius and Charles Knight were employed by American museums to paint dioramas in which stuffed specimens were shown against their typical habitats. By contrast, in London's Natural History Museum in South Kensington the wonderful Victorian gothic architecture of Alfred Waterhouse is so dominant that the visitor is often more aware of the building than of the exhibits.

Mammals in North America are on a larger scale than in Europe, where, with the exception of deer and wild boars, there are few mammals large enough to attract the attention of the hunter. Traditionally, therefore, the European sportsman took his rifle to Africa where he shot at the plentiful game. To remind himself of the excitement of safari, he wanted oil paintings as well as stuffed heads on the wall. In Germany were two artists expert in this field. They were Richard B.L. Friese (1854–1918) and Friedrich Karl Wilhelm Kuhnert (1865–1926). Another artist of German origin was Carl Rungius (1869–1959) who emigrated to the United States in 1894 and specialised in North American mammals. Another sportsman-

artist, he became an expert woodsman with an unrivalled knowledge of the Rockies and their wildlife. His paintings and drypoints are full of atmosphere with an overwhelming sense of real experience. His animals have a grandeur that matches his landscapes, but because there were animals in these landscapes, the art world refused to take his work seriously. According to Robert M. Mengel, when Rungius omitted the animals his work became acceptable. That 60 years later so-called wildlife art is still unacceptable to the artistic establishment suggests a certain tunnel vision on the part of the establishment.

While modern painting in the form of Impressionism and Neo-Impressionism did influence some artists such as Rungius and Liljefors there was little innovation in the early years of the century. One artist who was doing some radically different work was J.A. Shepherd, a cartoonist whose work appeared in *Punch*. His bird illustrations for *The Bodley Head Natural History* (1913) by E.D. Cumings were quite different from any then in print. Each bird is a charming creature, full of life, and each species is shown in several poses, a technique that was not to be used for another 60 years. Shepherd seems to have had very little influence at the time, but the simplicity of his approach was later emulated by R.B. Talbot Kelly, E.A.R. Ennion (1900–81) and several living British artists including John Busby.

To some extent British wildlife art ossified during the 1920s and 1930s. Thorburn, Lodge and their like had reached a style that was popular with buyers and the colour illustrated books published at the beginning of the century were still selling well. There did not seem to have been a very large market for painting, but wood engravings did enjoy a resurgence. A leading engraver and etcher was a young man of Cheshire farming stock, Charles Tunnicliffe (1901–79). Trained in London at the Royal College of Art, he returned to the farmyard scenes of his youth to provide subjects for his prints. His first published natural history illustrations were the wood engravings that he did for Henry Williamson's *Tarka the Otter* (1932). His skill as an engraver has been underestimated, perhaps because of his later renown as a watercolourist. It was largely through these illustrations for *Tarka*, and those for Williamson's other nature stories, that Tunnicliffe began to tackle wildlife as a subject. Although these wood engravings show him to be a worthy successor to Bewick, some show a weakness of observation. But this weakness did not persist: Tunnicliffe built up a huge library of sketches, made in the field and in zoos. To this he added a collection of measured drawings of dead specimens of birds and mammals, some of which have been reproduced in *Tunnicliffe's Birds* (1984), providing a fund of information for all naturalists whether they paint or not. Tunnicliffe could draw anything he saw. Looking through his notebooks, it is clear that he regarded buildings, farm animals, motor cars and farm equipment all as well worth drawing as birds. This eclectic approach could be why his work was taken seriously enough for him to be elected a Royal Academician, which is a very good reason for people who think of themselves as wildlife artists to practise drawing subjects other than wildlife. Only when they do so will people consider the painting of wildlife as important as the painting of portraits, landscapes or the human form.

The pre-war paintings of Sir Peter Scott never achieved critical acclaim, although they were hung in several Royal Academy Summer Exhibitions. Scott was a wildfowler who shared the Cro-Magnon desire to make representations of his quarry. His oil

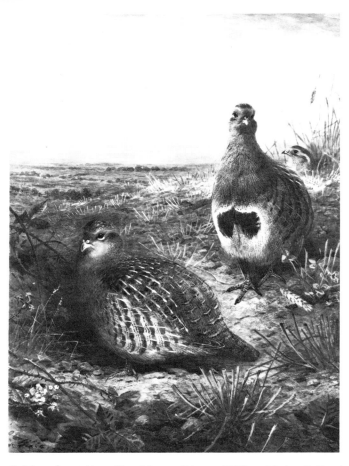

Red-legged partridges. Otto Murray-Dixon. (William Marler Gallery)

paintings of wildfowl flighting in across an evening sky showed just what he saw when he was lying in a punt in the Fens. He was a master of light and showed his birds in the colours in which he saw them, not as he knew them were. Scott was in the tradition of Liljefors, and he had in common with the great Swede the ability to paint convincing flying birds. Apart from Southgate, another hunter-artist, Scott was almost alone among British artists in being able to paint birds in flight that looked as though they might be keeping themselves aloft, rather than representing them as bedraggled lumps of feathers hung from a wire. Scott allowed limited editions of prints of his paintings, which brought him fame, fortune and accusations of hackneyed commercialism from the art world. Scott handles light in a way that few other artists can; however, his protégé, Keith Shackleton, has developed a style in which light plays a fundamental part and his treatment of seabirds and seascapes is unrivalled. Probably the confidence revealed in the oil paintings of Scott and Shackleton has particular appeal in the United States, where both artists are better appreciated than they are in Britain.

Most British wildlife art has been on a less grand scale than the oils of Scott and Shackleton. Most artists have chosen watercolour although some like Tunnicliffe have used oil on linen, a technique pioneered by Allen W. Seaby, Professor of Fine Art at Reading University until 1933. For his watercolours Seaby used tinted paper, allowing the texture of the paper to emphasise the texture of the background to the picture. Seaby was accomplished in a variety of media, including print-making and was much influenced by the Japanese.

Oriental art helped to release some European bird artists from the confines of over-realism and introduced a minimalist element into paintings of birds. One of the first to experiment with Japanese art was R.B. Talbot Kelly. After resigning from the army in 1929 Talbot Kelly, already a member of the

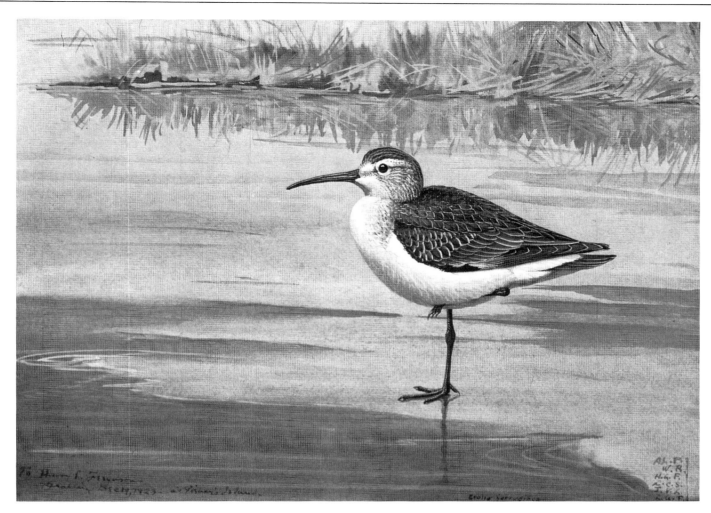

Curlew sandpiper. Louis Agassiz Fuertes

Royal Society of Painters in Water Colours, became an art master at Rugby School. His approach reduced birds to line and blocks of colour, sometimes caricaturing them in a way that Walt Disney might have envied. His approach, constantly changing, showed what could be achieved by looking at birds in a way that was oriental rather than European, creating pictures of living, moving creatures.

Almost contemporary with Talbot Kelly, but, like him, an inspirational teacher with a very individual approach was Dr Eric Ennion. Ennion was a general practitioner in the Cambridgeshire Fens for almost 20 years before devoting himself to drawing birds, writing about them and teaching people about natural history. He probably had an even quicker eye than Talbot Kelly and was able to catch the shape of moving birds in a way that has only been approached by John Busby, Liljefors or Lars Jonsson (1952–). Both Talbot Kelly and Ennion were to be influential on British bird painting: Talbot Kelly's *Bird Life and the Painter* (1955) and John Busby's *The Living Birds of Eric Ennion* (1982) should be required reading for all students of bird art. An understanding of some of the ideas in these books could increase standards of bird art in Britain.

Ennion in particular played an important part in encouraging the interest in natural history which blossomed in the United Kingdom immediately after the Second World War. His books for both adults and children and his work as a field centre warden were important in awakening and sustaining the interest of the young in natural history. Nevertheless it would be wrong to suggest that the work of illustrators was alone responsible for the creation of such interest. The major factors must have been radio and television, but even there the leading personality in natural history broadcasting was Peter Scott. The widespread use of

his paintings as prints to be hung on living room walls throughout the country and as greeting cards must have stimulated much of the interest later to be exploited by radio and, especially, television. As a result of this burgeoning interest in wildlife, greeting card manufacturers, advertising agencies and publishers began to take an interest in wildlife. By the 1960s conservation and ecology were becoming fashionable: the concern about the environment, aroused when it was almost too late, thrust forward organisations such as the National Audubon Society in the United States, and the Royal Society for the Protection of Birds in the United Kingdom. Opportunities for illustrators arose from this new awareness in the form of more greeting cards, gift items, magazine illustrations and educational material.

Among the young artists whose work was used by the RSPB was Robert Gillmor (1936–), a talented print-maker as well as a first-class illustrator. It was he, with Eric Ennion, who founded the Society of Wildlife Artists in 1964. A similar organisation, the Society of Animal Painters was founded in the United States in 1970. Initially the SWLA helped to raise standards by its selective annual exhibitions, but in recent years there has been a feeling of *déjà vu* among visitors to the exhibitions, some of whom have complained that the standard has not perceptibly improved. Now more than 20 years old, the SWLA seems to have done little to remove the artistic prejudice against wildlife painting. If they wish to be taken seriously SWLA members might be better employed making an all-out assault on the bastions of the art establishment by submitting to the exhibitions of the Royal Academy and the Royal Institute. Eventually the arbiters of artistic taste might realise that a painting of a golden eagle in flight has as much right to be hung as a painting of a female nude.

Of course, the lack of imagination shown by some painters of wildlife may have prejudiced the art critics against the genre. To look at some modern paintings of animals it is hard to believe that photography was invented more than a century ago; feather-maps are no longer needed but they are still painted. While Scott, Ennion, Busby, Talbot Kelly and Jonsson were all released from realism by the invention of photography and the more realistic painters such as Eckelberry, Gillmor and Shackleton employed a strong design element in their composition in a way that no camera could achieve, there are many painters still producing and selling work that could quite easily be photography.

To some artists photographs have created a trap, distracting them to paint in a more detailed fashion than necessary, sometimes slavishly copying unnatural postures exaggerated by the split second freezing of the photographic image. Some even go as far as painting the background as if it were going out of focus.

A further problem comes from the excellence of photographs today. Both still and cine photography produce beautiful images that are far better and far clearer than a viewer can ever hope to have in the wild. Unreality is exaggerated by editorial cropping of a picture to emphasise the size of the subject. Artists have yet to come to terms with this and to exploit the advantages over the photographers that they enjoy. Gradually they are realising that they can recreate experiences of wildlife and wild places that no photographer can hope to emulate. Some have also learned that to many lovers of wildlife, the places where animals live are as important as the wildlife itself.

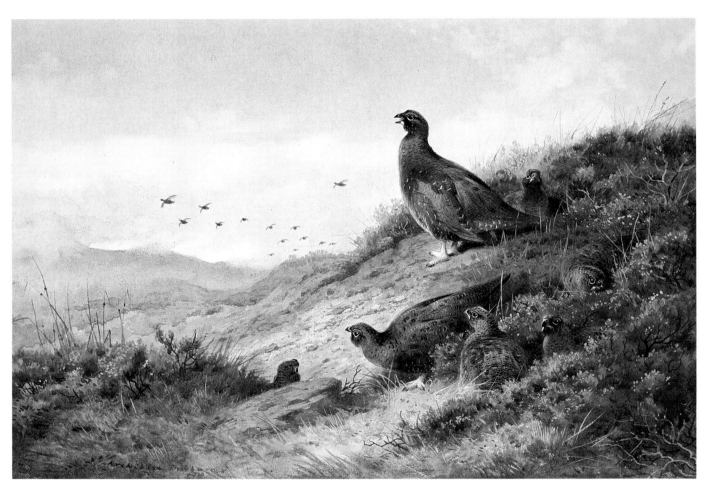

The beaters are coming: red grouse. Archibald Thorburn. (William Marler Gallery)

CHAPTER 4
Illustrations for Identification

Binoculars and field-guides have revolutionised the study of natural history in the twentieth century. Improvements in binoculars and, more recently, telescopes have helped the development of identification skills, particularly of birds, but it has been the 'field-guide' presentation of comparative illustrations that has really enabled naturalists to identify what they see more accurately.

There is an enormous gulf between the line engravings in Ray and Willughby and the colour illustrations in today's field-guides. Even so the field-guide and its illustrations are still changing, as artist, author and editor experiment with new approaches. The development of books that helped identification hastened the end of the gun as a necessary tool for the field ornithologist. It also took the skill of identification out of the hands of the museum men and put it in the grasp of the field men.

With increasing information from the birdwatchers themselves bird identification has gone far beyond the separation of similar species to cover age and sex differences once thought impossible to differentiate. Even more encouraging is the transfer of techniques long used by birdwatchers to other groups of animals. However, it is not surprising that with birds as the most popular creatures for study it was with birds in mind that the first field identification guides were published. Peter Tate in *A Century of Bird Books* (1979) suggests that the first field-guide might have been *Our Country Birds* by W.J. Gordon, published in 1892 and illustrated by G. Willis and R.E. Holding. The plates showed several similar species and, while they were not very good, did give people the chance for comparison. Tate's other candidate for the first field-guide is *Birds of the Ocean* by W.B. Alexander, published in 1928. In this book drawings and photographs appear with descriptions and notes on range and identification features. To search for candidates for the first field-guide is an academic exercise of passing interest which cannot be taken too seriously, because it is only too obvious that *A Field Guide to the Birds* by Roger Tory Peterson, published

in Boston in 1934, was the real first field-guide. More than 50 years later it is difficult to understand that there was reluctance among publishers to take this book. None could be found in New York and eventually the Boston publishers, Houghton Mifflin, published the field-guide, but they did so with less than

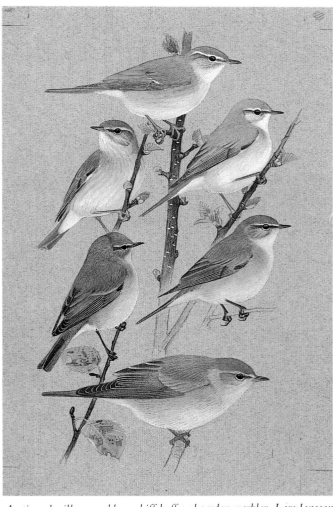

Arctic and willow warblers, chiffchaff and garden warbler. Lars Jonsson, from Fåglar i Naturen

wholehearted enthusiasm. Francis H. Allen, the
Houghton Mifflin editor who handled the guide, was
chairman of the board of the Massachusetts Audubon
Society and as such was enthusiastic about the project,
but nevertheless he sought the advice of Richard H.
Pough of the National Audubon Society, who was so
sure of the guide's potential that he said he would have
been prepared to have backed it with his own money.
Pough's confidence was confirmed by the first edition
of 2,000 copies selling out within a week.

The idea for the guide came when Peterson and a
fellow-naturalist, William Vogt, were duck-counting
on the Hudson river in December 1930. Awed
by Peterson's ability to identify birds quickly and
accurately, Vogt suggested that he should combine his
birding and painting talents to produce a guide. Vogt's
enthusiasm overcame Peterson's initial reticence and
within four years the book that was to be perhaps the
single greatest personal contribution to birding this
century was published.

Few owners of the field-guide have probably read
the preface, but to do so some 50 years after it was
written is to be reminded of some of the fundamental
virtues of the concepts which have been forgotten by
some of the illustrators of later guides: 'We found
many bird books but although descriptions were
complete and illustrations authoritative, the one thing
we wished for – a "boiling down", or simplification,
of things so that any bird could be readily and surely
told *from all the others* at a glance and at a distance – that,
except fragmentarily, we were unable to find.'

It is the simplicity that makes the illustrations to the
original Peterson so special. Only four plates were in
colour, but the remaining monochrome plates with
pointers to two or three salient features revolutionised
the way in which Americans looked at birds. In
publishing, too, it caused a small revolution. A new
format had been invented, but it was some years
before the concept really took hold outside the United
States, but now the field-guide market is well-
recognised in Northern Europe, Africa, Australasia
and Japan.

As a keen birder who spent many hours in the field
Peterson was well aware that many of the birds that
the birder sees are in flight. Flying birds are extremely
difficult to draw convincingly and few artists in the
first 30 years of this century attempted it. Liljefors did
it often and superbly, Fuertes did rarely and Lodge
often tried it but not very well. Peterson did it very
well in his field-guide, his simplified drawings clearly
showing the diagnostic characters for which the birder
should be looking. Having distilled the illustrations to
the features he could see, ignoring the features he
knew to be there but was unable to see, Peterson had
given himself a possible direction in which to take his
gallery painting. Instead he seems to have gone in the
opposite direction – becoming more rather than less
detailed.

Although he had retained the same simple formula
for his European field-guide published in 1954, 20
years later after the American original, his plates for
the Mexican guide, published in 1974, were in a more
detailed style. Most of the other illustrators in the
'Peterson Field Guide Series' and the Collins European
guides have become rather more detailed in their
approach. From a publisher's point of view there may
be good marketing reasons for this, because many
book buyers associate detail with quality. To many
readers the plates by Don Eckelberry for the *Audubon
Bird Guide* (1946) probably had more appeal, because
they show much more lively-looking birds, even
though it is doubtful whether they are better

identification drawings. More than a million copies of
this book were sold.

The third American illustrator of notable
field-guides to birds was Arthur Singer who produced
the plates for the Golden Guides and for *The Hamlyn
Guide to the Birds of Britain and Europe*. Published in
1970, this was the first European guide to show several
species in a plate opposite text about each of these
species. This was particularly useful for the less
experienced birdwatcher who could see instantly the
geographical distribution and habitat preferences of
the bird he was trying to identify. It also had vignettes
demonstrating behavioural aspects of each species.

One of the best series of comparative illustrations is
Peter Scott's *A Coloured Key to Wildfowl of the World*
published by the Wildfowl Trust in 1957. This must be
one of the best guide books ever published in any
subject and as a series of comparative illustrations of
similar bird species it has probably not yet been
bettered. In view of the artist, this should not perhaps
be a surprise, but Sir Peter Scott is usually thought of
as an artist of large oil paintings rather than as an
illustrator. In reality he is a first-class illustrator: his
plates of geese for *The Handbook of British Birds*,
published in 1938, were far better than any of the other
plates, most of which were a job-lot bought from a
Dutch publisher. Almost 40 years later, in the
successor to the handbook, *The Handbook of the Birds of
Europe, the Middle East and North Africa* (1977), the
editors took a rather more serious view of the
illustrations, but despite the improved standard of the
plates, it was Sir Peter's geese and swans which stood
out from the others in Volume 1.

The high standard of Sir Peter Scott's illustration
underlines the necessity for artists to know their
subjects intimately. Knowledge and enthusiasm are
the keys to the work of today's leading scientific
illustrators. In the United States Larry B. McQueen
and Guy Tudor are two artists who really know their
birds. Both have become knowledgeable about South
American species and both are working on plates for
handbooks.

In Britain Peter Hayman (1930–) is an artist
who has specialised in identification illustrations. An
architect by profession, Hayman came to bird
illustration through his enthusiasm for birds in the
field. It was his plates for *The Birdlife of Britain*,
published in 1976, that showed the direction in which
identification pictures were to go. They moved away
from the standard profile of a species, the male in
profile, the female respectfully behind, half-obscured.
Instead Hayman showed males, females and juveniles
from a variety of angles and in a variety of postures. As
a book it is beautiful to look at, but, more importantly,
it is a very useful source of reference.

A pocket version followed. This, *The Mitchell
Beazley Birdwatchers' Pocket Guide* (1976), despite an
eccentric ordering of species, is ideal for use in the field
in Europe, because again it shows a variety of
behaviour and rear views, which are particularly
useful for those of us whose birds are so often seen as
they fly away from us. Since working on a similar
book for the RSPB, entitled *What's That Bird?* (1979)
Hayman has produced the plates for *Shorebirds: An
Identification Guide to the Waders of the World* published
by Croom Helm in 1986.

At the same time as Hayman was working on *The
Birdlife of Britain*, a young Swedish ornithologist
and artist was working on a five-volume series for
Wahlström and Widstrand in Stockholm. Lars
Jonsson's illustrations combine the simplicity of
Peterson's field-guide plates and the behavioural

approach of Hayman. Very successful in Sweden, the series was remaindered when it was published in the United Kingdom. However, the fifth volume, *Birds of the Mediterranean and the Alps* (1982), was successfully published in the United Kingdom by Croom Helm. The standard of illustrations in this guide are far better than any other covering the same area, particularly the eastern Mediterranean. Jonsson is a first-class field ornithologist, who has watched birds on both sides of the Atlantic: his ability to sort New World migrants in the fall is envied by many native North American birders.

Most popular of all groups of animals, it is not surprising that the illustration of birds has developed further than the illustration of other groups, at least in terms of identification. The guides on other groups do not usually have the fundamental simplicity of those original Peterson field-guide plates. For example, Richard P. Grossenheimer's illustrations for *A Field Guide to the Mammals* (1952) and Denys Ovenden's for *The Mammals of Britain and Europe* (1980) both show mammals as animals covered in fur, when, in reality, we rarely approach wild mammals closely enough to be able to make out their fur. It would be interesting to see a mammal guide that employed simplified colours and shapes. Bats would be a group that would lend themselves to this treatment, especially if combined with a behavioural approach, despite the claims of some mammalogists that visual identification of flying bats is impossible.

The study of several groups of animals has barely progressed beyond the turn of the century in that identification can only be made if the creature is in the hand. Far too little work has been undertaken on behavioural characters as a guide to identification and yet it has been shown that such an approach can work for reptiles, amphibians and some insect orders, such as dragonflies and butterflies. The illustrations by Denys Ovenden in *A Field Guide to the Reptiles and Amphibians of Britain and Europe* (1978) are beautifully painted and exquisitely designed, but there is in them no suggestion of the behaviour or habitat of the animals shown. A change came, however, with Ovenden's illustrations for *The Collins' Handguide to the Wild Animals of Britain and Europe* (1979), which shows animals in their preferred habitat.

Entomologically, field identification has been slow to catch on, but as far as butterflies are concerned it becomes even more probable. Bjorn Dahl's *The Butterflies of Northern Europe* (1978), published in Sweden by Wahlström and Widstrand and in the United Kingdom by Croom Helm, makes an effort to show butterflies as they are seen in their habitat, not as specimens pinned out in a collection. Although Richard Lewington's excellent illustrations for *The Mitchell Beazley Pocket Guide to Butterflies* (1981) by Paul Whalley do show spreadeagled butterflies, they also show profiles of butterflies with their wings closed, which is the position in which we so often see them. Whalley's book is intended for use in the field

Bedriaga's rock lizard, Tyrrhenian wall lizard and Maltese wall lizard. D.W. Ovenden. From A Field Guide to the Reptiles and Amphibians of Britain and Europe

and having personally used it to identify species with which I was not familiar I can vouch that it does work. The efforts of Paul Whalley to encourage field identification, and photographs such as those by Frank V. Blackburn which show free insects in their natural habitat instead of over-lit close-ups, pave the way for artists to look afresh at insects.

Half a century after Peterson began the field-guide revolution there are still exciting challenges for the wildlife illustrator, not the least of which is returning to the provision of simple material for beginners. Apart from the challenge of developing the identification techniques for groups other than birds, there is the so far untapped potential of video and animation. Using ciné film for identification has many of the drawbacks that still photographs have as identification aids: poor light conditions changing colours, atypical individual birds and distortion through the lens. Animation could overcome many of these difficulties and still have the advantage over book illustrations of showing movement and aspects of behaviour. Somewhere there must be a successor to Peterson who can revolutionise identification once more by harnessing the extra dimension allowed by today's technological revolution.

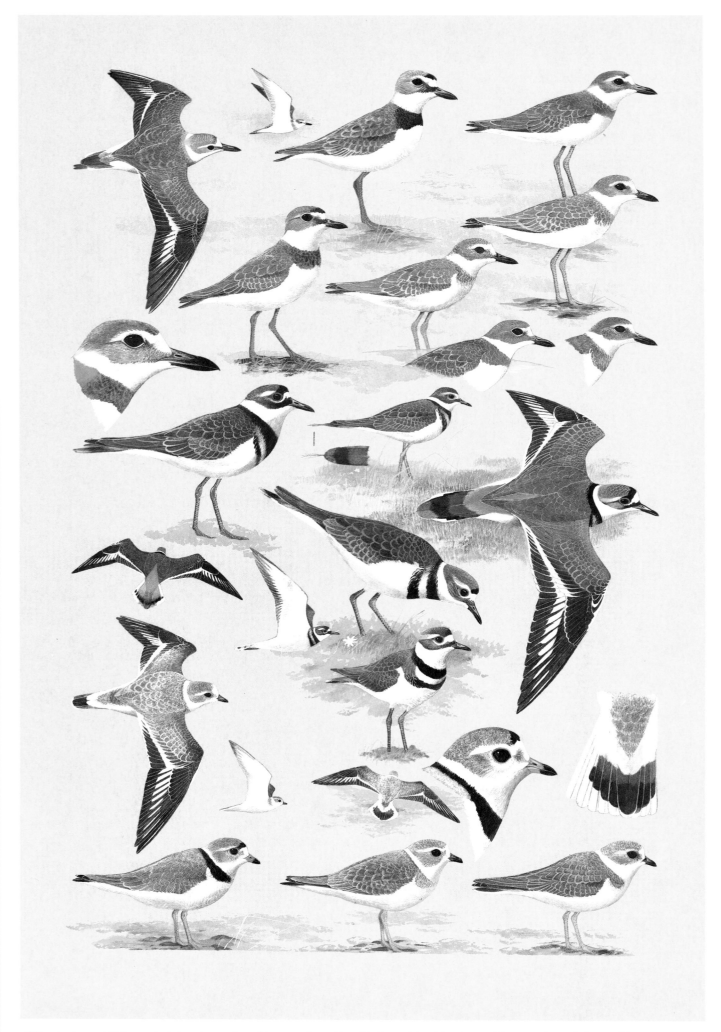

Wilson's plover, killdeer and piping plover. Peter Hayman, from Shorebirds: an identification guide to waders of the world

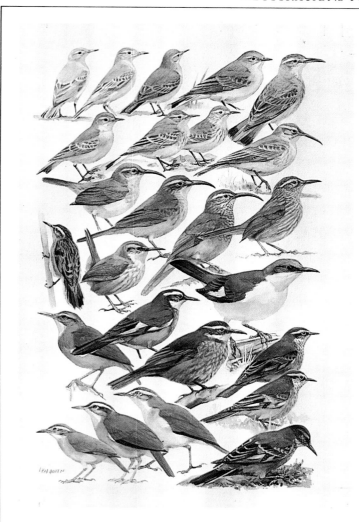

Miners, earthcreepers, cincoides and horneros. Lawrence B. McQueen, The Birds of Peru

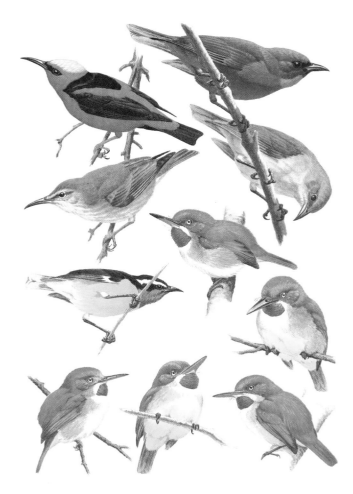

Hummingbirds. Don R. Eckelberry. From The Birds of the West Indies

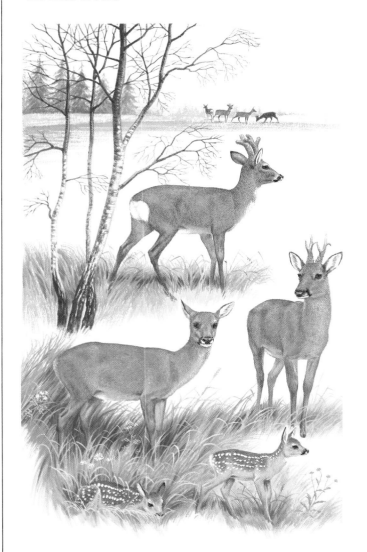

Roe deer, muntjac and Chinese water deer. D.W. Ovenden. From The Mammals of Britain and Europe

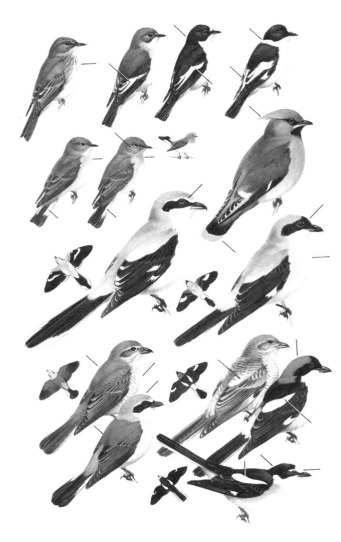

Flycatchers, waxwing and shrikes. Roger Tory Peterson. From A Field Guide to the Birds of Britain and Europe

Part Two
The Artists

WINIFRED AUSTEN

The sight of an old lady dressed in the subfusc tones of autumn and peering from the cover of a tree trunk was no surprise to the inhabitants of the East Suffolk village of Orford. Armed with powerful binoculars, which she no doubt referred to as 'field-glasses', and a sketch-pad, which she filled with drawings and notes, Winifred Austen would venture into the surrounding countryside in search of the animals that made up her subjects.

For almost 40 years, until her death in 1964, she lived in a 200-year-old redbrick cottage called 'Wayside' surrounded by pets and animal waifs brought to her by her neighbours. Across the estuary of the rivers Alde and Ore lay Havergate Island, an RSPB nature reserve established in 1948 to protect the avocets that had returned there to breed after an absence from England of more than a century. The countryside epitomises the East Anglian coastal scenery, the combination of sea, river and marshland, that Winifred Austen loved. Her love of the area began when she visited Norfolk on a winter holiday with fellow students from the private art school in London where she studied under Mrs Jopling Rowe and C.E. Swann. On that trip she was enthralled by the wildfowl which she spent many hours painting.

Born in Ramsgate in 1876, she was the daughter of a surgeon in the Royal Navy who later became a London doctor. His wife, in order to keep her young

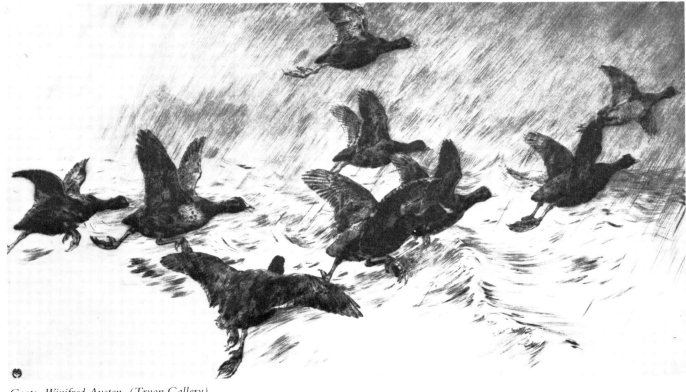

Coots. Winifred Austen. (Tryon Gallery)

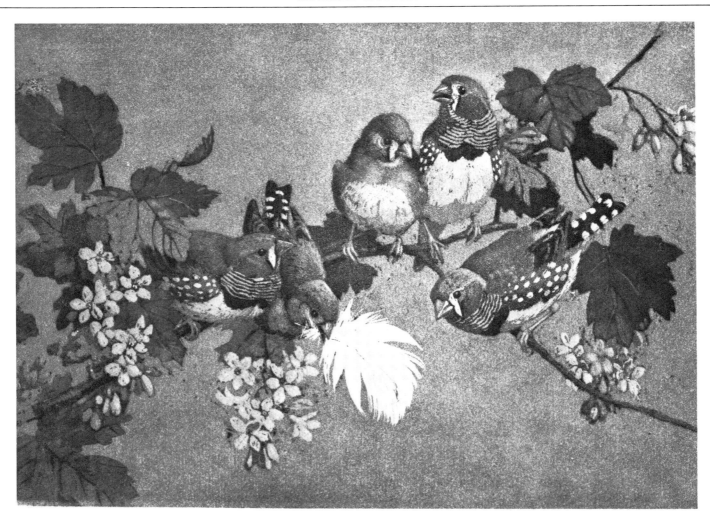

Zebra finches. Winifred Austen. (Tryon Gallery)

children quiet during surgery hours, set them to paint with a sixpenny prize for the best. Winifred always won. Many of the subjects that she painted were the pets that she always kept and later she would visit London Zoo to paint the inmates. Her first painting to be hung at the Royal Academy was the head of a lion drawn at the zoo. Lions were particular favourites with the Victorians, presumably because they were the symbols of the great British Empire. Winifred Austen was scarcely out of her teens when this painting was hung and her precocious talent was recognised.

Commissions for illustrations for books and magazines followed and soon she was successful enough to need an agent. It was her agent, Oliver O'Donnell Frick, whom she married in 1917. Frick was anxious that all her work should be pure 'art', and when she obtained a commission to illustrate some postcards a compromise was reached, whereby she signed them 'Spink', a local name for the chaffinch. Sadly, within six years she was widowed, just as she and her husband were about to leave London for Suffolk. She made the move on her own in 1926 having bought 'Wayside'. Her work continued to be in demand and in addition to commissions for illustrations there also came requests from people who wanted to own paintings of favourite birds or mammals. Magazine commissions came from mainly the United Kingdom and the United States and a set of postcards of British birds was published. As a schoolboy in the 1950s I can remember receiving these from my grandmother: to me these simple, gentle watercolours represented the real world that existed beyond the school gates. (Miss Austen preferred watercolour to oils because she never liked the smell.)

The most well known of the books illustrated by Winifred Austen was Patrick Chalmers's *Birds Ashore and Aforeshore*, published in 1935. For this she contributed 16 plate and 16 line drawings. It must be admitted that the quality of these plates is not consistent, but the best, such as the flock of eight bearded tits amid the reeds or the flock of 20 coots struggling to take off, demonstrate her lively composition and sharp observation of the birds. Others, such as the lapwings or herons, although charming, are rather weak.

Etching and drypoint engraving were also favourite media. She produced over 200 etchings. The first was a dormouse printed in 1908. She was particularly good at etchings of small animals, emphasising the expressiveness of their eyes. Many of her models for these etchings were animals brought to her by neighbours. One wood mouse, rescued from a farm dog, was cared for by her for three weeks and then released, having been the subject of a watercolour that sold immediately when it was hung at an exhibition of the Royal Society of Painters in Water Colours. The wood mouse, named Walter after the dog from which it was rescued, was also the subject of an etching. The whole edition of 100 sold within weeks of the opening of the 1945 Royal Academy Summer Exhibition.

After her first submission to the Royal Academy in 1899 Winifred Austen exhibited regularly, having over the years more than 70 pictures hung. In addition her work appeared at the Royal Society of Painters in Water Colours, the Royal Society of Painter-Etchers and Engravers and the Society of Women Artists, to each of which she was elected. She also exhibited at the Paris Salon.

Winifred Austen's work was very variable. The best, though, was very good and stood comparison alongside any other British wildlife artists of her generation. She was particularly skilful at bringing life to small mammals and birds. Although she did paint some good pictures of large birds, like herons, it was her groups of small birds that really come alive.

ROBERT BATEMAN

Although he is probably the world's most expensive painter of wildlife, Robert Bateman's advice to aspiring wildlife artists is to forget about selling paintings. 'Don't paint for the market' he advises, 'I never sold a painting until I was 35.' Too many young artists, he feels, aim at the market rather than painting what they want to paint. Sometimes they find a market too soon, never daring to develop in case their market fails. Bateman's not selling a painting until he was 35 gave him plenty of time in which to develop. But when he did begin to sell, he really sold.

Since childhood his twin enthusiasms have been wildlife and painting, but painting is no easy task for him. 'It certainly is not a pleasant relaxation,' he says, 'any more than playing golf is a pleasant relaxation for Arnold Palmer. It's serious work and very often it can get, well, almost depressing.' He often puts aside a painting soon after he has started it. He then goes back to another barely started painting. In this way he will finish several almost simultaneously. At his 1985 exhibition at the Tryon Gallery in London's West End there were several paintings dated '1985', but he explained to me how this resulted from his having a number of paintings in hand at the same time. This is helped by his training in the Kimon Nicolaides method of Carl Shaeffer. Nicolaides, coincidentally one of Roger Tory Peterson's tutors in pre-war New York, emphasised the need for economy and sureness of line to catch the essence of a subject. Perhaps economy of line is not an obvious facet of Robert Bateman's paintings, but it is his ability to catch the essence of a wildlife subject that gives credibility to his pictures. Animals are usually moving when they are seen and the artist has to be quick to capture their likeness.

'I learned to draw very quickly,' he says, 'to make mistakes and correct them and evolve a composition. I learned to make statements and to change them without using tissues.' Working like this is not easy, especially if the artist is to make the method work.

There can be no doubt that Bateman does make this method work. His best work shows the glimpse of an animal in a landscape. At first the eye may not notice the animal: the rough-legged buzzard is suddenly noticed among the entanglement of elm trees, the great horned owl in the canopy of spruce has been looking down at the viewer before it is seen. The strong patterns in these paintings have an abstract quality that balances their realism.

Once Bateman did paint in the style of abstract expressionism. Indeed, he is the reverse of the more usual progression from realism to abstraction. He went there and came back. It was a long journey that began and ended in Toronto via some of the world's wilder places. But for Bateman the light came not on the road to Damascus but at Buffalo, New York.

Neither of the Bateman parents was artistic, but two of their sons are artists. Wilbur Bateman was an electrical engineer with Canadian General Electric. His eldest son, Robert, was born in Toronto in 1930. Six years later Wilbur built a new house on the outskirts of Forest Hills, an affluent suburb of Toronto. Here young Bob was close to the Ontario countryside, near a barely used commuter railway line that passed through a well-wooded, animal-rich ravine. Moreover, the Batemans lived on the migration route known as the Toronto flyway; in two years Bob identified 100 species in the area, including a high-flying flock of white pelicans. When he was 12 his mother suggested that he and a friend should join the Junior Naturalists' Club at the Royal Ontario Museum. Inspired by books such as Ernest Thompson Seton's *Two Little Savages* and illustrations by Allan Brooks and Louis Agassiz Fuertes and the encouragement of the Royal Ontario Museum, Bateman decided that painting and natural history were to be the mainsprings of his life.

At the museum he was taught to carve balsawood bird models by Frank Smith. He was also shown how to make duck decoys, in the 1940s not yet fashionable objects of interior decor. The museum staff were

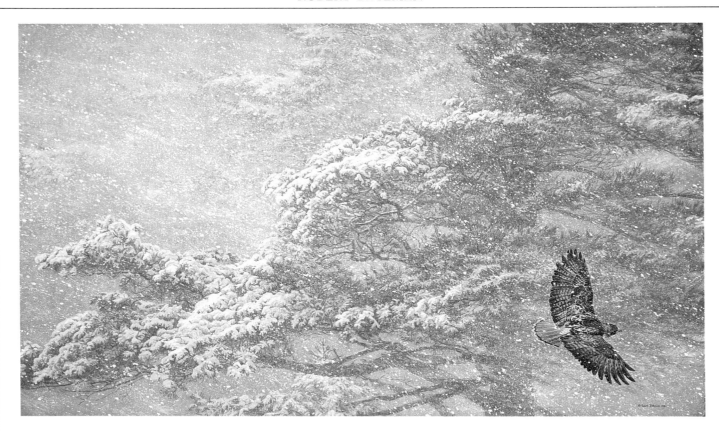

Sudden blizzard: red-tailed hawk. Robert Bateman. (Mill Pond Press)

wonderfully accessible to the young naturalist. Particularly significant for Bateman were the assistant curator of ornithology and Terence Shortt, chief illustrator and head of the department of art and exhibits. Shortt's modest expertise and accurate approach were object lessons to Bateman, indispensable in his later career. When he reached 17 he and his fellow junior naturalist joined with some of the returning young Second World War veterans to form the Intermediate Naturalists. Many of those members are now in the top positions in the Canadian conservation and biological establishment.

It was as a mammalogist that Robert Bateman began to make a mark. From the age of 17 he took a job for three summers at a government wildlife research camp at Algonquin Rock, the oldest of Ontario's provincial parks, situated on the edge of the Canadian Shield. Although he was only given menial tasks, he did have the chance to meet the scientists and listen to their debates. It certainly helped to develop his affinity for wildlife biology and zoology.

Despite this background he did not pursue zoology at university. He had neither the inclination nor the mathematical ability to follow pure science. Instead, he chose a geography honours course at the University of Toronto. The course, which he began in 1950, was broadly based which suited Bateman's interest in natural history and gave him a background in geology and physical geography as well as plenty of opportunity to go into the field. Throughout this period he was trapping small mammals, discovering more about their distribution and writing scientific papers, but he was not ignoring art.

At 18 he had won a Junior Art League prize of art tuition at the Arts and Letters Club. He studied with Gordon Payne for three years on Saturday mornings. Payne taught him the principles of academic painting and the habit of analysis, introducing him to abstract work. Then, beginning at university and continuing for five years, Bateman studied in the evenings with Carl Shaeffer.

The career that Bateman chose was teaching because he needed to earn a living and have the time and freedom to travel. After a course at Ontario College of Education he became a teacher of geography and art in high school.

Even with long school vacations his time for travel was not as great as he would have wished. This taught him to become a very organised traveller, making sure that every minute was well spent. 'I've always tried to get everything I can out of a place', he says. He certainly managed to visit a large number of places – Europe, Arctic Canada, western Canada and the United States, Mexico – and made a round-the-world trip. But longest of all was a two-year stint beginning in 1963 in Africa as a teacher of geography. Teaching Africans was a challenging task for a Canadian high school teacher. Nigerian students took their studies more seriously than their Canadian counterparts: to them success in their studies meant escape from subsistence in a village to urban affluence.

In 1963, before he left for Africa, Bateman visited an exhibition of paintings in Buffalo, New York. This was for Bateman an artistic landmark. Having begun to paint birds as a boy, influenced by Fuertes and Brooks, as a young man he came under the influence of the modern and the *avant garde* – first Monet, then Degas, Van Gogh, Gauguin, Rockwell Kent and Charles Burchfield. He flirted with cubism and Franz Kline, becoming an abstract expressionist, favouring bold shapes, flat patterns with strong forms. 'Artistically' he told me, 'I was a snob.' He visited the Albright-Knox Art Museum in Buffalo, New York, regularly. It was here that he had his revelation.

The exhibition was of paintings by Andrew Wyeth. To Bateman, that Wyeth's apparent realism was acceptable to the Albright-Knox meant that it was art. He was also perceptive enough to understand that Wyeth paintings could be viewed on two levels, because they had an abstract quality.

Shortly after arriving in Nigeria, Bateman and his first wife visited his fellow Canadian, Bristol Foster, in Kenya, where Foster was advising the government on conservation. While he was there Bateman noticed an art competition sponsored by Esso. He had made sketches of the East African animals that he had been watching and, inspired by the remembrance of the Wyeth paintings, he produced two entries for the

competition – a superb starling and a Thomson's gazelle. He did not win. Nevertheless these two paintings were popular with visitors to the exhibition and several commissions followed. His work was also hung in the Fonville Gallery in Nairobi.

Having found a style that satisfied both him and the buying public, he began in earnest to paint pictures for sale. On returning to Canada in 1965 he discovered that there was a market for his paintings at home. When he had the offer of a major exhibition at the Tryon Gallery in London he took a term's leave of absence from teaching. The exhibition was a sell-out and he decided that he could become a full-time artist. His exhibitions now habitually sell out: in 1980 the Bateman show at Sportsman's Edge in New York sold out and so popular were some of the paintings at his 1985 Tryon exhibition that a ballot was held for several of the paintings, whose prices were over £30,000. To cater for the less affluent devotees of Bateman, Mill Pond Press of Venice, Florida produces limited editions of prints of his paintings. Even so, buyers of Bateman prints must act quickly: the whole edition of the print 'Orca – Procession of Killer Whales' sold on the day of publication.

Now recognised as one of Canada's leading artists, Robert Bateman receives the honours of fame as well as the financial rewards. He has been made a Companion of the Order of Canada and it was he who was commissioned by the Canadian government to produce a painting of great northern divers as a wedding gift for the Prince and Princess of Wales. This sort of standing brings with it attendance at social events and public speaking engagements, but this is no chore because Bateman is a sociable person who enjoys meeting people and several of his friendships have lasted since his youth.

Robert Bateman also enjoys travelling to gather material for his paintings. In addition to sketches and photographs he does literally gather material: stones, mosses, twigs, plants are collected and carefully annotated so that he has references for the details

of his paintings. His travels are also sources of inspiration: a wide variety of things seen may inspire him to paint. He admits to finding inspiration in sources – photographs, films, sometimes even other paintings. Sometimes it is a place that triggers the painting and he finds an animal to fit the landscape; at other times it is the animal that he wants to paint and he has to find a landscape in which to put it.

Before starting a painting Bateman may prepare up to 20 thumbnail sketches. He always sketches animals from life. For details of birds he uses stuffed or frozen specimens, but he eschews stuffed mammals because he feels that they distort actual shapes. His paintings of mammals are notable for the texture that he manages to achieve. For both birds and mammals he uses his own and other people's photographs as references for details: up to 50 may be used in one painting. To try compositional ideas or the effects of light he employs the modelling skills that he had been taught as a Young Naturalists' Club member at the Royal Ontario Museum. He favours cardboard silhouettes or models of plasticine around an armature of silver paper. Living and working in a house, which he designed for himself, in the Ontario countryside, he is able to work

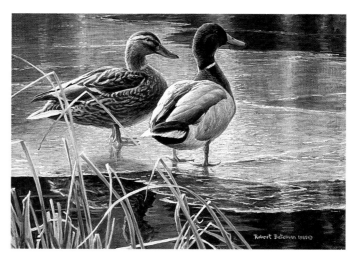

Mallard pair: early winter. Robert Bateman. (Mill Pond Press)

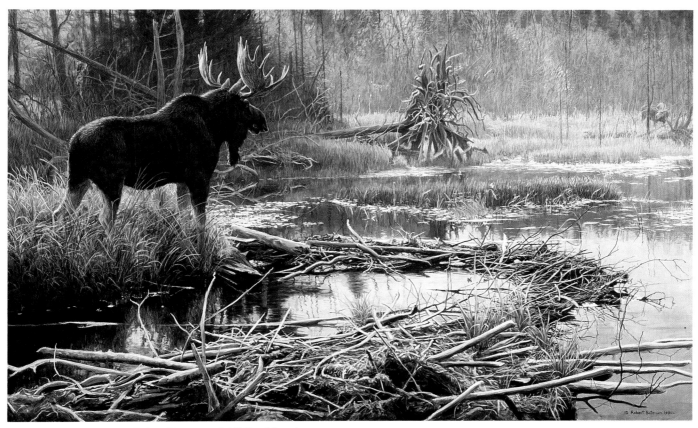

Autumn overture: moose. Robert Bateman. (Mill Pond Press)

on a painting both indoors and outdoors if he wishes.

When he starts a painting he has no idea of how it will turn out. Working chiefly in acrylics and alkyds he starts with the 'major strokes for big forms' first. Then he begins the background, never finishing one part of the painting before beginning another. Thus, he works all over the painting at once, using first one colour and then another, correcting all the time. He builds up the colour using the opaque acrylic and the transparent alkyds alternately.

A painter who is also a naturalist frequently faces the conflict between artistic and scientific accuracy. How can he reconcile the needs of good composition with biological fact? In *The Art of Robert Bateman* (1981), the artist describes this problem in relation to a dramatic painting of a pair of cock red-winged blackbirds struggling for control of a territory, part of a swamp, through which runs a rail fence. 'Here, two male red-winged blackbirds are fighting to control the

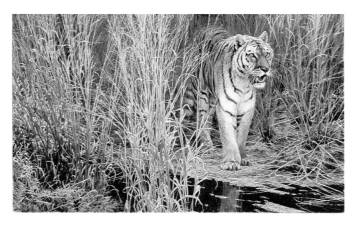

Tiger at dawn. Robert Bateman. (Mill Pond Press)

territory, and the composition reflects their conflict. The fence rails, which were the inspiration for the picture, seem to me like the slashing of a samurai sword or a piece of very bold Japanese calligraphy. They should be the positive spaces here, but they are fighting for dominance with the shimmering white negative space of the swamp behind them. I knew I wanted red-winged blackbirds in this landscape, because they have a military look with their sharp bills and red epaulets, and they are very active in the swamp at this time of year.

'Once the slashing shapes were established in the picture, I went back to the scene to look again at the split cedar fence rails to understand their characteristics in detail. Every rail of a cedar fence is an incredibly sophisticated series of planes and hollows, as individual as a fingerprint, and I made numerous drawings and notes and diagrams to paint each one of these in detail. I try to imagine what it would be like to be a snail crawling along these rails, feeling every bump and knot and ridge.

'I also spent many hours watching red-winged blackbirds in the swamp and sketching them in a variety of positions to capture their gestures and characteristics. The males arrive early in the spring, a week or two before the females and start singing

around the perimeter of a territory in order to claim it. To establish dominance, they fly up and down and hunch up to show as much of their red as possible. Here, the male on the right is fleeing from the one on the left. From my sketches I made preliminary cutout paintings of them to find the right position for them in the picture.

'An artist recreates the world and so can make his own rules, but he must pay the price of his rules. In terms of composition, I think I placed these birds successfully, but after the painting was finished an ornithologist friend pointed out to me that a dominant red-winged blackbird would never let himself get

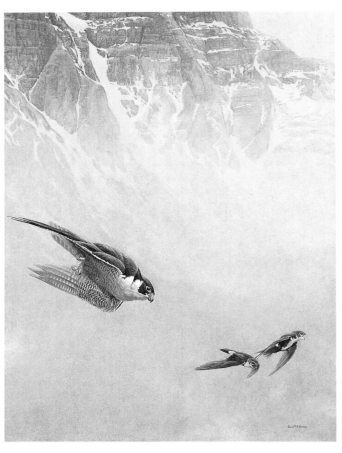

Peregrine and white-throated swifts. Robert Bateman. (Mill Pond Press)

below another male that he is driving from his territory. This bothered me but I decided to let the artist's world prevail over the natural world.'

Perhaps it is this conflict between the two worlds that has created the isolation of wildlife from the world of fine art. The 'non-art' tag which critics put on wildlife art is a source of frustration to Robert Bateman. On a pilgrimage to Sweden to see the work of Liljefors, he was disappointed to learn that this attitude is prevalent even in a country that can boast an artist of Liljefors's standing. Perhaps, because he admits to being an art snob, Bateman is driven by a desire for his work to be accepted as 'Art'. Although he has been invited to have a one-man exhibition at the Smithsonian Institution and plans some huge paintings for it, one suspects that to have one painting hanging in the Museum of Modern Art in New York would give him even greater pleasure.

GUNNAR BRUSEWITZ

'In the early days of my career I used to describe myself as a "drawing writer" but now I am a "writing drawer". For me writing and painting are inseparable and both activities are complementary to each other. If I spend two months writing a book, I don't feel regret for not having time to paint,' Gunnar Brusewitz told me. Although Brusewitz is one of Sweden's leading wildlife artists and nature writers, his work is not well known outside Scandinavia. His work has, however, appeared in exhibitions in London, Helsinki, West Germany and in Melbourne, in 1978, at the invitation of the Society of Wildlife Artists of Australia.

Brusewitz is widely travelled, helped by the fact that his mother has lived in Florida near the Everglades for more than 50 years. He has made two long trips to Australia, been all over Europe and also visited China, Japan, Thailand, Russia, Turkey, the West Indies, Africa and the Arctic. And yet he says that he sometimes regrets that he has not travelled more.

That he has not done so may be due to his enviable living and working conditions. His home at Lisinge is a 200-year-old manor house overlooking Lake Sparren in the countryside 70 kilometres north of Stockholm. Elk and roe deer are often seen around the house and from his lakeside studio Brusewitz can watch black-throated divers and goldeneyes, both of which are common. Passage migrants such as whooper swans, wildfowl and waders will stop for a few days as they pass on their way to and from their breeding grounds in the Arctic. He keeps a sketch-book ready on his worktable to capture any interesting animal he spies from his studio window.

His paintings and drawings show Brusewitz to be a man who is at one with his environment. 'I think I am primarily interested in the ecological aspect of natural science;' he wrote to me, 'much as Bruno Liljefors, my ambition is to show how animals function in their environment.' The inseparability of animals and the place where they live is an important part of both his art and his writing. This can perhaps be traced to

his early enthusiasm for nature, when as a 10-year-old he began to teach himself about the birds he saw as he wandered through the countryside around his hometown of Strängnäs. Born in Stockholm in 1924, his boyhood interest in birds was exceptional and in the 1930s the sight of a small boy armed with opera-glasses and a sketch-book going out birdwatching was not a common one in central Sweden. But an interest in nature and an interest in drawing consumed his young life. He would get up in the middle of the night in early April and go to the woods some kilometres from the town to look for courting capercaillie. Since he spent most of the nights in the woods, he would catch up on his much-needed sleep during boring Latin lessons, which he wryly recalls 'did not have a very good effect on my school reports'.

Per-Emil Brusewitz, his father, was a man of affairs – a civil servant, a politician and a writer. He wanted his son to be a doctor, not an artist. There was, however, an artistic streak in his father's side of the family. A great-great-uncle was Gustaf Brusewitz, an artist and historian, and Per-Emil's mother and two of her sisters were talented painters, one of whom studied in Paris and became a moderately famous portrait painter. Gunnar Brusewitz did not want to be a doctor. He wanted to be an artist. 'When I was 16,' he says, 'to my family's consternation, I left school in the middle of a term to start my education as a sculptor and painter.' From 1941 to 1942 he studied at Lena Börjesson's School of Sculpture, which he followed with a year at Signe Barth's School of Painting, the School of Book-Art and, in 1949, the Royal Academy of Art in Stockholm.

His first book illustration was published in 1943. Now he has illustrated over 200 books as well as having written and illustrated 30 books of his own. He has lost count of the number of magazine features he has written or illustrated. Each week he writes a column on nature and nature conservation in Sweden's second largest newspaper, *Svenska Dagladet*.

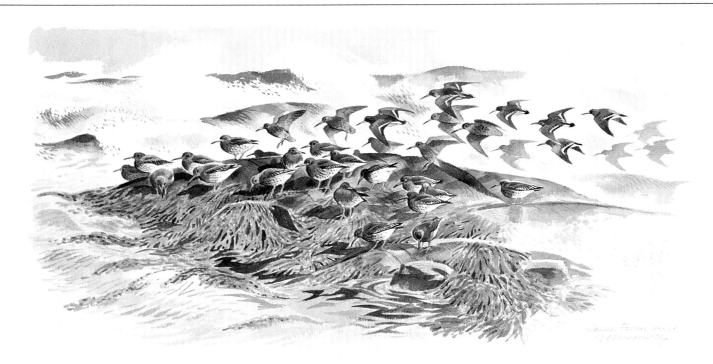

Purple sandpipers, Froan, Norway. Gunnar Brusewitz

He is also a broadcaster on both television and radio, a portrait painter and a designer of postage stamps and posters. Since 1963 he has been responsible for the design of the diplomas for Nobel Prize winners in literature, a very delicate task which may take up to a month's work.

In view of his involvement in nature conservation and communicating the need for it, perhaps it is not surprising that Brusewitz cites Peter Scott as a 'highly admired idol'. As a member of the board of the Swedish section of the World Wildlife Fund, he has met Scott. 'It is the fact that Peter Scott combines artist, author, naturalist and protector of nature and wildlife that I find so impressive and so worthy of imitation.'

Another artist who combined the animals that he painted with their environment was Bruno Liljefors, and he was a major influence on Brusewitz, who describes him as the 'inescapable grandfather of wildlife art'. He also mentions fellow Swedes, Harald Wiberg and Arvid Knoppel as influences and says that he has been strongly inspired by Barruel, Fuertes, Eckelberry, Hainard, the Dane Johannes Larsen, L.P. Robert and Tunnicliffe. It is difficult to see many similarities between the work of Brusewitz and the work of anyone on this list with the possible exception of Robert Hainard, with whom he shares an ability to reproduce the experience of seeing animals in their environment. His bachelor club of elks discovered grazing in the morning mist, or the ring-ousel about to fly off the moment the watcher makes a move are wonderful examples of his skill at capturing the moment. Although he is economical with both line and colour, Brusewitz manages to convey depth to his paintings: a flock of purple sandpipers resting on a seaweed-covered rock is given depth by the way in which he has painted the furthest birds in less detail.

His favourite medium is watercolour. Although he sometimes uses oils he prefers pen drawing with watercolour because it is the fastest technique. It allows him to record a scene as quickly as possible. Sometimes he will make a pencil sketch in the field and add watercolour washes later. He feels that experiences of nature are so transient that unless he can catch them very rapidly and find 'the right expression' for them, they can be very difficult later. He told Claire Walker Leslie, author of *The Art of Field Sketching* (1984): 'My method is very simple: just sitting on a stone or a stump with my sketch-book, making drawings from nature with my pencils. That's in fact all. Back in my studio, I start with brushes and watercolours . . . I don't like to overdo my sketches. I like them fresh and not too detailed and perfect . . . I always have a small pocket sketch-book with me when I am outdoors. If I find anything interesting I stop for a very rough pencil sketch, and if it still interests me when I am back in my studio I try to make something out of it.'

Brusewitz has the rare gift of appearing to know when to stop painting. He in fact claims not to know when a drawing is finished and also says that he is indifferent about whether the drawings appear 'finished or just sketches'. If anything, it is the 'sketchiness' of his drawings that makes them so exciting because they reflect his excitement at looking at nature.

Man's response to wildlife is a subject that fascinates Brusewitz, whose books include one about the historical and cultural aspects of hunting and others about the role of animals in mythology and folklore. For his work on the folklore of birds he was awarded an honorary doctorate at the University of Stockholm in 1982. It seems fitting that by leaving school to become an artist in the face of his father's wish that he become a doctor of medicine he should have started on a career that would eventually entitle him to be known as 'Dr Brusewitz'.

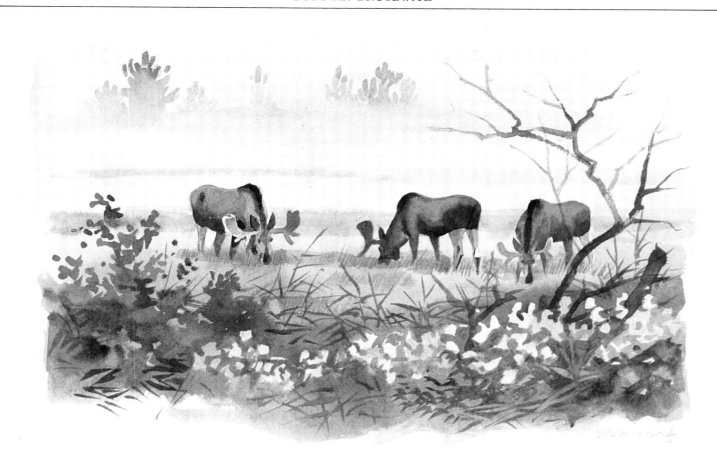

Bachelors' club grazing in the summer night. Gunnar Brusewitz

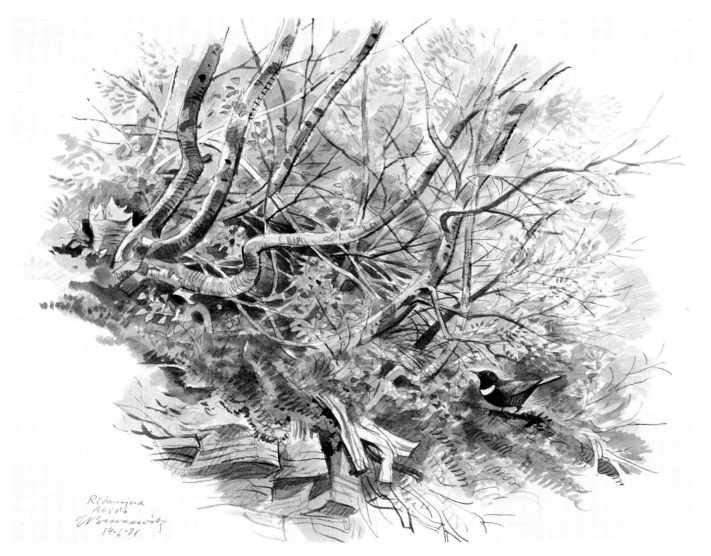

Ring ouzel in Swedish Lapland. Gunnar Brusewitz

JOHN BUSBY

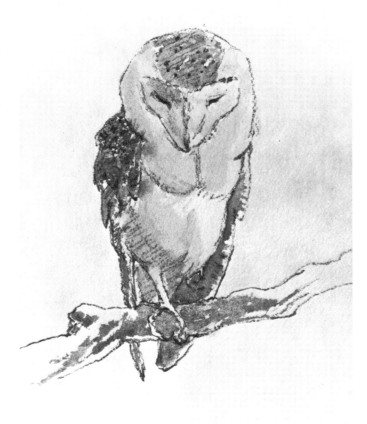

Barn owl. John Busby

mong the artists who paint wildlife in the
United Kingdom today John Busby is
remarkable for the intensity of his emotional
response to his subjects. He paints what he sees and
how he feels about it. He eschews the pseudo-scientific
approach of some illustrators, but he does approach
painting intellectually. Perhaps this is explained by the
combination of his work as a lecturer in painting and
drawing at Edinburgh College of Art, his almost
abstract oil paintings of landscapes, and his drawings
and paintings of wildlife.

He has very clear views about the painting of
wildlife and is highly critical of much of the output of
today's so-called wildlife artists. In his book, *Drawing
Birds* (1986), he states that those who maintain that
feeling should have no place in nature painting are
wrong. To argue that painting should be entirely
objective and free from expression of any kind to be
truthful is, he says, to confuse two forms of truth – one
made up of facts that we measure and record; and the
other revealed through the intrepretation of our
experience of reality. The ultra-realism, so popular in
North America today, where 'bird and background
are rendered, sometimes dramatically, but with an
indiscriminate objectivity' is not something that he
admires in artistic terms. Despite the painstaking
study of detail and checking for authenticity which
requires impressive skill, he does not feel that the
'subservience of cohesive pictorial thought to a
saturation of visual facts' is the business of art. He
likens the extremely detailed paintings of birds to
making models. Indeed, his view is that the much-
sought authenticity is lost because the effect is so
contrary to the way in which we perceive anything in
nature.

It is the work of Audubon and of Liljefors who
changed the way in which artists looked at nature that
Busby admires most. He describes Audubon as having
a passionate intensity that is striking even today.
Liljefors was remarkable for painting 'what he saw and
only what he saw'. Busby describes the work of

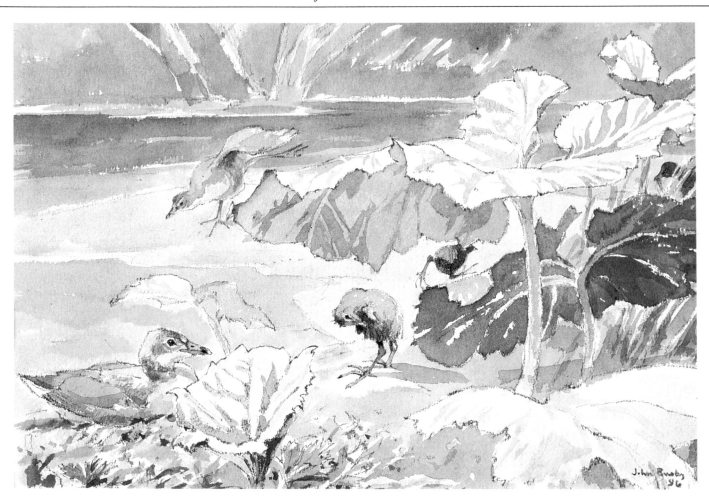

Moorhens. John Busby

Liljefors as having a 'breathless sense of "being there"' which might equally be applied to his own drawings and paintings.

The first artists to influence Busby were R.B. Talbot Kelly and Eric Ennion. When he was a schoolboy his great-aunt, who knew of his interest in birds, gave him a copy of Talbot Kelly's *The Way of Birds*. The illustrations astonished the boy who was used to the rather romanticised plates of pre-war bird books. 'Here', he recalled 40 years later, 'were illustrations of birds as living individuals, each one a record of a moment seen. This was the way birds should be painted, not as artfully posed book-plates, but from real experience.'

John Busby is a Yorkshireman, born in Bradford in 1928. His interest in animals goes back to his early childhood, when he used to draw dramatic scenes featuring exotic wild beasts. However, when the family moved to rural Wharfedale in 1935 the animals he could see, curlews and rooks, took over from the lions and tigers of his imagination. In rural Yorkshire in the 1930s there were few contemporaries who shared young John's passion for nature and he knew no grown-up with any great natural history knowledge. Busby had to teach himself and learn what he could from the series *Out with Romany* which was broadcast on the BBC radio programme *Children's Hour*. Then he had the fortune to meet Walter Flesher, a gamekeeper at Ilkley, who was a very good naturalist and encouraged the boy. Walter Flesher did an enormous amount to promote the study of natural history in Yorkshire. Through him John was introduced to the Wharfedale Naturalists' Society and to nature beyond birds.

At school the only subject in which Busby had excelled was art and his parents, instead of pressing him to join the family business, agreed to his studying art. After his two years' National Service in the Royal Air Force Busby went to Leeds College of Art and,

later, Edinburgh College of Art where he now lectures. As a student he made a trip to Monks House, a bird observatory and field-study centre run by Eric and Dorothy Ennion. Ennion's ability to capture fleeting movement and his all-round knowledge of natural history appealed to the young art student, for whom sketching birds was a relaxation from the large, ambitious compositions on which he was then concentrating. Ennion recognised Busby's talent for drawing and encouraged him to develop this ability to catch movement in a few strokes. Ennion also encouraged him to exhibit his work.

Busby and his wife, Joan, a singer, are fortunate in living in the East Lothian countryside, half an hour's drive from Edinburgh. They live in a house built amidst the remains of a mansion that was burned down accidentally when it was being used as a mess for Polish pilots during the Second World War. A select community of five families now live on the estate and Busby has a studio in part of the stables. The rural position is ideal for an artist who paints wildlife – sparrowhawks may be seen from the kitchen window, brown hares box in fields and a short drive away is the Firth of Forth with its magnificent seaduck and flocks of passage waders. Busby's studies of gannets on the Bass Rock made him an obvious choice as illustrator for Dr Bryan Nelson's monograph *The Gannet* (1978). The boobies have a particular fascination for him and he has drawn other species in the Indian Ocean.

Many of Busby's drawings are made on islands – Majorca, Seychelle, Orkney. Because they are landfalls for migrants, islands and estuaries such as the Firth of Forth are excellent places in which to see unlikely combinations of species. We become so used to seeing comparative illustrations of closely related species that we give little thought to the differences, or similarities, between very different species. In one John Busby drawing we discover that there is little difference in size between a turnstone, a grey plover

and a mynah which he saw at the same time, together with a whimbrel, on a beach in the Seychelle Islands. These unlikely accidents of very different birds being in the same place delights Busby who frequently uses them as subjects. He is also sensitive to the irony of beautiful creatures finding themselves surrounded by the uglier artefacts of man. The Lothian shore of the Firth of Forth provides many instances. One drawing shows a dunlin, feeding on the shore beside a discarded comic on one page of which were instructions entitled: 'How to make your own duck'.

Some people, reared on a diet of stylised perfection in art, cannot respond to such pictures. Imperfect in ourselves, some of us look for perfection in nature. 'The honesty of a Rembrandt in the world of bird art might be more difficult to live with' Busby wrote in *Drawing Birds*.

The work of Busby may not always be easy to live with. His composition is not a safe, easily recognisable one with the bird filling the middle of the frame, just as it does when you look through binoculars. His approach is much more subtle because he understands birds and their relationship to their environment. He avoids compositions in which the eye goes straight to the subject and stays there. This rarely happens when you see a bird in the field: its presence is 'unexpected and fleeting' or 'merging with the shapes and patterns of branches'. Busby's ability to show birds as he sees them usually inspires an empathetic response from birdwatchers, if not from all so-called bird artists. The chapter on composition in his *Drawing Birds* should be read by all students of bird art and, even more important, by everyone who wants to be thought a bird artist.

In considering Busby's work one returns constantly to the awareness of his having experienced what he paints. He manages to set aside the facts as he knows them in order to draw the facts as he sees them. As a teacher he is very aware of how inhibiting prior knowledge can be. It can also deter people from trying to make drawings of birds.

'Correctness can become an obsession, and in some pictures one can imagine the artist ticking off a strict check-list of detail to be included before a bird can be considered finished. This is a formidable inhibition; one that can make the beginner doubt his or her own observation and suppress creative feelings.'

To look at paintings with Busby is a revelation. His trenchant comments, delivered in his gentle, rather soft voice make it clear that he has little time for the hybrids between scientific study and popular, decorative images: 'The resulting birds look more often like paintings of porcelain figures, complete with a tasteful spray of appropriate flowers – any real experience lost to convention.' That is not to say that he dislikes all decorative paintings of birds. The best, he says, 'manage to combine the plumage details we so enjoy, while still retaining that liveliness that is so much of the charm of birds.'

Art is far from being a selfish activity in the hands of Busby. To him art is communication with other people. Therefore, all subjects are worth tackling and certainly everything has not been said about everything. He refutes the argument that the physical features of the house sparrow are so well known that any drawing of a sparrow must confirm to that knowledge. 'This stricture takes no account of the great diversity in the way people perceive things, to say nothing of the changing light and backgrounds,' he wrote in *Drawing Birds*. 'I am not suggesting that it is more artistic to get the sparrow wrong, but it is a function of an artist to open people's eyes to what has not been seen before, and, I firmly believe, to express a human response to it.'

Lack of interest in any form of art other than the painting of wildlife, is, Busby feels, a serious problem. Despite shutting their eyes to the values of the wider art world, many wildlife artists then complain that their work is not admitted to the same league. 'Knowledge of the subject matter alone is not enough. Art is a synthesis, a unity of the ideas and the means used to express them. There has to be a pictorial reason for the relationships which are made between shapes and spaces, lights and darks, colours, rhythms of line . . . To copy nature without resolving one's own thoughts and feelings is a barren experience.'

Busby is severe in his criticism of the painting of birds and other wildlife. There is, he has written, 'too little vitality in much current and past bird art'. Vitality is one quality that is not lacking from his own work. By being aware of the developments in the wider art world, and by relentlessly refusing to allow his vision to be blurred by his knowledge of natural history he has continued as the most exciting wildlife artist in the United Kingdom for 20 years or more.

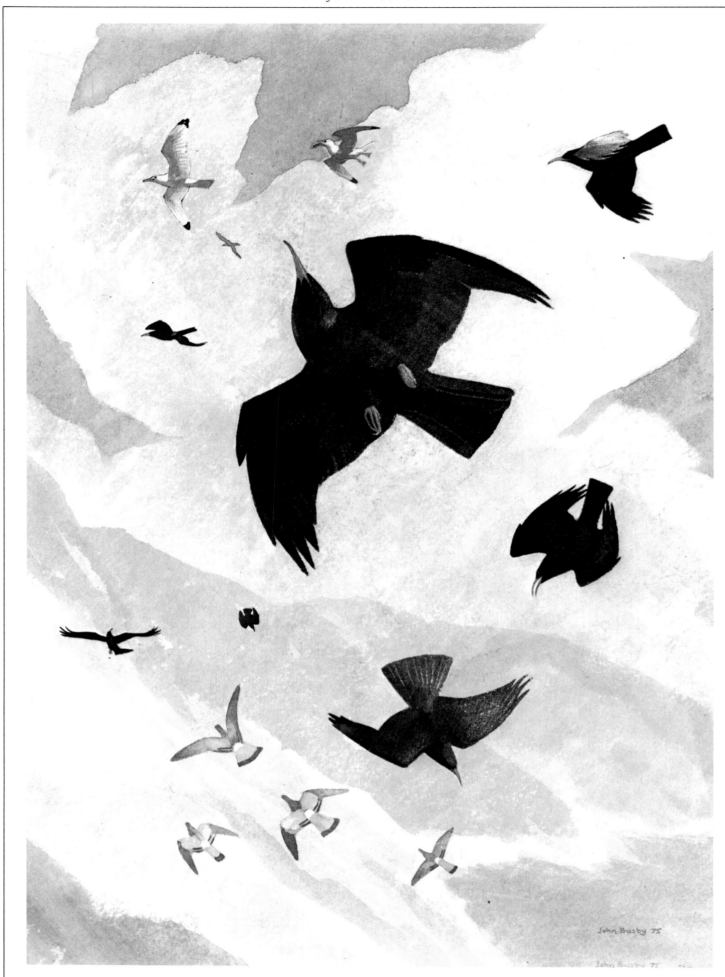

Chough, kittiwake, herring gull and rock dove. John Busby. (Royal Society for the Protection of Birds)

RAYMOND HARRIS CHING

The extreme attitudes of some of the birds in the illustrations in the *Book of British Birds*, published by Reader's Digest, drew forth some 'extreme attitudes' from the ornithologists when it was published in 1969. 'Who', they asked, 'is this Raymond Harris Ching person who drew them? We've never heard of him.'

They had never heard of him, because he was neither a native nor an accepted wildlife artist. Indeed, Ching knew very little about the birds he drew, but that did not detract from his ability as a draughtsman. The variety of postures among the birds, despite raising ornithological blood-pressures, was actually an element that made the book so attractive and while most of them were based on skins, the artist managed to imbue them with a liveliness rarely achieved with stuffed models.

Raymond Harris Ching was born in Wellington, New Zealand in 1939, but unlike most of the artists in this book he claims neither a childhood interest in wildlife nor a precocious ability to draw. He actually dropped out of school at the age of 12 and for several years led the life of a street urchin. His life changed when he met a couple of artists who encouraged him at the age of 19 to go to evening classes in drawing. It was then that he discovered his talent for drawing, a talent that was not particularly fashionable in the 1950s and 1960s but it did lead him into advertising work. When he came to England he was commissioned to illustrate *The Reader's Digest Book of British Birds*. He produced some delightful working sketches for these, which he donated to the Royal Society for the Protection of Birds for sale to raise funds. It was then that I met him. He was living in a beautiful old building in the Sussex town of Rye. I can recall being charmed by his whimsical approach to life, impressed by his ability to draw and slightly perplexed at his apparent eccentricity.

After the publication of the Reader's Digest book, he met and talked with ornithologists and began to concentrate his painting on the birds he knew. Now

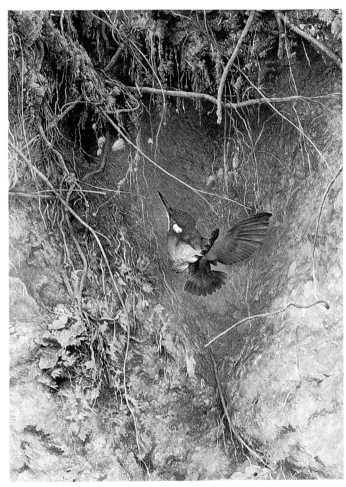

Kingfisher. Raymond Harris Ching. (Collins)

most of the birds Ching draws are the inhabitants of the garden of his East Sussex home – starlings, blackbirds, wrens and house sparrows. 'If one is going to draw a blackbird,' he wrote in *Studies and Sketches of a Bird Painter* (1981), 'then one has to get it right, even more right than, say, a bird of paradise. Everyone has seen a blackbird, so errors in the blackbird drawing will be more noticeable and spoil any pleasure you

may have in looking at it. Not only has everyone intimate knowledge of it, they have very definite feelings and emotions about it, and they run deep.' To make quite sure that his drawings and paintings of common birds are not criticised by all those people with an intimate knowledge of them, requires painstaking research and drawings.

There are several ways in which Ching is exceptional among the artists featured in this book. One is that he does not make field sketches of birds. He looks at birds without binoculars and without a sketch-pad. Instead he prefers to allow the bird to take shape in his mind. He makes pencil sketches of the bird's behaviour and postures from memory, filling in plumage detail with reference to skins. Occasionally this does not work and the birds appear in contorted postures. However, most of Ching's paintings have about them a great spirit of liveliness.

The landscape elements of his work are usually sketched in pencil *in situ*. A bush, a stream, the corner of an outbuilding will be sketched in detail. In a memorable watercolour a pair of wrens perch on a rusty tobacco tin, full of even rustier nails, in a corner of a windowsill in an outbuilding. The frame of the window is festooned in cobwebs spattered with wings of long-dead moths. These details were painstakingly drawn in pencil on site. The lettering on the Macneil's Cut Golden Bar box and the discarded Carter's seed packet is immaculately drawn.

The elements of the painting are drawn together in a pencil study which has such a degree of finish that it might be a black and white photograph of the final watercolour. Ching makes these detailed drawings because he makes his main decisions at this stage. 'If I started making decisions with the paint, I'd lose control of the painting. The more paint I add the more out of control I get, so that I want all the really serious work done long before the paint goes on,' he told Susan Rayfield, author of *Wildlife Painting: Techniques of Modern Masters* (1985).

When Ching has finished the pencil study to his satisfaction he then traces it on the painting surface.

For watercolours he uses a rag paper stretched taut. For oils he uses untempered masonite which he sizes carefully with four or five coats of gesso, applied with a 2-inch house paint brush and sanded between each coat. The final coat goes on with a smaller oil brush and then several thin washes of a neutral colour are added and rubbed off with a rag so that the remaining film gives the texture that Ching desires. This is typical of his careful and thoughtful approach to painting.

Colour is not the most important element of a Ching painting. As might be expected from such an extraordinary draughtsman, his palette is limited. He is nevertheless very careful about the way in which he paints. Not for him a pool of ready mixed colour; he mixes the colour from scratch between each brushstroke. He wears out watercolour brushes within a few days. The brushes he chooses are rarely finer than number 6, because he can exert more control over the brush if it has more body. He advises artists to use a brush at least two or three sizes larger than needed, but there are few artists working today who have such skill in painting detail without killing the painting.

With his work exhibited regularly in the United States, Australia, the United Kingdom and New Zealand, Ching has achieved a position that must have been far beyond the daydreams of the Wellington street urchin he once was. Although he admits to an admiration for the work of Andrew Wyeth, the main influence on him was the Pre-Raphaelite Brotherhood. Now many of the critics who dislike realistic or romanticised paintings of birds admit to an admiration of some of Ching's paintings. Not that such approbation would mean much to Ching, who has a confident individualism and a very positive view of painting.

'It has always seemed to me,' he has written, 'that paintings with messages of cynicism and protest do not last. The finest paintings are always a celebration – and the great beauty of birds is a natural fuel to this purpose.'

WILLIAM COOPER

An extremely hot day in January 1939 is recalled by William Cooper as being one of his earliest memories of wildlife. He was a few months under five and he was shown a white-throated warbler's nest. It was a time of depression in Australia and the Coopers lived in a tin shack in the bush. Cooper remembers it as being very tidy and his father, who was unemployed, as having quite a good bushman's knowledge of wildlife. On that hot January day his brother was about to be born. The doctor had driven to the end of the road and walked half a mile through the bush to the Cooper home. When he went inside Cooper's father suggested that they go for a walk. 'We walked down a rough track until we came to a spot where he lifted me onto his shoulders so that I could peer into the beautiful hanging nest of a white-throated warbler' he recalls. 'I remember clearly the wide open mouths of the fledglings all reaching towards the nest entrance as though I were about to feed them. I imagine that my father had known about the nest and had kept it secret till that very day, so that he might distract me from the events back at the house.'

The bush proved irresistible to the young Cooper who says that his formal education suffered greatly from his intense desire to be running barefoot in the bush with the creatures that fascinated him so much. 'When I left home in the morning, having every intention of going to school, the warm sun, the smells of the bush and the calls of the birds were often stronger than the desire to reach school and so I would spend the day being educated by nature.'

He had no formal art training. Instead he taught himself, learning what he could by studying the work of others and comparing it with nature. The first work to impress him was that of John Gould and his team of artists. Trips to town were few when he was a boy, but on those trips his mother would leave him at the library while she went shopping. The librarian would kindly take out the volume Cooper asked for and lay it on a table for him, keeping an eye on him while he sat for hours enthralled by the great plates.

Today the bush still keeps its hold over Cooper who lives on a 160-acre property 90 miles from the nearest postbox at Bunghwal, New South Wales. The Cooper property is hilly and heavily timbered with wet sclerophyll forest and rain-forest. Wildlife is all around. His studio overlooks a small man-made lake where there are usually ducks and herons and from the window he can watch birds of many species as they feed on the forest edge. Koala bears can be seen nearby and there are three species of wallaby that emerge from the surrounding forest to feed on the lawns. The skylight in the studio roof has louvre blinds that allow Cooper to control the amount of light, which is most important because he only paints by natural light.

For the past 20 years he has earned his living from painting. At first, before it was possible to do so by painting birds, he worked in oils on landscapes and seascapes. When he started to paint birds professionally he turned to gouache and watercolour. Now he paints mainly in watercolour, using only a small amount of body colour to finish the final touches of detail. His black and white drawings are pen, pencil or pen and wash. A recent change has been his use of acrylic on canvas for larger paintings of birds and mammals in their environment. The style of these is very different from the more detailed taxonomic studies for which he is best known outside Australia. Great enthusiasm greeted his plates in *Parrots of the World* when it was published in 1973. This was the first of a series of books which he has worked on with Joseph Forshaw. *Birds of Paradise and Bowerbirds* followed in 1977 and three years later they published the two-volume *Australian Parrots*. So far two volumes of the six-volume *Kingfishers and Related Birds* have been published since 1982.

How Cooper approaches his subjects depends on the particular group on which he is working. He tries to see the birds alive in their habitat, if possible. As a last resort he will paint zoo specimens. He also makes field sketches of environmental factors such as plants

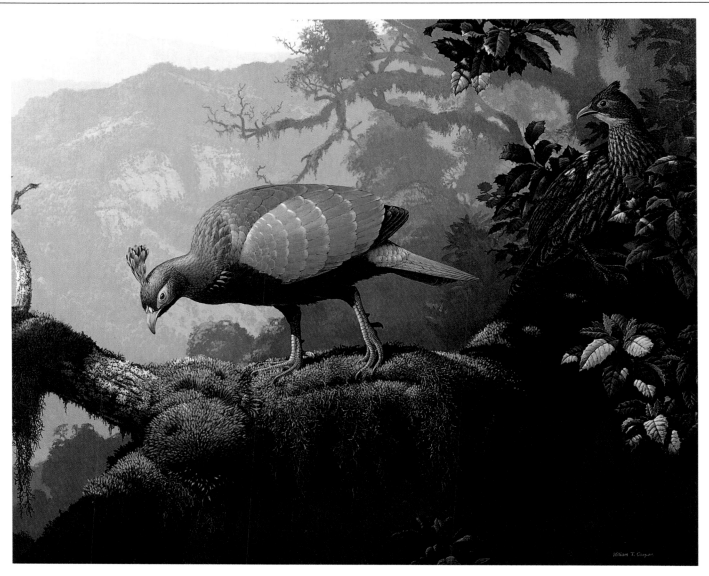

Impeyan monal. William Cooper

that will be used in the paintings. His quest for field sketches of birds in their natural habitat has led him on many expeditions. He lived under canvas in the high mist-shrouded mountains of New Guinea when he was working on *Birds of Paradise and Bowerbirds*. Often the conditions on these expeditions bring special problems – for example, the difficulty of working in the hot, humid conditions of the jungle on Cape York in tropical Australia, 'where fungus grows on your pans of paint and the paper goes damp and floppy from humidity' or in India 'looking into the pale, unblinking eyes of a tiger, standing only 20 paces from me'.

'Maybe almost as exciting' Cooper told me, 'was to watch five different species of hornbills feeding in a huge emergent tree in the Malayan jungle; these huge birds sailing into the tree, their wings cutting the air with a strange whistling sound, landing and then bouncing along the limb to reach the fruits at the very tips of the branches, while all around were the sounds and smells of the forest . . . If only, somehow, I could paint it all.'

His drawings made in the field are the basis for his finished paintings, but they are used in combination with museum skins, which he feels are essential for accurate taxonomic illustration. He also refers to, but does not copy from, photographs when he has been unable to see a species in the wild. He uses them as a guide from which to learn the shape or posture of a bird.

Although Cooper has had four one-man exhibitions in Australia he now does not exhibit his work for the simple reason that it is sold before it is completed. A large collection is owned by the Australian government and some of these paintings are usually on show at the National Library in Canberra. The government of Papua New Guinea also owns a collection of Cooper paintings.

With his idyllic home surrounded by forest and its wildlife, his wife (whom he describes as being 'of inestimable value' in his work) and the popularity of his paintings, William Cooper has an enviable life. The artist himself seems to be well aware of this. He says that he has no regrets: 'I am extremely happy with my life, and am grateful to all the people who have helped to make it so enjoyable.'

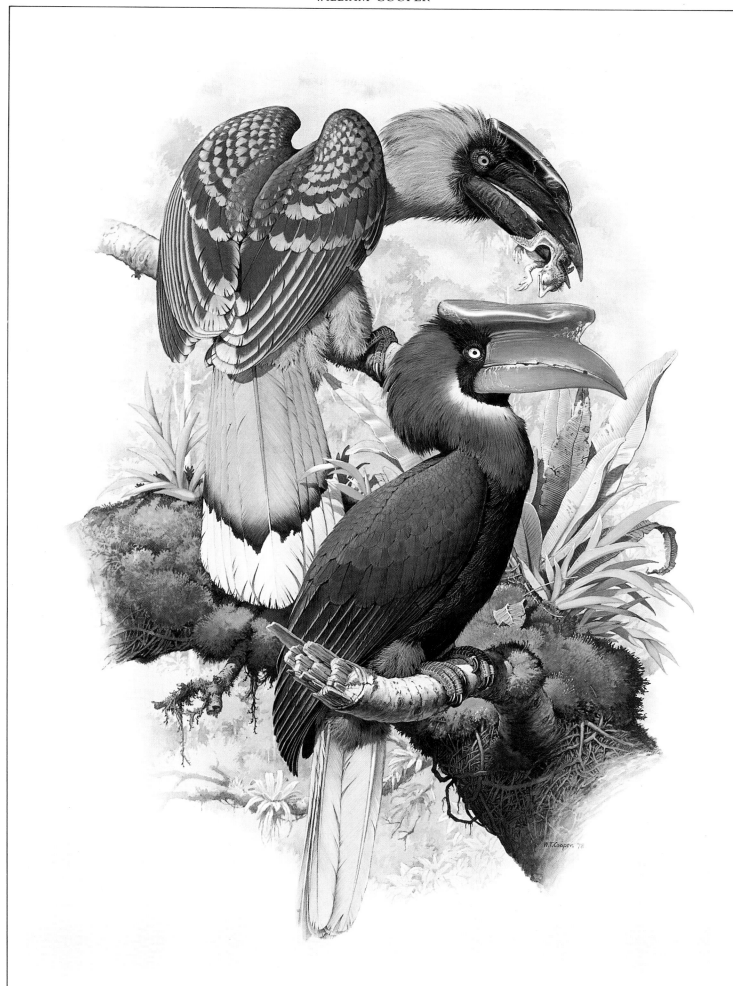

Philippine hornbills. William Cooper

HÅKAN DELIN

'A sparrow among the dancing cranes' or, in his native Swedish 'sparv i tranedansen' is how Håkan Delin described his inclusion in this book. Perhaps because he is not a professional artist, he is reticent about his inclusion among so many artists who make a living from painting. There is, of course, no reason why he should feel such reticence. The standard of his painting is far higher than that of many professional artists. His plates of owls for the fourth volume of *The Handbook of the Birds of Europe, the Middle East and North Africa* (1985) were one of the most notable aspects of the book's illustrations. And apart from being an excellent illustrator, he is a painter of pictures of birds in that free confident style that seems to signify Scandinavian wildlife art.

Delin is proud of the wildlife of his country. He lives at Djursholm, a wooded Stockholm suburb, but travels up and down the Baltic coasts and to the inland forests to watch birds. 'There is so much nature in Sweden,' he says. Like many northern Europeans it is the changing seasons and the effect on wildlife that really moves him and he appreciates the changes that occur in the quality of light and effects of the weather.

He is quick to deny chauvinism in his choosing three fellow countrymen to head his list of most admired wildlife painters. But then the first one is Bruno Liljefors, whose name crops up throughout this book. As a boy Delin was inspired by the photographic quality of some of Liljefors's paintings, but later came to enjoy still more their atmospheric quality. The second is Gunnar Brusewitz, whose ability to simplify with such apparent ease draws admiration from Delin. The third Swede is the young wildlife artist, Lars Jonsson: 'His bird portraits are as close to perfect as possible and more than anyone else he reveals the beauty of birds.' Among others very much admired by Delin are the line drawings of Robert Gillmor, the decorative paintings of Fuertes and Tunnicliffe's measured drawings.

Delin developed a very early interest in nature. He thinks this was innate, depending mainly on genetic combinations, 'a sort of inherited taste' is how he describes it. 'I think I liked the way birds moved and I have never ceased to like it,' he recalls. When he was a boy (he was born in 1939) his parents liked him to draw, but there appears to have been an unspoken understanding that he would not take up the hazardous life of a professional artist. Therefore, he had no formal art education. Instead he went to medical school and qualified as a doctor and now specialises in paediatrics.

The life of a busy paediatrician leaves him little time for painting and he expresses a wish to be able to organise his life better so there would be more time for his art. Although he does not regret his way of life, he does long for more hours in the day.

Mostly he works in gouache, but he also uses pencil and ink and has recently begun to experiment with oils. With great candour he admits to finding sketching in the field very difficult. 'My field sketching does not work very well,' he says, 'most of the birds that inspire me are distant and elusive ones.' This means that he has developed his visual memory, making his sketches when he returns home. If he is working on illustrations for a handbook he checks details against photographs, but he avoids starting from a photograph. The leaflet *Kronans Villebråd*, demonstrates the range of his work. On the cover a pair of sea eagles wheel above the clouds in a clear blue Swedish sky, demonstrating his ability to recreate the experience of seeing wild birds in their element, while inside are four plates of the species of mammals and birds protected in Sweden as crown game. These plates, although primarily for identification purposes, show animals that are full of life and expression, also a vital element of his line drawings for the magazine *Sveriges Fåglar*. He has also coped well with the difficulty of showing fur on the mammals without painting them into immobility.

For Håkan Delin, painting birds is a labour of love, an extension of his very intense feelings about them. He is almost as eloquent when he writes as

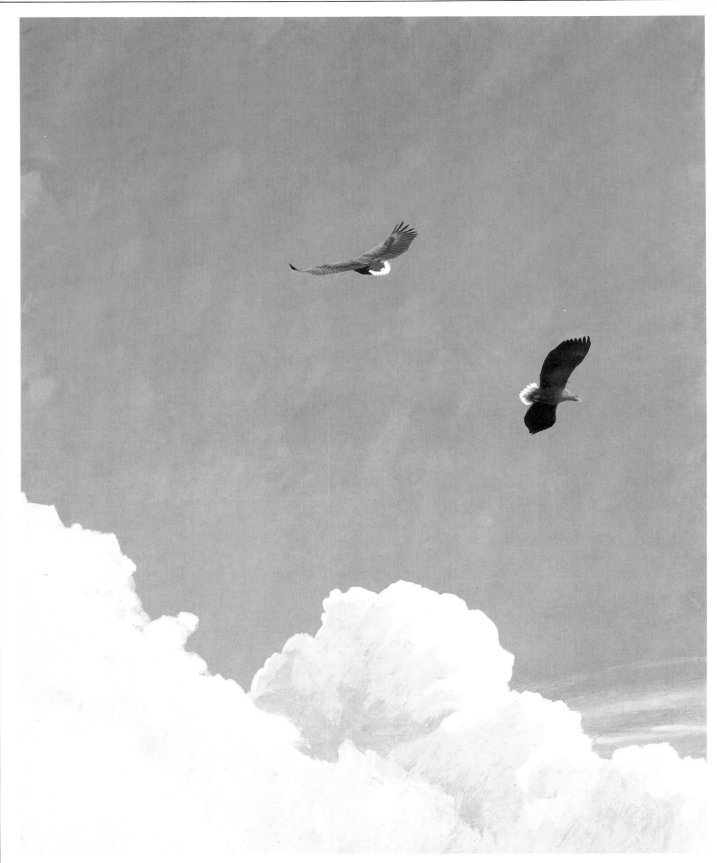

White-tailed eagles. Håkan Delin

when he paints. 'I think of myself very much as an ornithologist. Birds are not just models to me, they give so much just by existing. I like to discover them, identify them and just look at them. In one way I feel related to the Cro-Magnon cave-painters; there is a lot of looking before each painting.

I like to paint birds with much nature around: nature is large and birds are small. I don't think details are necessary if the overall impression is accurate. I think the picture should show the painter is very familiar with the habits of the bird.'

DON R. ECKELBERRY

Charm, intellect and an ability to communicate with other artists as well as his skill as an artist have helped to make Don Eckelberry one of the most influential modern painters of wildlife in North America. He has been generous in the help that he has given to younger artists and could well be described as the 'grand old man' of American bird painters.

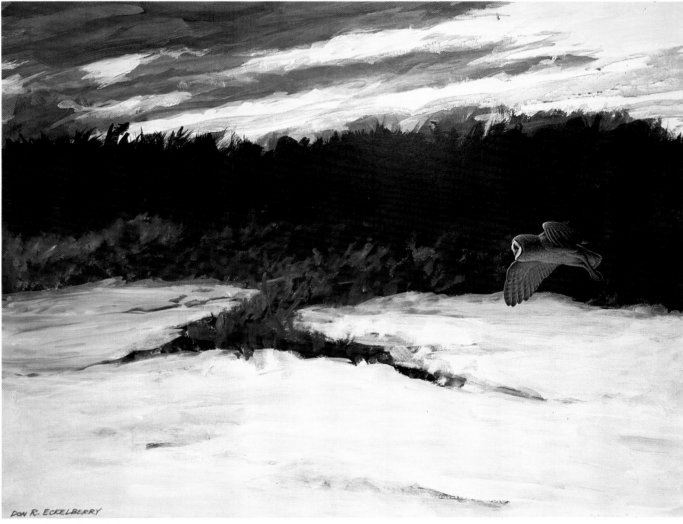

Barn owl. Don R. Eckelberry

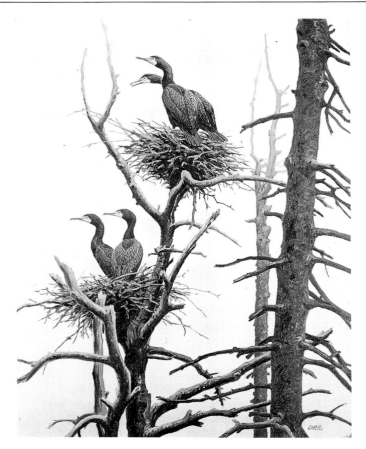

Double-crested cormorants. Don R. Eckelberry

Home for Don and his wife Ginnie, a textile designer, is a converted coach-house on Long Island. The coach-house, which once belonged to a large nineteenth-century house, long since demolished, stands among smart Colonial family houses with well-wooded gardens. In a well-grown garden and itself covered with climbing plants it has a somewhat Gothic aspect, but once inside it is easy to understand why it was once featured in *Homes and Gardens.* Between them Ginnie and Don converted this double coach-house into a smart, practical and comfortable home with one half of the ground floor a roomy studio in which both can work.

The high walls of the living room are covered with paintings. Several are by Eckelberry himself but among them are a large oil painting of a huge flock of Canada geese by Sir Peter Scott and a small landscape sketch in oils by Bruno Liljefors. The great Swedish artist is much admired by Don, some of whose own work has some of the grand quality of Liljefors. In 1977 he went with *Audubon* editor Les Lines and his picture editor, Martha Hill, to Sweden to see Liljefors's paintings and the artist's habitat. 'It was a pilgrimage for me,' he wrote later, 'as I consider Bruno Liljefors the greatest of all wildlife painters, and I was moved by the fidelity with which he interpreted his surroundings, how he made me familiar with a seascape I had never seen.' There have been occasions when Eckelberry has done this: an example is the large acrylic painting of four red-breasted mergansers skimming a rough, dark sea. Two other artists whose work Eckelberry admires were those twin influences on so many American wildlife artists – Louis Agassiz Fuertes and John James Audubon. Fuertes he describes as 'probably the best illustrator' while he rates Audubon highly as a fine designer and draughtsman.

Don Eckelberry was born in Sebring, Ohio in 1921. He drew from an early age, his passion for birds ignited with presents of a cheap bird guide and an airgun. He began to shoot his way through the book, keeping a tally-list of birds he had shot. Fortunately

for the bird life of Ohio and for ornithology, he gave up shooting when he wounded a red-winged blackbird that flew off before he could catch it. A sketch-book replaced the airgun.

The first real encouragement for his interest came through a visit to the Museum of Natural History in Cleveland. The country boy was somewhat overwhelmed by his visit to the big city, but he was sufficiently in control to make an important contact as he vividly explained: 'How can I describe my excitement of visiting the first such museum and the thrill of seeing mounted specimens of what was obviously the work of an artist in the field of taxidermy – a person who could revivify birds as I already, with my own experience, knew them to be. By sheer good fortune I met the man who had worked this miracle. I had been bubbling with excitement to the librarian just as Arthur B. Fuller passed by and she introduced me. Green country boy that I was, I blurted out my judgements on his highly professional efforts with this bird and that, and he – I couldn't believe it – took me up to his workroom.

'It was then and there that my absolute resolve to be a bird painter was made, for this was the first acceptance and understanding that I had ever had. He had known Fuertes and told me about him! On later visits he gave stiff criticism of my work and even plunked me down to draw before him from a mounted specimen.'

Although three of Eckelberry's uncles were artists, his talent was not welcomed by his immediate family. His father was certainly not convinced that wildlife painting would be a suitable way of making a living. He was probably right at the time, as there were few artists making a living by painting wildlife subjects. However, thanks to the generosity of his uncle and aunt, Viktor and Nadine Shreckengest, Eckelberry went through the Cleveland Institute and while there he stayed with Robert and Ruth Key, another uncle and aunt. Art school was an important way of learning technique, which was vital to a young man who was already achieving some commercial success: he had had a one-man show in Cleveland and was writing two regular newspaper columns.

On leaving art school he travelled around the United States learning about the birds and painting them. He earned a living where he could, taking whatever jobs were available. At 21 he was working in Hollywood, not in the glamorous world of film but as a foreman in an optical factory. He was an active birdwatcher in his spare time and with some birding friends he met John Baker, who was director of the National Audubon Society. After a three-day birding trip to the Salton Sea in the company of Don Eckelberry, Baker was impressed enough with the young man's skill both as an ornithologist and an artist to offer him a job with National Audubon. For the next two years Don worked in the field in Louisiana and New Jersey. He then became a layout artist and illustrator on *Audubon.* Dating from the period at the end of the war there are still some Eckelberry murals in the information area at the Audubon Center at Greenwich, Connecticut.

During this time he was painting for his own pleasure and he had a one-man exhibition in New York which led to a commission to illustrate Richard Pough's *Audubon Bird Guide* (1946). It would have been impossible to complete the 1,250 illustrations for the book, if he continued to work on *Audubon*. Eckelberry therefore decided to become a full-time artist.

More illustration work followed. His approach of

combining ornithological accuracy with a strong element of design was most attractive to publishers. Among the books he has illustrated is James Bond's *Birds of the West Indies* (1963). The other illustrator was Arthur Singer and comparison between the work of these two friends is most interesting. The Singer plates are much more tightly drawn. The Eckelberry plates are very bold: for example, in his plate of trogons, parakeets and kingfisher he allows the ringed kingfisher to overlap the tails of both female and male Hispaniolan trogon, strengthening the design of the plate but without obscuring any important identification characteristics.

Trips to the Caribbean and tropical South America introduced Eckelberry to the neo-tropical avifauna which fascinated him. 'I'm not too fond of dickie birds,' he admitted in an interview in *National Wildlife*, 'they have no character. I prefer long-necked, long-legged birds you really do something with them.' Nevertheless he is a first-class all-round ornithologist, quite painstaking in his approach to the problems of identification. Writing in *Audubon*, he recalled the difficulties of coming to grips with birds in the rain forest: 'On my first visit some years ago I often had heard a clear, piping whistle – usually of four notes. It began with a single note followed by a pause, then had three descending notes, the first on the same pitch as the opening one. Never able to see the bird, I finally tried imitating it and got an immediate and excited response.

'Within five minutes a black-faced ant-thrush, walking like a rail and flicking its cocked tail, appeared three yards away and made a complete circuit of me. So shy is this bird that it will fly rather than walk across all but the narrowest of forest trails. I now find I can usually get an ant-thrush on call.'

He dislikes working on birds with which he is not familiar. He relies largely on his own sketches. He sketches very quickly, which is necessary in the tropics where sweaty hands can ruin drawings; as he wrote in 1967: 'When an artist-naturalist who has been working as long as I have starts to plan a new painting he often goes to his "gold mine", his collection of notes and sketches, to get ideas going. Of course this is a

"salted" mine, by which I mean he puts his little nuggets in to be rediscovered and refined at a later date . . . Sometimes an old drawing can be used nearly as it is. More often, it has to be reworked in the light of added experience, skill and insight.'

In addition to reluctance to painting the unfamiliar, Eckelberry is almost obsessive about getting details right: the epiphyte growing from the branch on which a trogon sits must be of the right species. Even though one of his pictures may have little background, he likes it to be 'sufficiently decorative to be of interest aside from the subject.'

The kindness and encouragement that he received from Arthur B. Fuller encouraged Eckelberry to help others: 'It was his help and his honesty and good advice that decided me that I would in my turn help others like myself. There was no other way I could repay his interest in me which has continued all these years', he wrote in 1976. Many leading North American artists pay tribute to his influence. There is no doubt that Eckelberry has given many hours to helping young artists to improve their techniques. Al Gilbert readily acknowledges the help and encouragement that he received from Eckelberry who, he admits, had a profound influence on his style and approach to painting. And it was largely thanks to Eckelberry's recommendation that Gilbert was commissioned to paint some of the illustrations for *Eagles, Hawks and Falcons of the World* (1968) by Dean Amadon and Leslie Brown. Eckelberry himself was one of the team of illustrators and his studies of peregrines and other falcons showed his work to an enthusiastic audience beyond America, but even so his work is still not widely known in Europe.

Some of his work has been undertaken for the thriving North American art print market. One of his favourite paintings was reproduced as a print. This was a long painting of a group of skimmers resting on the south shore of Long Island near the Eckelberry home. Because of the black on the head of a skimmer, which descends below the bird's eyes, the watcher cannot usually see the eyes. This was how Eckelberry painted his skimmers, but the publishers of the print wanted the eyes to be highlighted. After much

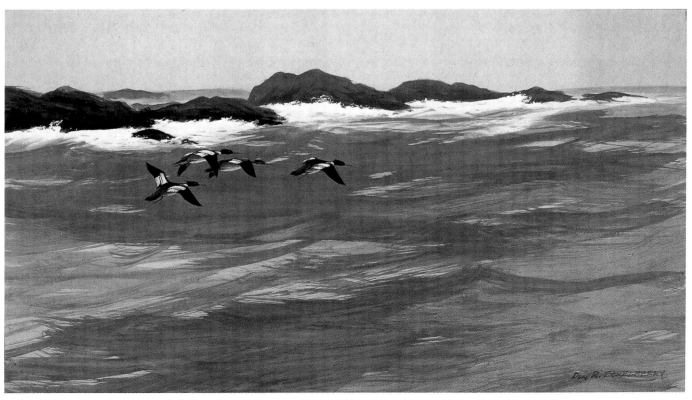

Red-breasted mergansers. Don R. Eckelberry

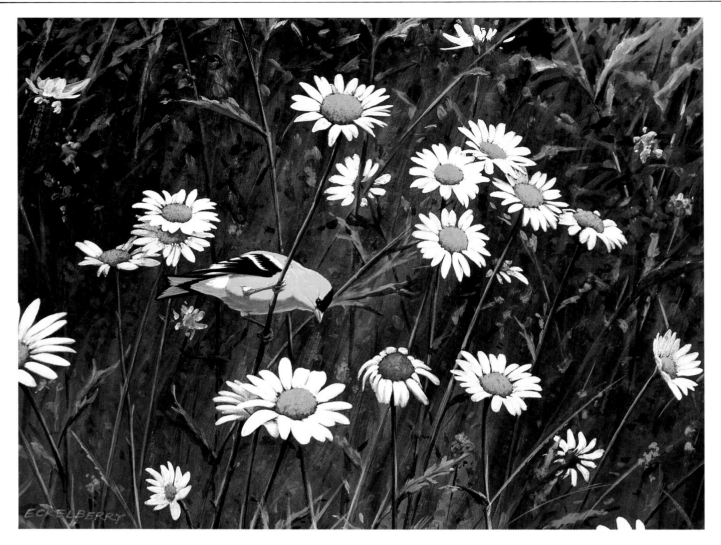

American goldfinch. Don R. Eckelberry

Black skimmers. Don R. Eckelberry

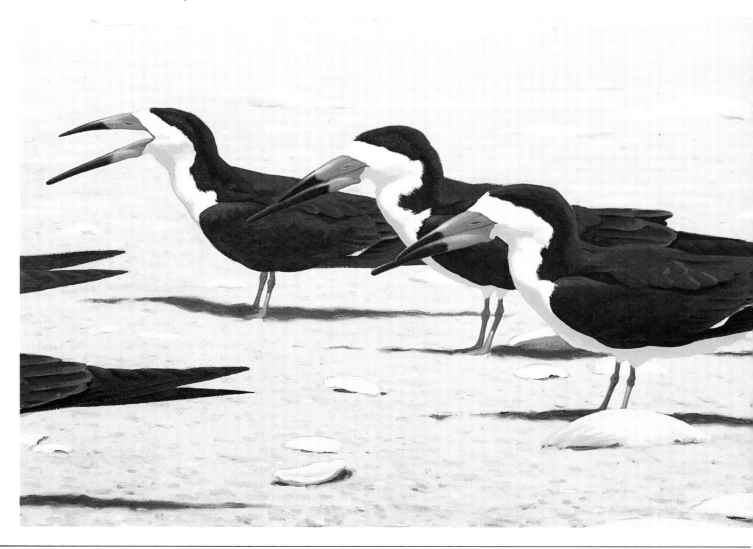

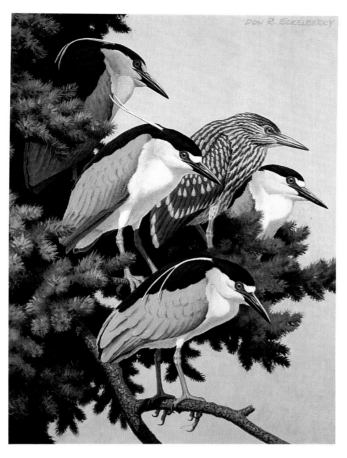

Black-crowned night herons. Don R. Eckelberry

wrangling the artist decided to do what the publishers wanted. However, the moment the picture had been photographed for reproduction, he painted the eyes matt again.

His approach to painting combines the aesthetic with the scientific. He knows his subjects thoroughly and appreciates their relationship to their environments. He understands the effect of light on their plumage and enjoys painting these effects. He has been likened to Fuertes, but this is an underestimate of his ability to produce pictures. He relies less on line than Fuertes and has produced the pictures, as opposed to illustrations, that Fuertes never managed. Sadly, however, Eckelberry's output in recent years has dwindled. Few wildlife artists working today can achieve the quality of Eckelberry.

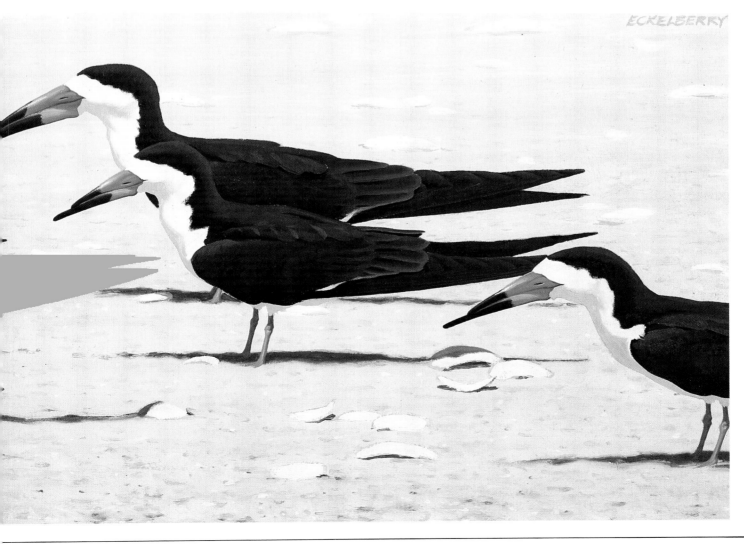

ERIC ENNION

'I knew him as an artist and teacher, and as both he was generous; generous with his mind, generous with his talents and generous with his energies' Brian Cairns told a packed parish church at Shalbourne in Wiltshire in March 1981. He was giving an address at the service to give thanks for the life of Eric Arnold Roberts Ennion. The generosity of which Brian Cairns spoke was a feature of Ennion's relationship with the people of all ages in whom he had inspired or encouragee love of nature and of painting. It was easy, for those who knew the artist towards the end of his life, to forget that he had not always been a teacher.

Eric Ennion was the son of a Cambridgeshire doctor, who practised in the Cambridgeshire village of Burwell and its outlying fenland. Here the young Eric seems to have enjoyed a sunny Edwardian childhood, an idyll of pets and adventures with nature. At the age of six or seven he made a decision to become 'either an archer or an artist', or, as an afterthought, 'a man-who-never-goes-to-church'. Unsurprisingly he failed in the first, but 'the other alternatives I have done my best to follow'. He also developed a deep interest in birds, in which somewhat surprisingly, given his early rejection of the church, the vicar of Burwell played a part. The vicar owned a set of stiff morocco-bound volumes of *Birds* by the Rev F.O. Morris. The small boy was allowed to borrow these under the strictest cautions to take good care of them; 'as if I needed special reminding to be careful with a bird book!' As recalled in *The Living Birds of Eric Ennion* (1982), the boy's visit to the vicarage to borrow each volume took no small resolution, but such was his enthusiasm and determination to make up his own book of bird paintings copied from Morris that he overcame any fears or religious doubts.

To anyone familiar with the watercolours of Eric Ennion it is almost inconceivable that he might ever had copied someone else's paintings. Indeed, he did not do so for long. 'I could not say honestly that, up to the age of nine or ten, I had tried to draw birds from

life. From imagination and in action – usually violent action – yes. There were eagles hurtling down on swans and geese; falcons locked in mortal clasp with herons or harrying ducks; and now and then a couple of curlews or a stand of peewits doing nothing in particular.

'It will have been between ten and eleven years old, that I first set out specifically to *sketch*, i.e. to seek the live bird in the field and bring its portrait back. Did many of us, I wonder, begin sketching birds much earlier than that? – as distinct from seeing birds outdoors and drawing them from memory, with or without the aid of books, when we got back? From then on birds, butterflies and moths filled holidays and every minute I could wrest from term-time, and all my waking thoughts; although how much time I spent sketching, how much just watching birds, I could not say. I know I usually slipped a sketch-book into my pocket, whenever I went out.'

In the years after the First World War there was no obvious career into which such enthusiasm and talent could be channelled, and after the Perse School in Cambridge and Epsom College in Surrey, Eric Ennion began to study medicine, first at Cambridge and then at St Mary's Hospital in London. He took over his father's practice in 1928. One imagines that his kindly, twinkling eyes and ready smile gave him an ideal bedside manner and he admitted to me that he enjoyed his pre-war doctoring. 'I had a large country practice in Cambridgeshire, about 20 miles from one end to the other which included all manner of country from Newmarket Heath to the Fens. On my own and able to do things my own way, I thoroughly enjoyed every minute of it. I'm afraid I'm a hopeless individualist' he told me in 1971. It was that individualism that made him give up medical practice in 1945. The proposed National Health Service was not welcome to a doctor of his independence. He, therefore, decided upon a new career.

As a naturalist Eric Ennion already had a high reputation in East Anglia and he was periodically

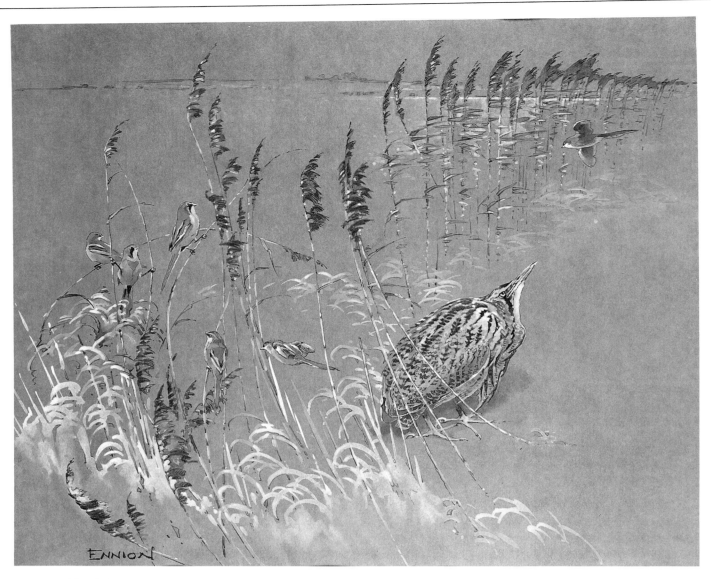

Bittern and bearded tits. Eric Ennion. (William Marler Gallery)

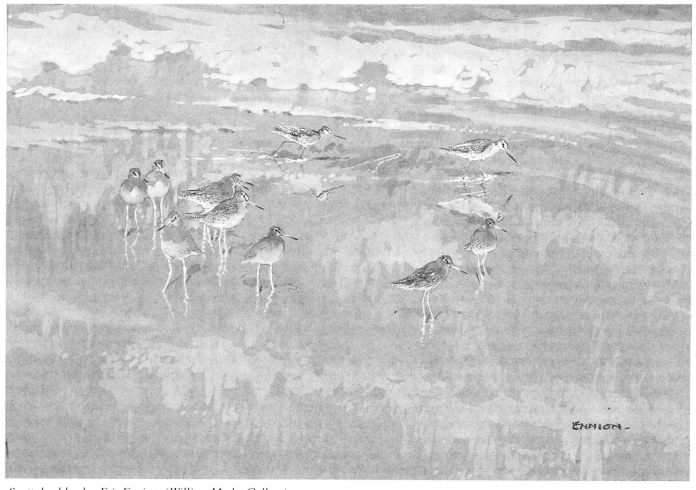

Spotted redshanks. Eric Ennion. (William Marler Gallery)

asked to advise the National Trust on matters relating to wildlife. It was through his contacts with the Trust's land agents that he was able to persuade them to buy Flatford Mill, a symbol of the great John Constable. Effectively it was thanks to Eric Ennion that Willie Lot's cottage was saved. And having saved it he had other plans for it, suggesting that rather than being left empty it became the nucleus of a field centre. Thus the country's first field study centre was established at Flatford Mill with Eric Ennion as its first warden. The activity of teaching was a learning process for Ennion, who used the need to teach unfamiliar subjects as a way of learning himself. Neither trained as a teacher nor as an artist – 'I once did a Hassell's course, a poster course, which I thought might be useful, but it wasn't' – he had the gift of imparting knowledge without diminishing the pupil. After five years at Flatford Mill, Ennion and his family moved to Monks' House on the Northumberland coast at Seahouses. Monks' House was his own privately run field study centre, where up to 30 people at a time enjoyed the enthusiasm of Eric and the kindness of Dorothy Ennion. Courses ranged over art and biology. It was at Monks' House that Eric developed ringing (banding) of waders on a large scale.

A regular visitor to Monks' House in the 1950s was John Busby, whose own work has been much influenced by Ennion. Busby remembered those days in *The Living Birds of Eric Ennion*. 'I have vivid memories of tours of the Farnes, with Eric drawing like mad, while everyone else struggled with cameras. I wonder who saw the most.'

In 1961 the Ennions moved south again. This time it was to Shalbourne in Wiltshire where, with their son, Hugh Ennion, they had a watercress farm. Still Eric ran courses and he continued to do so until his death. And the watercress beds were a wonderful place for Eric to see the water birds of which he was particularly fond.

Keen to encourage others to paint the birds and mammals that he loved, Eric organised, with Robert Gillmor, an exhibition by contemporary bird painters at Reading Museum and Art Gallery. As we have seen, this led to the foundation of the Society of Wildlife Artists, of which Eric Ennion was the first chairman of the executive committee. In 1964 the SWLA held its first exhibition in London. It was a few years later at an SWLA exhibition that I overheard Eric talking about another artist's work. 'You have to be able to draw very well to draw so simply' he was saying. The artist about whom he was saying it was John Busby.

There seems to have been a simplicity about Ennion both as a person and as an artist. John Busby wrote a tribute to him in *Birds*, shortly after his death. 'As a writer, broadcaster, through personal contact, and above all as an artist, he portrayed the countryside with the natural ease of a born teacher, drawing on a deep love of his subject, enlarging our vision by the simplicity of his means, an unerring certainty about essentials.' To this he might have added his knowledge of what he was painting. Like all good wildlife artists, Ennion was very familiar with his subjects, but he managed to keep his painting to the elements he could see, never allowing himself to cloud his vision with the things he could not see. Having learned precociously the need to sketch in the field and not from books, he developed the most acute ability to commit what he was seeing to paper. 'I paint in the field as much and often as possible, but you can't take all your clobber with you. I use as large a sketch-book as I can manage and one has to evolve rapid ways of painting. You obviously have to draw very quickly, very accurately, and to develop a retentive memory of what you see. This comes with practise until, even with a bird in flight, you can put down exactly what you saw although the bird was moving the whole time. You can't record it as you would with a camera, which, incidentally, "stops" the bird and destroys the movement.' Very rarely does one see an Ennion bird that could be said to have been frozen: each of them moves or waits, tense, about to move at the slightest glimpse of danger.

No bird can be divorced from other individuals and

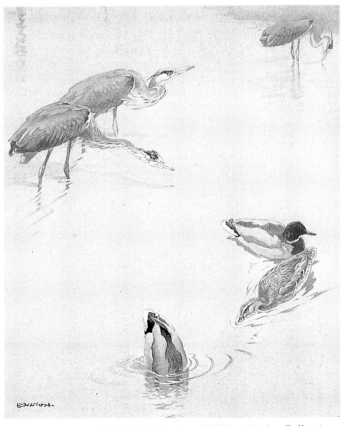

Grey herons and mallards. Eric Ennion. (William Marler Gallery)

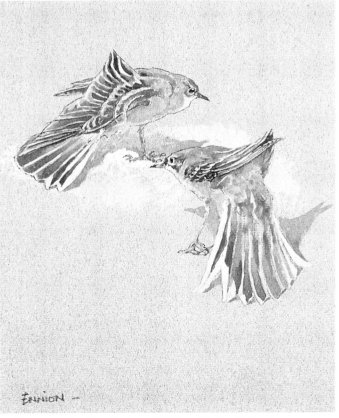

Yellow wagtails. Eric Ennion. (William Marler Gallery)

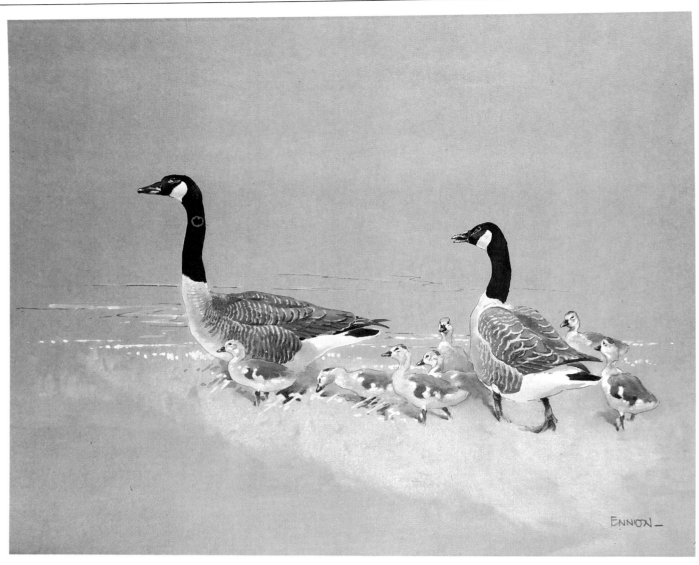

Canada geese and goslings. Eric Ennion. (William Marler Gallery)

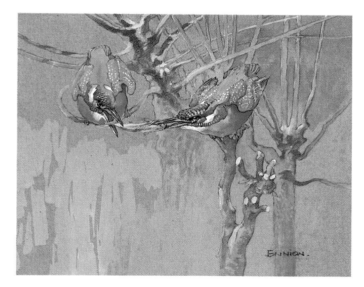

Kingfisher courtship. Eric Ennion. (William Marler Gallery)

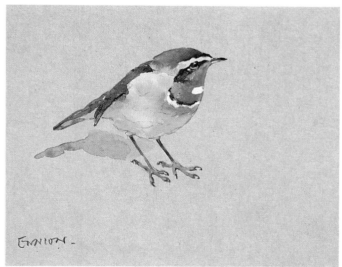

Bluethroat. Eric Ennion. (William Marler Gallery)

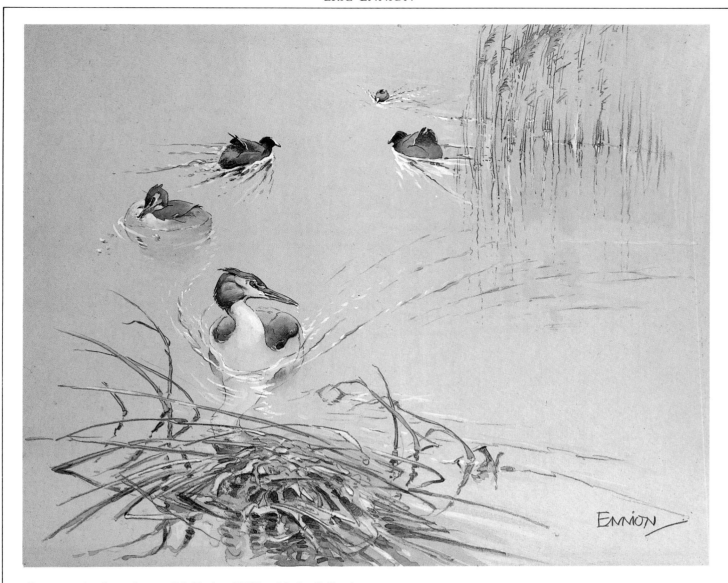

Great-crested grebes and coots. Eric Ennion (William Marler Gallery)

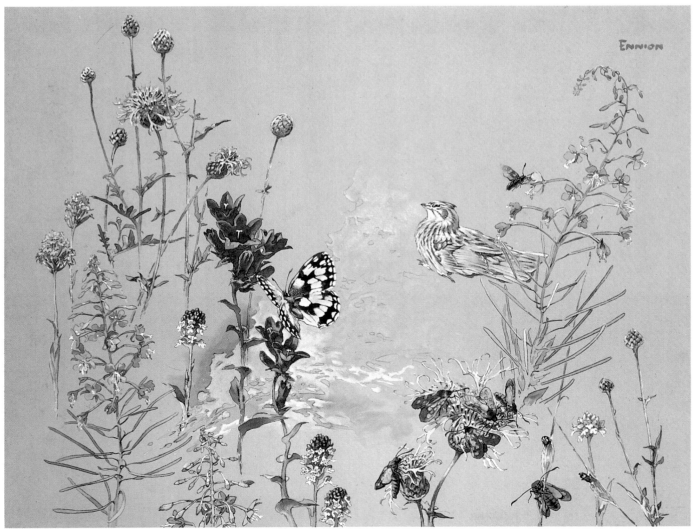

Skylark and marbled white. Eric Ennion. (William Marler Gallery)

Ennion paintings frequently show the relationship between individuals of the same species or between different species in predator and prey relationships. 'After I have been watching, say, a flock of birds I would come home with anything between fifty and a hundred sketches, most of them no more than a slant of the wing or tilt of the beak. As soon as your memory runs out (or the bird has flown!) never go on with the sketch. Don't try to "fill in": be content with what you have got and, later, looking through your sketches, probably you will find three and four sufficiently advanced to make a final drawing; and sometimes you can piece various bits together. In this way you are almost literally sketching direct from nature.'

This technique is no doubt the secret behind Ennion's exciting watercolours showing flocks of waders or ducks, each bird an individual and yet each bird merely a part of the whole flock. The clarity of Ennion's vision is shown in the way in which he varies the colour of each bird so that each takes on the local colour given by the light and shade of the ground or even other birds. And these major paintings also make allowance for the effects of wind on feathers, grains of sand, leaves or plants. In this way he manages to combine hundreds of details into apparently simple paintings. In terms of actual painting they may be simple and even quick, but there is far more to an Ennion painting. As he said: '"How long," says the viewer, "did it take you to paint that picture?" "The actual painting? – an hour maybe – plus fifty-odd years' experience."'

LOUIS AGASSIZ FUERTES

Despite his comparatively short life Louis Agassiz Fuertes has been this century's major influence on the drawing and painting of birds in North America. As well as his illustrations being influential he was personally very generous with advice to younger artists. In the case of George Miksch Sutton (1898–1982) he actually invited him into his home to learn painting and for Roger Tory Peterson the memory of the great man taking the trouble to discuss a 17-year-old's paintings at an American Ornithologists' Union meeting remains indelible. At the memorial service for Fuertes at Cornell University on 30 October 1927, his great friend, Frank M. Chapman, curator of birds at the American Museum of Natural History and editor of *Bird-Lore*, paid tribute to this kindness to other artists.

'It was one of the marvels of Fuertes's nature' he said, 'that much as he loved birds, he loved man more. No one could resist the charm of his enthusiasm, his ready wit and whole-souled genuineness, his sympathetic consideration and generosity of thought and deed. Everywhere he made new friends and everywhere he found old ones.'

Roger Tory Peterson has frequently given witness to the influence of Fuertes on him. In the introduction to *Louis Agassiz Fuertes and the Singular Beauty of Birds* (1971) he wrote about the dilemma that he shared with the great man. 'As one who paints,' he wrote, 'and who has been much influenced by Fuertes's approach, I have been fascinated by his early development and particularly by his artistic dilemma, one which has confounded me – whether to paint birds impressionistically, as the eye sees them, bathed in light and shadow, or to paint them as detailed feather maps devoid of modifying atmosphere.'

Fuertes tried to encourage both Peterson and Sutton to paint birds showing the disguise within colour and patterns. Peterson, however, felt that Fuertes himself never really practised this principle, but that may have been because of the two main and rather conflicting influences on the artist as a young man. As we have

already seen, artistically it was Abbot Thayer, a painter of rather idealised portraits of women and a keen ornithologist, who helped shape Fuertes's career as an illustrator; and ornithologically it was Dr Elliott Coues, an eminent ornithologist and author, who was to play an important role in Fuertes's early career.

It was Thayer who first demonstrated the principles of countershading, demonstrating that the undersides of birds were paler than the uppersides because they fell into shadow. Thus, in bright sun a dark back becomes lighter and a pale belly becomes darker and reflects local colour. This theory of protective coloration Thayer tried to apply to all birds and by the time of his death in 1921 he appeared to have become obsessive about it.

Thayer tried to persuade Fuertes to paint birds that merged with their environment, while the scientific ornithologists in Fuertes's life led by Elliott Coues were always encouraging him to paint birds that stood out from their backgrounds. It was the second school who held sway, helped no doubt by publishers and editors who were more interested in good pictures than the truth.

Fuertes's father was Professor of Civil Engineering at Cornell University. Louis was born at Ithaca on 7 February 1874, the youngest of six children, and named 'Louis Agassiz' after a recently deceased naturalist, a friend of his parents and a visiting professor at Cornell.

When Fuertes was 14 he discovered in the library at Ithaca a copy of Audubon's *Birds of America* and he was inspired by Audubon's joy in the form and beauty of birds to make careful sketches of the birds that he found. When the time came for Fuertes to go to college, Cornell was the obvious choice and he enrolled in the School of Architecture to major in engineering, but changed halfway through his sophomore year to take an art degree.

College was a good time for Fuertes. He was a convivial person, an excellent storyteller and a keen member of the glee club. It was through his singing

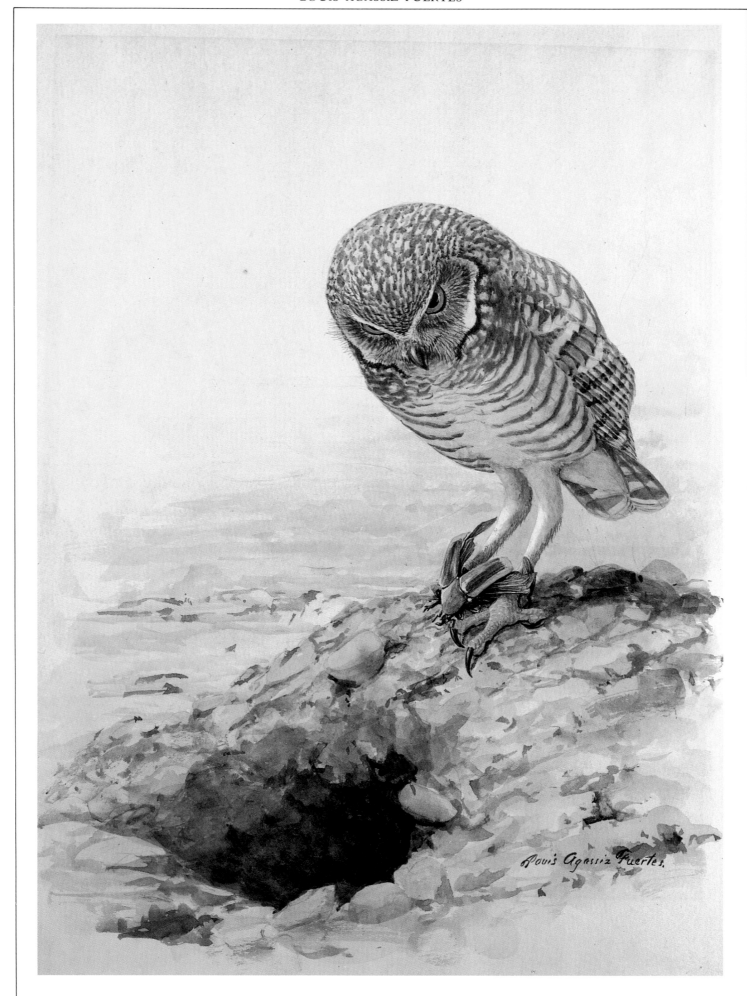

Burrowing owl. Louis Agassiz Fuertes. (Academy of Natural Sciences, Philadelphia)

that his first major chance came: one of his fellow singers was Charles Henrotin who was a nephew of Elliott Coues. On a visit to Washington, D.C., Henrotin arranged for his birdwatching friend to meet his uncle, who was 'crazy about birds'. Encouraged by talking to Coues, Fuertes determined to become a bird painter, although his father was unenthusiastic

about this plan. Coues, however, recognised the young man's talent and did everything he could to be encouraging. He arranged for about 50 Fuertes paintings to be exhibited at the American Ornithologists' Union meeting in 1895. This exhibition resulted in commissions for illustrations for *A-birding on a Bronco* (1896) by Florence Merriam for

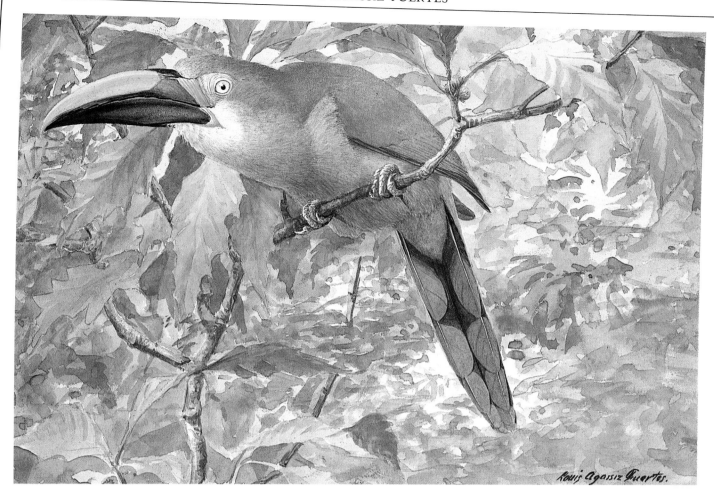

Emerald toucanet. Louis Agassiz Fuertes. (Academy of Natural Sciences, Philadelphia)

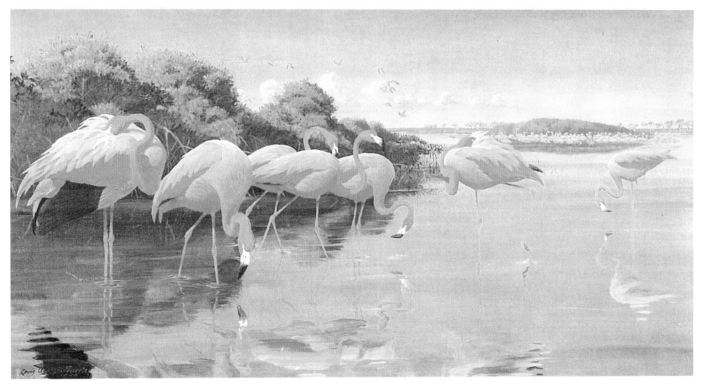

American flamingoes. Louis Agassiz Fuertes. (American Museum of Natural History)

the periodical *The Osprey*, and for *Citizen Bird* (1897) by Coues and Mabel Osgood Wright.

Fuertes's senior thesis at Cornell was on the coloration of birds. He graduated in 1897 and spent the summer at Dublin, New Hampshire with the family of Abbot Thayer, to whom Coues had introduced him in 1896. Abbot Thayer taught him some important lessons about coloration and the effects of light and shade on birds. The results of Thayer's teaching can be clearly seen in Fuertes's use of watercolour. It was with Thayer that he went on an expedition to Florida

in 1898 collecting and painting birds, the first of many expeditions made by Fuertes over the next 25 years or so. Even his honeymoon in Jamaica in June 1904 turned into a collecting and painting expedition. It was also the only expedition on which his wife, Margaret, ever accompanied him.

He was always welcome on expeditions because the other members found him such a delightful and knowledgeable companion. One man who went on a collecting trip to the South American rain forests was Paul Howes of the Bruce Museum in Greenwich,

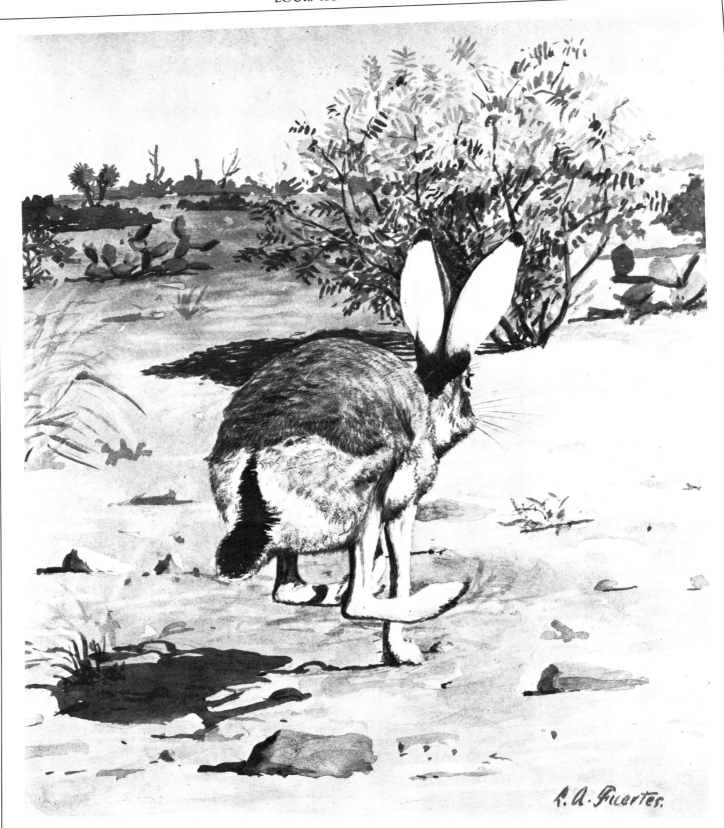

Black-tail jack rabbit. Louis Agassiz Fuertes. (Academy of Natural Sciences, Philadelphia)

Connecticut. In his book, *Photographer in the Rain Forests* (1969), he wrote about Fuertes's kind heart: 'Fuertes had a way of making odd sounds, sort of "purrings and croonings", when he was definitely conveying delight or deep appreciation of beauty and color, or the regret and pity or horror he felt at the sight of an injured animal or poor beggar or diseased person he saw on his expeditions.'

Howes also wrote about Fuertes's painting technique: 'Fuertes painted so rapidly and so expertly that I could not keep track of his methods. To me it was fascinating to observe this genius working with watercolors, how deftly and how confidently he made each stroke. It was amazing to see him create gloss and shading in plumage . . . and that subtle allowance of brilliant highlight left in the painted eye, a secret which if understood and properly attended to make all the

difference between good and bad bird or animal portraiture.'

One person who had the privilege of watching Fuertes at work in his studio was George Miksch Sutton, who was to become one of the leading bird artists in the United States. Sutton first discovered Fuertes's work in the years before the First World War. He wrote more than 60 years later about the fascination of the illustrations in Florence Merriam Bailey's *Handbook of Birds of the Western United States* (1902). Sutton was ten and used to help a kindly professor in the biology laboratory at the University of Oregon in Eugene, where he came across the book. 'While looking at them I wanted no one to disturb me. I had not the slightest desire to trace or copy them, but I did wonder how anyone could make a bird's bill look so hard, its feathers so soft, its toes so strong and

supple and its eyes so bright all on the same sheet of paper.' After what must have seemed a very long time Sutton was given his own copy – a fourteenth birthday present.

Making illustrations live was a skill that few other artists working in the United States at the beginning of the century could claim. It is small wonder that the young Sutton was so struck by Fuertes's illustrations. Still under 40, he was in a different league from any other artist then working in America. In 1913 Sutton wrote to the great man with some copies of his own drawings. And Fuertes wrote back.

'When Louis Agassiz Fuertes, an extremely busy man, then at the height of his career, decided that I was worth helping,' Sutton recalled, 'he revealed a generosity beyond any that I had expected outside my own family circle.' Fuertes thought the young man so worth helping that he invited him to spend the summer with him at Sheldrake Point, New York.

'When I arrived by train, I carried a suitcase whose two ends were competing fiercely in the race to dissolution. Fuertes was not at the station to meet me. I started walking toward "The Point", for I had been told the Fuertes house stood there. A truck drove past, slowly almost to a stop, and off hopped a man who waved thanks to the driver and called to me "George, I'm glad you're here. The place is yours. Just do anything you damn please while you're here!"'

Life in the Fuertes household was great fun for Sutton, a son of the manse. The Fuertes, Louis and Margaret and their children Sumner and Mary, were an uninhibited family. 'The meals' according to Sutton, 'were excellent, but even if they hadn't been, they would have been wonderful, because of the merriment and camaraderie.'

Although he was a jovial man, Fuertes was certainly not light-hearted about his painting. Sutton recalled that he worked hard and would not be diverted, but 'when mealtime came, he sought release from all that had driven him so relentlessly. Release took various forms – funny stories, many of which necessitated quotations in dialect; uninhibited comment about people in the public eye; pranks that merited the phrase 'hi-jinktum-jee'. There was simply no telling how that irrepressible fun streak of his would reveal itself . . .

'Every member of the Fuertes family was as smart as a whip. They awed me, not only the famous father, but the other three as well. Mrs Fuertes, whose first name was Madge, told stories extremely well, and her opinions on any subject were well worth listening to; she had a gift for leading the conversation toward a point where a story from her husband was completely apropos. Sumner, the son, was elegant even as a youngster, and handsome. Mary, the daughter, appealed to me deeply. She was a gentle child of great charm and a special, pale golden kind of beauty.'

The studio at Sheldrake Point was a small, but well-lighted room. 'Here he had a big table, drawing boards of various sizes, a vase full of watercolor brushes, tubes of paint, little pans of paint and paint boxes galore. Lying on the table was the beautifully prepared skin of a phoebe, the bird he was drawing. When I looked at the specimen carefully I realised that it was no average museum skin. Its back was not flat but rounded; its feet stuck up; its feathers had a fluffy recently preened appearance. All this was no accident: Fuertes himself had prepared the specimen to serve as a model.' Sutton was allowed to watch Fuertes lay washes for his drawing of the phoebe. It was only later that the young enthusiast realised how privileged he was to watch the great man at work. 'I was eager to learn and had traveled a long way. What I didn't

realise was that Fuertes may have been miserably self-conscious as I stood there observing his every move . . .: Having a worshipful youngster at his elbow might have flattered his ego, but it also divided his attention. Flowing-on a watercolor is extremely tricky: this I now know from long years of experience. I had no idea of it then. When Fuertes put the wash on that phoebe drawing he was working toward two ends, serving two masters. He was creating a background for what was presently to be a bird portrait of immense charm and appeal; he was also showing his pupil just what to do and perhaps, even more importantly, what not to do.

'The lightly penciled-in drawing was firmly attached to the drawing board with thumbtacks. The bill of the bird was slightly open. I thought that this was to indicate that the bird was singing. Not so. Fuertes picked up his model, looked carefully at its bill, examined his drawing, then stood up, saying, "We've got to catch a moth. Come on, help me find one!" So out we went and around we pranced until a moth of a proper size and beauty had been flushed from the grass and captured. I watched Fuertes pencil in that lovely lepidopteran held so tightly in the phoebe's bill. Who would ever know that I, not the phoebe, had caught it?

'The background wash, pale grayish-blue in the upper third of the picture, pale green in the lower two thirds was to go on before any part of the bird or its perch received color. Fuertes took a big brush from the vase, mixed some blue, added water, strengthened the tone by adding more paint, tested the color on a piece of scratch paper, poured in more water, then rinsed the brush thoroughly before mixing the green wash. The two colors were in separate saucers. "Be sure to have plenty" advised Fuertes. "And do all the mixing and all the testing before you start."'

A wash must be applied rapidly and Fuertes told Sutton never to allow the lower edge of the wash to dry. Fuertes tilted the drawing board so that the paint would flow downward, and he moved the paint-laden brush rapidly from left to right. 'I could see the color from the first stroke flowing down into the upper part of the second stroke. No edge formed. Presently the whole top third of the paper was grayish blue – all but the phoebe's head, up to the very edges of which the brush had moved swiftly, unerringly, as if by magic. Fuertes flicked the brush to rid it of blue, rinsed it, flicked it again, and started with the green. This time the stroke was not strictly horizontal, for the uppermost part of it was to represent a distant tree line. Nowhere did a hard edge form. The two tones flowed together smoothly, harmoniously. "Before you make another move," cautioned Fuertes, "that background has to dry."' So they both went for a stroll along the peninsula.

'When we returned to the studio the paper was quite dry. Now Fuertes was to astound me by painting a lot of seemingly unrelated dark spots and lines here and there within the area that was to become the phoebe. These were what he called "the deepest darks". The brush he used was very large, but it had a fine tip. After he had put in the very dark areas, he added less-dark lines and blotches, all of them neutral in color. The phoebe by this time had a somewhat leprous appearance, but I could see that the wing was beginning to take shape.

'The matching of colors, and ascertaining that when dry they would represent the bird's plumage properly, took time. I watched him test dabs of paint dry on the scratch paper. Finally the brush got to work. The phoebe's whole head, pulled together by deft strokes

of dark paint, became feathery. To accent a highlight, Fuertes "pointed" the brush with his lips and touched its tip to part of the fluffy crest, and lo, all at the same instant there came into being a curved surface, a softness, an effect of light and shadow, a three-dimensional quality. I had seen it all happen – right there within touching distance!

'So engrossed was the master by this time that he said little. He did not need to say anything. As the brush, carrying a pale tone, moved over the wing area, the coverts instantly shingled each other convincingly. An important fact was revealed – not every

feather need show, to delineate every one would be misleading, even dishonest.

'Fuertes painted the moth with special care. I marveled that the big brush could produce such delicate marking. After the moth came the perch and other accessory material, then finally the phoebe's eye. Suddenly the whole picture came to life. The eye twinkled. The soft plumage lifted and sank. I had to look twice to make sure that the moth was not disappearing down the phoebe's gullet.'

Specimens, such as the phoebe that Sutton saw being painted, were an important source of reference

Peregrine and green-winged teal. Louis Agassiz Fuertes. (Academy of Natural Sciences, Philadelphia)

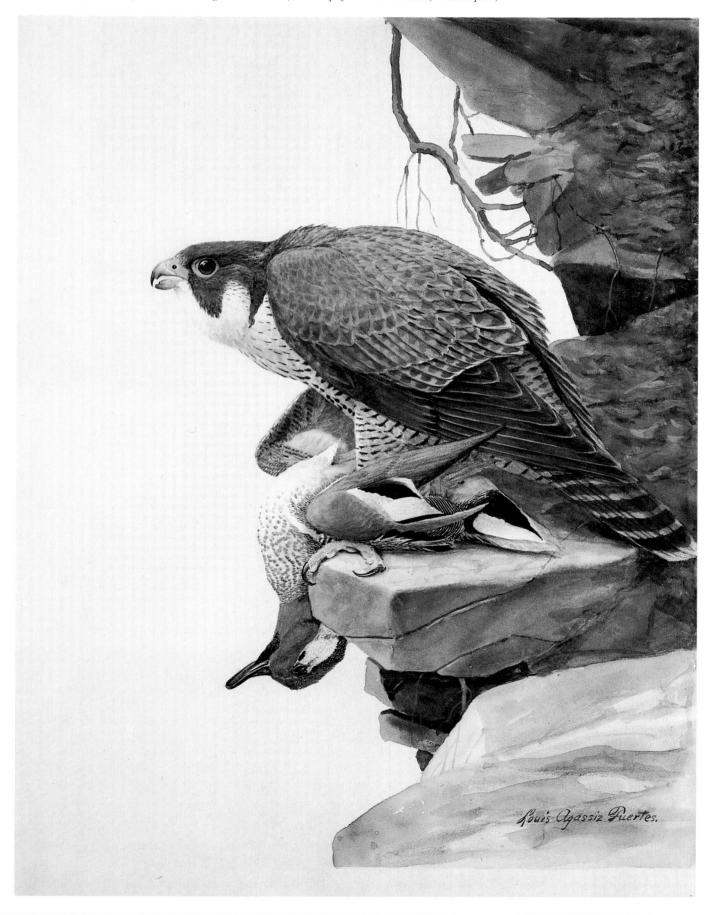

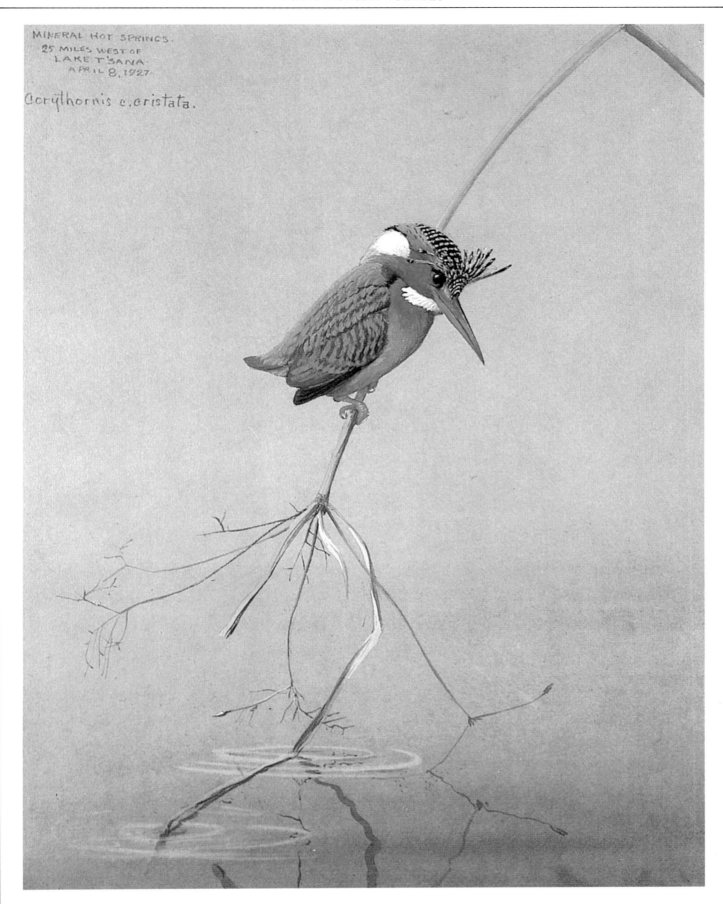

MINERAL HOT SPRINGS.
25 MILES WEST OF
LAKE T'SANA.
APRIL 8, 1927.

Corythornis c. cristata.

Malachite kingfisher. Louis Agassiz Fuertes

for Fuertes. Today, any artist who killed birds in order to paint them would be condemned by most bird-lovers, but in the early part of the century the study of natural history was still based on collecting. Fuertes's approach to collecting seems to have been undertaken as a matter of professional necessity rather than enjoyment. He did not kill for the sake of it. In 1915 Frank M. Chapman, who went on several expeditions with him, described his approach.

'Fuertes in possession of a freshly captured specimen of some bird which was before unknown to him is, for the time, wholly beyond the reach of all sensations other than those occasioned by the specimen before

him. His concentration annihilates his surroundings. Color, pattern, form, contour, minute details of structure, all are absorbed and assimilated so completely that they become part of himself, and they can be reproduced at any future time with amazing accuracy. Less consciously, but not less thoroughly and effectively, does he store impressions of the bird's appearance in life, its pose, mannerisms, characteristic gestures of wings, tail or crest, its facial expression – all are recorded with surprising fidelity.'

Despite his skill as a taxidermist it would have been impossible to produce such lively illustrations if Fuertes had not had a natural ability to memorise the

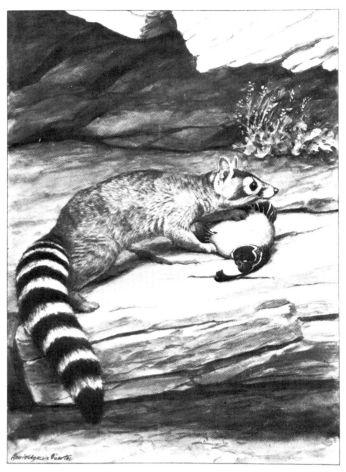

Ringtail. Louis Agassiz Fuertes

way in which animals move. Robert Bateman likened Fuertes's skill in drawing living animals to that of a natural ball player, a gift of which he made full use. His field sketches of black-necked stilts and long-tailed skuas show this ability. So do his finished drawings of a blacktail jackrabbit bounding for cover in the desert or a roadrunner at full pelt. And he was able to catch the essential character of an animal: one watercolour shows a ringtail alert over the body of a California quail.

Expeditions, throughout the New World and to all the world's other continents except Australasia and Antarctica, took up much of Fuertes's time: he went on more than ten major trips during the first quarter of the century, often going back to somewhere he had previously visited. There was a constant demand for his work as an illustrator – magazine articles, natural history, books, government reports, backgrounds for exhibits at the American Museum of Natural History (which organised several of the expeditions of which he was a member), cards to go in Arm and Hammer baking powder packets, even menus and a mural for the Flamingo Hotel, Miami Beach. Fuertes was the first of the American twentieth-century artists to

make a living from illustrating natural history subjects. Recognised by the general public and the ornithological establishment (he became a resident lecturer at Cornell in 1922), there is no doubt that he had a far-reaching effect on both public attitudes to birds and on the pattern of painting of wildlife in North America.

Ironically, the effect of his work may not have been totally beneficial. Fuertes's ability to infuse his subjects with life was limited to the birds and mammals that he knew so well. This ability seemed to leave him when he painted people and farm animals: his Brewer's blackbird has in the background a farmer ploughing with a pair of horses, neither of which would pass examination by an expert on horses. His landscapes, seldom more than a suggestion in the background were weak. His over-specialisation in natural history subjects has helped the art establishment in America to form its view that paintings of natural history belong in natural history museums and not art galleries. Robert Mengel, artist and professional biologist, who has reservations about the influence of Fuertes on American painters of birds, wrote, in *The Living Bird* (1980): 'I have heard the suggestion, and I agree, that emulation of Fuertes long had a deadening effect on American bird painting. It may account for the much greater freshness and variety, at least until recently, of European efforts where no such overpowering influence was felt.'

Had Fuertes had the opportunity, he would have developed as a picture-maker rather than as an illustrator. By the early 1920s, when he was still not yet 50, he had achieved the financial position that made him less dependent on commissions for illustrations and enabled him to concentrate on painting pictures. This was something he mentioned to the young Roger Tory Peterson at the 1925 show organised by the AOU in New York. Here he was again showing his kindness to the young, making a point of backing the young artist, encouraging him and promising further help. He also discussed his own paintings with Peterson: 'He had on exhibit a large oil of a great horned owl on the ground against a background of dead leaves, a bold treatment that reminded me of a canvas by Liljefors, the Swede. "This is the way I really like to paint," he said, "I'm going to do more of it from now on."'

This was not to be. At the end of 1926 Fuertes went on an expedition to Abyssinia, where he drew some excellent field sketches, returning via Europe in the summer of 1927. On 22 August, returning from a trip to the Frank Chapmans, with his wife and a carload of his Abyssinian sketches, he was struck by a train on a railroad crossing at Unadilla, New York. His wife and the paintings were unharmed. Louis Agassiz Fuertes was killed outright.

ALBERT EARL GILBERT

High in the Connecticut countryside, looking across a wooded valley towards the Berkshire Mountains is an artist's studio with a memorable view. Although the view is very different from the estuary that Charles Tunnicliffe looked over from his Anglesey studio, it had the same quality of surrounding the artist with his subjects. Owner of the studio is Albert Earl Gilbert. The studio is a substantial house standing in a garden cleared from the surrounding woodland. Although I did not see any of the local white-tailed deer when I visited Al Gilbert, I did see a chipmunk, a red squirrel and a ground-hog as well as several American woodland birds. Looking across the valley I thought that much of southern England must have looked rather like this before the trees were cleared. Later on that day in late May the humidity rose uncomfortably and a mist covered the hill tops. With a turkey vulture soaring above the valley, we might have been looking across tropical cloud forest.

Given Al Gilbert's enthusiasm for the birds and other animals of the tropics, the illusion seemed very appropriate. Gilbert's love affair with the tropical rain forest began in March 1965 when he went on an expedition to the Sierra Madre de Chiaspas in Mexico. Here in the cloud forest he watched and painted rare and interesting species, such as the horned guan, the quetzal and the black chachalaca. The paintings resulting from this trip were exhibited at the 1966 meeting of the Wilson Ornithological Society.

Many other trips followed, but it was the one in 1977 to East Africa and Madagascar that changed his life. Concerned about the rapid disappearance of both habitats and species in East Africa, Gilbert had decided to make the trip before it was too late. There he had plenty of opportunity to paint the big cats – lions, cheetahs and leopards. On the way back he paused in England, where he visited the Wildfowl Trust at Slimbridge. At this remarkable collection he drew countless sketches of the captive ducks. Like so many other visitors to Slimbridge, Gilbert was enchanted

with the hooded mergansers in the collection and it was his sketches of these that changed his life.

In 1934 the United States Government, whose long-standing record on the conservation of wildfowl should be envied and perhaps emulated throughout the rest of the world, instituted the Duck Stamp Design Contest. The purpose was to select a painting of wildfowl to decorate the annual licences for hunting migratory wildfowl. The stamp is sold and prints are made, the revenue for which is used to buy wetland refuges for duck. Fame and fortune come to the successful artist. Gilbert's hooded merganser sketches made at Slimbridge were turned into a delicate painting of a drake that won the 1978–79 contest.

The resulting income from the 5,800 signed prints, and the remarque edition of 1,350 prints with signature and a pencil sketch, enabled Gilbert to buy his Connecticut studio from film and theatre director, Mike Nicholls (whose work included *The Graduate* and *Midnight Cowboy*), and to set up a company specialising in limited edition facsimile lithographs.

Signing limited editions and drawing sketches for remarque proofs can be tedious and Al Gilbert was pleased to be able to get back to illustration work. For as long as he can remember he wanted to be an illustrator. He was born in Chicago in 1939 and the subjects of his first attempts at drawing when he was two or three were animals. He played hookey from school to visit the Brookfield Zoo and draw animals, in which he was encouraged by the bird curator, Karl Plath, who was himself an artist. Gilbert had realised at an early age the importance of painting from life and not copying other people's work or photographs. At 15 he summoned all his courage and sent some examples of his work to Dr George Miksch Sutton at the University of Oklahoma. Doc Sutton was generous with his advice, no doubt because he remembered the kindness that he himself had received from Louis Agassiz Fuertes when as a teenager in the early part of the century he had sent his work to the great man for criticism. Sutton's guidance gave the

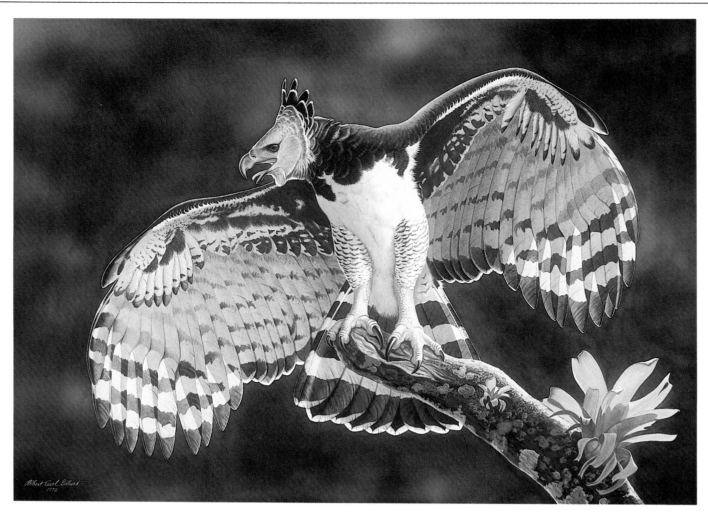

Harpy eagle. Albert Earl Gilbert

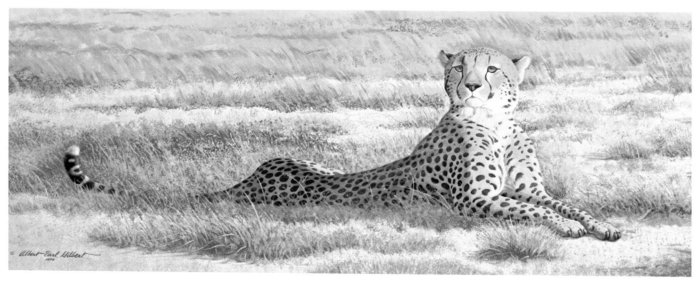

Cheetah. Albert Earl Gilbert

sensitive teenager from Chicago crucial confirmation that what he was doing was going in the right direction and that he had talent.

Now convinced that he could meet his ambition to be an illustrator of animal subjects, Al Gilbert chose not to accept a scholarship to Illinois University. Instead, he became a naturalist with the Cook County Forest Preserve, and decided to study art on his own. His employment helped him to do this, because among his duties were designing and painting exhibits for nature centres. He also learned about animals in the field and at first-hand, sometimes literally. For example, he learned to train birds of prey for falconry and found himself, not very enthusiastically, handling rattlesnakes. Thanks to Don Eckelberry, Gilbert later became an illustrator with the American Museum of Natural History in New York. Eckelberry gave the young artist considerable encouragement and helped

him to develop his style. At the museum he found himself illustrating books for the scientific staff, who demanded scientific accuracy. Gilbert considered this to be an excellent discipline that added to his own ability as a naturalist.

Watching James Perry Wilson, the landscape artist, at work on museum dioramas helped Gilbert to understand the effects of light on colour and consequently to develop his own palette.

Museum expeditions into the South American rain forests in the company of ornithologists such as Dr Dean Amadon taught him the techniques of scientific study as well as giving him opportunities to see exciting and beautiful birds such as toucanets, trogons, curassows and guans in their habitat. His travels took him to remote jungle areas of the Amazon where few Americans had been: 'Dean Amadon and I were the first Americans these Indians had ever seen.

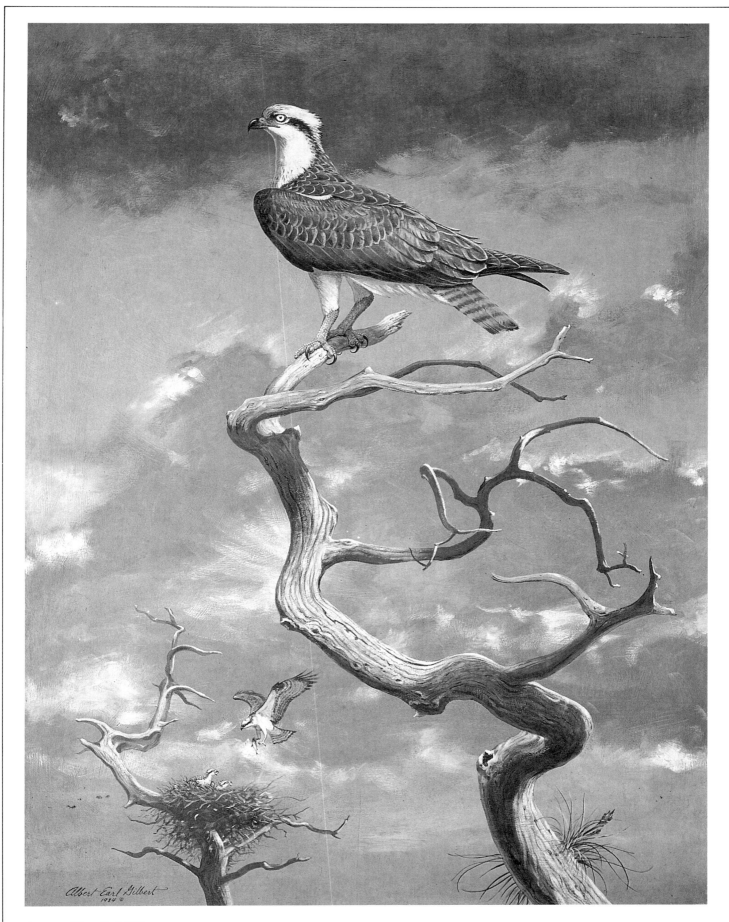

Osprey. Albert Earl Gilbert

When we were introduced, they immediately asked if we were the two Americans who had walked on the moon.'

Dean Amadon was the co-author, with Leslie Brown, of *Eagles, Hawks and Falcons of the World* (1968), for which Al Gilbert supplied 24 plates on the recommendation of Don Eckelberry, who was one of the other artists on the project. Gilbert's illustrations established him as an important wildlife illustrator, but it is instructive to look at these plates 20 years later and see how his style has developed. Another

significant illustrative contract was for *Curassows and Related Birds* (1973) by Jean Delacour and Dean Amadon, for which he produced a series of illustrations that are clearly of the twentieth century compared with the plates to so many modern monographs which could so easily have graced a Victorian monograph.

Drawing from life is a matter of great importance to Gilbert, who has an impressive library of sketches made in the field. He showed me several pencil sketches made on South American expeditions. Some

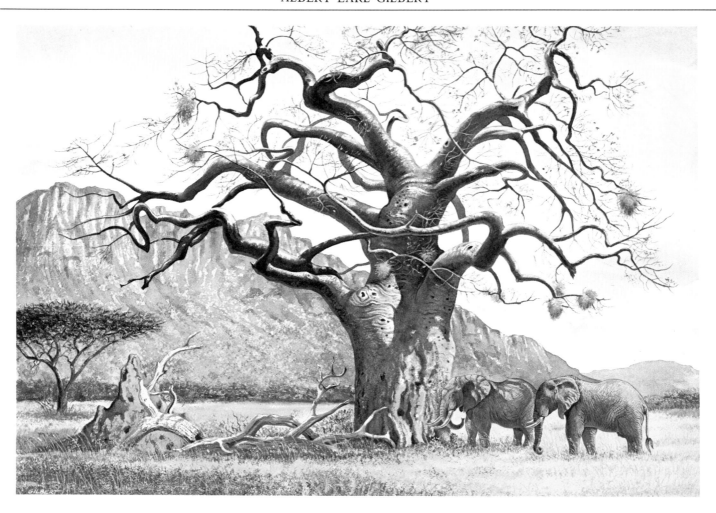

Elephants. Albert Earl Gilbert

were unfinished and showed the stains and marks that are inevitable to sketches made in the humidity of the South American jungle. He also makes sketches of birds that have been trapped before returning them to the wild. For detail he sometimes refers to specimens collected by the scientists on expeditions, but he never uses stuffed and mounted specimens because they often become distorted and the colours fade.

Photographs can be disastrous for the wildlife artist and, recognising this, Al Gilbert deliberately avoided taking photographs of birds and animals for at least seven years while he learned to paint what he could see of living animals. Now, however, he feels sufficiently confident in his abilities both as an artist and as a naturalist to use a camera. Even then he regards the camera as a useful information gathering tool to be used in combination with field sketches and his memory. Most of his photography is used for backgrounds and the plants and interesting branches that are what he describes as 'the authentic props for finished pictures'. It is, he claims, very obvious when an artist has made up such details from his imagination. In view of Gilbert's high standards of accuracy in his representation of animals it is hardly surprising that he takes such trouble over the non-animal aspects of his paintings.

The first stage to a finished painting by Gilbert is an initial sketch on fine quality vellum tracing paper. Sometimes this takes the form of a thumbnail sketch

which is refined and developed as necessary. It is at this stage that Gilbert solves all the problems of composition and design. Sometimes he produces colour sketches, but is wary of these because there is a danger of losing creative energy in painting them. When the initial sketch is complete the working drawing is transferred to illustration board or other painting surface. For large paintings of more than three feet by two feet, Gilbert enlarges the working drawing mechanically.

With his preferred medium, watercolour, Gilbert begins to work on the distant background, working down the painting through the middle ground to the foreground, only adding the animal subject at the last stage. With oil or acrylic he works over the whole picture, having covered the canvas from the sky to the foot of the painting.

Is it because of his lack of formal art training that Al Gilbert has a very objective approach to painting? Or is it thanks to his work on scientific expeditions that he takes this approach? Whatever the reason, the fact is that this man is one of the best wildlife artists working today. It is no surprise that he has been President of the Society of Animal Painters. Grateful to the interest taken in his work by Doc Sutton and Don Eckelberry, he in his turn takes great interest in the work of other artists and when I met him, he pressed the claims of Guy Tudor and Larry B. McQueen.

ROBERT GILLMOR

obert Gillmor's reputation as a wildlife artist began early, with his first illustrations published before he left school in 1954. 'I wasn't brilliant at an early age in the way that Tunnicliffe was' he told me, 'but I was in the right place at the right time.' Part of his good fortune was to have a grandfather who was both a very good artist and a very good teacher. This man was Allen W. Seaby, who had retired as Professor of Fine Art at Reading University in 1933, three years before Gillmor was born. He can remember as a very small boy the framed colour woodcuts by Seaby that hung on the walls of the Gillmor house in Reading. He also knew his grandfather well because he lived just over a mile away.

He spent many hours in his grandfather's studio, watching him at work woodcutting and printing, learning about drawing and painting in watercolour and oils. Through his grandfather's books he was introduced to the work of other artists. For example, he learned about Liljefors before he discovered many other bird artists. As a teenager his grandfather would teach him about painting, having already taught

him how to draw birds. He was a 'great teacher', a talent that his grandson also shares: I have seen children standing spellbound around Gillmor as he demonstrates so quickly and competently how to paint birds in watercolours. Seaby's greatest influence on his grandson was in graphic work rather than painting. He was a leading exponent of print-making using the Japanese methods, pioneered in England at the turn of the century by Morley Fletcher.

Seaby himself was an illustrator of bird books, having contributed to Kirkman's 12-volume *British Birds* (1910–13), but while he knew Kirkman and his collaborator, the Reverend F.C.R. Jourdain, he was not really of the ornithological world. Gillmor often went birdwatching with his grandfather and as a teenager used to identify bird song and calls for Seaby whose hearing was not very good.

The major influence on Gillmor both as an artist and an ornithologist was his school, Leighton Park, a Quaker establishment in Reading, where his interests were encouraged by the art master, Harry Stevens, and by J.D. Wood, whose subjects were French and history and who was also an outstanding naturalist and

Avocets. Robert Gillmor. (Royal Society for the Protection of Birds)

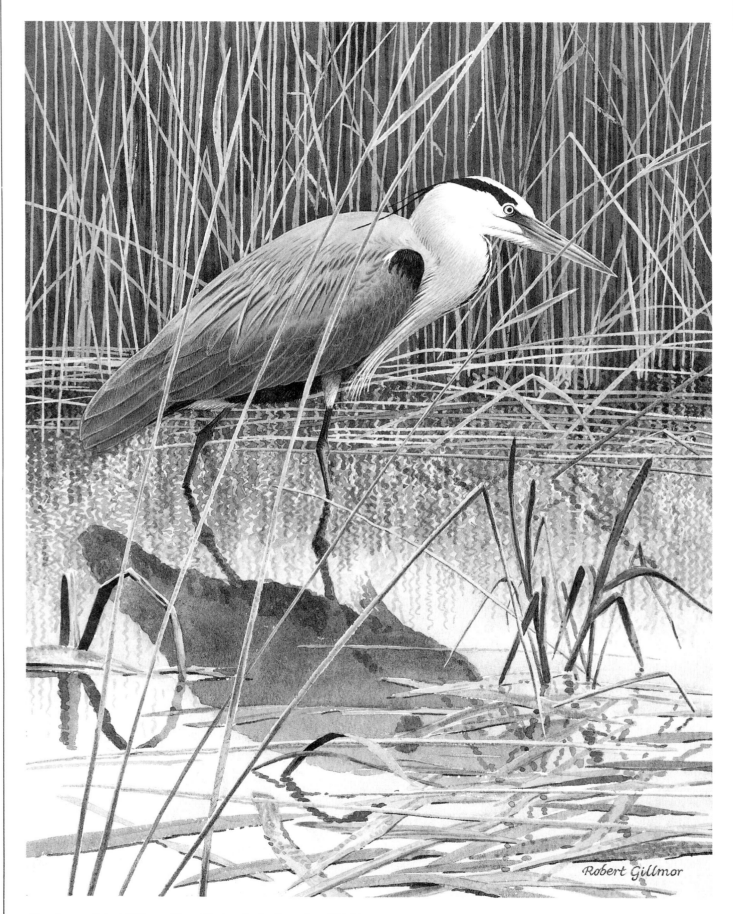

Grey heron. Robert Gillmor. (Royal Society for the Protection of Birds)

botanist. He organised a school bird club along formal lines, which provided an excellent training ground for its members later in life. This certainly seemed to have left its mark on the Reading Ornithological Club, of which Gillmor has been a moving force for over 30 years. The school bird club ran a ringing group and had close links with the island of Skokholm off the Pembrokeshire coast, where Gillmor first began to watch the auks and kittiwakes that have appeared in so many of his paintings and prints since. The schoolboys also had the opportunity to meet visiting speakers, among whom were many of the leading ornithologists of the day.

Gillmor's work first appeared in print in 1949. It was his design for the cover of the Reading Ornithological Club's Annual Report. That he has done every cover since must be a record that cannot have been equalled, in the United Kingdom at least. Before he left school he had illustrated two papers in the journal, *British Birds*; one of these was a paper on Manx shearwaters written by E.M. Nicholson and the other a paper on magpie behaviour from Derek Goodwin. It was about this time that Gillmor met Dr K.E.L. Simmonds, the behavourist, who was then teaching in Reading and who invited Gillmor to illustrate a paper for him. He has illustrated Simmonds's papers since 1953. Listening to Simmonds and other ornithologists Gillmor developed an interest in bird behaviour and his illustrations of aspects of behaviour have rarely been excelled. As a schoolboy he would also visit the Edward Grey Institute of Field Ornithology in Oxford, the British equivalent to the Cornell Laboratory of Ornithology, where he would sit with a schoolfriend and listen to the afternoon discussions of men like Dr David Lack.

For five years after leaving school Gillmor studied in the Fine Art Department that had been set up by his grandfather at Reading University. Since he was still in his home town he was able to continue his birdwatching activities and his involvement with the Reading Ornithological Club. Then, in 1959, he returned to his old school, Leighton Park, as Director of Arts and Crafts.

It was at Leighton Park that he began to make lino-cut prints of birds. He developed lino-cut printing as one of the options for the General Certificate of Education art syllabus. Such was his success that his pupils achieved very high grades in their exams and he recalls the heartening experience of being asked how he did it by other teachers at a conference in Cambridge. He used the press in the school to give his pupils the chance to watch the process working, and says that in fact he learned the techniques as he was teaching. Eventually, for £25, he bought himself a Columbian printing press, a Victorian monster that was rather impractical for use at home. Fortunately he discovered that the University Fine Art Department was looking for an example of the Columbian and happened to have two Albions which were smaller and rather more practical from his point of view. A swap was arranged.

The lino-cuts by Robert Gillmor are quite distinctive with their strong colours, careful printing and bold patterns. The limited editions that appeared at ornithological conferences and wildlife art exhibitions in the 1960s and early 1970s always attracted attention, and anyone who bought a Gillmor print then is fortunate because he has not had time to print any lino-cuts for more than ten years. The process was ideal for cover designs, for reports, magazines and book jackets, because the design could

be limited to a few colours and could be reproduced from line blocks instead of the much more expensive four-colour half-tone blocks. And the strength of the colours always caught the eye. His roe deer running through a birchwood, designed for the jacket of *The Handbook of British Mammals* (1964), is one of the most memorable jackets that I have ever seen. Two of the 13 covers he has produced for *Birds* magazine were lino-cuts, one of snowy owls is both suitably dramatic for a magazine cover and extremely clever in its use of just four colours.

Gillmor has been among the leading British wildlife artists for more than 20 years. As he readily admits, he was lucky to be in the right places at the right times. 'I saw my work in print ridiculously early' he told me. Since his work first began to appear when he was a schoolboy, he must have contributed to or even completely illustrated more than a hundred books and innumerable magazine features. He began to produce Christmas cards for the British Trust for Ornithology (BTO) in 1959 at the instigation of Dr Bruce Campbell, who was then Secretary of the Trust. Then he began to produce illustrations for gift items for the RSPB in the early 1960s when its offices were still in London. His very good designs gave the RSPB a range of gifts that outshone any other charity and which has rarely been equalled since.

But Gillmor's work for ornithological and conservation organisations has not been confined to producing pictures. He has served on the Councils of the British Ornithologists' Union, the RSPB and the BTO of which he is also a Vice-President, and has organised art exhibitions for them. He has also been in demand as an adviser on matters artistic. It was largely Gillmor, together with Peter Conder, then Director of the RSPB, who was in 1966 responsible for setting *Birds* magazine on its course of high-quality artwork covers. His advice is also in demand from publishers, who want him to suggest authors and artists, from gallery owners who want to use his knowledge of the work of other artists and from aspirant wildlife artists seeking critiques of their work. He is also art editor of *The Handbook of Birds of Europe, the Middle East and North Africa* (1976–), which involves him in enormous amounts of time selecting, briefing and chasing artists. He was a co-founder of the Society of Wildlife Artists in 1964 and is still very much involved with the Society. And there is a queue of magazine editors and publishers wanting his watercolour paintings.

Time, it is clear, is in short supply for Gillmor, but he enjoys his involvement in conservation and ornithology. He does, however, regret not having more opportunity to go into the field. 'I could be an infinitely better artist if I spent more time in the field,' he admits. In addition to his work as an artist and various commitments as a leading ornithologist, there is Robert Gillmor family man, a commitment which he takes very seriously. For many years he was a bachelor who appeared to be totally involved in natural history and art, travelling to the USA and Africa and throughout the British Isles. Then he married Sue, also an artist. They now have a son and daughter on whom Gillmor dotes.

Watercolours by Gillmor have a vibrance and clarity of which Tunnicliffe, one of his heroes, would not be ashamed. Most of his work is for illustration and he has painted relatively few gallery paintings. This is sad, but most of his illustrations, especially his large plates for *The Herons of the World* (1978), could well have been painted with exhibition in mind. Given greater opportunity he would surely be able to

Snowy owls. Robert Gillmor. (Royal Society for the Protection of Birds)

produce even greater paintings than Tunnicliffe. But Gillmor is a happy man, content with his way of life, although he does admit to wanting more time for print-making which he hopes to return to soon. He sums up his contentment with the statement: 'I have just been so fortunate to be able to earn a living from doing what I enjoy.' And that includes all those other things that take him away from his studio.

Lapwings. Robert Gillmor. (Royal Society for the Protection of Birds)

ROBERT GREENHALF

'If you sit in a wood for half an hour, you will gradually become aware of the creatures that have been there all the time but which only slowly reveal themselves,' says Robert Greenhalf. This feeling of emergent life is a quality of many of the etchings and watercolours of this very talented young artist from Sussex. In an exhibition it can be easy to overlook his work alongside the flashier offerings of the more commercially aware. Greenhalf's work is very distinctive but there is nothing flashy about it. His approach to representing nature is thoughtful. He even manages to avoid exaggerating the splendour of the scarce swallowtail butterflies that are the focus of an etching inspired by a trip to Majorca.

Born at Haywards Heath in Sussex in 1950, Robert Greenhalf still lives in the county of his birth. He lives with his wife, Sally, a professional musician, in a flint cottage near Hastings. From the cottage garden he can look across the last folds of the South Downs to the English Channel. He began his art training not far away, at Eastbourne College of Art where he was introduced to silkscreen printing. I bought a print of a grey heron made when Greenhalf was still a student: it is much bolder than his later work but even then he managed to convey the feeling that the heron was a vital part of its environment.

At the Medway College of Art, Maidstone, he came under the tutelage of Graham Clarke, a leading British print-maker. On his graduation in 1971 with a Diploma in Art and Design in Graphics he worked with Clarke. He later described the arrangement as 'loosely apprenticed' to him. Clarke is a skilful lino-cut printer and taught his pupil the elements of this medium, but it was his etching that really enthused his pupil.

The particular appeal of etching to Greenhalf was in its being a long process, giving the artist plenty of opportunity to change and develop ideas. The ideas came from Greenhalf's own experience of the countryside and its inhabitants. An active birdwatcher, he makes trips locally in Sussex and further afield in the British Isles and Europe, building up a collection of sketches and watercolours of the things he has seen. Everyday activities also provide him with subjects. An etching of rabbits in a Rackhamesque wood was inspired by the view from his garden when he lived on the outskirts of Rye. While living there he would commute by bicycle from this cottage to his printshop/studio in an old barn on a farm five miles away. The daily ride provided him with a wealth of subject matter – the high lanes, the flocks of birds in fields, the travellers' joy spilling out of the hedgerows.

When Greenhalf starts to produce a print he uses memory or sketches, or sometimes a combination of both, as a basis for the composition. For example, one particularly popular etching showed an otter on a woodland stream: the otter had been seen and sketched on the treeless Shetland Island of Fetlar but the stream ran through a Sussex wood. Perhaps the popularity of this print lay in its reminiscence of the Tunnicliffe wood engravings for *Tarka the Otter*.

A Greenhalf etching may be printed in as many as eight colours, using just one plate. This makes a long process even longer and it may not always be successful. To prevent too many hours from being wasted on an unpopular edition, about ten artist's proofs are printed and offered through galleries. If the proofs sell well, a final edition of up to 100 will be printed. Should there be little interest in the artist's proofs, there will be no limited edition and Greenhalf literally goes back to the drawing board. A month's work may have been lost, but Greenhalf feels that inevitably he will have learned something.

Not all Greenhalf's pictures are etchings. He is an accomplished watercolourist and feels that watercolour had the immediacy necessary to capture experiences that particularly move him – a combination of bird species thrust together by bad weather, a flock of birds in a landscape, a singing reed warbler beside a marshland drain.

Although his interest in natural history began with

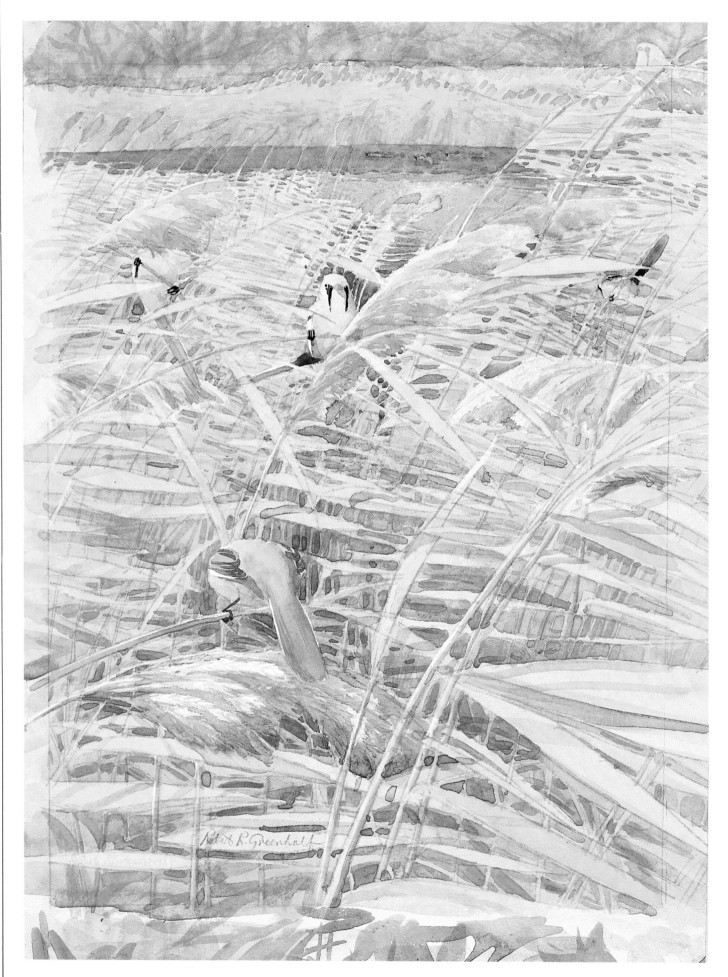

Bearded tits. Robert Greenhalf

Spring. Robert Greenhalf. (Royal Society for the Protection of Birds)

birdwatching, Greenhalf's subjects go beyond birds. Butterflies, bees, hoverflies and a little green beetle crowding the blooms of a buddleia or the remarkable horned poppy, its root threading through shoreline shingle in search of water, are as likely as Wilson's phalaropes or bearded tits to be the subjects of a Greenhalf picture.

Because they are far from the chocolate box or the scientifically acceptable feather-maps, Greenhalf's etchings and paintings may have a chance of achieving artistic respectability. He has had work hung in Royal Academy Summer Exhibitions and has been elected a member of the Printmakers' Council and an associate of the Royal Society of British Artists, as well as being a member of the Society of Wildlife Artists. Even so his work deserves to be better known. His ability to make his animals one with their environment makes him the most interesting of today's younger British wildlife artists.

ROBERT HAINARD

Long days have characterised Robert Hainard's long life. Since his birth in 1906 he has lived in or near Geneva. The length of his days is dictated by his choice of subjects and by his choice of medium. Of all the animals in his pictures – snails, insects, birds, mammals – it is mammals for which he feels real affinity. But mammals, in Europe at least, are very much more difficult to watch than most other animals, which means that Hainard must spend many hours in the field. His chosen medium, wood-engraving, is also a time-consuming process, especially when engravings are printed in up to 20 colours.

A typical day for Hainard might begin with his getting up at an early hour, writing, printing from the woodblocks and carving until lunch, afternoon in the field, back after sunset for supper and then to the workbench in his living room to work on some wood-engraving. Sometimes the routine changes to allow a night-time expedition in search of nocturnal animals. Hainard, who has travelled widely in Europe, told me when I talked to him at an exhibition in London in 1970 that he had seen all but one species of European mammal: the Pyrenean desman. He is an expert naturalist: Edwin Mullins, describing a trip with the artist to see beavers across the Swiss border in France, wrote 'Hainard slid into the thickets with the agility of a lizard'. His interest started in his childhood when he learned how to move quietly and merge into the landscape. He also learned how to track animals. He is truly 'un coureur de bois'.

Living in the village of Bernex, much of his time is spent in the Alps and the Rhone Valley, but his travels have taken him to East Africa, where he made sketches of big game, and to the British Isles where he sketched kittiwakes on breeding cliffs and ducks in Norfolk. Each subsequent engraving is labelled with the date and place that the sketch was made. Spontaneity is retained because he sketches as he watches, eschewing photography with the comment that he can draw faster than a photographer can work. By becoming at one with the scene before him he avoids problems of composition, allowing the facts to dictate how the picture should be compared. 'My sketches represent an entire, actual scene, as I have seen it in the exact relationship between the animal, the environment and the light,' he wrote in his book, *Mammifères Sauvages d'Europe* (1949–51). 'In this way I have avoided arbitrary compositions, which, overloaded by precise details make a false, often contradictory ensemble.'

Hainard's father was an artist, a sculptor and lecturer at the School of Industrial Arts in Geneva. Under him Hainard studied sculpture in wood and stone, before moving on to wood-engraving. This medium gave him the opportunity to combine the elements of the animals and the places where they lived. Since 1929 he has had an enormous output, producing an average of 15 wood-engravings a year. The appeal of his engraving lies in the simple forms broken down into patterns, separating a scene into its component colours.

Simplicity is the key to Hainard's approach to a technically complex medium. His reference for an engraving is a single black drawing with notes about colours scribbled on it. Watercolour sketches would, he feels, introduce an extra medium and so complicate the process further. With a separate block to be made for each colour, the part of the picture to be printed in a colour is traced in carbon on a block of pearwood. The carving can then begin. Hainard uses a workbench in his living room. Edwin Mullins described him 'bent over his workbench . . . chisel in hand, glasses down his nose, electric ceiling-light pulled to below eye-level.' The chisel, like his other tools, Hainard has had since he was an art student. Throughout the actual engraving Hainard refers to the working drawing.

The blocks are printed on an Albion press, manufactured under Royal Warrant by T. Matthews and Son at the end of the nineteenth century. Although made of metal and rather ornate this press is fundamentally unchanged from the wooden presses used by Gutenberg and Caxton. And the techniques of

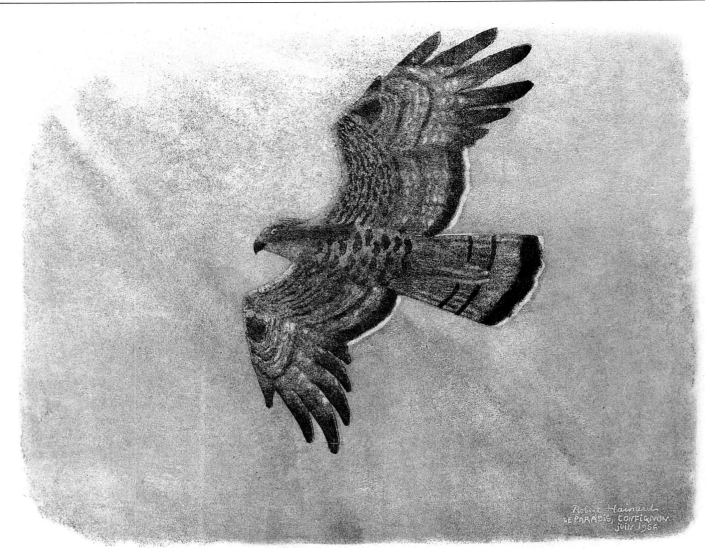

Honey buzzard. Robert Hainard. (Tryon Gallery)

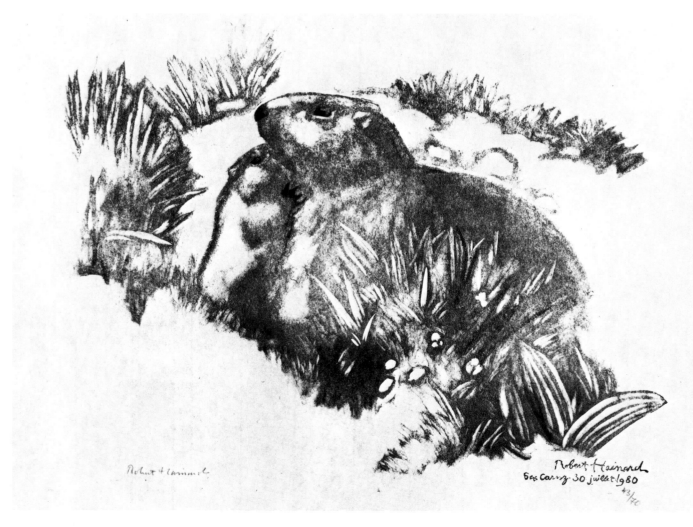

Marmots. Robert Hainard. (Tryon Gallery)

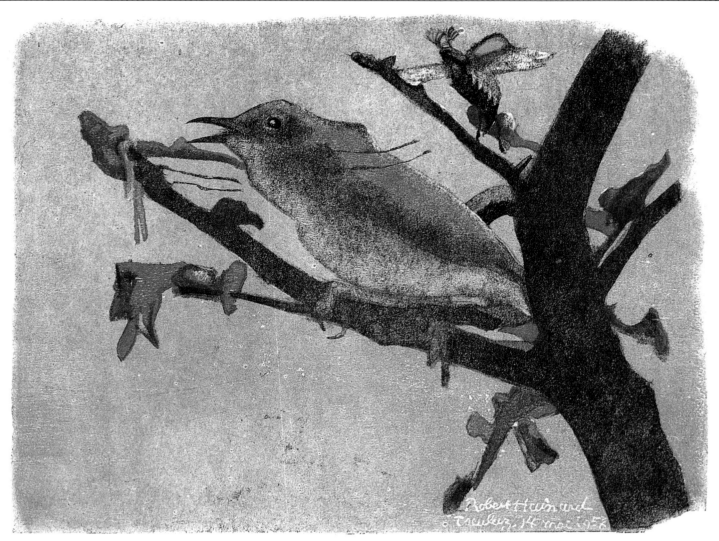

Garden warbler. Robert Hainard. (Tryon Gallery)

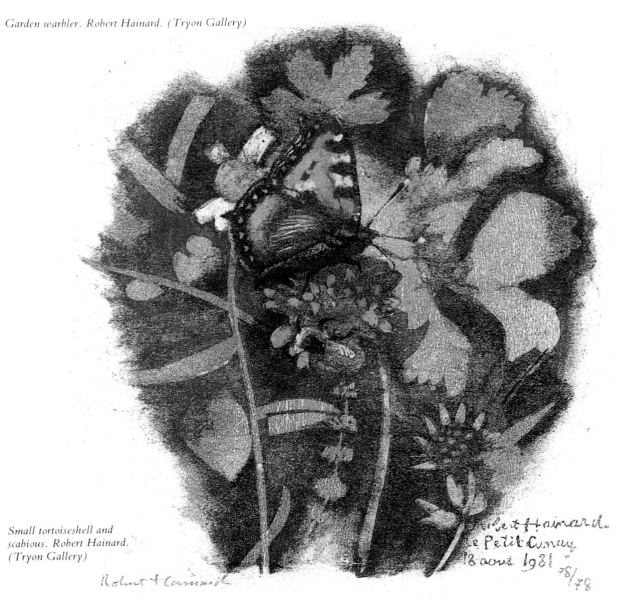

Small tortoiseshell and scabious. Robert Hainard. (Tryon Gallery)

printing are just the same. Hainard uses slivers of paper behind the blocks to alter the depth and consequently the amount of ink used. Printing, often in six or seven colours and sometimes in as many as 20, each of which must be done separately, takes time. Like the whole of the process it is very hard work, but hard work clearly has never been feared by Hainard. Indeed, he sums up his passion for engraving as 'the taste for physical work, plus a love of wood, plus a tactile sensibility tied up with a sensitivity to visual things.'

To look at an unframed print of an Hainard engraving is to be struck by the almost flimsy, fluffy softness of the paper. This fine Japanese paper is the key to Hainard's work, because it has texture that complements the blurry, twilight quality of his subjects. It is this quality that Hainard shares with the work that has influenced him. First, there were the Cro-Magnon cave-painters with whom Hainard shares an intuitive understanding and respect for wild animals. He puts his passion for wild mammals down to primitive feelings. 'It seems to me there is a difference between ornithologists and mammalogists, with something more primitive, more wild, more Paleaolithic among the latter', he wrote in a magazine article in 1978. Then there was the work of the great Japanese print-makers, Hiroshige and Hokusai, who took print-making to lengths seldom matched in Europe. Finally, there was Gauguin, from whose woodcuts Hainard learned how he could alter shading of a single colour by paring the block.

Despite choosing such a technically complex medium, Hainard's response to wildlife and landscape is essentially an emotional one, but he does not see that this response should alter scientific truth. 'Remain scientific, of course, but without being too subversive, I also wish your thoughts to be supple as a bone in a stone marten, warm as blood, soft as fur, velvety as the night', he advised in 1978. His empathy with animals is over-riding, because of his understanding of them, which in turn leads to his respect for them. 'We must lose our foolish superiority over animals', he has written. That foolish superiority leads to the dissectional school of wildlife art that reduces an animal to an amalgam of details. It is the simple, primitive impressionism of Hainard, one of the greatest twentieth-century wildlife artists, that will lead us back to a respect for and not a condescension towards Nature.

CHARLES HARPER

His art, and the humour with which he approaches it, appear to have developed around Charles Harper as protective coverings. At school in West Virginia his ability to draw gave him an opportunity to succeed. 'I decided to become an artist' he wrote in his book *Birds and Words* (1975), 'when I discovered that I could draw better than anyone else in the fourth grade.' In high school before the Second World War, he found that he got better grades when he illustrated his homework and his portraits of American presidents enabled him to make his history grades.

His humour, so strong in his limited edition silkscreen prints of animals, masks deep feelings for and about his subjects. They also demonstrate a philosophical turn of mind. In his caption to a silkscreen print of grazing Hoseteins he asks: 'Can a nature lover ever find true happiness at the top of the food chain?' This question, he says, sums up his feeling about nature. When he was a boy he was less than enthusiastic about cattle or any other aspects of farming. Brought up on a farm he admits that he disliked farm work and 'goofed off a lot'. When his parents learned that he wanted to be an artist rather than a farmer they were surprised but not unreasonable.

'When I was about three' he recalls, 'I fell out of a second-floor window and hit my head on a stump. It didn't hurt the stump or, apparently, me either. But years later, when I told my parents that I wanted to become an artist, they blamed it on the accident. I don't think they even really understood how this could happen in their family – having a son who wanted to paint – but they were very co-operative and supportive once the shock wore off. They paid my way through art school and were properly proud of my successes.'

A year at the West Virginia Wesleyan College was followed by the Cincinnati Academy of Arts, but Harper's studies were interrupted by the Second World War. He served in an infantry reconnaisance platoon in Europe, during which time he learnt to draw quickly between mortar barrages. As a returning serviceman he was able, thanks to the GI Bill, to go back to art school. He chose the Art Students' League in New York City, but after only one semester he decided that he did not like New York and returned to the Cincinnati Academy of Arts. Here he met and married a fellow art student, Edie. Because he had won a travelling scholarship on graduation, they went west for their honeymoon. Both the newly-weds were painters and made good use of this opportunity both to paint and photograph the landscapes very different from those in Ohio. It was a revelation to young Charley Harper.

'In school I painted super-realistically – highlights on hairs' he recalls. 'In the Great American West I began to feel that this method of dealing with form revealed nothing new about the subject, never challenged the viewer to expand his horizons, denied me the freedom of editorialising. I dealt with the Rockies by walking away from them before I put brush to paper, eliminating perspective and shading, recording only what I felt to be their essence. It was the most exacting painting I have ever done.'

But he had to earn a living. His first work was for Proctor and Gamble, where he was expected to produce illustrations of happy, glamorous housewives using soap powders with enthusiasm. Charley Harper knew that real housewives were not the goddess-like creatures of the adman's imagination, but the worried, wrinkled women of Harper's illustrations were returned time after time by art directors. To survive, the young commercial artist devised a new, personalised style, based on a compulsion to simplify, learned from Nicolaides's *The Natural Way to Draw* (1941), to which was added a touch of whimsy. It is still the same style today, but no longer does the artist have to paint housewives.

Wildlife entered Harper's life through a commission from *Ford Times* magazine. He remembered how this came about. 'When Arthur Lougee, the *Ford Times* art

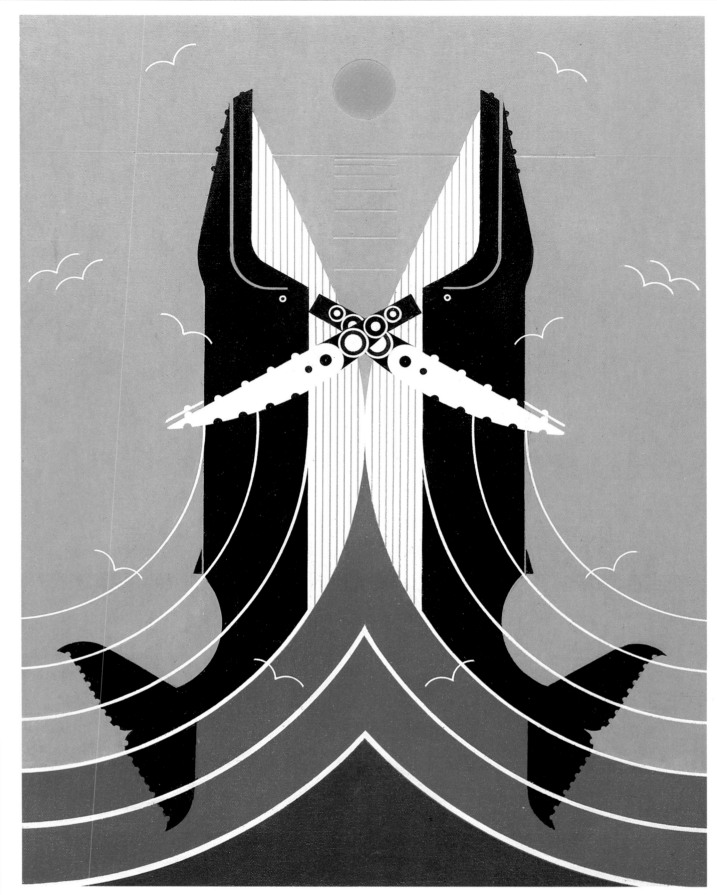

Love on the Richter scale. Charles Harper

director in the 1950s, asked me to paint some feeding station birds, he pointed me in the direction of wildlife art. This was before I knew what a wildlife artist was, and almost before I knew what a bird was. After I found out what a feeding station was, I hung around one for a while, trying to do my field work. But the birds kept hopping around or flying away. When I tried to follow them with my binoculars, I couldn't find and focus in time. When I stalked them, I stumbled over rocks and snapped dry twigs. Finally, I bought a bird guide illustrated by Don Eckelberry; it showed all I needed to know and the birds didn't

move. I skipped the introduction and the diagram of a bird with all the parts labeled: scapular, auricular, superciliary, tarsus – words that still baffle me – and feasted my eyes on the plates, enchanted by the patterns, colors, textures, lines. When I got to behavior, I discovered a treasure chest of ideas from which I am still deriving inspiration.'

These *Ford Times* birds were made into 73 silkscreen prints offered to readers. These Harper printed in his basement. Today, although still closely involved in the actual process, he uses a commercial silkscreen printers. Silkscreen printing, or 'serigraphy' as Harper

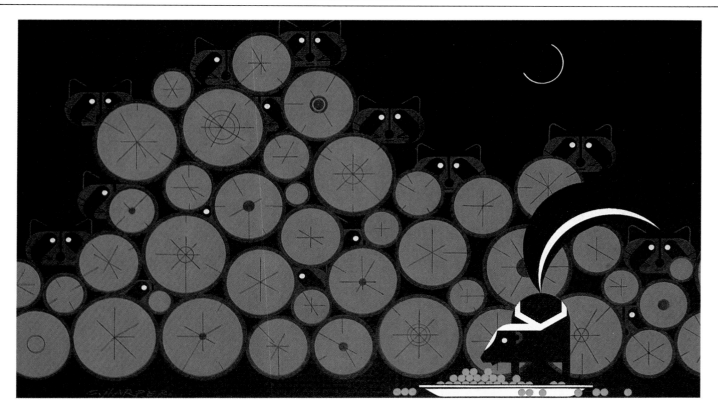

Raccoonaisance. Charles Harper

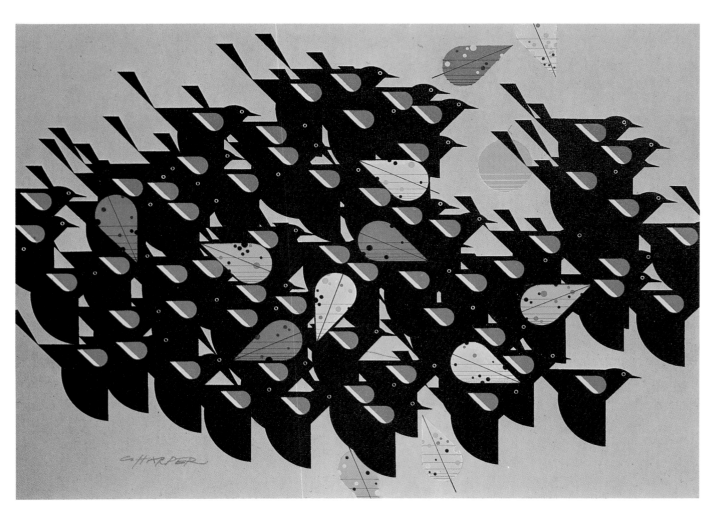

Birds of a feather. Charles Harper

always describes it, is ideal for making prints for designs with hard edges. It also allows the artist to be more closely involved with the reproduction of the prints and is nearer to the original painting than offset lithography.

Harper has a love/hate relationship with the silkscreen process: 'We *love* serigraphy' the Harpers wrote in 1983, 'because we believe it is the best possible way to make prints of our own work. It's ideal for printing flat, hard edges, which are basic to our visual vocabulary, and the ink has a rich surface finish that is unobtainable by any other process. Best of all, the artist can be involved in the printing as much as he chooses, doing it all if he is so inclined . . .

'We *hate* serigraphy because there are so many ways it can go wrong; it involves so many variables, most of them related to the stubborn stencil, some of them beyond mortal control. We have yet to complete a

serigraph that didn't reveal to us some new and diabolical perversity of the process. Some frustration so immobilising as to lead us to vow that we would never again try it.'

Looking at a Harper print it is hard to imagine it in any other medium than silkscreen, because flat, strong colours with hard edges are fundamental to their composition. Despite this, Harper animals are identifiable, not only from their patterns, reduced to the minimum, and even though the shapes are reduced to the geometric, from their 'jizz'. This the artist describes as 'minimal realism' or 'wildlife art without the furs and feathers'. 'I never count the feathers' he claims, 'I just count the wings.'

Harper continues: 'Realistic painting persuades the viewer he is looking into space rather than at a flat surface. It denies the picture plane, which I affirm and use as an element of design. I avoid the use of linear perspective because it punctures the plane; I eliminate light and shade because they are transitory, constantly shifting, and have nothing to do with the true form of an object, which exists unchanged by either the presence or absence of light.'

The technique works extremely well in graphic terms. A series of silkscreen posters for the National Parks Services in Washington, D.C., shows the webs of life in a variety of American habitats. Here insects and spiders crawl among the recognisable plants and flowers, prey of the birds and mammals, and occasionally a snake peers out unblinking.

Harper illustrations have appeared in the pages of *Audubon*, *National Wildlife* and *Ranger Rick's*; his limited edition silkscreen prints are published by Frame House Gallery in Louisville, Kentucky. They are wildlife pictures with humour, often in the titles one can see that Charley Harper loves a pun: 'Blackbeary Jam' has a single blackberry in the centre of the picture, around are jammed the heads of six black bears, while 'Terns, Stones and Turnstones' shows a shingle beach with a flock of turnstones and a single tern. Not all the prints have puns; in some the joke is visual. In 'The Last Aphid' an aphid is surrounded by four ladybugs, each unable to move any closer. 'Antithesis and incongruity fascinate me' says the artist.

'I have no formula for creating ideas. They might come from something observed or read, word play, a sudden fitting together of two bits of information that had previously seemed unrelated. Many ideas ferment for years, half-formed but persistent, until they burst forth full-blown at unexpected moments, demanding to be painted. What can I do to nurture ideas? Learn as much as I can about the creatures that interest me (they all do), observe them if I can (often impossible), find out how they interact with each other and their environments. And ask myself "What if?" What if, for example, a possum, who plays dead when he's in danger, is accosted by a buzzard, who won't eat anything unless its intended meal is dead? The answer has to be that the mild-mannered marsupial will win his Purple Heart – possumously.'

While his interest came through a commercial assignment in the 1950s, it was the 1960s that brought Harper a realisation for the need for conservation of wildlife. He sees his work as a way of helping wildlife conservation. He denies that his approach is anthropomorphic. 'I like to relate the lives of animals to people without being anthropomorphic about it. We didn't know that animals operate from the same motives as we do. I try to avoid assuming that, but you can draw comparisons between the acts of animals and humans without assuming the motives. Somebody has said there's nothing to be gained by comparing animals to humans, but there's much to be learned by comparing humans to animals.

'It is a useful device for cultivating among humans a sense of kinship with animals and concern for their welfare, which can be of great value in promoting the preservation of endangered species.'

The paradox of humour and seriousness has been cleverly exploited by Charley Harper. Reading through interviews that he has given it is clear that while much of his comment is well-rehearsed, his wit still carries a conviction in conservation. He claims that he is the only American artist never to have been compared with Audubon. Perhaps this is because Charley Harper's sense of humour is obvious, whereas John James Audubon was not renowned as a humorist. Nevertheless there are similarities. The work of both shows strong compositional elements and neither was frightened of large numbers of animals in one picture.

DAVID REID~HENRY

reath-taking detail but birds that really lived made the paintings of David Reid-Henry most unusual among the work of wildlife artists. Despite the detail there was great vigour about his paintings. A similar vigour was shown in his life. He held strong views which he would express very directly, and, according to his brother, Bruce Henry, another wildlife artist, he was especially passionate in his opinions of politicians and bureaucrats. With a quick sense of humour and noisy laughter he made his presence felt. During the 1960s and early 1970s he was often accompanied by his African crested eagle and it would have been difficult to overlook him whether he kept silent or not.

Reid-Henry's father, also a painter of wildlife subjects, was an entomologist employed in government service in Ceylon, when his younger son was born in September 1919. The first ten years of David's life were spent in Ceylon, where his father taught him about the natural history of the island, drew the birds he had seen on expeditions into remote parts of the island and built an aviary in the garden of their home in Colombo. However, following the usual custom, both David Reid-Henry and his brother, Bruce, were sent home to England to complete their education. After some years at Colchester Royal Grammar School, David went to Mount Radford School in Exeter. Even at school he managed to eke out his pocket money by selling drawings to his friends.

He had to learn his painting technique by trial and error and by studying the work of artists such as Roland Green, Wilhelm Kuhnert, George Lodge, A. W. Seaby and Archibald Thorburn. On their father's occasional leaves in England both his sons took advantage of his rare presence to learn through advice and demonstration how to draw birds. They had no binoculars, relying on fieldcraft to approach birds closely and on memory and field sketches for the basis of their pictures.

David Reid-Henry left school just before the beginning of the Second World War and took a clerical job in an office in London until he was conscripted into the Royal Tank Regiment in 1940. Soon after he was sent as an officer-cadet to the Royal Military College, Sandhurst, which was as much a stroke of fortune for his painting as for his military career. Sandhurst is on the edge of the town of Camberley, home of the artist, G.E. Lodge. Reid-Henry was welcomed into the veteran artist's home. While he was at Sandhurst, he appears to have spent most of his free time at the Lodge house, charming Lodge's elderly spinster sister and her niece, and learning from Lodge about both art and hawking. After being posted to Egypt and taking part in the North Africa campaign, Reid-Henry contracted hepatitis followed by rheumatic fever. He was then posted to the Military Police in Calcutta and while in India he drew and painted various pets that he kept. Postings to Singapore and Ceylon followed.

On his return to civilian London after the war he renewed his friendship with Lodge and began to meet some of the leading figures in post-war British ornithology. Among them was the Keeper of Birds at the Natural History Museum, J.D. Macdonald, to whom he was introduced by his father. Macdonald was looking for an illustrator for *The Birds of Sudan* (1955), of which he was co-author. Reid-Henry was given the job and his career as an illustrator was launched. Other commissions for book illustrations followed, several for the Edinburgh firm of Oliver and Boyd, who specialised in publishing handbooks of birds abroad. He also designed postage stamps for Mauritius and Botswana.

However, life was not easy. He had married in 1949 and lived with his wife and two daughters in a terrace house in Woodford Green, bursting with Reid-Henry's paraphenalia for both painting and falconry. His fortunes seemed to improve in 1960 with a commission to go to Rhodesia to paint antelopes. But the project fell through and no fee was paid. In Africa he acquired a female African crested eagle that he named Tiara and brought back to England.

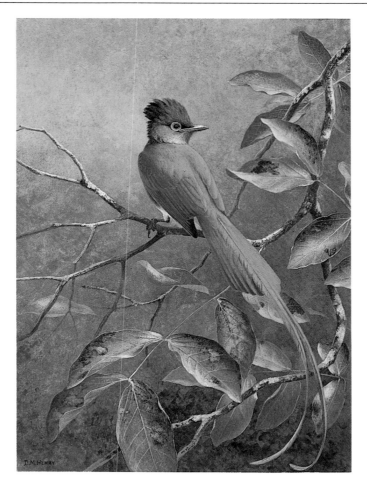

African paradise flycatcher. David Reid-Henry

As well as acquiring Tiara in Rhodesia he discovered a love for southern Africa. He liked the space, the scenery, the wildlife and the climate and to live there seemed the obvious course. His marriage had been under strain for some years and ended in divorce. Having already taken Rhodesian citizenship, Reid-Henry married Dr Louise Westwater in 1976. A medical practitioner by profession, she was a botanist and ornithologist by inclination. Sadly, he died in 1977 shortly after his 58th birthday. It was particularly sad that he should have died quite so soon after the Rhodesian phase of his life had begun. Those few years were very productive. He had managed to struggle beyond the grind of illustration work and had a greater demand for his work than he could satisfy. Sometimes he would accept commissions, but he preferred to paint what moved him and to exhibit the finished paintings in exhibitions in southern Africa and London.

His paintings were based on his first-class knowledge of animals and how they lived. But he made few field sketches. Instead, he relied on his power to concentrate on the subject – he would spend hours watching through binoculars, taking in the feel of his surroundings as well as the details. He had a photographic memory, which enabled him to return to base, recall what he had seen and commit it to paper in a series of sketches. He would make outlines showing a bird in several poses so that he could choose which fitted best his composition. Bruce Henry says that his brother was able to reproduce authentic settings several years afterwards. For details of the birds' plumage he would confirm his memory with museum skins.

Detail was most important to Reid-Henry and for this reason he preferred working in opaque colours, oils, gouache or tempera, rather than watercolour. Because when the human eye looks at a scene, it can select and focus in detail on particular parts of scenes, he would paint detail into backgrounds as well as in the main subject of the painting. Despite his concern for detail this did not always work: I can recall one painting of a pheasant in spring, in the foreground of which is a violet whose leaves are rather thick and look more like those of a butterwort.

If he was dissatisfied with a painting, he would leave it to work on another picture until a better idea was forthcoming. He had what Eric Hosking in his obituary described as a 'typical artist's temperament, and if he was not in the mood for painting nothing would make him do so.'

Bruce Henry clearly feels that his ability to be distracted prevented his brother from painting as much as he might. 'It is hard to avoid the conclusion that his concentration suffered as a result of the time devoted to other activities,' he says. But perhaps, a more single-minded man would have been less interesting both as an artist and as a person.

According to his father, G.M. Henry, Tiara became 'a dominating influence in his life, colouring it completely as he manned her'. The very large bird with her dramatic crest attracted enormous attention. The press photographed Reid-Henry with a hooded Tiara sitting on the upper deck of a London bus or striding through the West End with the eagle on his wrist. She was also wonderful for attracting the attention of the press to wildlife art exhibitions or game fairs, but she was not an easy bird to handle. Although Reid-Henry was the only person who could do anything with her, even he had problems sometimes. 'On more than one occasion' wrote his father, 'her terrible talons put David into hospital when, by accident or design, she lacerated his arm.' And on another occasion she killed an Alsatian dog by tearing out its jugular.

His interest in hawking distracted Reid-Henry from painting. Another passion was cricket which he played all his life with apparent disregard for any possible damage to his hands. In 1973 when he was 53 he was badly injured on the cricket field, breaking his left arm and injuring his right hand. Six weeks before his death, when his brother was staying with him, he was looking forward to a game of cricket.

FRANCIS LEE JAQUES

But for Rosenkranz and Chapman, Jaques might have remained in Duluth, Minnesota, a commercial artist with an interest in taxidermy. Rosenkranz was an artist who generously showed the young commercial artist how to improve his painting technique and it was Dr Frank Chapman, curator of birds at the American Museum of Natural History, who offered him a job on the strength of a

The passing of the Old West. Francis Lee Jaques. (James Ford Bell Museum of Natural History)

Francis Lee Jaques. From Francis Lee Jaques: Artist of the Wilderness World

the farm wanted to work the land himself. They moved to a new farm. This one was in Minnesota and they went there by small covered wagon, Lee and his father walking while his brother drove the wagon with his mother and sister as passengers. This 750 mile journey gave the young man an opportunity to note the changing landscape as they moved north. In Minnesota Lee worked for his father farming and hunting for food and sport. When the weather was too bad to work Lee would stay indoors and draw. His drawings were being published by *Field and Stream*.

Hunting led the young man to taxidermy. He became assistant to a taxidermist in Aitkin and after a year the taxidermist moved and sold the business to Lee for the ten dollars he owed in wages. Lee worked as a taxidermist for the next nine winters, living in the shop for six days each week and walking home seven miles each Sunday. Living at the back of the shop he had time to paint. 'Young artists ask me for advice' he wrote later, 'showing a dozen drawings they have done in the last year; this is like trying to become a pianist by practising every two months. When I was young, I drew constantly though I had no idea I might do this as an occupation.'

After an unhappy romance he left Aitkin for Proctor to get a job on the Duluth, Missabe and Northern Railroad. For three years he alternated between the

letter and three oil paintings. 'Next to Rosenkranz, who showed me the way I needed to express myself in painting, which I might never have discovered without him' Jaques wrote, 'my greatest debt is to Dr Frank Chapman. He gave me the chance without which my life might have been a dreary monotone.'

Little in Francis Lee Jaques's background suggests his life would not be monotonous. He was born on 28 September 1887 at Genesco, Illinois, within sight and sound of the tracks of the Rock Island Railroad, which might account for his lifelong passion for railways. The family were small farmers with a family name pronounced disyllabically in the Elizabethan fashion (Jay-quis). His father, as a young man, had hunted buffalo for early settlers in Kansas and Nebraska and he was an accomplished sporting and nature writer.

When Lee was eleven, his father and grandfather had a row which meant a move for the family to Elmo, Kansas. Elmo had been founded by the father of Lee's mother, but it had failed to grow to more than 200 inhabitants. Lee's grandfather, a dour disciplinarian, took advantage of his grandson by paying him half the wages of a hired man. He was worked hard, ten hours a day for six days a week and, if nothing else, he learned how to persevere with little encouragement. It was while the Jaques were at Elmo that Lee saw huge numbers of migrating wildfowl. This was the inspiration of Lee's work as an artist and it was, incidentally, the subject of his last painting.

Soon the family moved again when Lee's father took the tenancy of a farm at Durham, Kansas. Here the boy had two years' schooling at a one-room school, the last of his formal education, but he read a great deal throughout his life. He could draw and was a fanatical hunter, so it was natural that he began to draw the wildfowl that he hunted. In 1902 he plucked up courage to send some drawings of duck to the editor of *Field and Stream* and they were accepted. Neither Lee nor his family seemed to show much excitement and the incident seems to have had little effect.

Once again the family had to move. The owner of

Francis Lee Jaques. From Francis Lee Jaques: Artist of the Wilderness World

railroad and taxidermy and then enrolled in the School of Electrical Engineering at Milwaukee. After this he got a job with the Duluth Power Company. It was when working here that he went on holiday to the area on the Minnesota-Ontario border between Lake Superior and the Lake of the Woods that he called the canal country.

Jaques was drafted into the army in 1918 at the age of 30. At first he was stationed at San Francisco, where he visited and admired the Academy of Sciences in the Golden Gate Park. Then he went to France where he was posted to Bordeaux. When he was demobilised he was offered a job by the Duluth Power Company, but they offered him the wage which he had received when he had first started working for them. Finding this unacceptable, he went off to the shipyards to work, but the work, dependent on a government contract, did not last long and once again he was unemployed.

He became a commercial artist and it was then that he met Clarence C. Rosenkranz. Although he did not have great ability as an artist himself, Rosenkranz was a talented teacher who helped Francis Lee Jaques to develop his talent. He showed him how to mix colours rather than use them directly from the tube. He taught Lee to paint trees that belonged to recognisable species and how to use light and shade. Jaques had a sense of composition but Rosenkranz showed him how to make the most of this. 'I owe more to Rosen's help than I got from all other sources combined. I feel the debt is still far from settled, though I have tried to

repay it by helping younger artists.'

His next big break was to come shortly. He had been thinking about the exhibits he had seen in the Academy of Sciences in the Golden Gate Park, particularly the diorama of mule deer in a snowy forest. Prompted by this memory he wrote to the director of the James Ford Bell Museum of Natural History at Minneapolis offering himself as an artist. The museum was not large, the director was conservative and his reply was discouraging.

Shortly after this, in 1924, he shot a black duck and painted it. He sent this and another two oil paintings to Dr Frank Chapman at the American Museum of Natural History in New York City. Dr Chapman was extremely impressed by this work and showed it to the artist, Courtney Brandreth, and also to John Holman of the Audubon Society. Chapman offered Jaques a job without having met him. Chapman, in an article in the magazine *Country Life* in 1925, recalled the surprise that they felt on seeing Jaques's work. 'Frankly, we were not a little surprised that anyone could exhibit so high a degree of skill in the technique of realistic bird portraiture without having come in contact with ornithologists. It was much as though an unknown writer's first contribution to the literature of technical ornithology should take its place with the best work of leaders in science.' This betrays some of the arrogance

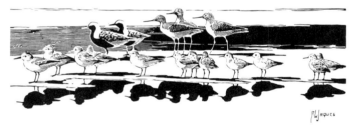

Francis Lee Jaques. From Francis Lee Jaques: Artist of the Wilderness World

of ornithologists when looking at paintings of birds and there is of course no reason why an artist needs to mix with ornithologists. Chapman, however, had been a great help to Louis Fuertes and by the 1920s Fuertes had become the standard by which American bird pictures were judged. Jaques's lack of contact with ornithologists until he was in his thirties was a strength and allowed him to see and depict birds in landscape.

Chapman was an enormous help to Jaques by introducing him to the ornithological world and encouraging him. Lee accompanied Chapman and his wife on an expedition in 1926 to Barro Colorado in the Panama Canal Zone, collecting material for the Museum's tropical rain forest exhibit. The next year he went to Peru to make studies for illustrations for Robert Cushman Murphy's *Oceanic Birds of South America* (1936), but unlike so many other North American wildlife artists, Jaques showed no great enthusiasm for jungles, describing them as 'fussy'. Expeditions followed to the Bahamas, the Arctic Sea, the Pacific Islands, England, Canada and Switzerland.

While working in New York City Lee stayed with the family of Professor Galloway and it was there that he met Florence Page, who was at graduate school at Columbia University. They were married in 1927 and Florence joined in her husband's enthusiasms for nature, painting and railroads but, according to her friend Mrs Harriet G. Buchheister, she managed to do so 'without dimming her own personality'. She accompanied him on many expeditions and became a

very good writer. Lee illustrated her books and *Canoe Country* (1938) about their beloved Minnesota wilderness was in print for many years.

The illustrations were scraperboard (or scratchboard) drawings in a style that became a Francis Lee Jaques trademark, developed in the days before printing techniques could deal with fine detail. He exploited the ability this medium gave to show the contrast between dark and light. He advised Eckelberry, 'If you're going to do a scratchboard, don't try to duplicate a half-tone photographic type of effect. Don't try to get all the shade. Do black and white and maybe two or three intermediate grays at most. Otherwise you'll sap the vitality from the other thing scratchboard has – snap.' The accuracy of some of the birds in these drawings might be criticised but Jaques had a magical ability to show animals in their environment. Jaques was undoubtedly better at depicting larger animals. His oil paintings feature larger birds because to relate a bird to a landscape requires the bird to be visible in that landscape. Eckelberry remembers his saying after a day's birding on the Hudson River, 'The difference between warblers and no warblers is very small.' Where Jaques painted studies of birds his work is less successful and they lack the magic of his birds in landscapes. It is interesting that he seemed to find difficulty in handling detailed studies. Perhaps he was aware of this because he warned, 'Never paint more detail than you can see.' Wildfowl seemed to sit oddly on the water.

His museum work, of course, depended on his ability to put animals in landscapes. The landscapes were based on sketches made in the field. His diorama of an English wood was based on sketches made in May in the New Forest. These sketches were in pencil and while he did not use colour for these, he had a sophisticated system of notation, using numbers and letters corresponding to a colour chart. Many of the backgrounds were curved so that he used a grid in

Francis Lee Jaques. From Francis Lee Jaques: Artist of the Wilderness World

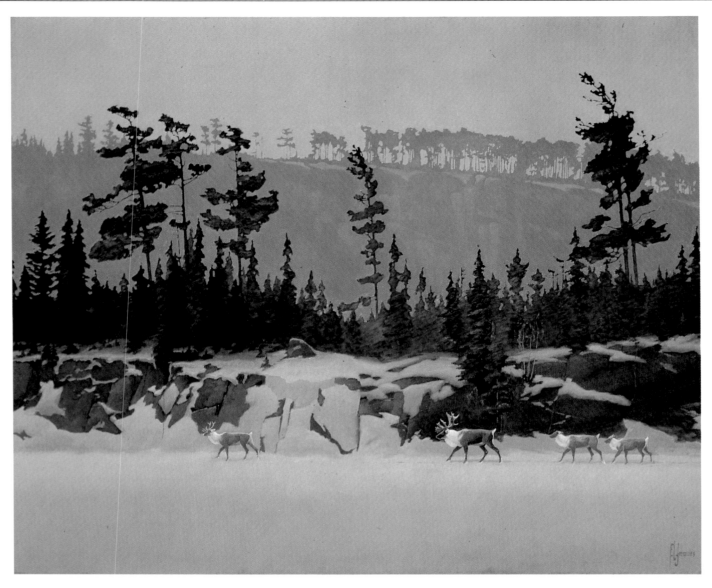

Caribou on ice. Francis Lee Jaques. (James Ford Bell Museum of Natural History)

order to overcome perpsective problems. To create an illusion of depth he used glass panels on which animals and plants were painted. Sometimes, as in the Olympic Rain Forest exhibit in the American Museum of Natural History, he used mirrors to increase the illusion of height.

In 1941 Jaques retired from the museum but he and Florence stayed in New York. They took on work for the University of Minnesota by writing and illustrating a sequel to *Canoe Country*. Lee also undertook dioramas for the James Ford Bell Museum of Natural History. A little over ten years later they moved to Minnesota where they enjoyed country life at North Oaks. When he was 78 and Florence 75 they went on a trip camping and canoeing in the wilderness they loved.

Three years later Lee painted his last picture 'The Passing of the West'. In the foreground is a derelict hayrake and a deserted farmstead against a yellow sky crossed by skeins of geese. Here he really did capture the feeling of space. It was his favourite picture and he said of it, 'I don't think any other bird artist could have shown the arrangement of geese in flight as well as this. Except maybe Peter Scott in England.'

A heart attack struck in February 1969, but Lee recovered. However, by the summer surgery became necessary. Lee recovered from the operation and he and Florence looked forward to the future. Suddenly on 24 July 1969 Francis Lee Jaques died from a pulmonary embolism. His widow, missing him terribly, set about three projects on his behalf. She arranged for a Francis Lee Jaques gallery at the James Ford Bell Museum, she placed his model railroad in the Duluth Museum and she completed *Francis Lee Jaques: Artist of the Wilderness World* (1973). Her friend, Mrs Buchheister, records that having done these three things, she seemed withdrawn and not long after, in 1972, she died.

In her book Florence Page Jaques quotes a letter from her husband's surgeon. Having praised Lee's uncomplaining courage he wrote: 'I like to think, with Shakespeare, that nature, which he painted so well, might stand up to all the world and say "This is a man".'

LARS JONSSON

Having failed to enter the Royal Academy of Art in Sweden in 1971, Lars Jonsson went on an expedition from Sweden to West Africa. His rejection was perhaps understandable: he was only 18 and had not been to another art school. The normal practice of the Academy was to take students who had had previous training. That Jonsson should try to short-circuit this system might have been youthful arrogance, but it also might have been an accurate assessment of his own worth. At 15 he had had an exhibition at the Riks Museum in Stockholm and by the time he was 18 his work showed an ability and maturity envied by many an older artist. Nevertheless he claims that this talent had not always been obvious.

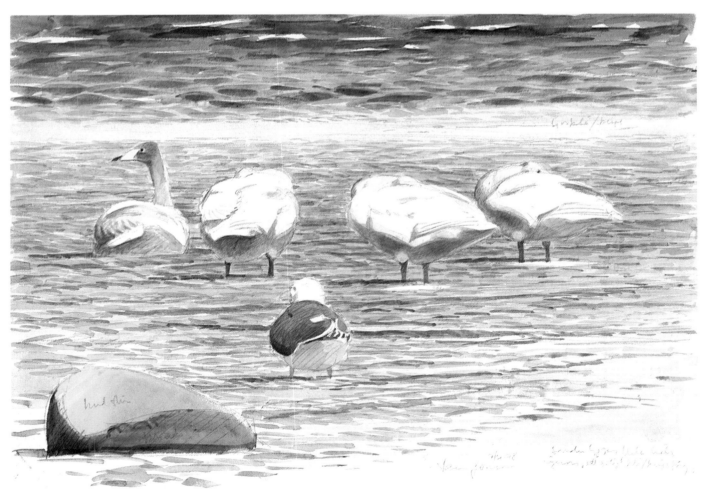

Great black-backed gull and whooper swans. Lars Jonsson. (Royal Society for the Protection of Birds)

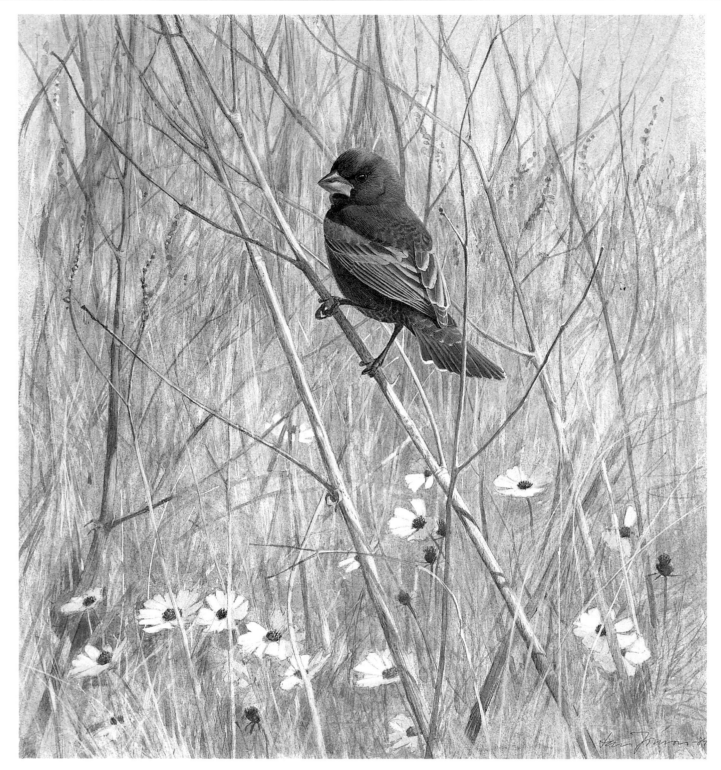

Blue grosbeak. Lars Jonsson. (Mill Pond Press)

Birds began to push themselves into the consciousness of the young Jonsson when he was four years old and his parents took a holiday home for two or three summer months on the Baltic island of Gotland. Most of it is sheep pasture fringed with damp meadows, an ideal habitat for breeding waders and wildfowl and in autumn a convenient resting place for migrants on their passage south. Jonsson's parents encouraged the interest that had been stimulated by the birds of Gotland, but he says that they did not push him. Nor did they push his interest in drawing and he claims that he did not really develop as an artist for several years.

In Stockholm he joined a branch of the Field Biologists' Society. There his talent for ornithological illustration was spotted and encouraged by one of the members who worked at the Riks Museum and an exhibition of the 15-year-old's work was arranged. Such early attention and success could easily have spoiled such a young person and stifled any need for

him to develop his work. But it seemed to provide a stimulus for further development and despite even greater success later his work has continued to change and become even better.

Perhaps that failure to get into the Royal Academy of Art was fortunate as far as Jonsson's artistic development was concerned. It was certainly good for his field ornithology. Instead of academia he went with his brother and a friend overland from Sweden, around the Sahara Desert to West Africa. Determined to become an artist, he returned home with a huge list of new birds that he had watched and sketched. At first he did not earn enough to live on and he signed on the roll of school helpers who could be called in to look after classes when teachers were away from school. This was sporadic which gave him plenty of time for painting.

When I first saw Jonsson's work I was amazed that it could have been painted by someone so young. In 1972 he sent me an unsolicited packet of transparencies

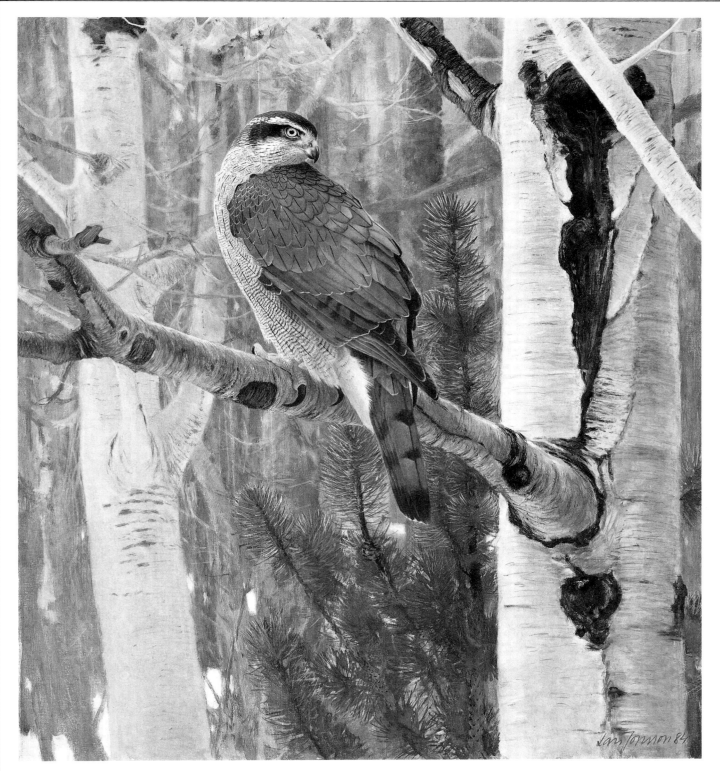

Goshawk. Lars Jonsson. (Mill Pond Press)

which was the most exciting work that was submitted during the 19 years during which I was directly responsible for *Birds*. It was difficult to believe that this was the work of a 19-year-old; it had such confidence and such enthusiasm for the experience of looking at birds. One of the transparencies showed a snipe standing in water, its reflection broken by a mussel shell in the shallow water. I asked to see this with the possibility of using it as a cover illustration. It arrived by the hand of the artist himself, who turned out to be a very tall Scandinavian. He was a charming young man with an enormous knowledge of birds and an interest in a wide range of other topics. As a monolingual Englishman, I was impressed by Jonsson's ability to make awful puns in English and even in one case across our two languages.

He was able to commit himself to painting full-time when he signed a contract with Wahlström and Widstrand to write and illustrate a series of five field-guides on European birds. The contract meant

that he no longer needed to be a school helper. However, it also meant that for five years he had to tighten his style to make it suitable for illustration.

His *Birds of the Mediterranean and Alps* (1982) contains quite the best illustrations of these species: to use it alongside other field-guides covering the area is to realise just how good an illustrator Jonsson is. He manages to depict birds with all the necessary field characteristics obvious and yet which are in attitudes that clearly show them to be living animals.

Five years' hard labour on the guides put Jonsson, still in his twenties, in a position where he no longer needed to take commissions for book illustration. Instead he could concentrate on gallery paintings of wildlife as well as landscapes and portraits. It also gave him the opportunity to travel outside Europe and he set out for the New World.

North America welcomed the work of the young Swede. Mill Pond Press of Venice, Florida, now represents him in the United States and have published

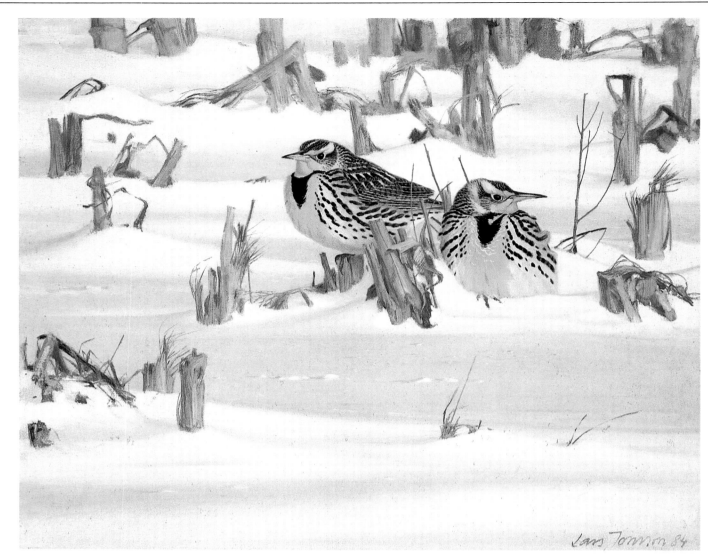

Western meadowlarks. Lars Jonsson. (Mill Pond Press)

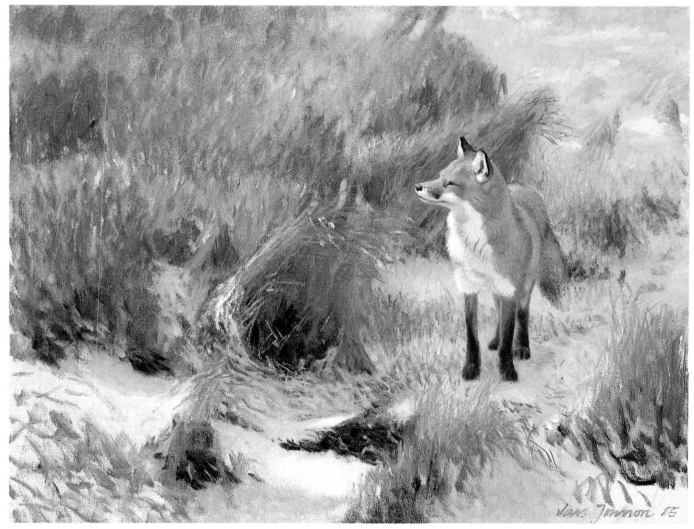

Red fox. Lars Jonsson. (Mill Pond Press)

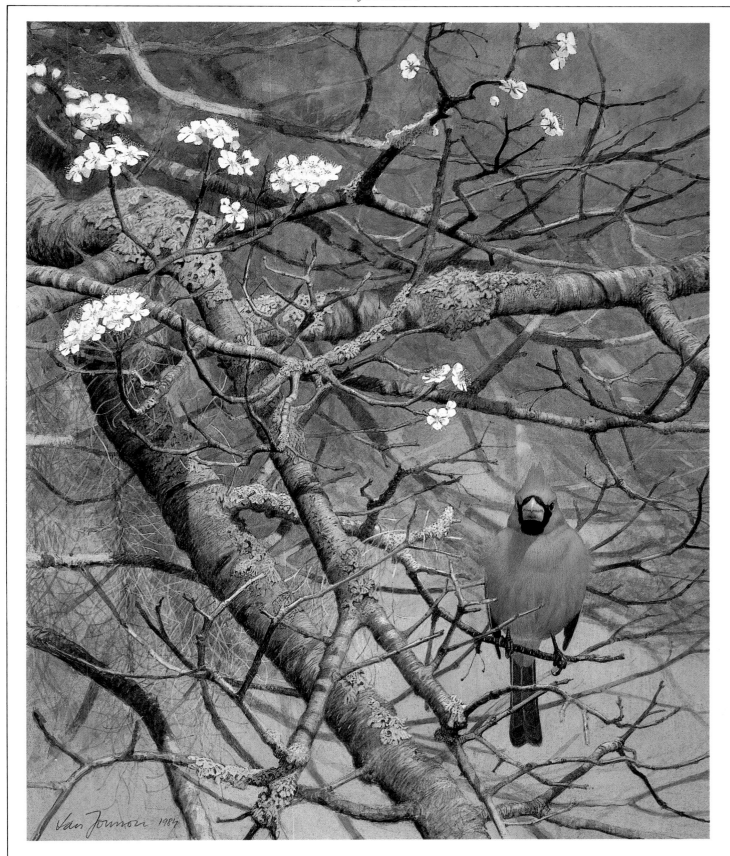

Signals of spring: cardinal. Lars Jonsson. (Mill Pond Press)

a number of limited editions of his work. It was also as a field ornithologist that he was noticed. 'He puts us to shame when it comes to sorting out autumn warblers', one American birder told me with just a tinge of envy.

Although still a young man, Jonsson has achieved celebrity in Sweden where he had a major exhibition at the Riks Museum in 1980. His study in oils of the head and shoulders of a golden eagle made a dramatic poster for the exhibition. He is good at painting birds of prey, but his paintings, like those of Bruno Liljefors, do not imbue the birds with that false nobility which so many raptor fanatics seem to demand. His gyr falcon design for a Swedish postage stamp in 1982 was voted Sweden's most beautiful stamp. The list of exhibitions in which his work has appeared is impressive and,

outside Sweden, includes several Leigh Yawkey Woodson art shows and the Royal Ontario Museum's 'Animals in Art'.

A book of his paintings was published in 1983. Called *Ön*, it was published in English as *Bird Island* and told the story of a sandspit and the birds that use it. Because he paints the birds as he sees them, Jonsson provides the reader with a series of surprises. On each spread one is forced to look at birds in a new way: a multi-legged avocet created by a brooding parent about to settle on its young; Caspian terns towering above a common tern; a starling in that curious stage where the adult spangles are moulting through the dull brown immature plumage.

Watercolour is a medium that Jonsson uses

frequently. He lays on a wash background and then paints over it. For brightly coloured birds, such as cardinals, he paints on tinted paper with gouache. Sometimes he uses oils. This is the medium he uses for his big paintings, as large as 39×47 inches. In one painting of avocets at sunrise he has used oils to create an almost abstract use of colours. Bands of yellow and brown dominate the picture with the black and white birds moulded with blue shadows. 'Details', Jonsson says, 'such as additional colours, must suffer, not detract from the original intent.'

Preconceptions from other paintings are a danger that Jonsson tries to avoid. He paints what he sees, not what he ought to see. Since so many of his paintings have the fresh quality of field sketches, it is no surprise to learn that he places great importance on sketches made in the field. These, he feels, establish the artist's personal contact with nature.

The secret of Jonsson's success is undoubtedly his involvement with nature. 'Never hesitate to take risks' is his advice. 'Being there in nature, experiencing it – that's what it's all about.' And that is just what Liljefors did. Liljefors was a painter and hunter, which is perhaps to be expected of someone born in the nineteenth century. That Jonsson is a painter and birdwatcher perhaps typifies the changing standards over the last hundred years. It also seems appropriate that one of the few artists whose work might fairly be compared with the great Liljefors should be another Swede and one who shares with the master the ability to paint subjects other than wildlife.

BOB KUHN

ominating the prints for sale at Sportsman's
Edge in New York was one of a grizzly
emerging from a river carrying in its mouth a
salmon, watched by a group of California gulls. The
picture is full of movement, the bear an enormous
bulk moving to the left with the gulls apparently
looking away from it but all the time alert to the
chance of a small share in the salmon. This print is
from a painting by Bob Kuhn. The broad brush
strokes give an air of a casual record of an incident in
the Rocky Mountains, but it was in reality very
painstaking. In his book, *The Art of Bob Kuhn* (1973),
the artist describes his approach: 'My aim . . . is to
produce a carefully, often painfully worked out design
and make it look easy.'

Kuhn is one of the most exciting of today's North
American painters of wildlife. The power and drama
of his work that came from 25 years as a magazine
illustrator, is now in his gallery paintings. In his book
he is candid about his failures as well as his successes.
He also offers good advice for artists and allows some
insights into Bob Kuhn as a painter.

In his home town of Buffalo, New York, he
remembers visits to the zoo from the age of five,
usually with his father and grandfather. Later he
studied art at the Pratt Institute in New York. He now
lives and works at Roxbury, Connecticut, within
relatively easy distance of New York. That 25
years as an illustrator is regarded by Kuhn as an
apprenticeship. His work appeared in magazines such
as *Readers' Digest*, *Argosy*, *True*, *Field & Stream* and
Outdoor Life as well as advertisements and commercial
calendars. Among his calendar commissions was one
for the Remington Arms Company; Jack Mitchell
recalled how the plates Kuhn painted for the
Remington Game Art Calendar between 1965 and
1971 were so popular that irate dealers would
telephone long-distance to the company's head office
to complain if they had not received a copy.

By 1971 Kuhn had an accumulation of unfulfilled
commissions for paintings and he decided that the

time had arrived when he could give up commercial
illustration and paint what he wanted. More
importantly he would have control over the flow of his
work. As an illustrator he admits to having done as
much bad as good work. There were, he says, two
main reasons for the bad work. Firstly there was
indifference to or no enthusiasm for particular jobs and
secondly there were deadlines to be met, which might
leave him with no time to improve bad illustrations.
Thus, because of the nature of illustration work, this
mediocre work did see the light of day and his greatest
regret is that there are examples of mediocre or 'just
plain bad' work done for illustration in attics and
cellars across the United States. Now he would like to
take it all and burn it. No longer does he have any
problem with mediocre pictures surviving, because he
will not allow bad work to leave his studio. Within a
few days of beginning a painting he has a good idea of
how well it will turn out. If it is not going to work, he
will paint over it.

Kuhn now says that in his bones he is not an
illustrator and never has been. This does not mean that
he did not enjoy some good relationships with art
directors and editors. And, above all, the discipline of
illustration work was good training.

The principal characters of Kuhn paintings are large
mammals. He does sometimes paint birds but usually
they figure in walk-on parts subordinate to the
elephants and bears and buffaloes that are the
principals. His scenes are set in the wilderness areas of
America or the plains of Africa. The appeal of his
paintings lies in his ability both to capture the character
of his animals and the atmosphere of their habitats. He
says that he likes to sketch apes, but he rarely paints
them. 'Possibly this is because my sketches of them
seem to work and the sketching chalk is for me the best
language.' Perhaps, too, apes are not popular with
purchasers of paintings by Kuhn. Many of them are
hunters and, as the artist writes, the primates are not
generally hunted and 'shooting a gorilla would be very
much like doing in your Uncle Louie'.

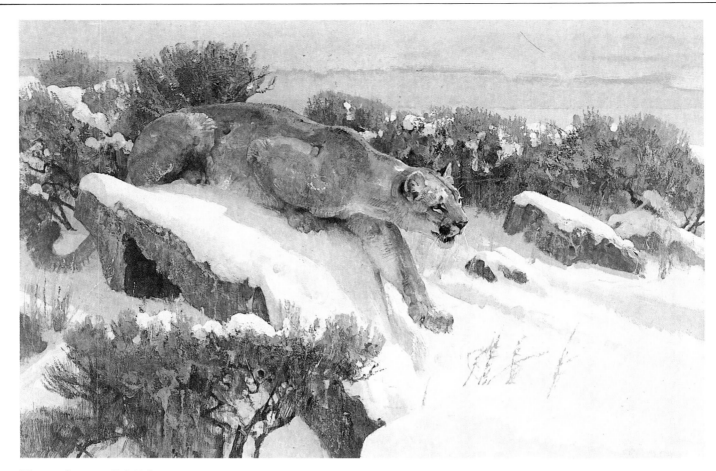

Silent as the snow. Bob Kuhn. (Sportsman's Edge Gallery)

Interaction between individual animals seems to fascinate Kuhn and provides him with excellent topics for paintings. It may be a relationship between predator and prey, a coyote chasing a rabbit, or the competition between animals for food, the bear and the gulls mentioned earlier, or a lioness keeping vultures from a carcase. The painting 'Flap of Vultures' was inspired by some transparencies of hyenas and vultures. To Kuhn a lion seemed a more leading character for a painting and he substituted a male lion for the hyena. His wife remarked that the lion, rearing up on its hind legs and swiping at a vulture with its front paws, looked just like the cowardly lion in *The Wizard of Oz*. Immediately Kuhn decided to perform a sex change operation. 'The minute I peeled off the mane,' he says, 'the shape began to make sense.' With its combination of abstract elements, the atmosphere of the African plains and the movement of the lioness and vultures, it is a wonderfully dramatic painting. Kuhn thinks it one of his best, but it did take him five years to complete and there were times when he almost abandoned it.

Photographs are important to Kuhn. He has taken over 1,500 of African buffaloes alone. His collection of photographs are used to check the way in which animals move. It is extremely difficult to portray movement within the two dimensions of a painting. Photography, particularly at slow shutter speeds, shows movement by extended forms and blurred edges. Capturing movement is a particular skill of Kuhn but he admits to 'cheating a little when my picture needs require'.

As well as being references, photographs may provide Kuhn with inspiration. He sees himself as a reactor rather than an initiator. His reactions may be activated by all manner of stimuli – photographs, the combinations of colours in an advertisement, a gesture or the posture of a domestic animal. Inspiration for a large painting of a leopard half sitting, half standing in a tree came from seeing a cat in a parked car, its

Drinking tiger. Bob Kuhn. (Sportsman's Edge Gallery)

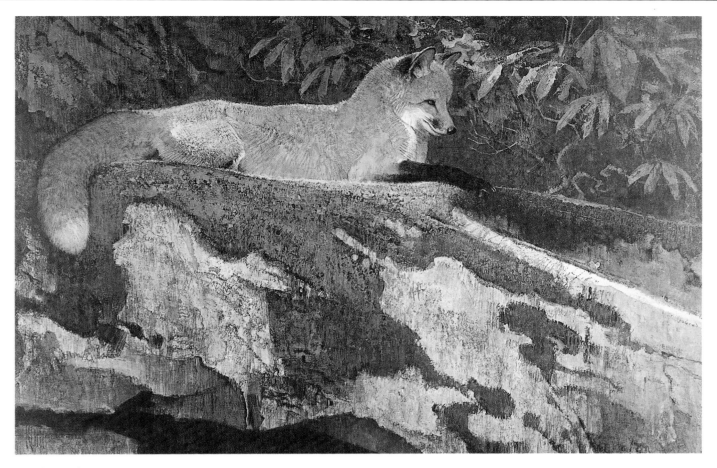

Brer fox. Bob Kuhn. (Sportsman's Edge Gallery)

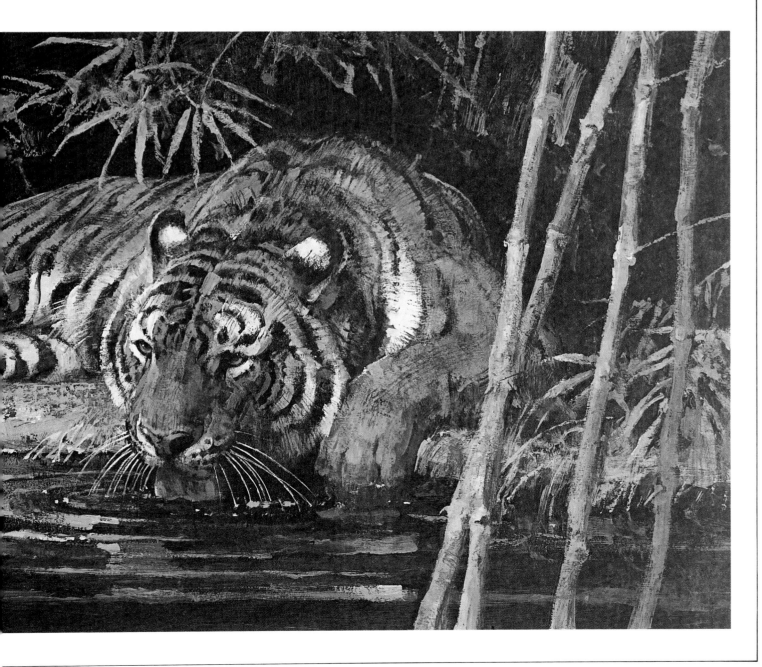

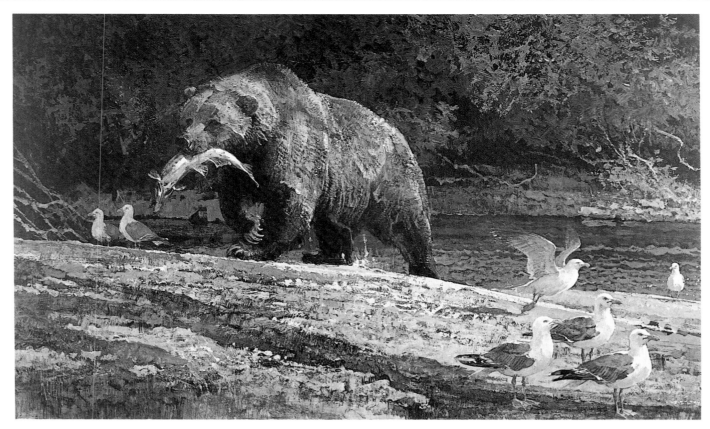

Poached salmon. Bob Kuhn. (Sportsman's Edge Gallery)

haunches on the steering wheel and its front feet planted on the driver's seat.

Although Kuhn puts great thought into his paintings, they do have an element of spontaneity. Although he makes thumbnail crayon sketches, Kuhn does not produce carefully worked out colour drawings because these do reduce the spontaneity in his final painting. He also makes thousands of doodles of endless arrangements of animals. Sometimes these are useless, but occasionally a really good arrangement or gesture will arise.

Untempered masonite, an eighth of an inch thick, is the base for Kuhn's final paintings. This he has cut in batches at a local timberyard to the sizes that he likes using from 14×30 inches to 30×48 inches. His chosen panel is given two coats of white acrylic mixed with small amounts of ochre or raw umber. The second coat gives texture that may well be used in the final painting. The crayon thumbnail sketch of the animal to be painted is mechanically enlarged on tracing paper so that he can move it around the panel to find the best position. Once the position of the animal has been decided the drawing is traced down on the panel and painting can begin. The paint used is acrylic, which he mixes with water rather than a thinner: as an illustrator he used tempera and is therefore quite at home with a quick-drying medium.

To save time in cleaning palettes, Kuhn uses a large-size paper palette block. He paints with oil bristle brushes, size 4 and 5, and Winsor Newton Series 7 sable (sizes 4, 5 and 6). In addition to a palette knife he uses a small plastic sponge to create a range of textures and to obscure detail where necessary. Final details such as wind-shaken leaves may be achieved by the spatter technique, which he uses 'lovingly but sparingly'. Crisp little accents for the texture or direction of fur or for an indication of the turn of muscles are achieved by a 2B or 3B Wolff pencil.

As he paints he constantly checks details among his vast collection of transparencies, or library of reference books. If he is unable to verify a particular

point he will visit the American Museum of Natural History in New York or one of the zoos. Although his original interest in animals was stimulated by visits to the zoo, Kuhn advises against relying too much on animals in the zoo. 'When pursuing the elusive but essential ingredient called animal character' he wrote in *The Art of Bob Kuhn*, 'it is imperative that one sees his subject in the wild state . . . the difference between a wild and a zoo lion is astonishing.'

Sometimes a painting stops working for him. 'One of the great enemies of productivity as far as I'm concerned is the temptation to chase a good idea too far', he has written. When he can push the development of a painting no further he stops painting. The picture is put aside for a few weeks. When it is returned to, the easel passion has given way to objectivity and he is usually able to correct it as necessary.

Frames are most important to Kuhn, who has a friend and neighbour who produces custom frames. Together they decide on the type of frame, materials to be used and colours. In this way the frame becomes an extension of the painting.

Kuhn seems to have developed the habit of listening to other people's views, an important asset for the successful illustrator, but one that seems to have developed early. A major influence on him as a boy was the illustrator Paul Bransom, whose work he would cut from magazines and copy. Eventually he wrote to Bransom and was encouraged by him. They later met and became close friends. Another illustrator Kuhn admired was Charles Livingston Bull. Other artists who influenced him were Wilhelm Kuhnert and Carl Rungius, both of whom chose to paint the big game that is the subject of many of Kuhn's own paintings. The Western artist, Frederic Remington, was another influence and Kuhn has won awards from the National Academy of Western Art Annual Show and the National Cowboy Hall of Fame, but the artist he most aspires to emulate was 'the greatest of them all' – Bruno Liljefors.

J. FENWICK LANSDOWNE

ew artists can have had such an eventful early life as J. Fenwick Lansdowne. He was born in Hong Kong in 1937. His father was a British electrical engineer working in north-east China and his mother, the daughter of a British shipping executive, had been born in Manchuria. When he was only ten months old Fenwick Lansdowne caught poliomyelitis, a disease now largely eradicated thanks to vaccination, but then a scourge popularly known as infantile paralysis. Lansdowne was left 75 per cent paralysed. In search of treatment his parents took him to England where he contracted pneumonia and almost died. The family returned to Hong Kong in time for the beginning of the Second World War.

The approach of the Japanese Army led to the evacuation of almost 1,000 women and children to Australia. Edith Lansdowne, fearing that the crowded conditions on board ship would worsen her son's poor health, went to her parents' home in northern China. Later, Ernest Lansdowne obtained permission to take his family to British Columbia and then himself returned to suffer three years of house arrest and two years' internment.

After a year in a solarium Fenwick Lansdowne returned to his mother's home in Victoria, British Columbia where he was confined to bed. His world was then the house and the view from his window and it was then that he began to take an interest in the birds that he could see in the garden. His mother used to encourage this interest and would carry him into the garden on fine days. She bought him bird books and recalls that by the time he was three or four he knew any bird by its song or its flight.

Edith Lansdowne was an accomplished watercolourist and encouraged her son to paint. His right hand was useless so that he painted with his left. When he was six he painted a nesting female humming bird, but his subjects were not usually birds. 'I used to paint a lot' his mother recalls. 'My paints were always available to him and he used to sit beside me and paint. But he always did pirates, somebody with a sword in

his teeth or cowboys, something like that.' Within a year of a series of operations on his spine when he was seven, Lansdowne was able to begin to walk on crutches. His mobility had begun and he was later to spend many hours in the field.

The family was reunited in Hong Kong at the end of the war, but the result of Ernest Lansdowne's treatment by the Japanese was a breakdown in his health. In 1947 he was diagnosed as having tuberculosis and the family returned to Canada.

Though confined to a wheelchair for much of the time, Lansdowne went to school in Victoria, British Columbia. When he was about 13 he began to draw birds, encouraged by his mother, but she says she did not teach him. The first birds to catch his eye as an artist were a pair of goosanders. 'From then on,' says his mother, 'he began and I don't think he's ever stopped.' He soon determined to make his career as a bird painter, although he did flirt with the idea of becoming a biologist. He worked in the summer vacations in the laboratory of the Provincial Museum in Victoria. There he learned to dissect and skeletonise birds and mammals. He also learned about birds in the field and encouraged by the staff at the museum he used to go on field trips. These staff also gave him valuable criticism of his paintings. They also arranged a small exhibition of his work at the museum in 1952. By the time he was 16 he was able to save enough money to buy himself a car with specially modified controls through selling paintings to friends and neighbours.

Just before his graduation from high school in 1955 some transparencies of his work were sent to Toronto for appraisal. They were seen there by the executive director of the Canadian Audubon Society, John A. Livingston. So much did they impress Livingston that he arranged an exhibition of 40 Lansdowne watercolours at the Royal Ontario Museum in October 1956. This exhibition of Western Canadian bird and flower paintings was greeted enthusiastically by naturalists and art critics. Magazine features

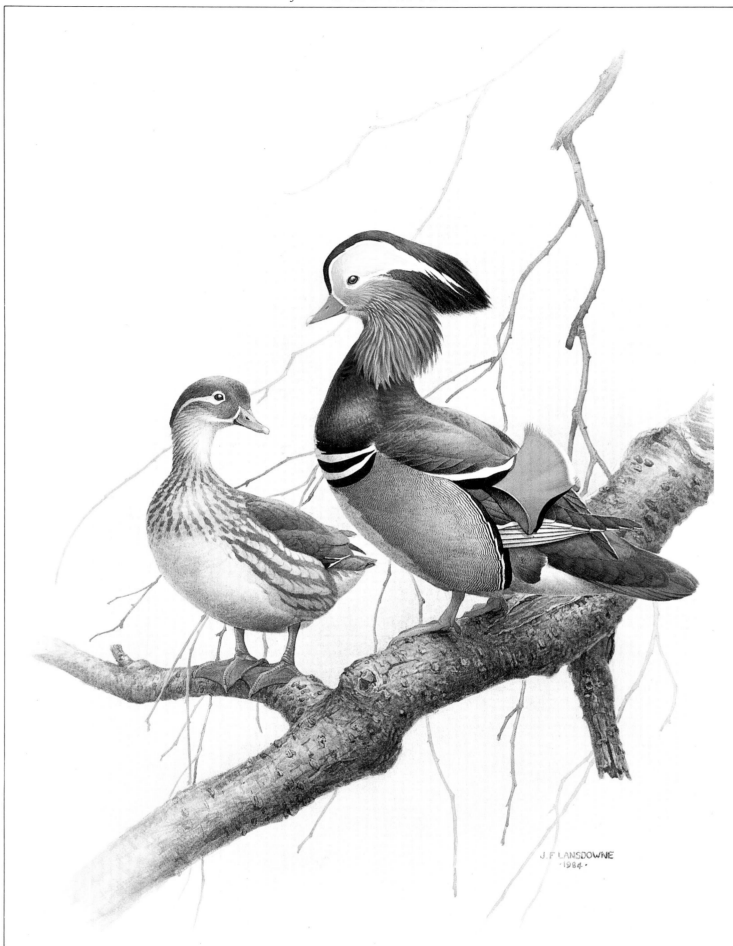

Mandarin ducks. J. Fenwick Lansdowne

appeared in the popular weekly *Maclean's* and in one of them Lansdowne was described as having depicted his birds faithfully but 'with the imagination of a poet and the creative hand of an artist'.

Within two years an exhibition followed at the National Audubon Society headquarters in New York and in 1961 he had a one-man exhibition at the Tryon Gallery in London. Some of his paintings of British

songbirds were used by Whitbread Brewery for advertising purposes on a calendar and on posters in the London underground. I can recall being transfixed by these delightful images and on one occasion deliberately missed a train in order to look a little longer at the poster.

According to his fellow Canadian, Robert Bateman, Lansdowne is the first living artist to have a

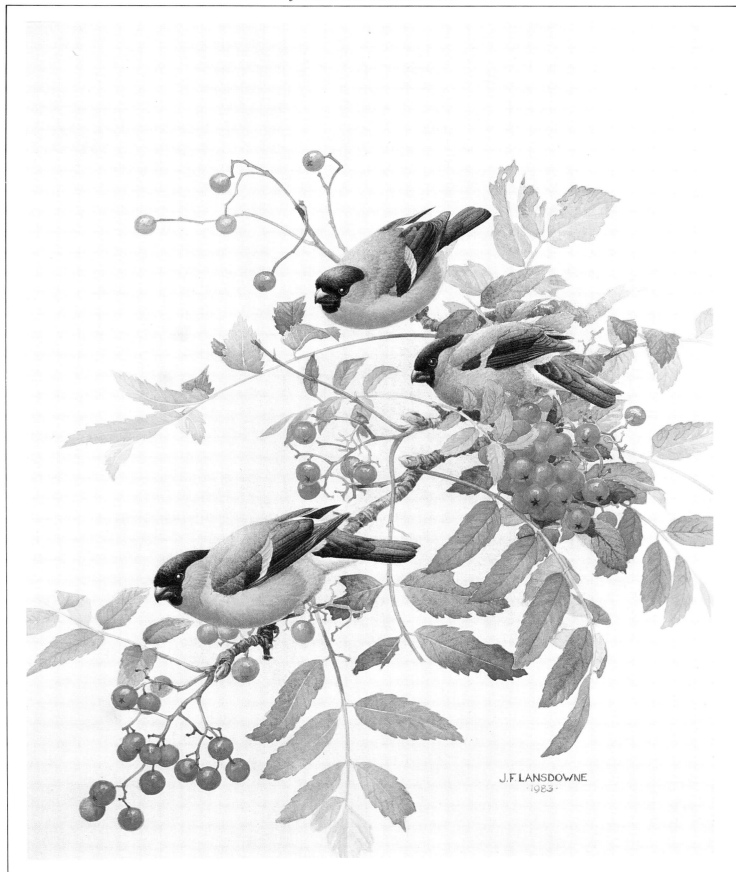

Bullfinches. J. Fenwick Lansdowne

one-man show at a major art gallery. This took place in September and October 1981 at the Vancouver Art Gallery. Bateman also says, 'he has always painted for himself' adding, 'imagine painting *Rails of the World*'. This beautiful book, published in 1977, was certainly a labour of love but it was also very successful and accompanied by an exhibition throughout the United States and Canada.

Lansdowne's book illustrating career began through a collaboration with John A. Livingston on his *Birds of the Northern Forest* (1966). Another six books followed culminating with *Rails*.

'The highest compliment I can receive' he says, 'is to be told "You are a good painter", not "You are a good wildlife painter".' Nevertheless his main models are birds. He is attracted by 'their freedom and their flight'. He was asked in an interview published in *Reader's Digest* whether his physical handicap had anything to do with his choice of birds as subjects. It certainly has coloured my life and personality – my acid tongue no doubt comes from that. I don't think my interest in birds and painting is a direct result of being immobilised as a child, but it certainly has warped it, warped me or twisted me in some direction or another.

'I think I would have been a painter, fascinated by birds anyway. I don't think an active childhood would have eliminated it. It probably gave me a lot more time

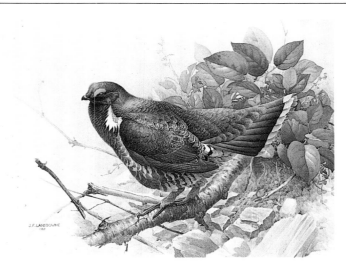

Blue grouse. J. Fenwick Lansdowne

to develop this side of me.'

Those paintings that are not for publication are commissions. As well as those from private sources there are commissions from government agencies for presents to Royalty, the first of which he undertook in 1962.

Having spent many hours in the field, Lansdowne used to produce field sketches. 'I used to do a lot of field sketches. I have built up a storage bin. Now I go out and look. It's all in my mind.' Nevertheless he does stress the need to get to know the way a bird lives. He does use skins for colour and detail. Museums lend him skins and he is brought road casualties by his neighbours. Rather than skinning these he injects them with formaldehyde. This is much quicker and as the body dries he can set the wings in whatever position he wishes. Photographs he sees as no more than useful adjuncts, but he does not take them himself. 'They are not a reliable source of information except incidentally, for general appearance of the birds in life, or perhaps even for ideas.' He also feels that the colour is often not really accurate.

Lansdowne is a humorous and fluent person, who speaks with a deep, mid-Atlantic accent. He is remarkably honest about his work, confessing to finding it difficult to loosen his style. 'The looser, freer parts are often the backgrounds. With the main subjects I'm simply too tight. I always try to loosen, to make it open, but it usually tightens up against my will. I'm better than I was, but it's been a twenty-five year struggle to be a freer painter.' There is inevitable comparison with Aubudon. Lansdowne admires Audubon's work, particularly his 'harmonious combination of scientific accuracy and high artistic

quality'. Compliments of his own work seem to surprise him. To him his painting seems so very simple and he finds it difficult to realise that he has anything important to say.

Some ideas for paintings will stay in his mind for several years. He develops the idea by making a few sketches with a ballpoint or whatever other implement is available: it could be one of his son's crayons. The rough sketch is often left overnight to see if he likes the idea before starting to paint. He makes a master drawing on paper in order to get the composition right. This is traced on to a wet-stretched watercolour paper.

Lansdowne paints for five or six hours a day. He finds he works better in the morning and will put in three hours before lunch. After lunch he will paint for two more hours. He is a slow worker, taking from two to ten months to complete a painting, and he is only able to tackle one painting at a time. Delicate detail he finds particularly tiring and he can certainly spend no more than six hours a day on them. When he does, the patterns stay with him at night, appearing before him every time he closes his eyes. But that is not to say that he finds painting a chore. It never really drags, he says, and is 'always a pleasure when it's going well'.

The project on which Lansdowne has been working in the 1980s is a series of paintings of endangered birds of China. This has a particular attraction for him because of his family connections with that country. The species to be painted include some beautiful cranes and pheasants. The main problem is his lack of field knowledge of these birds, but there are a number of the species in captivity and he has been looking at them in several zoos, notably San Diego. Another problem is the lack of material for the backgrounds. Bamboo does grow in his garden and he can use rocks and dead leaves, but he also intends to have some foliage sent to him from China.

The remarkable accuracy and delicacy of Lansdowne's painting makes it quite unlike that of any other contemporary artist specialising in wildlife. He suffered cruel blows in his early life, but thanks to his own and his mother's tenacity he survived to earn very early success. The fact that his style has continued to develop and that he still recognises that he has room for improvement almost 30 years later says much about him. Since he was born in China, it seems to be very fitting that he is currently working on Chinese birds. Perhaps it is also fitting that one of the paintings here should be of mandarin ducks, birds from China that have settled so successfully in the West.

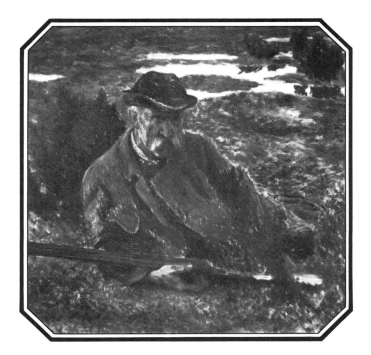

BRUNO LILJEFORS

ears before anyone really understood the principles of aerodynamics a Swedish painter was painting canvases of aerodynamically accurate flying birds. Bruno Liljefors was almost 40 when the twentieth century began, but the work he produced in the remaining 39 years of his life was better than most wildlife painting produced since. Flying birds are very difficult to paint and few painters dared tackle the subject in the last century. Most of them were content to use stuffed birds as models and

not really attempt to show them moving. For example, Thorburn, an almost exact contemporary of Liljefors, never really seemed to get the hang of painting flying birds.

The Swede understood the vitality of animals, making it quite clear that, even if they were still, his birds could fly and his mammals could run. This feeling is missing from most contemporary wildlife pictures. All too often the subjects seem to have been chosen, painted and put into a landscape with an eye to

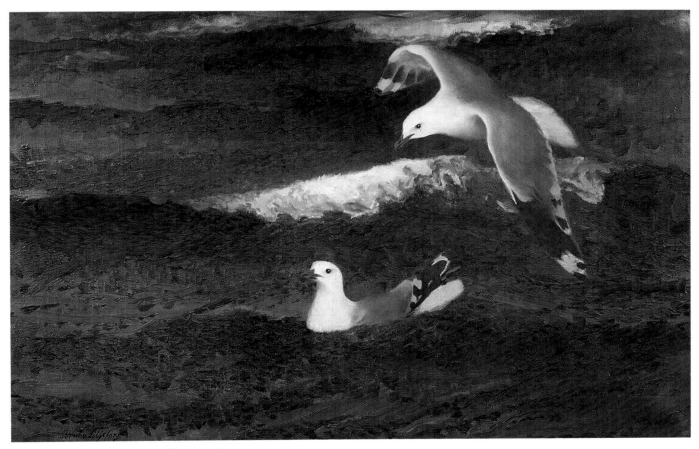

Common gulls. Bruno Liljefors. (Thielska Galleriet)

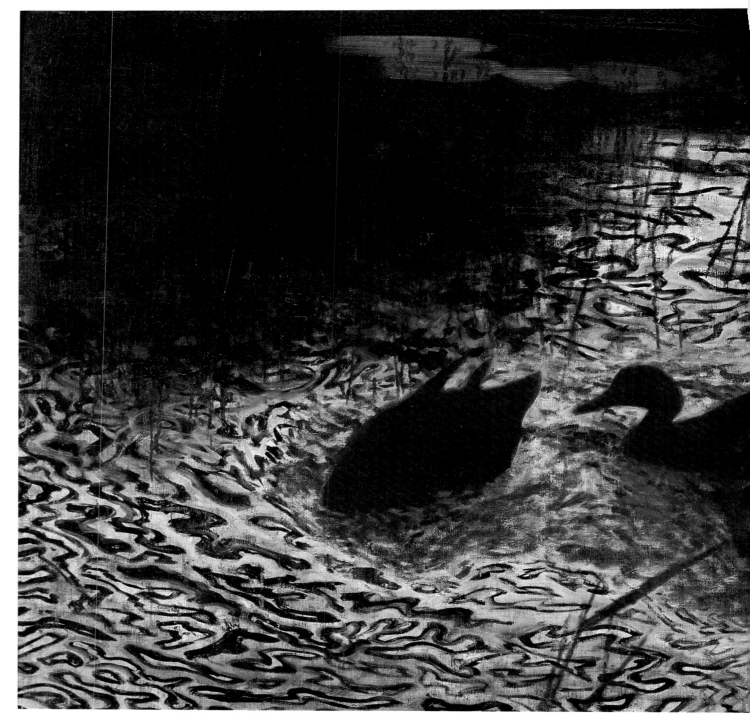

Wild duck in the reeds. Bruno Liljefors. (Thielska Galleriet)

the cash register rather than from an overwhelming desire to record the beauty of nature.

More than 80 years after Liljefors painted it, in 1904, his 'Golden Eagle Chasing a Hare' has never been surpassed. This large canvas shows an immature golden eagle that has surprised a hare. Liljefors noticed that hunting eagles swept low enough for their wings to touch heather or long grasses and to disturb resting hares. In this picture his hare is running for its life, but its right eye, the only one in view, is searching for a place of refuge. The hare knows the lie of the surrounding ground and has a good chance of survival. Already it appears to be jinking and if it makes the right decision the eagle may not be able to catch it. Catching the hare is not as simple as it might seem. The eagle must slow down before it hits its prey. If it fails to do so there is a risk of cartwheeling as it collides with the hare. In addition, the bird will have to turn to catch its prey and, because it is so close to the ground, its wings must help its tail to do this, which is why the left wing is flatter than the right. When a bird of prey is turning rapidly the tips of the primaries will turn and quiver. The first and second primaries have turned and the third and fourth, which must have been

quivering, are shown as little more than shadows. Notice also how the secondaries on the right have turned to allow air to pass them, thus putting the weight towards the front of the wing.

All these features were correctly observed by the artist, but it was painted long before anyone had any real idea of the mechanics of flight or before camera shutter speed was just enough to freeze such movement. Liljefors got it right because he had seen it. He must, it is true, have been blessed with a particularly quick eye and retentive memory, but the truth of his painting lay in his having experienced the events he portrayed. He had seen this drama enacted many times. And it was this point of the drama that he chose to paint, the crux when the outcome, although close, is not yet clear.

Liljefors lived very closely to nature and that led to an understanding that is lacking in much of the painting of wildlife both earlier and later than his. He never seems to have tried to paint subjects he did not know well. 'Since childhood I have had a strong and unusual affinity for watching wild creatures in their environment' he wrote.

He was born on 14 May 1860 in Uppsala, an ancient

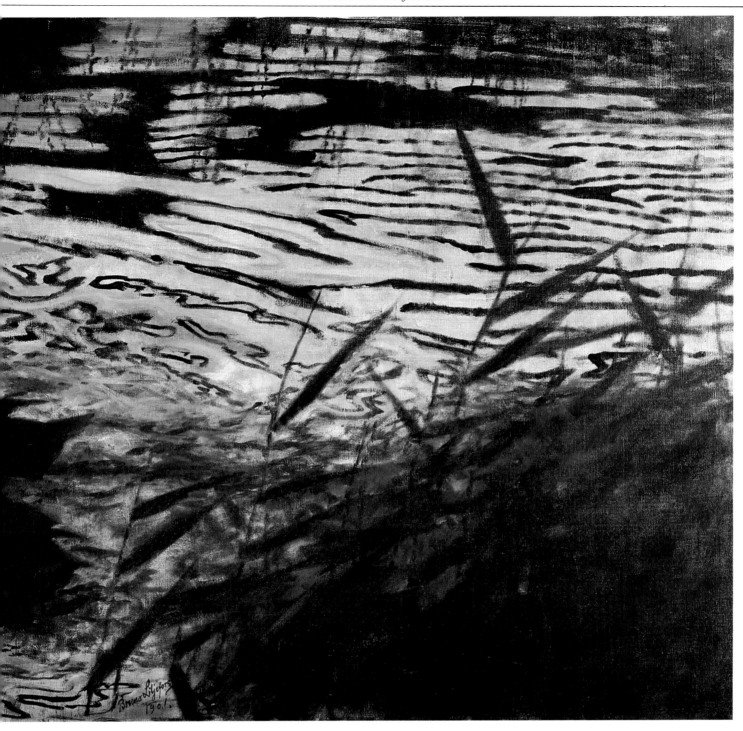

university city in the lowlands north of Stockholm. The way of life in the city and surrounding countryside had barely changed for hundreds of years, because industrialisation reached Scandinavia rather later than England or Germany. His father, Anders Liljefors, ran a gunpowder shop that was used by farmers and hunters from the province of Uppsala. This environment provided his son with a source of subjects for drawing caricatures as well as an interest in the quarry that the hunters sometimes brought in.

Bruno was a sickly child and was unable to go to school until he was seven, but his parents engaged a tutor who encouraged his interest in drawing, an interest stimulated by his mother who from an early age used to show him reproductions of paintings by great masters. The tutor, the daughter of a local artist, showed the six-year-old how to model form by using shadow and highlight on coloured paper, an introduction to painting technique that few receive so early. When he went to school little Bruno was still frail and was bullied by other pupils and subjected to the harsh punishments of strict Calvinistic teaching. It was at this time that he began to develop his enormous capacity to concentrate, a capacity that later helped to

achieve such understanding of the animals and the way they behaved. As he began to develop physically he discovered that he could stand up for himself and he began to train seriously, becoming good enough to join a Swedish team of gymnasts on an exhibition tour of Europe in 1879.

Reading James Fenimore Cooper inspired Bruno's interest in the Red Indian ideal, as did his own expeditions into the surrounding countryside, so it was with Indian weapons, bows and arrows, that he first hunted. Soon he graduated to a shotgun and began to skin and mount the specimens he shot. This was important to his development as an artist, not because he provided himself with models, but because it taught him about the anatomy of animals.

This practically based learning was somewhat different from the academic approach that Liljefors found when he went to the Royal Academy of Art in Stockholm. Although he won prizes for animal painting, this type of work was not considered very highly. Live animals were not considered proper models: plaster casts and stuffed specimens were preferred by the academics. By the time Bruno was at the Royal Academy a post-industrial economic

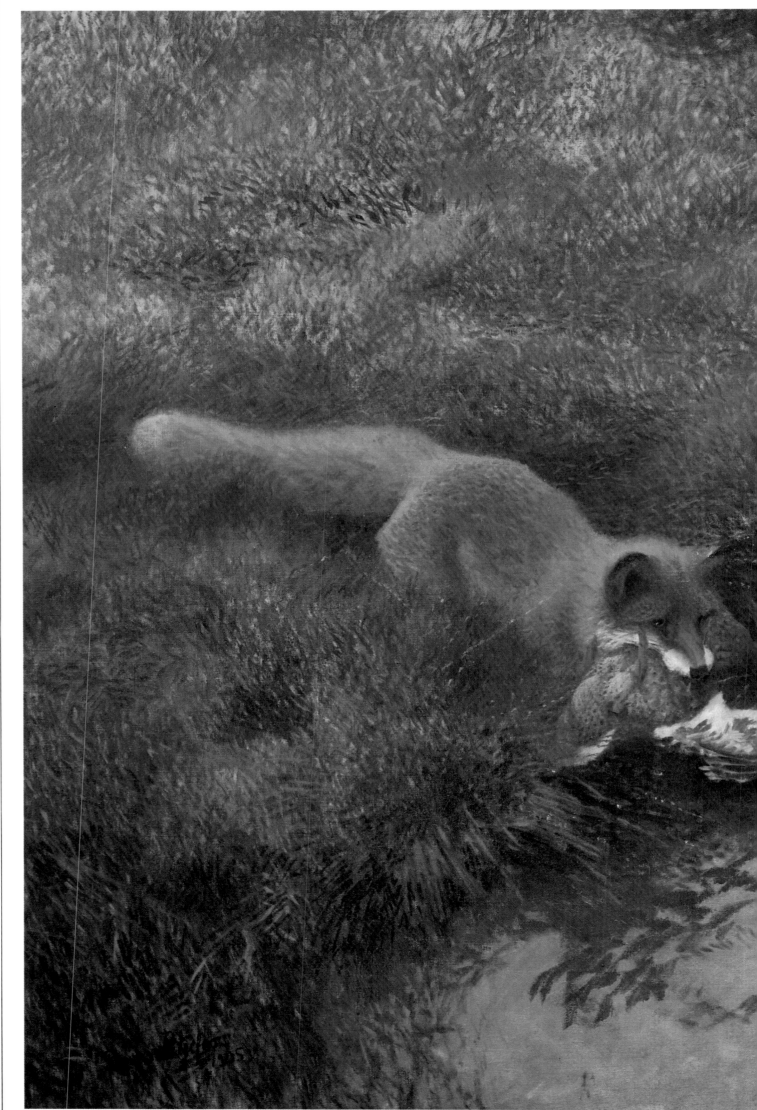

Fox and wild duck. Bruno Liljefors. (Thielska Galleriet)

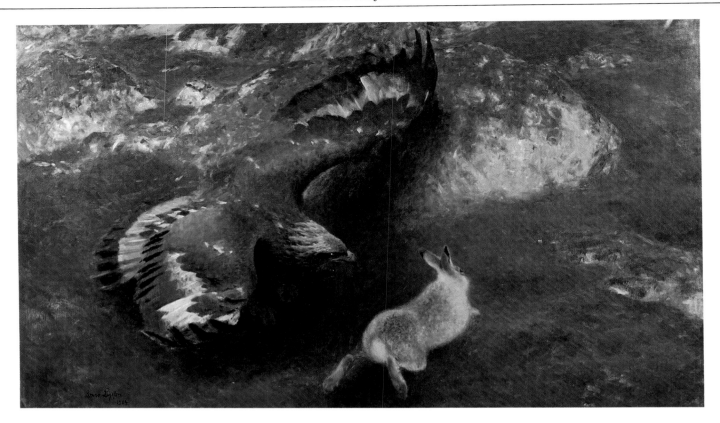

Golden eagle and hare. Bruno Liljefors. (Thielska Galleriet)

depression hit Sweden and Anders Liljefors found it increasingly difficult to subsidise his son. Bruno, therefore, used his skill as a caricaturist by freelancing his work to newspapers. Because of the urgency and topicality of this type of work, he sometimes cut lectures in order to meet deadlines. This brought a warning from the Academy's principal, but it was not for this reason that Liljefors resigned from the college in 1882.

A fellow student at the Academy was Anders Zorn, a particularly accomplished artist who later became famous as a portrait-painter. He obviously had a strong personality and became a major influence on Liljefors and his work. For example, it was Zorn, rather than any of the teachers, who showed Liljefors how to tackle the extremely difficult task of painting the coat of a fox. The younger man had been finding it impossible to draw a fox skin. It looked, apparently, as though he tried to paint each hair individually. Zorn offered to show him how to do it. 'He began thoughtfully to drop blots of pure colour on soaked paper' Liljefors later recalled, 'To keep it from running off, he held the block horizontal on his knees. He then fiddled with his three or four tones so that I thought it was all a joke. Then suddenly, as if by a magic wand, there was the fox pelt in all its beauty. It looked as if it were done in detail, though not a single hair was drawn – as though I could blow the fur apart and see the underlying wool'. In his many paintings of foxes, hares and cats it is clear that Liljefors really learned from Zorn's lesson.

Zorn became more and more irritated with the unimaginative regime of the Royal Academy and he resigned in protest in 1881. A year later Liljefors followed him, no longer prepared to paint plaster casts when he could paint living models at home in Uppsala. Head of the Academy, Count Rosen, suspecting that this decision may have been because of his admonitions for truancy, tried to persuade Liljefors to stay. But the student, despite the Count's opinion that he was too young to start on his own without further training, was determined to go.

That year he set off on a tour of Europe. First stop was Düsseldorf, where he studied for a while with the German animal painter C.F. Deiker. He then went south to Bavaria and Italy, before arriving in Paris. Here he saw the Salon of 1883 in which were hung paintings by the leading Impressionists. He approved of the freshness of their work, but he felt that the very obvious brushwork was snobbery. He made two more short trips to France in 1884 and 1887, spending most of his time with the Scandinavian-American colony of artists at Grez.

While at the Royal Academy Liljefors had fallen in love with Anna Olofsson. In 1885 he proposed and they were married. They went to live at Kvarnbo to the north-east of Uppsala. Here Liljefors built a house with a large studio, a kitchen, a small bedroom and a large balcony on which he could put out food to attract birds. As an artist he had to rely on caricatures and commissions. He found commissions difficult because they meant painting things someone else wanted him to do rather than subjects he wanted to do. Life for Anna must have been difficult: money was short and there were three children in the family. In 1895 they were divorced. Liljefors went off to spend a cold and lonely winter on the island of Idö in the Stockholm archipelago. He lived in a rough hut and spent his time painting the wildlife – divers, eiders, sea eagles and eagle owls.

He was tempted back into society by his ex-wife's sister, Signe. She had returned from America in the spring of 1896 to find that her sister was no longer married to Liljefors, of whom as a child she had been very fond. Her sunny nature and compatible sense of humour cheered Bruno greatly and this affection became deeper. Before the end of that year they had married. His island winter had inspired Liljefors to concentrate on seascapes and the newly weds went to live on the Baltic coast at Engsholmen. This area with its wooded hills and shallow beaches was a popular summer resort among Stockholm society.

The name of Liljefors was becoming quite well known and he was achieving some acclaim elsewhere in Europe, but his paintings were not selling that well and he had to rely on commissions. He wanted to paint

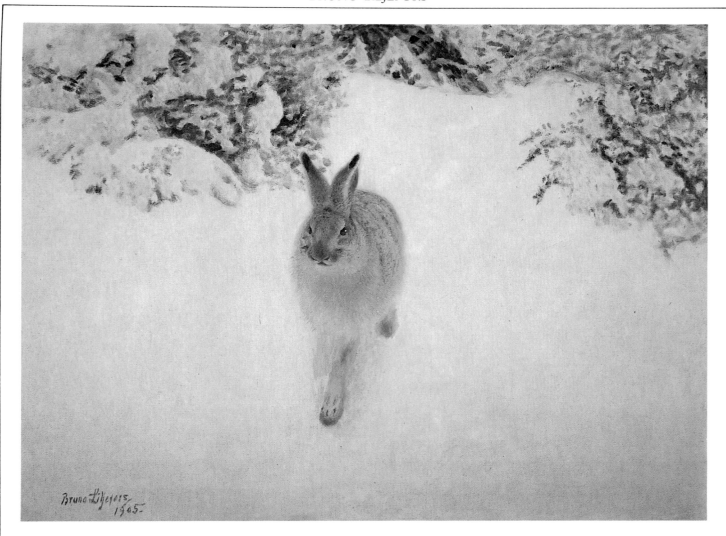

Winter hare. Bruno Liljefors. (Thielska Galleriet)

some large canvases of his own choosing, especially those with his new-found inspiration, the sea. But he could only do this if he was financially secure. Help came from no less a source than Crown Prince Eugene, who was both a painter and the patron of others. He formed a syndicate of ten men to back Liljefors with 10,000 kroner (about 500 guineas) in return for a 40 per cent discount on paintings purchased from him.

This patronage brought Liljefors the time he needed and allowed him to paint one of his best-known pictures – the famous 1897 canvas of two sea eagles hunting a red-throated diver. The National Museum in Stockholm bought the painting immediately and it was a great popular success. Among the people enraptured with it was the banker, Ernest Thiel, who lived near Liljefors at Engsholmen. Thiel already had some of his work but now he offered Liljefors sponsorship in the form of an advance of 15,000 kroner to paint for a year, put on an exhibition which should raise enough money to allow him to repay the loan and set him up for more painting. Unfortunately, the money ran out before there were enough finished pictures for the exhibition. The banker, therefore, entered into a new agreement to buy 20 Liljefors paintings at 2,000 kroner each, but should there be any higher bidders for any of the pictures the artist was free to sell to them. The gallery that Thiel built at the turn of the century as a home for his large collection of paintings now belongs to the Swedish nation.

Any financial worries that Liljefors still had disappeared in 1906 when he mounted a major exhibition in Stockholm and sold paintings worth a total of more than 100,000 kroner. This was a fortune and the success of the exhibition ensured that his future paintings would sell.

The archipelago of Bullëro, 365 islands and islets in the Baltic Sea is convenient for anyone wishing to see birds migrating from Finland. In 1908 Liljefors bought Bullëro as a summer home and for spring and autumn shooting trips with close friends. He had a studio on the shore and high-powered binoculars in position to study the birds. To bring birds close he dammed a tidal pool, one of the earliest examples of habitat management for the purpose of watching, rather than shooting, birds. So that birds were not scared off he banned shooting on the main island and employed a warden to discourage uninvited hunters.

The rest of the time the family lived at Ytter Järna on the coast near Engsholmen. He built a large house and it needed to be large because there were eight children in the family by then and there was the menagerie of animals which modelled for him.

By 1917 there were eleven children and the family moved again, this time to Österby near Dannemara north of Uppsala. This was an estate with woodland and an elegant manor house. There was a lake beside which was a coachhouse converted to a studio. Österby seems to have had an almost magical effect on the family and indeed on visitors. Baroness Wera Von Essen described her feeling of being transported 'to the Indian world of childhood fantasy with the Great Chief himself as the central figure'. His children were educated by governesses, Liljefors, perhaps understandably, having no fondness for schools. There was plenty of space and Liljefors used this imaginatively so that members of the family did not crowd each other. As well as his large studio he had a small house built almost entirely of glass on an island in a nearby marsh. Each member of the family, including Signe Liljefors, had a small blockhouse in the forest.

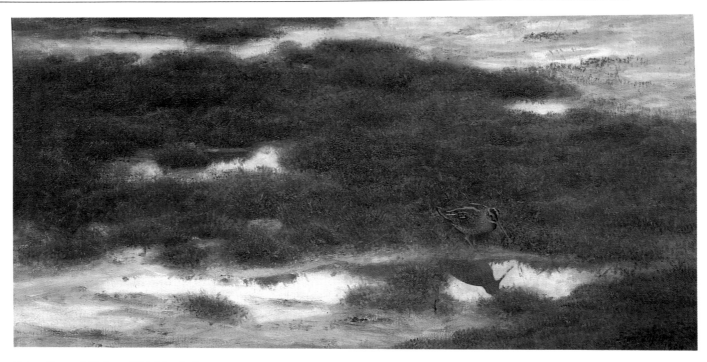

Snipe. Bruno Liljefors. (Thielska Galleriet)

Idyllic as the artist's life at Österby may seem, it must have been hard work. During the 1920s when Liljefors was in his sixties he was completing at least two canvases a week for Fritzes, his Stockholm gallery. Each Saturday a man was sent from Stockholm by the gallery to pick up two paintings.

The sickly child was left behind long ago and in his later years Liljefors was remarkably fit. But from 1925 he became plagued by neuralgia. Sometimes the pain was so bad that he was unable to work. Doctors in Breslau in Germany removed a piece of his jaw which seemed to put an end to the pain for several years, but the attacks returned. A piece of his temple was removed but he still suffered until 1932 when his trigerminal nerve was cut. This cured him and there was no more pain. He continued to work right up to his death in December 1939, a bare five months short of his eightieth birthday.

In addition to his skill and creative ability, Liljefors had that important quality so vital to great artists – stamina. Much of his work was painted in the open and not always in high summer. He was, however, a practical person. He knew that no one does their best if they are too uncomfortable. According to his youngest son, Lindorm, 'The most striking thing was his practical outfit. His outdoor painting was hard school – winter and summer. A trigger-happy, hardy seafowl hunter may endure cold and wind on bare cliffs in April, but most people would have difficulty enjoying the work of the painter, holding the brush in stiff, swollen fingers and sitting in exactly the same angle against the wind. He really understood the need for a good outfit. In April migration he wore immense lynxskin trousers that reached his underarms, a leather jacket and cap and woollens underneath.'

Solitude was necessary for him to formulate his pictures and to approach his subjects as closely as possible. He was often away for days, sometimes pushing a small handcart with his painting materials so that he could tackle any subjects when he came upon them. He hated anyone to see him working or for them to see a canvas before it was completed. 'If anybody looks on while I paint, it seems as though he were reading a letter over my shoulder when I was writing.'

Don Eckelberry was fortunate enough to see boxes of Liljefors's sketches in the archives of the National Museum in Stockholm. In a subsequent piece in *Audubon* he wrote: 'Whereas sketches and working drawings of many artists are as interesting as the ultimate paintings, sometimes more so, the doodles and smudges we reviewed here bore little resemblance to any finished paintings. It struck me then that Liljefors was not only influenced by Eastern composition (perhaps indirectly through the Impressionists, for he was an Impressionist even if he did not declare himself so) but also by his combination of drawing and painting in a single act in response to an intense effort to capture the vital moment to the extent that if he seriously sketched at all, he did so in oil and mostly in the field, and these reflect his disinterest in line.'

By being so thoroughly steeped in his knowledge of animals and their environment it was perhaps unnecessary for Liljefors to make very detailed sketches. His pictures are, above all, portraits of animals in their landscapes and he needed to absorb both simultaneously. Too much concentration on field sketches and the line of animals could have destroyed the unity between the animal and the place where it existed. Liljefors himself stated that it was a confession of weakness, painting as he did, 'to try to make a thing more distinct than it really is'. He revelled in cryptic colouring, preferring greyhens to blackcocks and female to male capercaillies. 'Nature must have required aeons of time to produce anything so wonderful as the somewhat cold pigmentation of the forehead [of a woodcock], side by side with the warmer greyish-yellow of the cheeks, and also the dark brown markings of the woodcock or a pure tortoiseshell cat.'

Perhaps this admiration for camouflage and the delicate tones it creates was the reaction of Liljefors, the hunter, appreciating the difficulty of finding prey. Certainly his pictures of quarry species, grouse and capercaillie, for example, have none of the phoney grandeur of the gamebirds of the sub-Thorburn school. But then he had so much greater an understanding of both hunter and hunted than do many of today's so-called sporting painters. It was this understanding that helped to make him such a great painter of wildlife.

GEORGE McLEAN

iving and working in a house surrounded by 51 acres of his own land, George McLean has come, metaphorically at least, a long way from his boyhood in the low income section of Toronto 'which I am pleased to have left far behind'. His present home is Bognor, 120 miles north-west of Toronto, where he lives in a fieldstone building dating from 1876.

McLean's parents encouraged his artistic pursuits, although no one in the family was an artist or indeed even knew much about art. His interest in animals is deep. 'I have always loved animals of all sorts' he says, 'and have no way of communicating my feelings for them, except through my work. When I was quite young, I found I could draw and by drawing whatever animal subject that came to mind, I could understand and own that very elusive part of him which I loved best.' Just to get close to animals he used to hunt and trap, but today what he describes as a 'primitive urge'

is satisfied through his work as an artist and he has not 'killed anything bigger than a mosquito for years.'

Born in 1939 McLean went to an art-orientated high school in Toronto, but he could not wait to get out of school to follow his life-long mania to draw and paint animals. His teachers assured him that he would never make a living at it. 'For a while' he told me, 'I thought maybe they were right, but I make a good living now, and must say I got most of my education on the road, the way most everyone else does.'

He began work as an illustrator and had his work published in several Canadian and American magazines, calendars and books. Life was a struggle, but gradually his work became well known and he has exhibited paintings throughout the United States and Canada as well as in Europe.

He has worked in several media, but now he works exclusively in casein on prepared masonite panels. He particularly likes the matt finish of casein and the

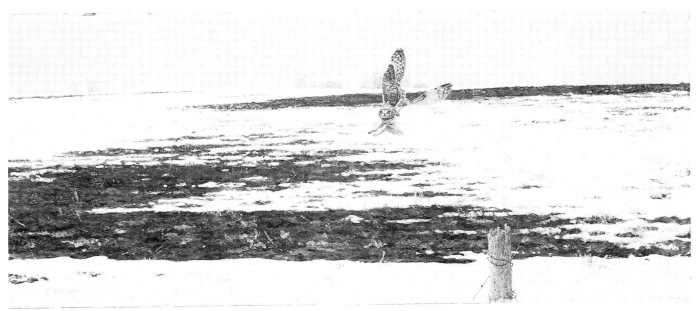

Short-eared owl. George McLean

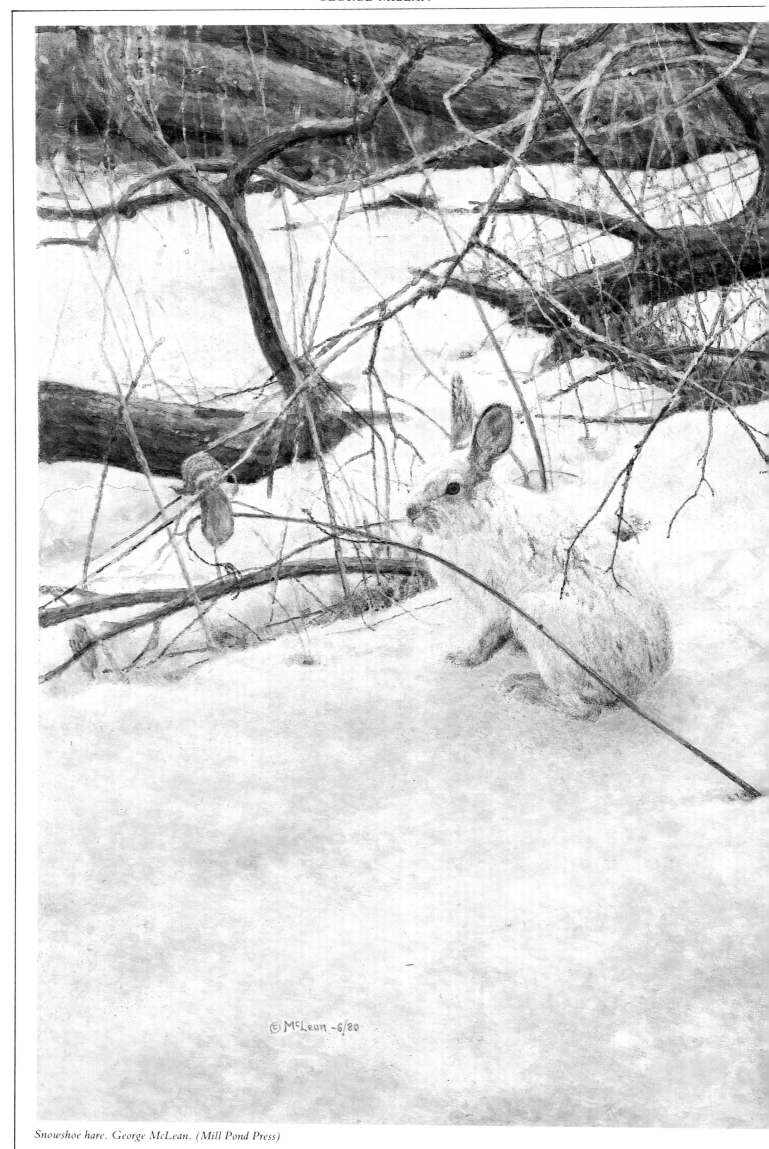

Snowshoe hare. George McLean. (Mill Pond Press)

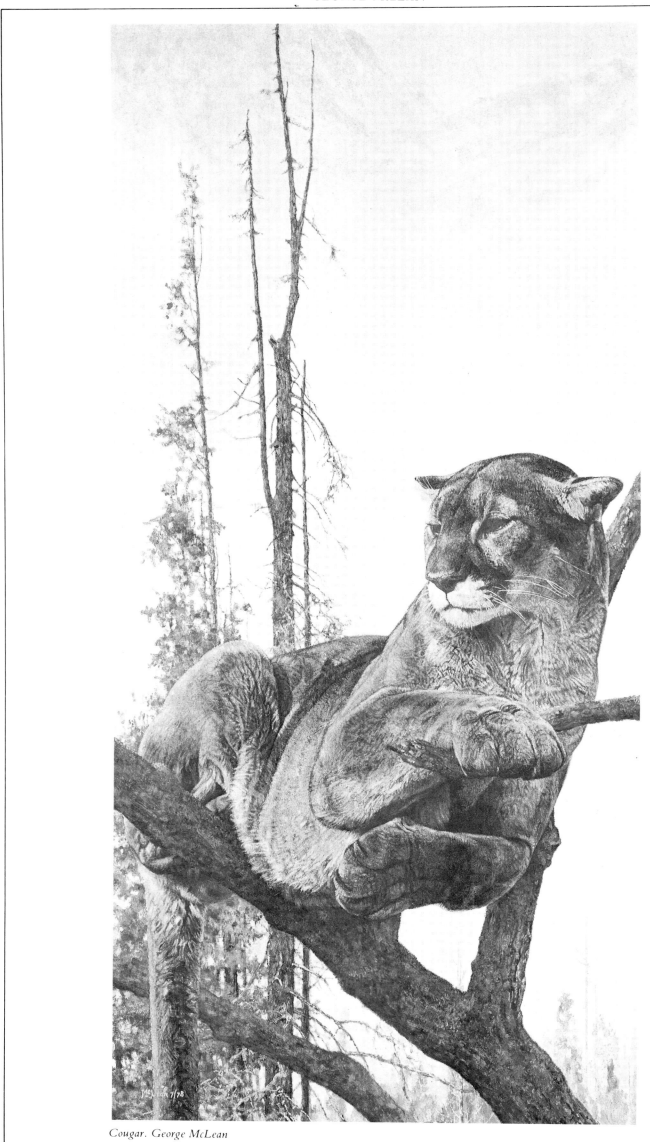

Cougar. George McLean

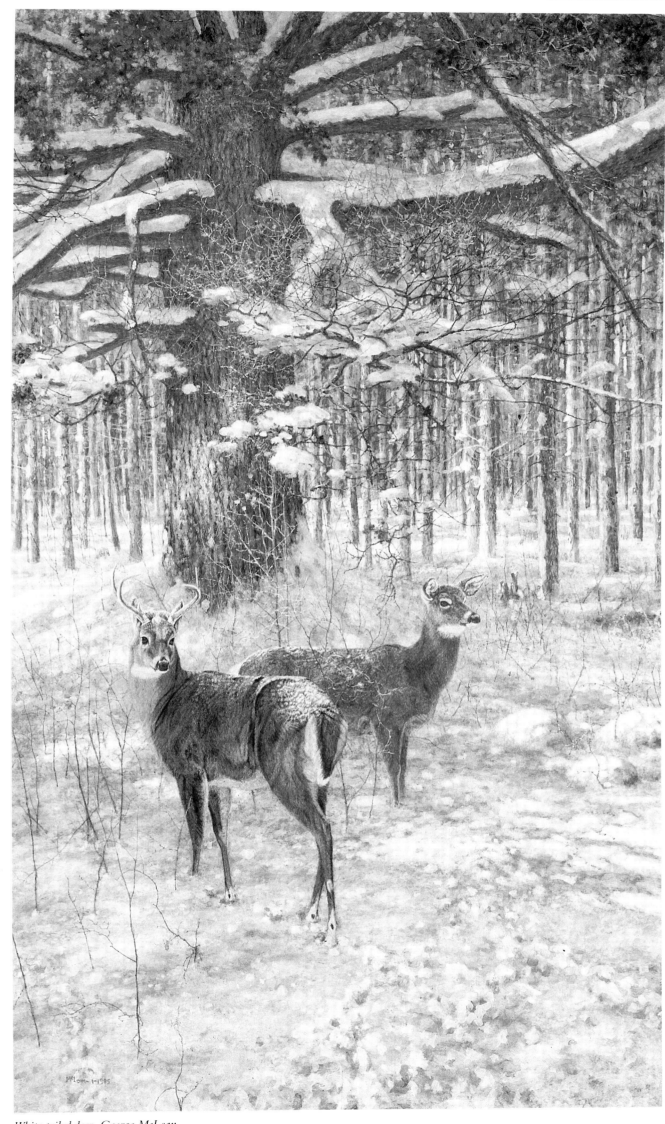

White-tailed deer. George McLean

Red-tailed hawk. George McLean. (Mill Pond Press)

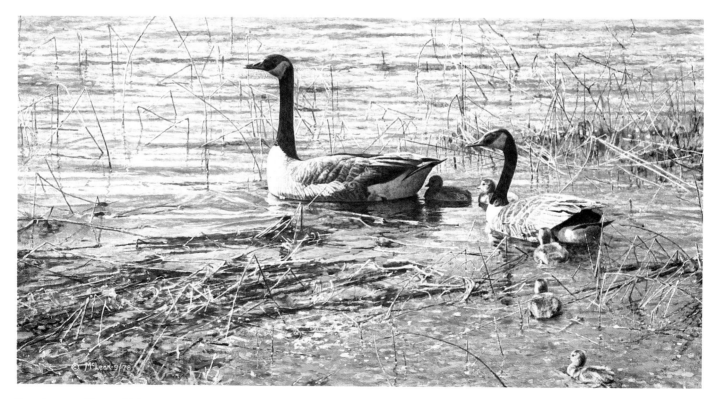

Canada geese. George McLean

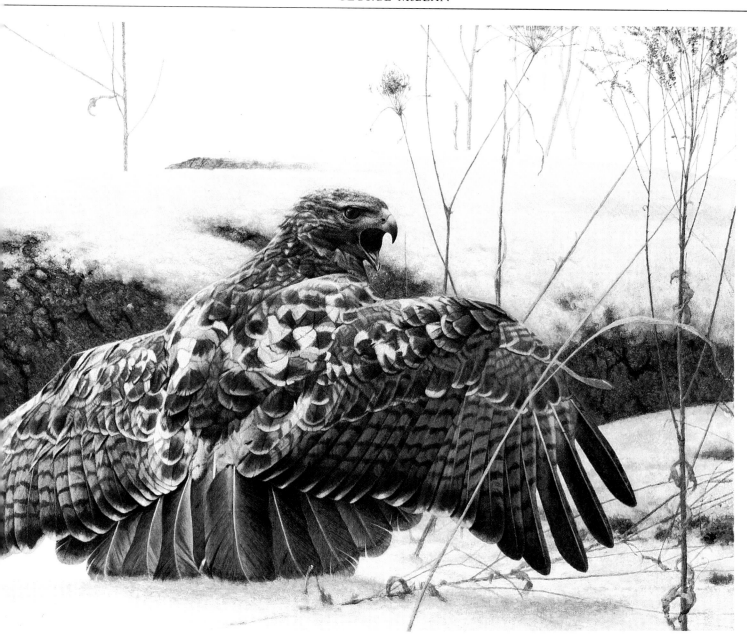

controlled texture of gesso on masonite. He has an ambition to paint more pictures better and to deal with subjects in situations that cannot be photographed.

He is very critical of the use of photographs by some contemporary painters of wildlife. 'Much contemporary art relating to wildlife is, in my view, unartistic reworking of photographs and gives the entire genre a bad reputation. The great animal paintings are all intelligent, personal statements with which no photograph could compete.' McLean's own paintings have a realism about them that the thoughtless might deem to be photographic; in most cases the composition and lighting would be impossible to capture with a camera.

In building up a painting McLean uses a variety of references – his own sketches, skins, dead animals, photographs and his own knowledge of the animal. His paintings are on a grand scale and in them can be seen elements of Bob Kuhn, Bruno Liljefors and Carl Rungius. Each of these has been a major influence on

him and he describes them as 'the best the Western world has ever seen: they are the masters.' Other artists that he mentions with admiration are Raymond Harris Ching and Leo Paul Robert as well as Sargent and several of the Impressionists.

Despite those early years of struggle McLean has no regrets about his life. 'I have been a truly free man and have exercised my abilities in the one direction that excited me,' he says. But he is not a self-satisfied person and adds, 'I would do it all again, only better, if I could.' He works in relative isolation, especially in the winter, which in Canada is far too long for him. One of the reasons is that he lives at the end of a half-mile long lane which has to be cleared of snow twice a day so that his wife, who is a teacher, can get to school and back. He is a fit person who lists his pastimes as weight-lifting and running. McLean's surroundings, rough, rocky farmland scattered with woods, streams and marshes provide him with the contact with animals that means so much to him.

LAWRENCE B. McQUEEN

The power of first-class illustrations to fire the imagination of youngsters should never be underestimated. Brought up in the small Pennsylvanian town of Mifflinburg, Larry McQueen became interested in birds at an early age. This led to his being given a copy of *The Junior Book of Birds* with illustrations by Fuertes, Sawyer, Brooks, Horsfall and Peterson. These pictures stimulated the young birder to take up drawing.

Fuertes and Eckelberry have been the greatest influence on McQueen's artistic work. However, it is Roger Tory Peterson, he feels, who has probably had a greater impact on modern bird illustrators than any other artist. As a result, McQueen says, many of today's illustrations are more precise and more revealing of the artist's complete knowledge of birds than those of the past. McQueen himself is plainly immersed in his subject, as much an ornithologist as an artist, trained both in biology and art.

'I've been watching birds since my childhood in Pennsylvania,' he remembers. 'I was encouraged by my parents and joined Bucknell University Ornithology Club when I was ten.' When he left school in 1954 he went to Bucknell to read biology, completing his degree at Idaho State University. He even managed to indulge his obsession with birds when he did his military service; he was sent to the Marshall Islands in the Pacific to study birds. For two summers after receiving his Bachelor of Science degree McQueen worked for the Idaho State Game Commission on the predator/prey relationship between golden eagles and pronghorn antelopes.

The purely scientific approach to birds was not enough for Larry McQueen. He wanted to paint them better. This led him in 1963 to a course in art at the University of Oregon at Eugene. More than twenty years later he still lives in Eugene, where he has been a graphic artist, a part-time staff artist at the Oregon State Museum of Anthropology, a lecturer in ornithology and painting at adult classes and, of course, a freelance painter of birds. In 1976 he also studied with Don Eckelberry in Trinidad.

McQueen, like many of his compatriots, has been influenced by Fuertes, Audubon and Peterson. It is somewhat surprising that an artist with such a scientific background and so great an interest in ornithology should paint in so loose a style. This could be the influence of Liljefors, Winslow Homer and Van Gogh, each of whose work he admires. 'For wildlife art in general, I adhere to no "correct" approach,' he says. 'I do regard as essential accurate and strong drawing. The integrity of the animal should come

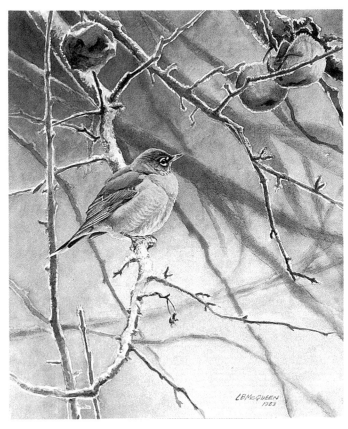

Frost robin. Lawrence B. McQueen

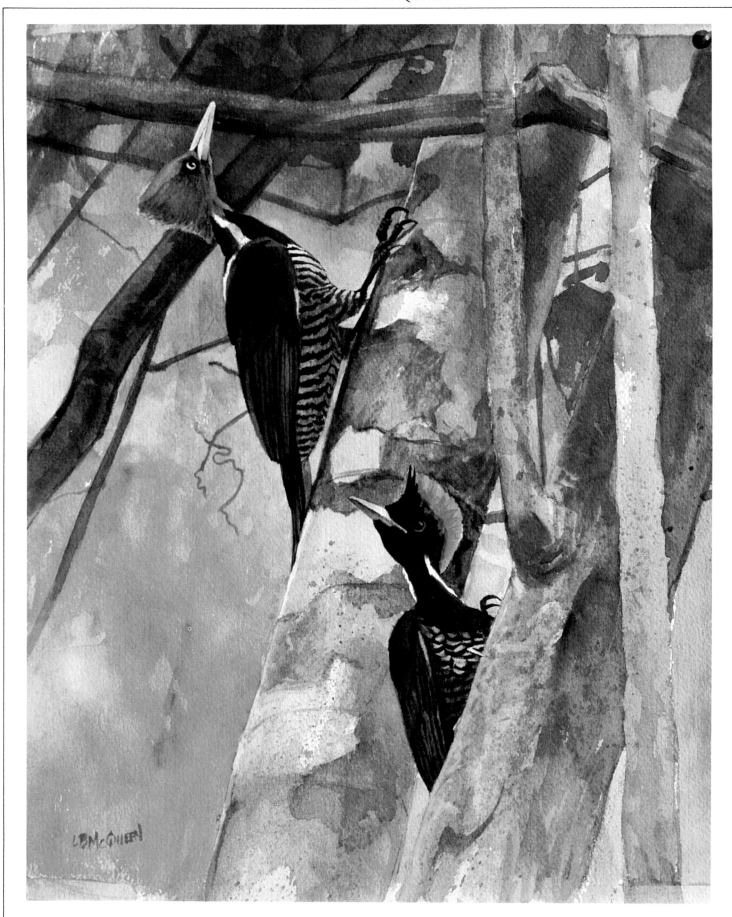

Pale-billed woodpeckers. Lawrence B. McQueen

through, as a representation of its species, and the whole composition should be interesting and pertain to the life of the animal in some way.' But he is quick to point out that he does not like to rely on detail to carry the painting. 'The strength of a painting needs to be within the drawing – the original concept – and not dependent on its surface. If that foundation is there, then detail can be perceived without being filled-in by the artist.'

Much of Larry McQueen's work is for exhibition. He has had four one-man exhibitions in Oregon, but he has submitted to and been accepted by several juried exhibitions across the United States, including the National Collection of Fine Arts, Washington, D.C., the British Museum (Natural History) and annual exhibitions of the Leigh Yawkey Woodson Art Museum at Wausau, Wisconsin. Group exhibitions at which his work has been hung include the Smithsonian Institution.

His gallery paintings are always carefully composed, telling the viewer a considerable amount about the behaviour and habitat of the species –

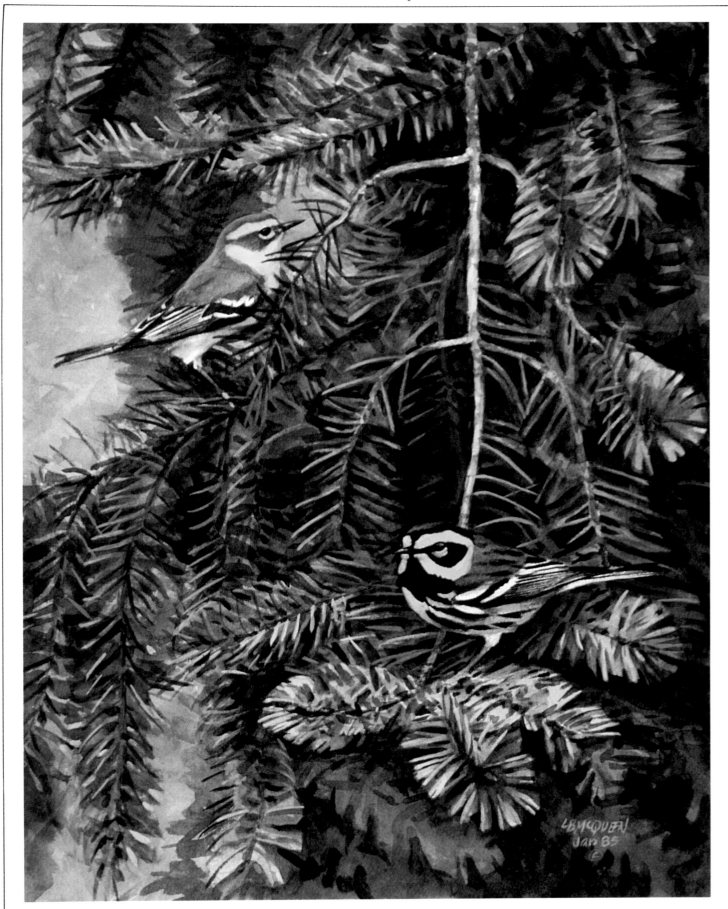

Townsend's warblers. Lawrence B. McQueen

white-bearded manakins displaying on the forest-floor of Arima Valley in Trinidad; cliff swallows flying in and out of their colony of mud-nests clinging to the rock face; or rosy finches searching for food in the snow. These all demonstrate McQueen's belief in knowing about, and thus identifying with, his subjects.

Conscientious fieldwork is the key to this work. 'I'm open to ideas from many sources.' he says. 'Although most of my information comes from observation in the field, I also take a lot of photographs. Photography is another way of seeing and capturing aspects of the environment. Sometimes I'll take compositional ideas I come across in books, other artists' work or magazines.'

His strong feeling for composition is shown in his illustrative work. It is surprising that he has not been more often commissioned to illustrate books. Apart from *Familiar Birds of the Northwest Shores and Waters* (1975) and *Familiar Birds of the Northwest* (1981) for the Portland Audubon Society McQueen has not been the sole illustrator of any books. However, his 50 colour

panels for *The Audubon Society Master Guide to Birding* (1983) are among the best in the book. He has also worked alongside Guy Tudor on plates for a definitive handbook on Colombian birds and is presently working with Dr John O'Neill on a handbook of the birds of Peru. To these illustrations he brings his ornithological knowledge, immense fieldwork and a compositional ability that enable him to cram a large number of species together in one plate but not to lose sight of the detail.

'The illustration work for *The Birds of Peru* has perhaps the most rigid parameters of all my work,' McQueen says, 'but it calls for challenging resolutions. For this work, I am interested in depicting the species as they appear to me, but in the field-guide format. Plumage characters are essential to define, but all birders soon realise that they become secondary to such aspects as habitat, behaviour, posture, size, proportion and – so important in tropical rain forest – stratified distribution. Of course not all these aspects can be represented by the artist, but they all affect the way the species might look in the field.'

Much of his work is in watercolour because it has immediacy and allows him to commit images to paper while they are fresh in his mind. 'I use transparent watercolour, often with some opaque, because this medium is easiest to carry in the field and fast to apply when I am doing field studies,' he says. 'With watercolour, I can best describe plumage texture and soft and delicate coloring.'

What about other media? 'I do use other media: oil being my favourite. With oils it is possible to make major changes during construction of the painting and I tend to use oils experimentally, rather than for finished works, although I expect this will change.' Such a change by McQueen with his knowledge and ability could produce some very exciting paintings indeed. While his illustrations for Peruvian and Colombian guides will no doubt contribute to the knowledge and record of species in endangered habitats, gallery paintings of birds in tropical rain forest could play a significant part in encouraging interest in birds in the shortening shadow of extinction.

Coastal miner. Lawrence B. McQueen

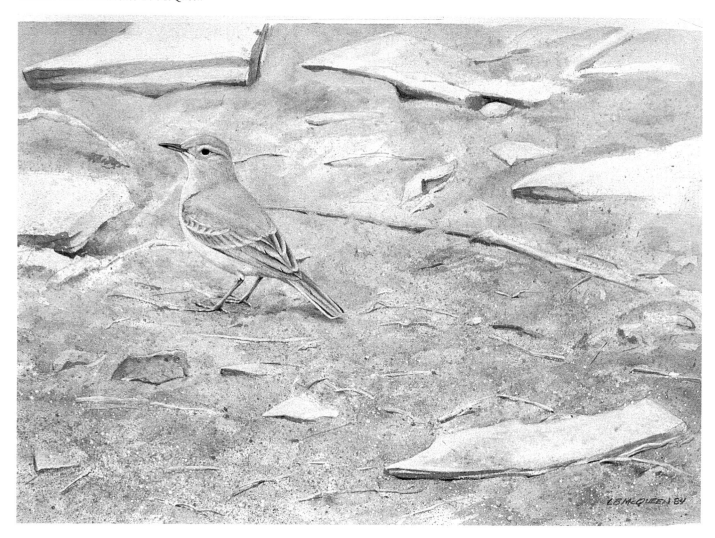

ROBERT M. MENGEL

Anyone who has worked with professional biologists knows that on occasions they can become very involved in detail. As a biologist who is also a painter, Professor Mengel may well be an exception. Curator of Birds and Professor of Biological Science at the University of Kansas, he is also an accomplished watercolour painter of landscapes and animals. He might be expected to paint detailed anatomical maps of the birds and other animals that are his subjects as a scientist.

The following quotation, however, demonstrates

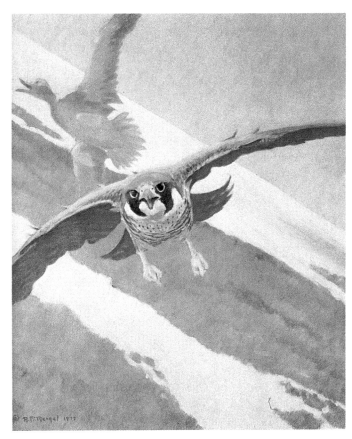

Peregrine. Robert M. Mengel

his understanding of man's perception of birds. It is from his masterly exposition of the art of natural history in *The Living Bird* (1980) and could well describe Professor Mengel's own approach as an artist.

'The perception of essence is critical, in wildlife art and elsewhere. By essence I mean special character, unrelated to dress, detail, feathers. We know our good friends in the rain, muffled in coats, at half a city block. From the highest row of seats, the devoted football fan knows which back has the ball, without benefit of number. In poor light and a moment a gifted field ornithologist recognises obscure species that challenge beginners under ideal conditions.

'The gifted animal painter comprehends these distinctions, his sketched outlines requiring no feathers or details for recognition by fellow intellects.'

Mengel's training was as a biologist. Born in Louisville, Kentucky in 1921, he graduated from Cornell University and then went to the University of Michigan where he obtained his master's degree and a Ph.D. His ornithological background is impeccable. He has been editor of *The Auk* and of the *A.O.U. Monographs*, is a fellow of the A.O.U. and has written numerous scientific papers and two major books. He also illustrated many papers in *The Auk, Condor,* the *Wilson Bulletin* and *The Living Bird.* As well as his own *Birds of Kentucky* (1962) he has illustrated four volumes of *The Handbook of North American Birds* (1962–). His abilities as an author and artist were brought together in his paper, 'Beauty and the Beast: Natural History and Art' in *The Living Bird* in 1980. In this he described very aptly the feelings of the unaccustomed art critic:

'While I have often enjoyed criticising art critics, I find it sobering to be in their shoes. I discover that an art critic needs, aside from some qualifications, strong opinions, iron nerve, thick skin, robust ego, a gift for oversimplification and the willingness to be wrong more often than might be wished.'

Mengel's comments about the state of wildlife are trenchant and perceptive. He also puts forward an

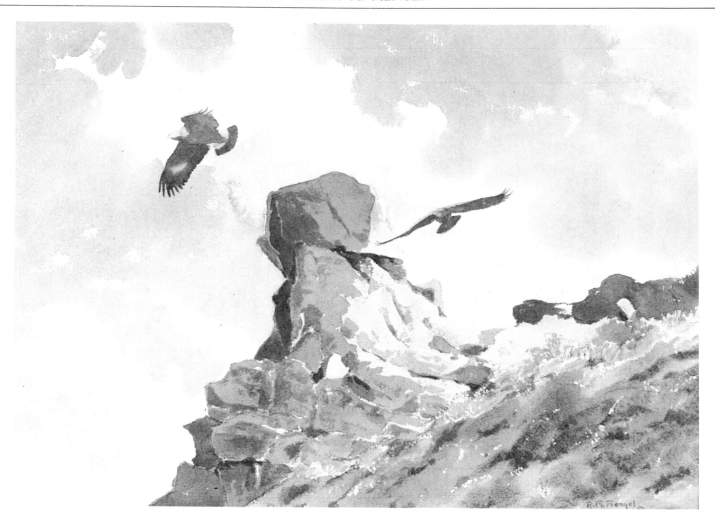

A sky for eagles. Robert M. Mengel

argument against separating wildlife art from other forms of art. He would like to see the idea of 'wildlife art' become an anachronism, but sees little hope of it 'until those artists whose strongest stimulation comes from wild nature and the beauty of nature cease to huddle apart in separate enclaves and to paint solely for the satisfaction of specialised and too frequently undemanding audiences.' He feels that those who select for these specialised exhibitions may also be undiscriminating. For this reason it is the shows of the Kansas Watercolor Society that he is most proud to have taken part in. Mengel told me that he found the competition and jurying in these shows 'considerably more rigorous than anything I have experienced with bird painting exhibitions'. These Tri-State Exhibitions are juried and invite submissions from the states of Missouri, Oklahoma and, of course, Kansas.

Mengel has had a one-man show at the Cornell Laboratory of Ornithology and his work has appeared at Leigh Yawkey Woodson Art Museum Annual Bird Art Exhibitions. Since acquiring a suitable studio in the early 1970s he has been painting with increasing intensity. He is primarily a watercolourist who paints landscapes as well as wildlife. 'My own ambitions,' he says, 'however slightly realised, are to be a good watercolourist, a good landscapist, and a sensitive interpreter of wild birds and mammals.' His painting has been influenced by the work of Winslow Homer and Carl Rungius. He also studied informally with fellow academic biologist and painter George Miksch Sutton. His use of watercolour in his illustrations is reminiscent of Sutton's, although his other paintings clearly owe much to Rungius. His line drawing has a quality about it of work by Francis Lee Jaques. In a review of *The Handbook of North American Birds* in *Ibis*, Mengel's line illustrations and colour plates were described as 'both useful and decorative, and often catch the magic of waterfowl delightfully'.

Many biologists first become interested in animals because of the emotional response that animals stimulate. Often, however, that initial emotional response becomes sublimated to an intellectual response to their rapidly acquired store of knowledge of animals. Robert Mengel is one of those very fortunate individuals who can ignore that vast store of knowledge and paint what he sees so that he shares the experience of his emotional response. There are many artists who are unable to do this. To be an artist as well as a biologist and still be able to share the excitement of looking at animals takes a rare talent and one that Professor Mengel possesses.

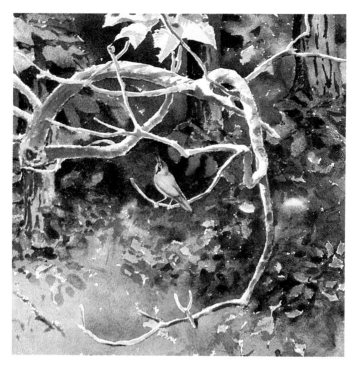

Kentucky warbler. Robert M. Mengel

KILLIAN MULLARNEY

In the last 30 years several extremely good young ornithological artists have developed on both sides of the Atlantic. Lars Jonsson is perhaps the best example of this group of artists: in the United States there are artists such as Larry B. McQueen and Guy Tudor and in Britain there are Alan Harris and Laurel Tucker. Ireland, too, has a fine ornithological artist whose work should be much more widely known than it is. His name is Killian Mullarney.

The Mullarney family is large. Killian is one of eleven children and was born in 1958 in Dublin. As well as having a large family the Mullarneys had unusual views on how their children should be

Adult little gull. Killian Mullarney

Little gulls. Killian Mullarney

143

educated. Therefore, until he was eight years old Mullarney was educated at home. Maire Mullarney, his mother, had read that Japanese children were given paint brushes at a very early age with very impressive results. Consequently she treated her own children in the same way, but they were simply allowed to paint whatever and however they wanted. One of the places they painted was a white-tiled kitchen wall and particularly good pictures were left there for a few days before being washed off. The principles behind the education of the Mullarneys was the Montessori method which relied very much on the natural curiosity of children. Mullarney's curiosity extended beyond drawing and painting to birds which became the focus of his interest from the age of three and throughout life. 'I believe' he says, 'this encouragement coupled with a passionate interest in nature, especially birds, was what determined my direction in life.'

At the age of eight he went to St. Kilian's German School where his interest in arts and crafts was further stimulated, but at his secondary school art was not considered a worthwhile part of the curriculum. When he left school he considered the possibility of art college, but for a variety of reasons he decided not to go. He became a commercial artist, but now sometimes wonders whether a few years at art school might have taught him some of the techniques that he is having to master on his own. It might also, he feels, have provided him with a broader base of experience than he now has. Of course, his seven years as a commercial artist have provided him with some very different experience.

As a child the illustrations in *Birds you Should Know* (1925) by Roland Green (1896–1971) excited his interest. He enjoyed 'the many beautiful and exciting portraits of birds "doing things" and his backgrounds/surroundings were always so well observed and so skilfully drawn as to never appear contrived.' Mullarney recalls how puzzled he was when he came across some work by the same artist in a very different style. It was only the initials 'RG' that gave him a clue. Quite soon, however, he discovered that this 'RG' was not Roland Green but Robert Gillmor. He spent many hours studying Gillmor's painting and trying to emulate his technique. An enthusiasm for Tunnicliffe followed and then he saw Eric Ennion's work in a copy of *Birds*. 'I loved his work, but I don't think it influenced me a great deal at that stage; Ennion's style was, quite simply, way out of my reach at that time, for I was much too bound up in improving "technique" and I saw things in terms of numerous details, rather than as a simple "whole"'.

By the mid-1970s Mullarney was working almost exclusively in line and pencil, very much influenced by the work of Gillmor, but appreciative of the skills of Ennion and John Busby. One day in 1978, browsing in a Dublin bookshop he noticed some copies of the series of newly published *Penguin Nature Guides*. The illustrations by Lars Jonsson were a revelation. 'I received such a shock that I literally broke out in a cold sweat' he recalls. 'I immediately bought the two books and spent the best part of the following week or two buried in their pages and taking them round to show friends. Jonsson's work was so fresh and what was most remarkable was his ability to paint birds that were not only alive, they were superbly accurate too. Here was proof that the elusive balance could be achieved.' In 1982 he went to Sweden and met Lars Jonsson, who gave him a great deal of invaluable advice on field sketching and painting. Jonsson's work has, Mullarney claims, been a constant inspiration to him. Looking at Mullarney's drawings, the influence of Jonsson is clear.

Like Jonsson, Mullarney is as much a field ornithologist as an artist. He is, therefore, wedded to the practice of field sketching and most of his work has gone into his sketch-books rather than into finished. 'I have not devoted sufficient time to learning how to paint skilfully and especially to observing and painting the other elements of composition – that is excluding the birds – that are most important to successful paintings.'

Having moved from Dublin in September 1985 Mullarney now lives and works in a country cottage in County Wexford, less than half-a-mile from the South Slob, an internationally important wetland with wintering flocks of Greenland whitefronts, Bewick's swans and other wildfowl. It is also very good for migrants which gives it a particular interest for Mullarney who has a fascination with rare birds. Even his garden is good for birds and during the hard winter of 1986 snipe, curlew, lapwings and oystercatchers were all feeding in view of his studio window. Indeed, he has a blind that he pulls down when the sun becomes too strong or the birds too distracting. Much of his time is spent in the field and he is well aware of the frustrations and discomforts of field sketching.

A major frustration for any artist is the way a subject can be very unco-operative – moving very quickly or changing posture. To overcome this, Mullarney deliberately gives himself the opportunity to get to know the bird. He does this by sketching small details, shapes and rough impressions of postures as they strike him, but making no attempt to link these in a more complete sketch until he really feels he is getting to know the bird better. 'Thus, I may end up with a page or two of barely recognisable, scribbled bits and pieces, but at this stage I will often have gained the confidence to sketch the whole bird more rapidly, and not have to stop and check details so frequently.' An important tool in the field for Mullarney is his Kowa telescope with an angled eyepiece which gives him the opportunity to see both his subject and the page of his sketch-book without moving his head. He prefers using Faber-Castell coloured pencils for field sketching which give him simple, spontaneous effects. When he works in line he finds himself becoming too involved in detail.

Back in the studio he surrounds himself with as much reference material as possible. He is modest and obviously concerned about his technique. 'If my technique was good enough I would prefer to use pure watercolour, but it isn't, so I usually find myself working in mixed media, generally a combination of gouache and watercolour.' He has used both oils and acrylic, which he enjoyed.

Too little of Killian Mullarney's work has appeared in print. His illustrations have appeared relatively frequently in *British Birds* and *Irish Birds* as well as on the covers of local bird reports. So far he has illustrated three books: *Ireland's Wetlands and their Birds* (1979) by Clive Hutchinson, *Detective in the Wild* (1982) by Éamon de Buitléar and *Birds New to Britain and Ireland* (1982) by J.T.R. Sharrock and Peter Grant. Undoubtedly more Mullarney illustrations will appear now that he is working full time as a wildlife artist. Even more exciting is the possibility that he will begin to paint and exhibit pictures in which he shares the excitement he feels when he sees birds.

JOHN PAIGE

One delight of the annual exhibitions of the Society of Wildlife Artists in London is the submissions from John Paige. The work of many of the regular exhibitors is predictable, but not that of Paige. Sometimes they may fail to move the viewer in the way he intended, but they almost invariably make the viewer think. Even his choice of media is not predictable – he works in silkscreen, ink and gouache washouts, collage, pencil, watercolour and oils with enormous enthusiasm. It is a surprise, therefore, to learn that this is not the work of one of the younger artists. John Paige was born in 1927 and shows a freshness of approach that is difficult to believe in a man of almost 60.

As a boy Paige was interested in drawing and birds. At Rugby School during the Second World War the art studio was a 'second home' to him. There he came under the influence of Denys Watkins Pitchford. Although not so renowned a bird painter as R.B. Talbot Kelly, the famous Rugby art master, who was serving in the army, Pitchford was extremely good on painting technique. He was also an illustrator and author of children's books under the pseudonym of 'BB'. Watkins Pitchford also wrote about the countryside and encouraged Paige's interest in natural history. Because it was war-time Paige was given permission to miss games in order to take part in a national wood pigeon survey. He later enlarged this into a full-blown bird survey of Stanford Reservoir.

After leaving Rugby Paige had no more art training for almost 20 years. He went to Cambridge University to read law, but did not graduate. He spent 15 years as an officer in the Royal Armoured Corps: it is extraordinarily hard to imagine so gentle a person as a professional soldier. There were short spells as a game warden in Uganda and as a corn merchant until he decided to try his hand as a painter. On an unsuccessful trek around London trying to interest publishers and galleries in his portfolio he was advised to go to art school, which must have seemed a huge challenge to someone in his mid-thirties. But it was

nevertheless a challenge that Paige took up.

At Birmingham College of Art he studied graphic design, and he learned about several media. It is a credit to his open-mindedness that he learned so much about these different media and has continued to use them long after leaving art school. Although he does draw in pencil and paint in watercolours and oils, much of his work is silkscreen printing, collage and washouts in ink and gouache. His two collage covers for *Birds* were notable. The first was a great spotted woodpecker hacking chunks from a post, based on a 'jolly little bird' he had watched looking for grubs in a rotten post in Wales. A few reactionary readers complained about the almost humorous approach, but it was definitely one of the covers that gave the magazine its reputation for encouraging different approaches to wildlife illustration.

John Paige always carries a sketch-book. He will draw anything that catches his eye – people, dogs, farm animals, flowers. 'Sketching from life' he says, 'is vital to me. Only by experiencing something myself can I begin to understand it properly and hope to produce a picture of some originality.'

Most Paige pictures do have originality. Many of the subjects centre on the countryside around the Northamptonshire village of Kings Cliffe, where John lives with his family in a converted brewery. Subjects include the fallow deer in the nearby woods, tawny owls that nest in his garden and wigeon on the water meadows beside the River Nene. When Paige and his watercolourist wife, Jane, first moved to Kings Cliffe there were no other artists in the village. Since then several have moved in, providing a small, artistically stimulating community. John Paige and his wife have run summer schools at their house.

Variety seems to be the key to Paige's art. In addition to varying media he varies his subjects. As well as a wide range of wildlife subjects he paints landscapes and portraits. One of his enthusiasms is steam trains and he has produced a series of friezes of trains primarily for children. His work is put to a

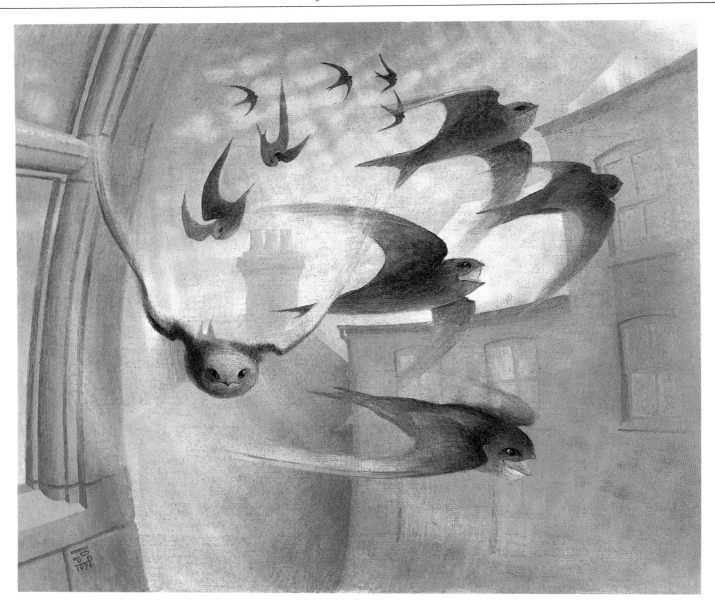

Swifts. John Paige

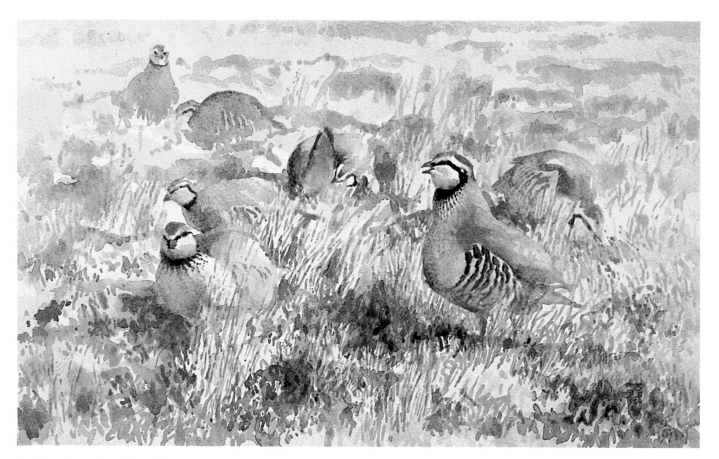

Red-legged partridges. John Paige

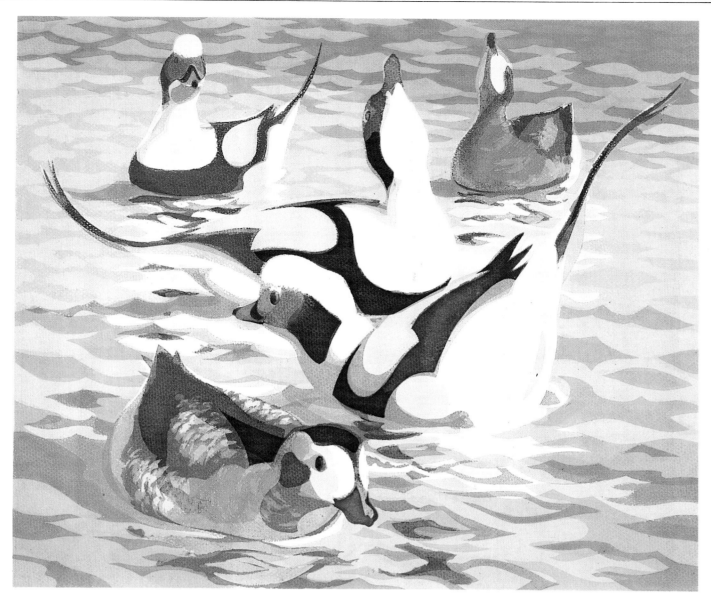

Long-tailed ducks. John Paige

variety of use too: his illustrations have appeared in children's books and early learning series, on a pub sign, as a mural in a bank in Stamford, Lincolnshire and even a Queen's Silver Jubilee mug that he designed for Kings Cliffe village.

As an artist John Paige is greatly underestimated, perhaps because he underestimates himself. People so often take others at their own valuation and may thus be misled by modesty. Or it might be because he is so versatile: specialisation is very attractive because it enables others to label artists. Ironically, if more so-called wildlife painters were as versatile as Paige both in choice of subject and of media, perhaps pictures of wildlife would be more acceptable among art critics.

BRUCE PEARSON

His optimistic and positive approach to life and work is typified by Bruce Pearson's smile. He sees life as a series of good breaks, each of which he certainly seems to have grabbed with enthusiasm. Beneath his modest, self-deprecating charm, there is a determination and degree of single-mindedness that has put him among the leading British wildlife artists.

Born in Newmarket, Suffolk, in 1950, most of his life has been spent in East Anglia. He now lives and works in Cambridgeshire. At school he was good at art and it was not surprising that, when he left, he attended a foundation course at Great Yarmouth College of Art. This was a stimulating experience with his being introduced to a wide range of media, including photography and screen printing, both of which he enjoyed, but it was painting that he really wanted to specialise in. I remember him showing me some of his work at this time. He was particularly interested in the effects of light and showed me a series of studies in which he experimented with light on birds. Even then he realised that the 'colour of plumage was only a function of reflected light'.

After his year's foundation course he went to the Leicester College of Art, where he studied for and received a B.A. (Fine Arts). But after Great Yarmouth, Leicester was a disappointment. He found it neither so exciting nor so stimulating, a fact that must have mystified his lecturers, who were so enthusiastic about the art of the pop culture of the late 1960s and early 1970s. The young student who wanted to learn to draw and paint traditionally was definitely out of step. 'I was a square peg in a round hole' he recalls, 'they wanted me to make kites, not to paint them.' Such was his disillusion that he reached a point where he stopped bothering with the fine art course and began to attend lectures for the photography course. He saw photography or film as being the way for him to find a career in the field of natural history, because he had neither the ability nor the inclination to obtain scientific qualifications to become a biologist.

At college he made some natural history film in Super 8 mm without any guidance, but he put on a small show linking the film with photographs and paintings and invited Anthony Clay, then Head of Films at the RSPB. In 1973 Pearson became a trainee production assistant with the RSPB film unit. During the 18 months he worked for the RSPB he painted in his free time. Some of his illustrations were used in *Bird Life*, the magazine of the Young Ornithologists' Club which is the junior section of the RSPB. He also painted enough to mount an exhibition of paintings and drawings of East Anglian wildlife at the Assembly Rooms in Norwich. By the time the exhibition came to be hung, in autumn 1975, Pearson was on his way to Antarctica, and his parents had to man it and sell the pictures.

His trip to Antarctica was a big break. A friend, Peter Prince, worked for the British Antarctic Survey (BAS) and was to lead a small project looking at the breeding behaviour of two species of mollymawk albatross on Bird Island of South Georgia, and he needed a field assistant. Pearson's six months on Bird Island were a revelation. He found himself painting and drawing at 'fever pitch'. He had no system for making sketches or selecting subjects. He just made masses of sketches.

On his return to the United Kingdom Pearson immediately made plans to return 'south' as soon as possible. He and Prince managed to obtain permission to film from the BAS and raised enough cash from friends and relations to make a 16 mm film about fur seals. So in 1976 he returned to Antarctica. Once again he accumulated a pile of full sketch-books and Pearson and Prince came back with a film that was later shown on BBC Television in David Attenborough's series, *Wildlife on One*.

The income from this film enabled them to return to the Antarctic to make a film about krill. Once again Pearson helped BAS as a field assistant giving him the opportunity to make sketches of wildlife. This time his drawing and painting was much more systematic

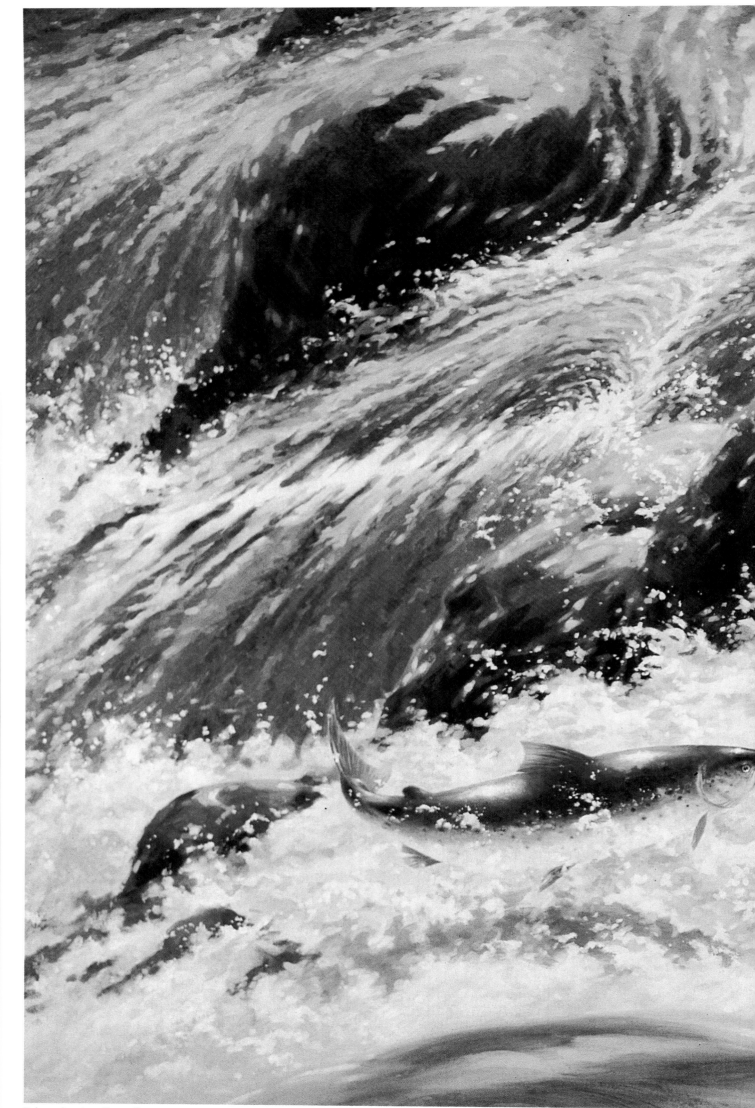

Salmon leaping. Bruce Pearson

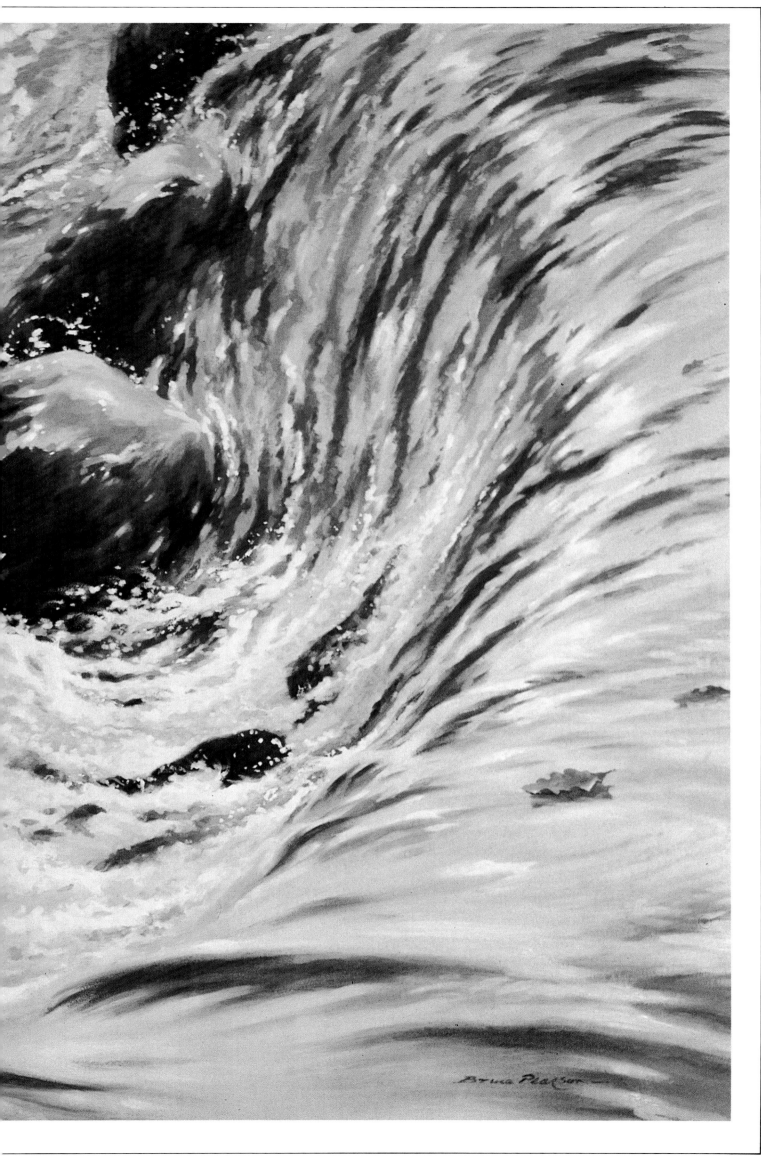

with rather more sophisticated equipment. So tame were the birds in the seabird colonies in Antarctica that he could check details of birds' plumage on the birds themselves. He returned to the United Kingdom with even more sketches and drawings.

Anxious for guidance as to how to make the most of the material that he had produced, Pearson approached his hero, Eric Ennion, a collection of whose printed material he had built up over the years. Sitting in the living room of his home at Shalbourne Mill, surrounded by Pearson's sketches, Eric Ennion beamed his enthusiasm and encouraged the young artist to exhibit. He also suggested that Pearson

submit some paintings to the annual exhibition of the Society of Wildlife Artists' Annual Exhibition. This he did and in a couple of years Pearson had been elected a member.

Six months after returning from Antarctica he had enough finished paintings to put on an exhibition at the Scott Polar Institute in Cambridge. Many of the people who bought paintings there were old Antarctic hands who admired the way in which he had captured the atmosphere and the character of the animals of the southern oceans.

Those three trips convinced Pearson of the need for a wildlife artist to have field experience. Pearson's own

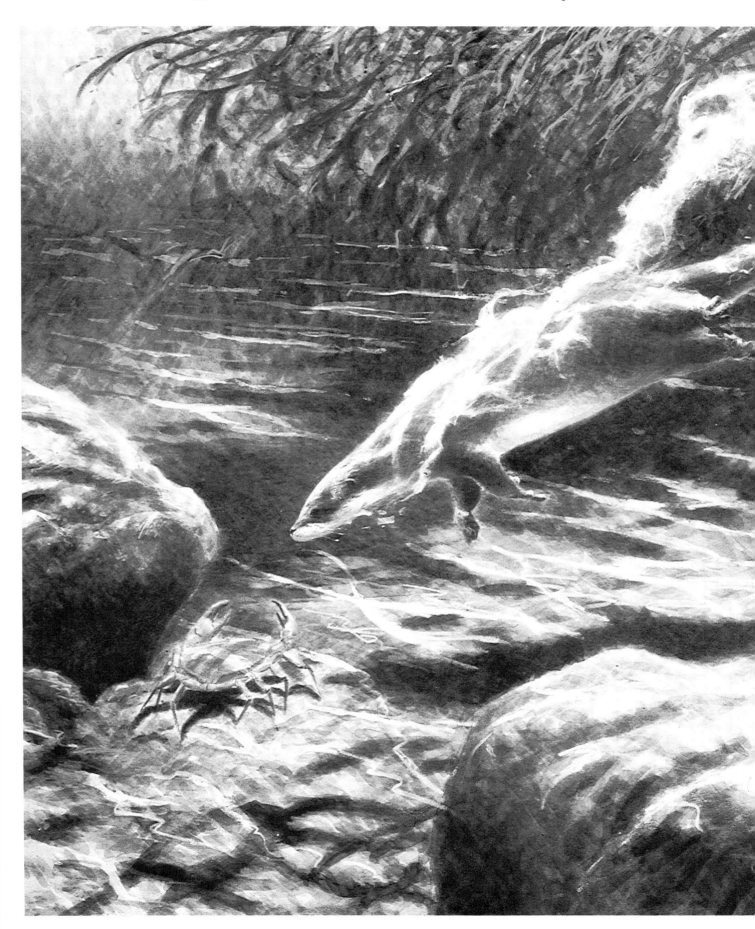

field experience includes going underwater with an aqualung to look at animals. One of his 'underwater' paintings, a little grebe in a flooded gravel pit, was used on the cover of *Birds*. He admitted to me that he had been unable to sketch successfully under water and therefore had to rely on his memory, returning to the shore to commit what he had seen to paper. He also confessed that he had not painted as many bubbles around the bird as he had seen: apparently when a grebe dives the air caught in its feathers is released in a mass of bubbles which can obscure the bird completely.

Pearson had done little illustration work, but he was

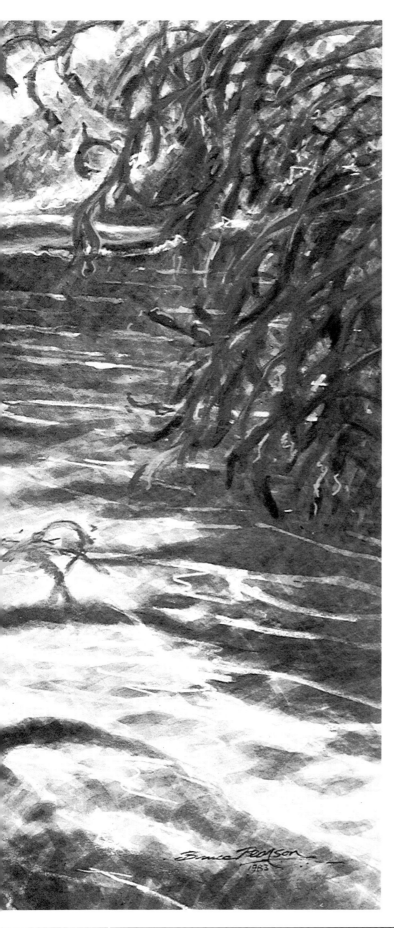

chosen by John A. Burton to illustrate the Collins' *Gem Guide to Wild Animals* (1980) which provided him with enough cash to keep going for 18 months, selling the odd painting through the SWLA exhibitions.

Then came another break. A friend from his Antarctic trips wanted an assistant for three months to help him with overland tours in East Africa. The landscape and wildlife of East Africa was as overwhelming to Pearson as Antarctica had been. Once again he returned home with a huge collection of sketches. The resulting paintings sold well. Another friend from Antarctica was a zoologist who had gone to study black rhinos in Zambia. He arranged for Pearson to visit him, offering a free flight in return for six paintings to be used in a calendar to be published by the Zambian Wildlife Society. Another four trips followed on the same basis with the Zambian Wildlife Society delighted by their calendar plates and the artist delighted with the opportunity to build up a portfolio of sketches of Africa and its wildlife. Then, he won a trip for two to Zambia in the Wildlife Illustrator of the Year 1983 Competition run by the magazine *Wildlife*. This time he was able to take his wife, Sarah, a botanist working for the Nature Conservancy Council.

Africa really caught Pearson's imagination in the way that Antarctica had; and meeting at an SWLA exhibition fellow Africa enthusiast, Brian Jackman, provided yet another break. Jackman had been commissioned to write a book about the British countryside in winter and he needed an illustrator. Pearson did not need to consider the project for very long: it would be prestigious because as an evocative writer about the countryside and wildlife Jackman has no equal and it would give Pearson an opportunity to spend two winters travelling throughout Britain sketching material. The resulting *The Countryside in Winter* (1985) is a delight and has confirmed Pearson as an important illustrator.

Now that he has financial stability, Bruce Pearson has a chance to develop his painting and keep his illustration work to a minimum, but he still works hard on field studies. In order to capture the atmosphere and time of places he visited he used a large sheet in the middle of which he would paint the landscape and in the margin around this he would sketch the birds and mammals that he saw. At first he viewed these as important reference material and although he exhibited them, they were marked 'n.f.s.'. Now he paints two of these atmospheric sketches of each place. This enables him to sell one and keep one for reference. These sketches always attract attention at exhibitions and sell very quickly.

There is, he feels, a middle-ground between these sketches and large-scale works like those of Liljefors, another Pearson hero. It would be very easy for him to be caught in that middle-ground, painting 20×16 portraits of tawny owls and not have the chance to develop. He is, therefore, now concentrating on large oils using four- or six-inch brushes. As he says, there is no point in painting a close-up portrait of a golden plover, when what really moved him was the sight, not just of one bird, but of a whole flock of golden plovers one wintry afternoon on the Somerset Washes. It is scenes like this, or a golden eagle sailing above a snow-covered Cairngorm or a salmon leaping from a Scottish river that deserve to be recreated in oil.

Having mentioned Ennion and Liljefors as heroes, Pearson talked to me about Sir Alfred Munnings. Although Munnings was not a painter of wildlife, his work can, according to Pearson, teach wildlife artists a

Otter underwater. Bruce Pearson

great deal about how to paint animals and he instances an oil painting of a white horse in a chalkpit in which Munnings used barely any white paint. And then,

among Pearson's own contemporaries, there is Lars Jonsson whose ability to paint animals and recreate atmosphere he envies.

Cairngorm. Bruce Pearson

ROGER TORY PETERSON

No single artist has made so great a contribution through his art to other people's appreciation of his birds and their conservation as Roger Tory Peterson. John James Audubon may have been the father of the American natural history movement and Louis Agassiz Fuertes was an undoubted influence on many American twentieth-century bird artists, but they never made the same impact on so many ordinary birdwatchers or, indeed, on the general public as has Peterson. Like Sir Peter Scott, he has made an enormous impact on the public and not just through his painting. Peterson's major contribution has been to enable people to identify birds more easily and so identify with their problems.

The Peterson system of identification drawings, in which the salient points of identification of each species are shown by arrows, revitalised birdwatching in the United States after the publication of *A Field Guide to the Birds* in 1934 and in Europe when *A Field Guide to the Birds of Britain and Europe* was published 20 years later. The bright, rather schematic illustrations in the European 'Peterson' were a revelation to British birdwatchers: most of us had been using books illustrated with the romanticised plates of Thorburn, Keulemans or Gronvöld. By comparison the Peterson illustrations were so clear. There was one disadvantage to learning birds from Peterson. So enchanting were the Peterson illustrations that there is sometimes a feeling of disappointment where a bird fails to come up to its illustration.

Peterson is aware that birdwatchers often see birds as he painted them rather than as they actually are. When he redrew some of the illustrations for the 1950 edition of his American guide, they were criticised as not being as good as earlier illustrations. The artist thought that they were better and that the criticism stemmed from this habit of seeing the illustrations rather than the birds.

In the United States Roger Tory Peterson is the best known naturalist by far. He has a long list of honours and awards, most prestigious of which is the

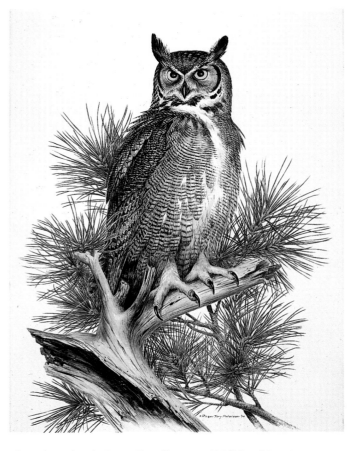

Great horned owl. Roger Tory Peterson. (Mill Pond Press)

Congressional Medal, the highest honour that can be awarded in the United States, presented to him by President Carter. In addition he has twelve honorary doctorates and innumerable awards for services to conservation, education, literature, public service, science, natural history and, of course, ornithology.

All this and yet he recalls that at the age of eleven in Jamestown, New York, he was well on the way to becoming a tearaway. He was saved from such a fate and, more importantly, set on the road to fame, by the

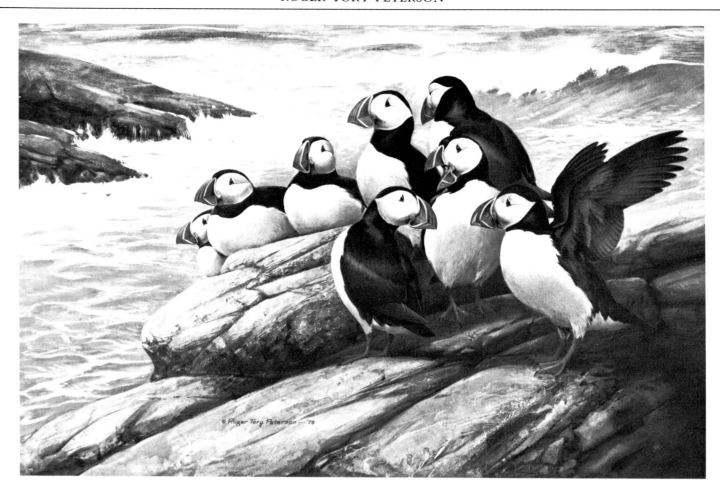

Puffins. Roger Tory Peterson. (Mill Pond Press)

interest of a teacher, Blanche Hornbeck. Miss Hornbeck started a junior Audubon club and this sparked off Peterson's interest. 'My first birding trip took place on 8 April 1920,' he wrote in *National Wildlife* in 1984, 'near my home in Jamestown, New York, where I vividly remember surprising a flamboyant flicker as it slept against a tree . . . In class, Miss Hornbeck handed me a box of watercolours and asked me to copy a color plate of a blue jay by Louis Agassiz Fuertes, considered then, as now, to be the finest bird artist of all time. That blue jay did it; I became hooked on birds.'

At high school the young Peterson was very good at art, his grades in both art and mechanical drawing were good, but, somewhat surprisingly, in view of his subsequent career, his biology grades were not very good. Apparently he was too argumentative with his biology teacher. At 16 he graduated from high school and had to earn his living. The choice was either working as a draughtsman or as a furniture decorator. He chose the latter: it was a trade that was flourishing on the current fashion for chinoiserie with its lacquered cabinets, chairs and tables. He worked for the firm of Willem Dieperink Von Langereis alongside five other artists.

At this time he was still a keen birdwatcher. In November 1925 he visited New York City for a three-day meeting of the American Ornithologists' Union at the Museum of Natural History. He also submitted two paintings to an exhibition held at the meeting. The trip from Jamestown to New York was not cheap and to pay for it he had saved 80 dollars from his pay. Upon arrival in the city he made straight for Central Park West and the Museum. He was overwhelmed by the ceiling of one of the galleries: it was a 2,700 square foot oval dome representing the sky and suspended from it on invisible wires were a variety of wildfowl 'dominated by a wedge of geese'. Wandering in the hall where the paintings, including

his own two, were being hung, he met a man in his thirties. This turned out to be Francis Lee Jaques, the man who created that spectacular ceiling. This encounter, though, was less significant than an introduction to Louis Agassiz Fuertes, who actually went to look at the seventeen-year-old's two paintings. Peterson, in his introduction to *Louis Agassiz Fuertes and the Singular Beauty of Birds* (1971), wrote: 'Just what the great man said about these drawings I do not remember, but I know he was kind. Later, as we walked down the broad steps to the first floor of the museum, he reached into his inner coat pocket and withdrew a handful of red sable brushes. Picking out a flat one about a half inch wide, he handed it to me, saying, "Take this; you will find it good for laying in washes." I thanked him and before we parted he added, "And don't hesitate to send your drawings to me from time to time. Just address them to Louis Fuertes, Ithaca, New York."

'Actually I never did send any of my drawings to him for criticism; I had decided to wait until they were worth his time. And so, by delaying, I forfeited a priceless opportunity, for less than two years later Fuertes met his tragic death at a railroad crossing. As for the paint brush, I never used it. I had discovered some white paint caked in the heel at the base of the bristles; the master himself had actually painted with that brush. Therefore, I put it aside as a treasured keepsake.' Inevitably, Fuertes's work has been a major influence on Peterson, but he also pays tribute to Ernest Thompson Seton, whose *Two Little Savages* with its exciting line drawings was his favourite book as a boy.

Shortly after the AOU meeting the Cooper Ornithological Society organised the first American exhibition of bird art. This was held in Los Angeles in April 1926. Although Peterson could not afford to make the journey across America to Los Angeles he did send an oil painting of a horned owl and a charcoal

drawing of a screech owl. While still a teenager he was
already beginning to acquire a small reputation in
ornithological circles. Von Langereis was proud of the
success of his young employee and persuaded him to
follow some academic training. For a short time
Peterson thought of reading biology at Cornell
University at Ithaca where Fuertes lived, but he could
not afford the course. Instead he enrolled in the Art
Students' League in New York from 1927 to 1928.

Two lecturers at the Art Students' League had a
particularly strong influence. One was Kimon
Nicolaides. 'He used a very light fluid line – a sort of
feeling out of line, first lightly on the paper, then
boiling, boiling, boiling, modifying and bearing on
harder with bolder lines until the form reasserted
itself. It wasn't one of those block-out kind of
drawings', Peterson told his autobiographers, John C.
Devlin and Grace Naismith. The other influential
lecturer was John Sloan, a painter who specialised in
painting ordinary scenes in the lives of ordinary
people, the 'Ashcan' school of painting. 'To this day,'
Peterson admits, 'I follow some of his precepts in my
own painting. Sloan insisted that there was no such
thing as shadow, so he eliminated cast shadows from
his paintings and advised his students to do likewise. I
could never quite accept it. At that time Sloan was in
his "cross-hatch" period in which his drawings of
figures were modeled and shaped with a cross–hatch of
numerous short lines.' At art school Peterson learned
to paint all manner of subjects. Indeed, he later said
that there was a period at art school when he drew the
human figure better than he could draw a bird.

In addition to being an influence as a teacher, Sloan
was influential in arousing Peterson's interst in the
National Academy of Design. The Academy,
founded in 1825 on the pattern of the Royal Academy
of Arts in London, was anathema to Sloan, who
fulminated against it in a lecture that Peterson
attended. The student had never heard of the Academy
before and his lecturer's strongly worded
condemnation aroused his interest. He discovered that
students were admitted on their talent alone and that
no fees were charged. He was enrolled and spent three
years at the National Academy, learning about realism
in painting.

Art school certainly did not extinguish Peterson's
interest in birds. In New York he lodged with a fellow
birder, Bernard Nathan, and he used to attend
meetings of the Linnaean Society of New York. He
also went birding with a remarkable group, known as
the Bronx County Bird Club. It was founded by nine
teenagers, several of whom were to become
ornithological luminaries. Among them were Allan
D. Cruickshank, who became the United States' most
famous bird photographer, and Joseph J. Hickey, who
later became President of the AOU and Professor of
Ecology at the University of Wisconsin.

Life for the young Peterson was busy. On top of his
art studies and his birdwatching he had to earn enough
to live. This he did by returning to the trade of
furniture decoration. He worked in a studio loft in
Washington Heights, decorating furniture with
flowers or Oriental designs. Peterson was convinced
that much of the bedroom furniture he painted was
sold to bordellos.

For five successive summers Peterson worked as a
camp counsellor in Maine and this led to his first job
after leaving art school. At the end of the summer of
1931 he was appointed as an assistant master teaching
science, drawing and painting at Rivers County Day
School in the Boston suburb of Brookline. This was
a preparatory school and so Roger Tory Peterson,

from a humble background in upstate New York
found himself teaching the sons of the wealthy and
well-connected of Boston. It was something of an
education for him and he admits that it smoothed
away some of his rough edges. But his teaching was a
more than average education as Elliot Richardson,
one-time United States Ambassador in London,
averred in his foreword to *The World of Roger Tory
Peterson* (1977). The headmaster's wife recalled how
Peterson had the boys 'with their mouths hanging
open, wanting to touch, clinging to him, hating to see
him go out of the classroom'.

At this time he had already recognised that to
identify birds people needed simple illustrations, like
those he had so much enjoyed in *The Two Little
Savages*. The idea of a field-guide was first discussed in
December 1930 when he was counting ducks on the
Hudson River with his friend William Vogt, who was
a drama critic and nature columnist. Roger Peterson
was, according to Vogt, the best identifier of birds in
the region and, because he could paint, it seemed
logical to pass it on in a book. Peterson was not
enthusiastic, largely because he did not think anyone
would buy such a book, but Vogt promised he would
get it published.

At the same time that he was working on the
field-guide Vogt persuaded him to write some articles
on identifying birds for magazines such as *Nature
Magazine* and *Field and Stream*. Vogt also hawked the
finished field-guide manuscript around New York
publishers. None accepted it and it was Houghton,
Mifflin of Boston who eventually took it, but even
they did not realise what a hot property they had.
Only 2,000 copies were printed and the author's
royalties began only after the first 1,000 had been sold,
but Peterson did not have to wait long for payment,
for within a week of publication it had sold out and a
reprint was on the way.

While he was working on *A Field Guide to the Birds*
Peterson had shown some of the plates at a meeting of
the AOU in 1933. One of the members who had seen
these and been impressed was John H. Baker, who was

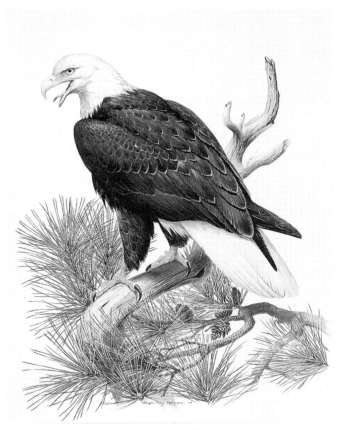

Bald eagle. Roger Tory Peterson. (Mill Pond Press)

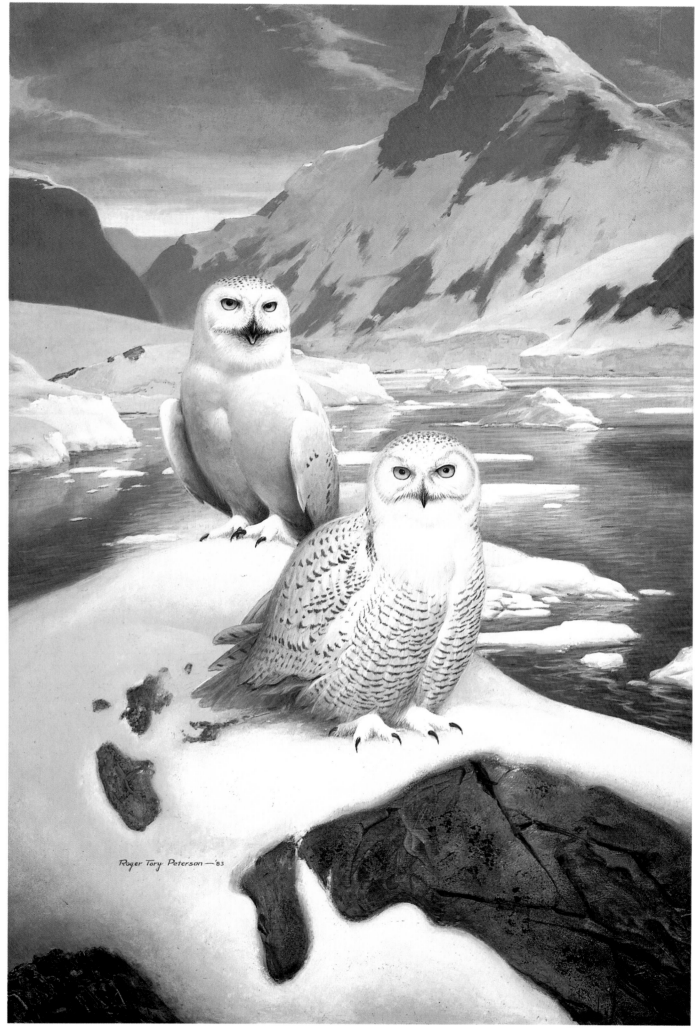

Arctic glow: snowy owls. Roger Tory Peterson. (Mill Pond Press)

about to become Director of the National Association of Audubon Societies. Baker invited Peterson to join the Audubon staff, which he did on 1 November 1934. His first job was to redesign the cover of *Bird-Lore*, predecessor of *Audubon* and edited by Peterson's friend, William Vogt. Employed as a designer and illustrator, Peterson worked on magazine features and changed the Audubon educational leaflets in order to make them understandable by children. He later became educational director of National Audubon and laid the foundation of the educational success of the Society.

Peterson's influence at Audubon lasted for many years after he left the staff. Peter Dunne in an article for *Bird Watcher's Digest* described the effect Peterson's work had a good 20 years after he first joined the Audubon staff. Dunne described himself as a 'scrawny kid who used to wait anxiously next to the mailbox in Roosevelt Avenue in Whippary, New Jersey. No zip code. They didn't have zip codes back then.

'He was waiting for the mail truck that was moving down the street, methodically stopping at each yard like a hummingbird going down a row of flowers. He was waiting for the manilla envelope with the bold blue label that read: *FROM:* NATIONAL AUDUBON SOCIETY; *FOR:* PETER J. DUNNE. Inside were leaflets, Junior Audubon Society leaflets all about different birds. They were ten cents each – if you ordered six, they were only five cents each. But even five cents each was tough on a budget of 35 cents a month, and it had taken a long time to get all the leaflets he had wanted . . .

'Each leaflet contained a color plate (which he called a picture) and a matching line drawing (to color in). And he read them – until there wasn't any need to anymore, because he had memorized them. They were written by a man named Roger T. Peterson.

'When he was 12, he had received a marvelous gift – a two-volume book about birds published by the National Geographic Society. Inside the book, *Song and Garden Birds*, was an essay by Roger Peterson entitled "What Bird is That?" It described the Peterson system for identifying birds. There were eight questions to ask when you wanted to identify a bird – and the boy memorized them too . . .

'But even that is a long time ago now; a distant point on a road that carried a surburban kid with an interest in birds to Cape May, New Jersey [where Peter Dunne is director of the bird observatory]. And all along the route was a man named Peterson. A man who had helped and guided a million young minds (just like his). The man who taught first one generation, then another and another, the skills they needed to learn about and enjoy the world they found around them – *Roger Tory Peterson.*'

Thousands, if not millions of birdwatchers could parallel Peter Dunne's experience, even if they have not managed to achieve Dunne's outstanding ability as a field ornithologist. When the 1984 New Jersey big birdwatching day was being set up, Peter Dunne, who never actually met Peterson, phoned the great man to ask him his opinion of the idea. Not only was Peterson enthusiastic, he actually asked if he could take part. And asked if he could be on Dunne's team. 'This' wrote Dunne, 'as we birdwatchers know, is a little like having the Pope ask whether he can come to church with you on Sunday.'

Such celebrity is easy to understand 50 years after Peterson joined Audubon. Back in the 1930s he was not quite so celebrated, but as we have seen he had a charismatic effect on the children he taught. He also attracted the attentions of some of the older naturalists

he met. Among these was a fellow counsellor at the Audubon Camp in Maine. This was Mildred Washington, a descendant of the first American president's uncle. They married in December 1936, but the marriage was not a success. Although interested in birds Mildred Peterson lacked her husband's almost obsessional interest and the marriage was dissolved in 1942. But Peterson is an attractive man and he married his colleague at Audubon, Barbara Coulter, curator of the photo library, in 1943. She was an excellent manager, who realised that there was potential in Peterson to achieve even more and with her help he would.

In 1943 Peterson was drafted and served in the Corps of Engineers until 1945. His experience at National Audubon was put to good use by the army: he was posted to a base near Washington, D.C., where

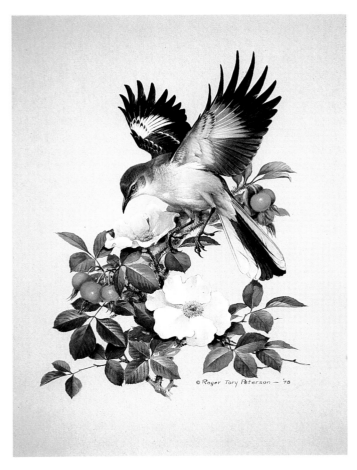

Mockingbird. Roger Tory Peterson (Mill Pond Press)

he worked on training manuals. He also developed aeroplane identification techniques based on his bird identification system. Barbara moved nearby and they set up home at Glen Echo, Maryland, where their two sons were born and where they lived for the next ten years.

At the end of the war Peterson embarked on a career as a writer. He was a good writer and wanted to help to form opinions about birds and conservation. His output included the semi-autobiographical *Birds over America* (1948) and many articles for *Audubon*, *Life*, *National Geographic* and *National Wildlife*. For *Life* he produced a dozen picture stories between 1938 and 1948 and these provoked a greater reader response than any feature outside the art section. At the same time he continued to paint and to lecture on behalf of the National Audubon Society. He also revised his field-guide, wrote another on Western birds and became editor of the whole of the Houghton Mifflin field-guide series. A trip that he made through America with James Fisher became immortalised in

one of the classics of bird literature, *Wild America*, published in 1955.

While some wildlife artists never use a camera, others are extremely talented photographers. Roger Tory Peterson is one of these. His first camera, a Primo Number 9, was bought with cash earned as a newspaper boy in Jamestown. Now, in his studio in Old Lyme, Connecticut, where he moved in 1955, he has over 100,000 transparencies of birds, taken on his travels throughout the world. In addition his transparencies are carried by international agencies in both the United States and Europe.

'Photography' he says, 'can be as much of a personal expression as painting, if the photographer is aware of the limitations of the camera and uses it in such a way that conveys exactly what he has in mind, the feeling he wishes to portray. It is basically a matter of seeing and then using the camera in such a way that the impression is captured – and in a moment in time. That is the important thing. A photograph is a permanent record of a bird at that given instant. A photograph can only freeze one aspect of the bird.'

For many years he has used photography both for reference and for the sheer joy of doing it. Indeed, at one point he became more enthusiastic about photography than about painting. 'I prefer photography to painting' he has said, 'I enjoy photography more. But I am an artist. Painting is sweat and blood – pleasure mixed with agony. It is extremely hard and demanding work. I find in photography a kind of relaxation. It has a kind of therapeutic effect on me. I enjoy it. Painting is so demanding. I do not do it easily. Furthermore, photography is not as confining as painting.'

Perhaps because he does not see himself primarily as a photographer, Peterson does not throw away transparencies that are not up to reproduction standard. A wrongly exposed transparency might not have much chance of publication but it can still be used as a reference. While he keeps his sub-standard photographs for reference, he only uses them to check detail: his most important source of reference remains his field sketches.

As painters of wildlife become successful, so their chances to travel increase. Probably no other wildlife artist, with the exception of Sir Peter Scott, has travelled as widely as Peterson. Indeed in 1974, he won the Explorer's Medal at the seventieth annual dinner of the Explorer's Club in New York 'in recognition of his being the world's most traveled ornithologist'.

The amount of travelling that he has done must have restricted the time that he could devote to painting. He is also much in demand as a speaker in the United States and is involved with numerous organisations. For someone who is as much of a perfectionist as Roger Tory Peterson it must be most frustrating. He is also sensitive to criticism and admits to uncertainty about whether he is an artist or an illustrator. There is the ghost of Fuertes, renowned as an illustrator but only just beginning to produce grand paintings when he died.

Peterson paintings start life as pencil sketches on tissue. Using tissue overlays he modifies the pictures before transferring them to drawing paper, ragboard or Masonite coated with three or four applications of gesso. He used to work mainly in transparent watercolours, building up tones in the traditional English fashion. To give body he sometimes used gouache. Then he discovered acrylics. 'You can do so many things with acrylics' he told Patricia Van Gelder, who featured him in her *Wildlife Artists at Work* (1982). 'They dry the same color as when wet. All my recent paintings have been in watercolor or gouache with a little acrylic. I might isolate a shadow with acrylic medium and then give it a glaze.'

Now in his seventies, but looking younger, Peterson is still at work painting, editing, writing and lecturing. He is apparently not naturally a well-organised person but has a talent for choosing wives who help to organise him. His third wife, Ginny, an attractive and talented person, makes up for his vagaries with a brisk charm, but when one talks to them there is a suspicion that Peterson's vagueness is perhaps more apparent than real. There is, however, no question but that the greatest of his millions of fans is his wife.

No doubt the birds themselves, were they capable, would be among his greatest fans too. Some people have suggested that the expansion of the last 50 years of the ranges of Northern American species, such as cardinal and tufted titmouse, are due to the spread of interest in birds stimulated by the Peterson field-guides. This interest has been manifested in the increase in garden bird feeding, which helped birds to exist further north in winter. That is a truly practical achievement for a bird artist. Perhaps it is an even greater honour than all the medals, awards and doctorates that Peterson has been awarded: it has come from the birds themselves – quite an award for the man who decided to become an artist rather than a biologist.

RIEN POORTVLIET

G nomes are a rare subject for wildlife artists but Dutch artist, Rien Poortvliet, has illustrated a book of them. He has also illustrated horses, dogs and the Bible. This imaginative, somewhat mystical, painter is someone who has a great love and respect for animals. He has no feeling of superiority to animals and this refusal to look down metaphorically on them is extended to his painting. As an artist he feels that he should not physically look down from human heights: he is prepared to get down to the

Wild boar. Rien Poortvliet. (Uitgeversmaatschappij J.H. Kok B.V.)

animals' level so that he adopts the same perspective. For him, the artist should 'be a cousin, a brother of the rabbit, the fox, the roe'. Just as the gnomes might.

Poortvliet is a very positive man, emphatic about his lack of training and indeed very proud of it. 'Not even one hour at drawing school' he says. Like several artists in this book he is completely without formal training, his ability and desire to draw animals fuelled by twin enthusiasms for art and nature. There was no artistic influence in his family to guide him and he attributes his ability to the 'inspiration of God's creation' combined with an instinctive, God-given talent and knowledge and appreciation of animals and the way they live.

He claims to be able to draw an animal from any perspective, even if he has never seen that animal from all angles. This is because of his enthusiasm and instinctive affinity for animals. If a subject does not interest him he is incapable of drawing it. He reckons that he couldn't draw the dashboard of his car to save his life.

Touch is important to Poortvliet as a painter. He often uses the heads of mammals as models and finds that touching them gives him a great deal of information. This may account for the predatory expression in his carnivores and the aura of prey about his paintings of hares and other prey species. In his dramatic oil painting of a fox chasing a hare the intent shows clearly in the fox's eyes and the search for safety is clear in the hare's. The blurring of the limbs to give a feeling of speed accentuates the steadiness in the eyes of the predator whose whole being is taut with intent. It is not surprising that Poortvliet has great respect for Bruno Liljefors, the master of predator–prey relationship. The Dutchman's approach is somewhat different in that, while Liljefors painted the facts that he saw, Poortvliet romanticises the scene.

Poortvliet's interest began at the age of six in 1938 when he used to sit on the stairs of his parents' house to wait for the house mouse to come by in the evening. Now he lives and works at Soest, ten kilometres north-east of Utrecht, surrounded by forest and forest

animals. He is also surrounded by his four dogs which are the only living creatures allowed into his studio when he is working. 'I like working,' he says, painting to the music of Johannes Sebastian Bach, 'I hate to be disturbed'. People are kept out when he is busy. He is so committed to his work that he paints seven days a week and his wife has to make him promise to take real holidays.

Fox and hare. Rien Poortvliet. (Uitgeversmaatschappij J.H. Kok B.V.)

JOHN REANEY

On the walls of a gallery alongside bright, romanticised studies in watercolour and gouache, John Reaney's pastel drawings could easily be overlooked. In so many pictures the wildlife dominates the environment, but not in John Reaney's.

At a glance almost every one might be described as 'just another landscape' until examination shows that among the mounds of spread hay in the twilight meadow are two badgers nuzzling after insects.

A bachelor in his forties, Reaney is a shy person who

Pheasants. John Reaney. (Brotherton Gallery)

lives in an Edwardian terrace in Brighton with his mother and a cat, one of whose predecessors appears as a whimsical suffix to the artist's signature. Reaney's fondness for cats may be accounted for by a shared preference for the night. He is a creature of the night and many of his drawings show nocturnal scenes. Another favourite subject is late evening as mammals begin to forage and owls come out to hunt.

There is no obvious clue in Reaney's work that he spent 18 years as a draughtsman in the electronics industry. Frequently artists who have spent years at the drawing board doing architectural or technical drawings are left with a legacy of detail, forcing them to define too clearly their subjects. Perhaps his use of pastels has prevented Reaney from falling into this trap. His subjects lack definition so that they melt into the twilight or shadows as they do so often when seen in life. Nevertheless, he feels that the precision needed for drawing printed circuits was good practise 'even if it was the most uncreative sort of drawing'. During his time as a draughtsman he spent three years at art evening classes and drew landscapes, wildlife and farming scenes, experimenting with various media before settling for pastels.

His draughtsman's precision and neatness are shown in his sketch-books. These are crammed with studies of mammals and birds as well as details of landscape – trees, gates, hedges which might be used in a finished drawing. Even though the wildlife in his drawings is rarely shown very large he does think it is important to capture the 'jizz' of an animal and he can successfully show in his drawings the difference between the lope of a fox and the scuttle of a badger. An important aid to him in this is the use of his own 8mm films, taken for the purpose of recording movement, so that he can play the films through an editor as slowly as he wishes to capture movement.

Throughout his sketch-books there are notes about colour, shade and light. He feels that these are vital to capture atmosphere, because that is the element that so many viewers of his pictures enjoy. In looking at a Reaney there is a real feeling of sharing an experience. Because it is so easy to lose the feeling of atmosphere, he likes to produce the finished drawing as soon as possible after making the sketches. After three days he feels the experience becomes stale. It is hardly surprising that among his favourite artists are the Impressionists, particularly Claude Monet.

Despite being a retiring person and someone who does not enjoy socialising Reaney does like to discuss his drawings with other people, relying on them for criticism and encouragement. It was thanks to the prodding of friends among the birders in Sussex that he eventually made the step from a safe job to become a freelance artist. This happened on 2 February 1976 and the fact that he recalls the date so accurately emphasises the moment of the occasion. It was in a way a brave decision, because his style is not ideal for most illustration work, although he has produced some very good watercolour illustrations. This has meant that he must rely on drawing pictures and selling them. It also means little of his work has been published.

Reaney only draws subjects he knows so that most of his work has Sussex subjects, but recently he has travelled more widely. For example he was commissioned by the Royal Society for the Protection of Birds to produce a set of six calendar plates depicting some of the Society's nature reserves throughout Britain: these were re-used with great success in the book *RSPB Nature Reserves* (1983). In recent years he has travelled to Spain, the Camargue and Botswana, which presented him with subjects very different from the gentle Sussex countryside. It is clear from his foreign drawings that he has an ability to catch the atmosphere of very different landscapes and to understand the subtle relationship between the landscape and its animals.

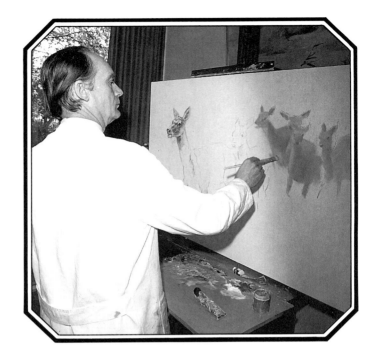

MANFRED SCHATZ

From his paintings it is clear that Manfred Schatz is among the most painterly of wildlife artists. To him art is of primary importance. And yet there is little in the appearance of this gentle, softly-spoken man to suggest he is one of the most exciting painters of wildlife working today. Slight, neatly groomed and conservatively dressed, Schatz lives in Meerbusch, a comfortable suburb of Düsseldorf alongside lawyers, accountants and other professionals.

Schatz's painting is a form of Impressionism. 'I try to paint only what the human eye can catch' he says. Exact representation, he believes, should be left to the photographer. It is the moment that he aims to catch, which means that the detail can get lost and the contours become blurred. Thus in his paintings of

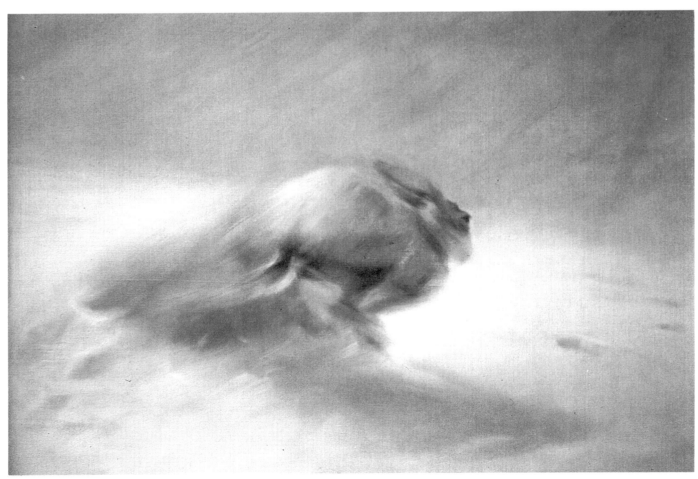

Hare. Manfred Schatz

mallard rising from the water, where he is showing a split second, there is no chance to capture details of the eye or the feathers. All that is left is a fleeting moment, a memory.

It is the recognition of these captured moments that attracts the eye of people who know the excitement of seeing animals in the field. The accurately detailed paintings of animals produced by other artists very often appeal to people who have no real idea of how the animal looks in the wild. Schatz is able to share his enthusiasm for the experience of seeing an animal, not just for the animal itself. This sharing of excitement has the bonus of communicating ideas. Arne Axelsson, director of the Skanes Djurpark in Höör, Sweden, is sure that this is good for conservation. 'I have great admiration' he says, 'for the works of Mr Schatz, especially in his major contribution to those species threatened by extinction. Schatz has achieved something not achieved by anyone before. When I look at his lynx or wolf paintings, I see that no other artist has presented these species so convincingly for us or for posterity. Through his work, Schatz reminds the world of the threat to near extinct species. His work talks with each stroke of the brush more than words ever can. He is one of the greatest living artists

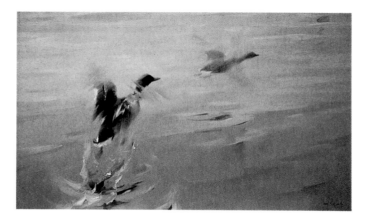

Mallard rising. Manfred Schatz

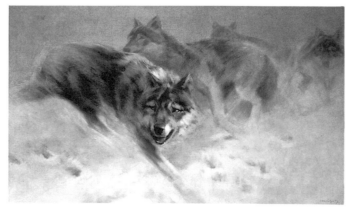

Wolves. Manfred Schatz

Mallard landing. Manfred Schatz

of our time.'

From the age of twelve Schatz dreamed of being an artist; but it was not until he went to the National Academy of Arts five years later that his teacher, Professor Ulrich, having seen some of his drawings made at a circus, suggested that Schatz specialised in animals.

Schatz was amazed because he had always planned to work on figurative and portrait painting. He was born in 1925 in Bad Stepnitz, which was then in eastern Germany and is today in Poland. His father was a portrait painter. Although the youngest student ever accepted by the prestigious National Academy of Arts, Schatz did not have much opportunity to

practice his painting. There was a war on and he was conscripted into the Wehrmacht and after basic training found himself on the Russian front. He was captured there and spent the next four and a half years in a prison camp in Russia, living in the most appalling conditions: he had only two hot meals during his imprisonment. Conditions were harsh and the regime was brutal. When one of the drawings that Schatz made in the camp was found by a Russian officer, he thought he would be severely punished. But the officer was impressed by the quality of the drawing and asked him to copy an illustration from a book on hunting. Other officers asked for copies and he eventually painted the illustration 26 times. It was

looking at the work of Russian painters of animals that inspired Schatz to begin to develop his free, rather Impressionistic style.

By the time he was repatriated from Russia in the autumn of 1949 Schatz was suffering badly from tuberculosis. During treatment for this, he again met Ilse Kray, a technical translator from Düsseldorf. They had known each other before he joined the army and in 1950 they married. Later, when Schatz was recuperating from tuberculosis, he visited his brother who was chief warden of a large hunting preserve in northern Germany. It was there that he began to paint animals seriously. 'On my first day there' he told Mark Wexler in an interview for *International Wildlife*,

'my brother took me on his rounds and I remember seeing a flock of mallards flying up out of a pond. After all those years of confinement the sight of so many birds was so moving that I was hypnotised. I couldn't raise a pencil to sketch them.'

Since then Schatz has been a painter of animals, working hard and constantly reappraising his work. It seems that painting is an almost sacred duty to him. He feels that the work of an artist reflects his soul, developed through knowledge and with years of perseverance. His success, he believes, is due to his carefully trained eye combined with the dexterity and skill that he has developed over the years. Still he spends at least three months in the field and makes

winter trips in search of mammals such as wolves and moose. Snow fascinates him and he has spent hours looking at it in different lights and conditions. He also makes field sketches of snow in colour. Look carefully at the snow Schatz paints and you will find that he has used very little white paint.

In Germany Manfred Schatz is recognised as the country's leading animal painter. He has been honoured by his government, has been the subject of television programmes and was described by the magazine, *Die Welt*, as the 'greatest living animal painter'. He has had many exhibitions and has contributed to many more. He was among exhibitors from 28 countries and won a gold medal for a painting of a lynx at the Interfauna Exhibition in Düsseldorf in 1968. His fame has also gone beyond Germany; at the 1975 Animals in Art Exhibition at the Royal Ontario Museum in Toronto he was proclaimed the 'most important painter of living animals'.

Despite all this success and his high reputation he still works and is self-critical, ever striving to paint better. To do anything less would not be either in his nature or part of his philosophy because it would be a betrayal. 'Art is the greatest, most precious expression of feeling' he says. 'It is the visible expression of the artist's mind.'

SIR PETER SCOTT

Had Sir Peter Scott not been so good at so much more than painting his reputation as an artist might have been much higher. Instead, Scott the painter seems to have been undervalued by both critics and naturalists. The extent of Sir Peter's contribution to nature conservation is undeniable. It was he who, in the post-war years, did so much to make an interest in wildlife acceptable in Britain through his broadcasting and who was one of the leaders of the international conservation movement in the 1960s and 1970s. We must remember that it was because of his renown as an artist that he first came to public attention.

Few other Englishmen in the twentieth century have encompassed so many varied talents. No doubt he was helped by being the son of Antarctic hero, Captain Robert Falcon Scott and the sculptress, Kathleen Bruce. He may not have been born with a silver spoon in his mouth, but one suspects that there may have been a silver visiting card in the pocket of his romper suit. His social connections were undoubtedly good. Captain Scott, who died just short of the South Pole in 1911, when his son was two, became a national hero. Mrs Scott was a fashionable sculptress and among her commissions was the statue of Peter Pan in Kensington Gardens. In his autobiography Sir Peter writes of his playing as a small child with the sons of the Chancellor of the Exchequer and describes visiting his godfather, Sir James Barrie, the playwright.

To these family connections must be added Sir Peter's talents and his ambition. Drawing and animals were two of his earliest enthusiasms and when he went to Oundle School in the early 1920s both were encouraged. The headmaster, Kenneth Fisher, father of James Fisher, the most erudite of popularisers of ornithology, was himself a keen amateur ornithologist. At Cambridge the young Scott became a very serious wildfowler and like Neolithic cave-painters he made pictures of his quarry. His first published pictures were simple watercolours in *Country Life* in August 1929. 'They were', he wrote

more than 30 years later, 'rather simple watercolours of wild geese, reproduced in monochrome and accompanied by a bloodthirsty little article, of which I am not very proud, describing my wildfowling adventures. The birds were poorly drawn and I had as yet no idea of how to make the air support them; they were simply stuck on the sky. But the compositions were quite pleasant and already I had begun to understand that the movement of birds through the air could be more easily suggested by the pattern of the flock than by the shape of individuals.'

His first exhibition of between a dozen and twenty watercolours of duck, geese and snipe had been held at Bowes and Bowes in Cambridge. These paintings stemmed directly from the wildfowling urge. In *The Eye of the Wind* (1961) Sir Peter writes: 'But now I found a new delight in painting birds I spent so much time in pursuing. My pleasure was to recreate the tense excitement that I felt when I was out on a marsh, recapture some of it each time that I looked at the picture, and convey some of it with those who had shared the experience. If those who had never seen the birds flighting at dawn and dusk and under the moon also happened to like the pictures, that was purely incidental and of no significance to me. Basically I was painting on the roof of my cave just as the Cro-Magnon hunters had painted their quarry on theirs. Perhaps, like them, I was seeking some kind of magic which could be exploited to bring wildfowling success if the paintings were good enough.' This emotional commitment is what sets apart the pre-war Scott paintings of wildfowl from several inferior imitators.

While at university his paintings were watercolour but he admits to finding it a very difficult technique. He found oils simpler because of the build-up of body colour that is the normal part of the process of painting in oils. In 1930 he made the decision to earn his living as a painter and on coming down from Cambridge he went to the State Academy School in Munich followed by a two-year spell at the Royal Academy

Honkers coming into winter floods. Sir Peter Scott. (Mill Pond Press)

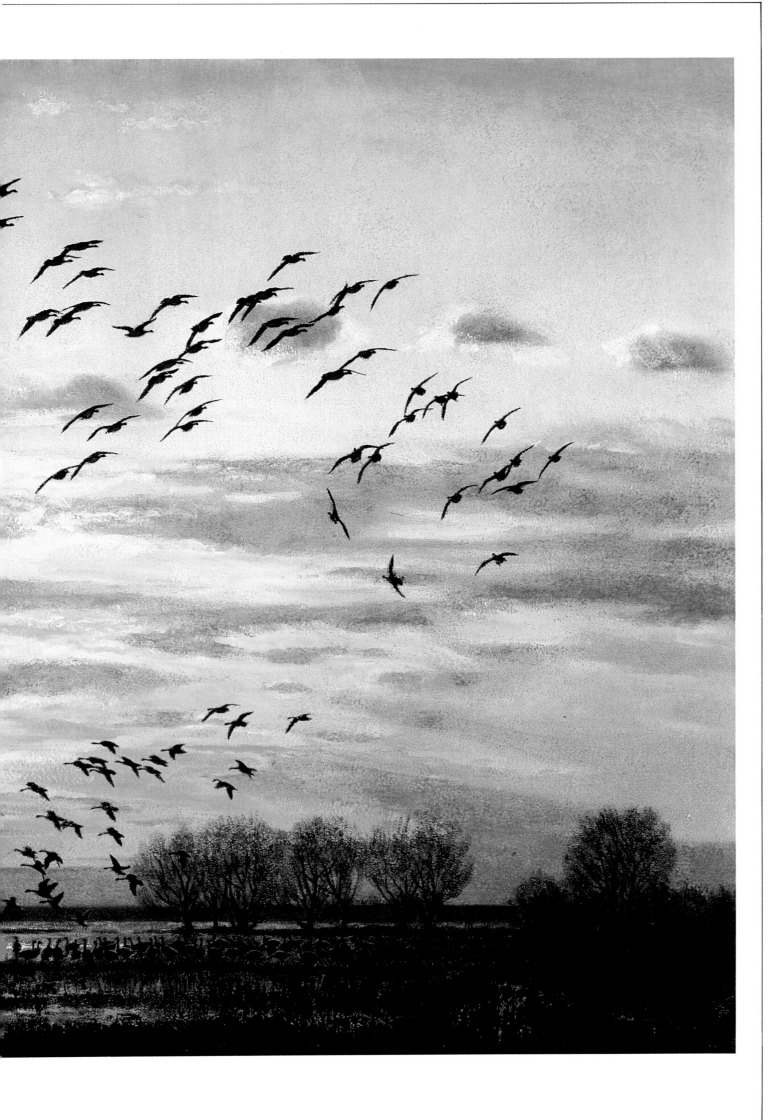

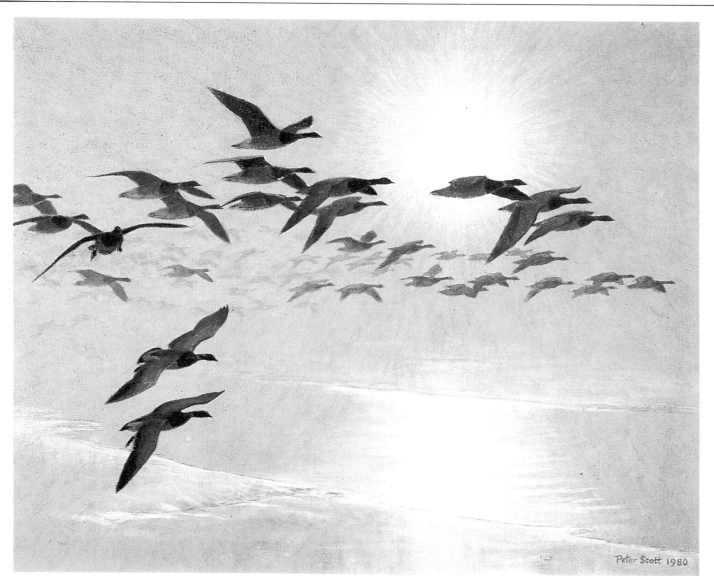

Brants in the morning mist. Sir Peter Scott. (Mill Pond Press)

Schools in London. His painting was approached with single-mindedness. He wanted to learn to paint in order to portray his beloved geese better and the experience of meeting other art students was not a total success. Nevertheless in *The Eye of the Wind* he wrote: 'One or two of them [fellow students at the Royal Academy Schools] are famous, not necessarily the expected ones, but there were young artists of staggering promise whose names I have not heard of since. At the time it was vastly discouraging to find so many who were so much better at it than I. This may be true in any school, but in an art school it seems more significant because inborn talent seems more than ever important. But the two years were, on the whole, more stimulating than discouraging.'

Once his academic training had finished he had to make a living as an artist. He decided to go to live at the Borough Fen Decoy in Northamptonshire. 'I was likely, I thought, to paint best there things which moved me most. That meant my wildfowl. They had never been painted in the way I saw them. The great Swedish painter, Bruno Liljefors, also a hunter, had come closest to it; but even he did not know them quite as I knew them. Frank Southgate, a Norfolk watercolourist of some distinction, who had died in the First War, had come some of the way from the conventional painters in the direction I wanted to go. For the rest, they had been trying to do something different. Old Archibald Thorburn, who painted feathers of birds with exquisite truth (and may, in that field, never be surpassed), had come to Leinster Corner . . . to criticise my drawings of birds and deer.

His advice had been wise and useful at the time, but it was not his road that I now wanted to extend into the jungle. What I wanted to do was extraordinarily simple and easy. I had only to put on the canvas to the best of my oil painting capacity the birds as I had seen them at dawn or dusk or moonlight, or in storm or frost or snow, and I could not fail to be doing something original. It remained to be seen whether those who looked at the pictures would be moved in the same way as I was when I watched the flight of the wild geese, and heard their music.'

These quotations again demonstrate the very strong emotional content of Peter Scott's pre-war painting. He was not scientifically or coldly recording on canvas the behaviour of wildfowl. He was rather recording experiences, no two of which were the same, except in that he was moved by seeing and hearing wildfowl. Light and weather were obviously two very strong influences and helped to give each painting individuality. His flying ducks and geese must sometimes be identified from their shapes and flight patterns because the light is such that their colours and wing markings are obscured: to do this successfully an artist really must know just how the birds look in the particular light he is showing.

These were points missed by contemporary critics, perhaps because the only experience of wildfowl for most of them was walking through St James's Park. From a commercial point of view it really did not matter what the critics thought: there were plenty of other enthusiasts for these paintings of wildfowl. Each summer from 1933 to 1939 Ackerman's Gallery in

London's Bond Street held annual exhibitions of about 40 Peter Scott paintings. These shows were usually opened by a celebrity and visited by royalty. He also exhibited at the Royal Academy Summer Exhibition in 1933. After this some of his paintings were hung annually but some that he knew were better than the 1933 paintings were rejected. Perhaps the lack of critical approval communicated itself to the Hanging Committees. Or perhaps Peter Scott was becoming too successful and too popular.

During the 1930s there were 31 limited editions of Peter Scott prints sold by Ackerman's. One print published by the Medici Society sold more than 350,000 copies. The original painting for this was commissioned by Sir John Beale of Oulton Broad in Norfolk. He wanted a canvas eight feet broad by five feet deep. Indeed it was about four times bigger than any picture the young artist had done before. When one day Sir John announced that he would visit Scott's studio the next week to see how the painting was progressing, the canvas was still untouched. Within the week the painting, showing a flight of shovelers and a pair of garganey springing from a reed-bed, was almost complete, but the artist's mother had to help out with some of the reeds. The picture was used by the Medici Society for a print entitled 'Taking to Wing'.

This painting was also used as an illustration in *Morning Flight*, Peter Scott's first book. This was first published as a signed limited edition of 750 copies in October 1935, to be followed by the first ordinary edition six months later. By 1942 it had reached a sixth impression. Among the other illustrations was a delightful oil painting of three tufted drakes, one of which has just emerged from a dive and the disturbed water surface is cleverly depicted with a palette knife technique. But it was Scott's ability to capture the effects of skies that attracted attention and the illustration in *Morning Flight* of pink-footed geese flying in from Holkham Fresh Marsh demonstrates this. Perhaps it was this picture that drew from Francis Lee Jaques the tribute to Sir Peter Scott's ability to paint birds against a sky.

The illustrations in *Morning Flight* show a range of techniques from realistic bird portraiture to almost abstract paintings that might have been used for textile design. They emphasise the deep feeling of the artist for his subjects. The earlier work painted at Borough Fen was, in the artist's retrospective assessment, crude and hasty. When, in 1933, Scott moved to a lighthouse on the Wash his work became more considered, but perhaps because of this there was a danger of it losing vigour. He discovered that he could ruin a painting by working too long on it. 'Working fast', he wrote later, 'was the secret of quality as well as quantity. But I was also brimming over with new ideas. I could not wait until one picture was finished before starting the next, and I soon found this was in fact a practical method; the first stage of one picture could be drying while the next was started. It also gave the chance to adjust my work to my mood. If I was feeling creative I could start on a blank canvas, if not, I could go quietly on with the chores – putting on a large area of blue sky, or laboriously painting up flocks of birds whose shapes and patterns I had already determined.'

Scott relied on his memory rather than field sketches or painting in the field. 'I had in my mind a conception of what had stirred me when I had seen it on the marshes. The picture became a mixture between this image which I could still dimly see and the chosen subject expressed in words. By this I mean that the completed work was in part a direct visual translation of what I had seen and in part an indirect, almost literary translation of what I imagined it ought to look like. The preponderance of one influence over the other varied from picture to picture.'

This was the technique used to paint some of his experiences as an officer in the Royal Naval Volunteer Reserve during the war. These paintings were not part of his naval duties; he was a naval officer, not an official war artist, but his skill and reputation as an artist did lead him to become involved in schemes for the camouflage of warships. In a BBC television series on artists and war Sir Peter, who had patently been a first-class naval officer with three mentions in dispatches, an MBE and a DSC and bar to his credit, clearly stated his abhorrence of war. Nevertheless he had become one of the heroes of the public and was one of the commentators for BBC radio on the Victory Procession in 1945. His broadcasting career was to blossom in the next decades.

When he became a serving naval officer, he had been on the brink of branching out into new fields of painting. 'I had been planning vast ambitious canvases, allegorical works, abstractions, goodness knows what. I wanted only to return to the old things, to "get back to normal", to recapture the happy pre-war life. I was keen to paint birds again in no particularly new way, but rather to revert to the precise point at which I had broken off and from there set out again; it was the manifestation of my safe return.' He was also painting portraits and in 1947 he made portrait drawings at Buckingham Palace of Princess Elizabeth and Princess Margaret.

His post-war activities also included sailing. In 1946 he won the Prince of Wales Cup for international 14-foot dinghies: he had won it twice before the war as well as winning a bronze medal for Great Britain for single-handed sailing in the 1936 Olympics. As well as participating he also took part in the administration of the sport: he was appointed chairman of the Yacht Racing Association Olympic Committee and found himself responsible for organising the sailing events for the Olympics held in Britain in 1948. He continued to take an active part in sailing and was involved in the Olympics in Australia (1956), Italy (1960) and Japan (1964). For 14 years from 1955–69 he was President of the International Yacht Racing Union.

After the war he learned to fly and gained his pilot's licence. He took up gliding, became national gliding champion in 1963 and was chairman of the British Gliding Association.

While managing to achieve these successes he also began to make his enormous contribution to conservation, both nationally and internationally. First he established in 1946 the Severn Wildfowl Trust at Slimbridge on the Severn Estuary in Gloucestershire. Here he was able to realise his war-time dream of a new collection of wildfowl on which could be based the scientific and educational effort needed for the conservation of wildfowl. Development of the Wildfowl Trust led to expeditions to the Canadian Arctic and Iceland. During the same period his career as a broadcaster was developing. With such a full life it seems amazing that time was left for painting, but one of Peter Scott's talents is organisation and he organised his time to allow for painting.

It was birds in flight that made Sir Peter Scott's reputation – landscapes with birds in which his talent for showing the effects of light was clearly demonstrated. In the 1950s he painted many canvases of ducks on water. There were usually groups of birds, well composed and showing his ability with light

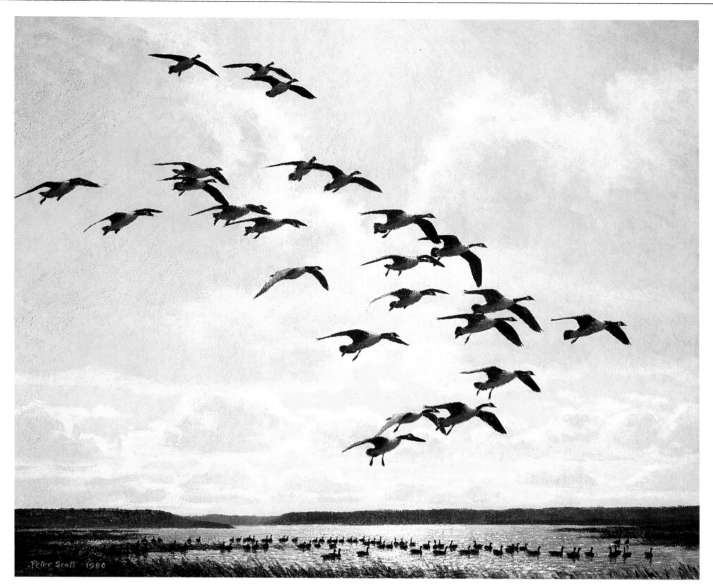

Canada Geese. Sir Peter Scott. (Mill Pond Press)

effects. These birds were convincing, solid creatures that really did displace the water. If only Archibald Thorburn had lived to see these paintings, he might have looked again at ducks and learned how they look when they are in the water.

His understanding of form has enabled Peter Scott to do some very impressive line drawings. One of these has become one of the most famous symbols in the world. This is the panda symbol of the World Wildlife Fund. Scott had become involved in the 1950s with the International Union for the Conservation of Nature and Natural Resources. In 1962, on his way back to England from a meeting of the IUCN Survival Service Commission in Switzerland, in discussion with E.M. Nicholson, then Director-General of the Nature Conservancy (the United Kingdom government conservation agency), the idea of a professional international organisation to raise funds for conservation was discussed. This was the beginning of the World Wildlife Fund.

International conservation and in particular the WWF took up a great deal of Peter Scott's time in the 1960s and 1970s and without a doubt his eloquence has played a large role in changed public and governmental attitudes. In 1973 he was knighted for his services to conservation. Even so he continued to find time for painting. Often these paintings had direct links with conservation projects in which he was involved – nenes flying above the slopes of the Hawaiian volcano, Mauna Loa, where they had been reintroduced under a Wildfowl Trust scheme, or brent

geese at Foulness, threatened for a time as a possible site for a third London Airport. In the 1970s there were also some spectacular large canvases of flocks of geese receding into the misty distance. Although wildfowl still figured largely in Scott paintings, subjects included other birds and mammals.

Skin-diving on a trip to the Great Barrier Reef in 1956 introduced Sir Peter and Lady Scott to the beauty of coral fish. 'For a part of these three days I have been in a new world' he wrote in his diary on 25 December 1956. 'Nothing I have done in natural history in all my life has stirred me quite so sharply as my first experience of skin-diving on a coral reef.' After this scuba-diving became an important part of their travelling. On the way back from Antarctica they went snorkelling among the humpback whales off the Hawaiian island of Maui. This resulted in an oil painting showing both Sir Peter and Lady Scott swimming, unafraid and quite safe, among these huge mammals. It is rare that a wildlife artist has the opportunity to show his involvement with his subject to the extent of being able to show himself in a picture with his subjects.

Without a doubt Peter Scott's paintings show a deep emotional involvement with his subjects. Sometimes the pictures may not succeed, but when they do they really communicate the beauty and excitement of nature. To have that talent as well as to achieve so much in so many fields is a very rare gift indeed. To have made so much of that gift is even rarer.

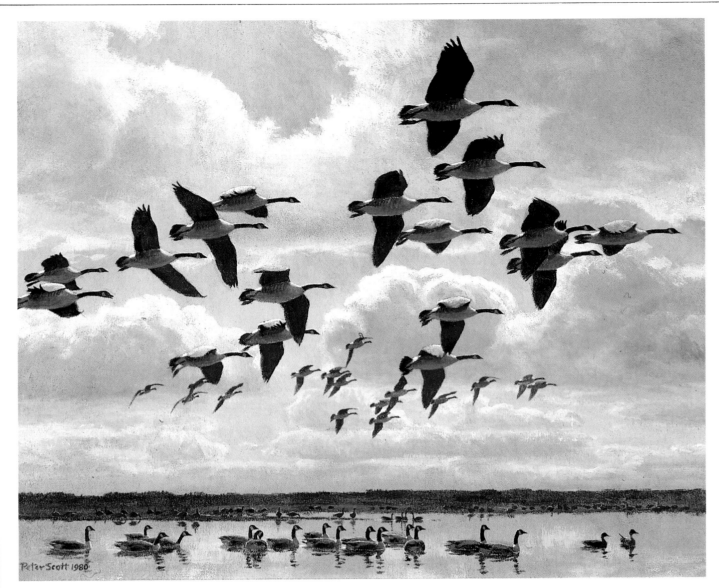

Honkers against a cumulus sky. Sir Peter Scott. (Mill Pond Press)

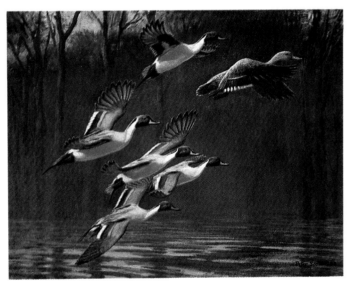

Pintails. Sir Peter Scott. (Mill Pond Press)

ALLEN W. SEABY

Allen W. Seaby's story is a classic tale of Victorian self-improvement. He was born in 1867, the son of a craftsman and died in 1953, having been Professor of Fine Art at Reading University. His father, Augustin Seaby was a cabinet maker and carpenter in London, but he was asthmatic and moved, on medical advice, from Victorian London fogs to the small Surrey town of Godalming. It proved a lucky move for Seaby who, as a consequence, grew up in the Surrey countryside and went to the Godalming Board School, where at the age of 14 he became a pupil-teacher. His schoolmaster recognised his talent both as a draughtsman and as a teacher and encouraged him to become qualified. At 17 Seaby won a scholarship to the Borough Road Training College in Isleworth, then part of rural Middlesex rather than metropolitan London. Two years later he qualified and took a teaching position in Reading.

The remainder of his long life centred on Reading. He attended evening classes at the Reading School of Art, where his results in the examinations of the Department of Science and Art were excellent. The Art School became part of the University College of Reading and Seaby continued as a student until 1899 when he became a member of staff under F. Morley Fletcher. It was Morley Fletcher who pioneered the use of Japanese wood-cut printing in Britain around the turn of the century. Seaby, too, became an expert print-maker and one of his prints was used on the cover of *The Studio* in 1927. His grandson, Robert Gillmor, who used to watch him at work, describes colour wood-cut printing as 'a calm process, a lovely process to watch'. The wood-cuts were made from cherry-wood blocks and were printed with watercolour paints mixed with rice paste. The depth of colour was varied by the intensity of the paint on the block. Rice paper was then laid on the block and then pressed on to it with a burren (round rubbing pad) covered with a hard, slightly ridged, bamboo leaf. No two prints were identical. Seaby's prints were

characterised by great economy of line, a trait emulated by Robert Gillmor in his own lino-cut prints. Seaby exhibited prints in London, Los Angeles, New York and Milan where, in 1906, he won a Gold Medal.

In 1910 Seaby took over from Morley Fletcher as Head of the Reading School of Art and when the University College became a University in 1926, he became Professor of Fine Art.

At a time when it was the norm for painters of wildlife to base their work on skins, Seaby, who was a good field naturalist, would draw from life. His sketches were made with charcoal or carbon pencil and most of his paintings were watercolours. An admirer of Joseph Crawhall (1860–1913), he followed the Scotsman's technique of painting with watercolour on Holland linen. Crawhall apparently took to using linen on an occasion when he could find no paper. Seaby's linen was a natural brown Holland that became taut when dampened and added texture to the finished painting. In a letter to his friend, Paul Stride, Seaby described the method as allowing 'one to use something of the strength of oil paint without its difficulty of handling'.

Another Glasgow School artist with whom Seaby corresponded was Edwin Alexander (1870–1926). They met in Edinburgh before the First World War. Seaby was always keen to learn about other artist's techniques and was recommended by Alexander to paint on the grey paper used as a carpet underlay. It is very porous and allows the watercolour to sink into it. 'Also the grey tone gives one a start, so to speak' he wrote to Paul Stride. 'The theory is that tones lower than that of the paper can be washed in transparently and highlights put in body colour or any tones lighter than the paper.'

In Kirkman's 12-volume *British Birds* (1910–13) 135 of the coloured plates are by Seaby and are among the liveliest in the book. Each bird is full of life and Seaby manages to give a very good indication of its habitat by use of typical plants. He also drew pen and ink

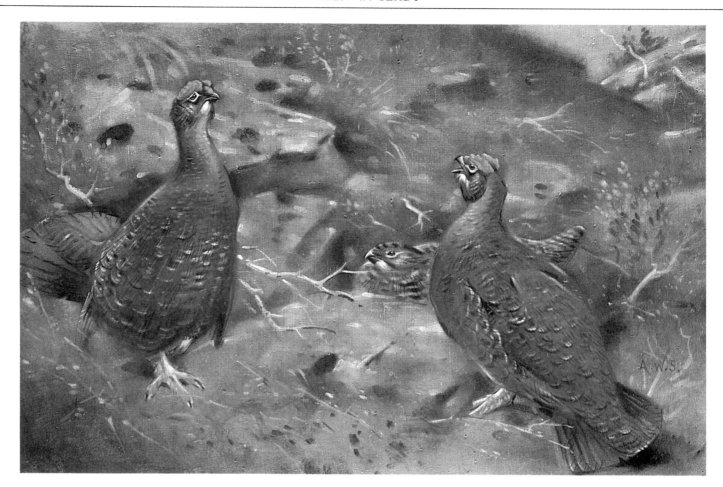

Red grouse. A.W. Seaby. (William Marler Gallery)

sketches for the *English Year* books by Beach Thomas. Despite his personal interest in natural history Seaby was never really part of the small world of British ornithology at the time. He probably never even considered himself a wildlife artist.

As an artist and teacher he wrote three books for students including *Art in the Life of Mankind* (1923) as well as stories for children. He was a founder member of the Graver-Printers in Colour and the Colour Print Society. After his retirement from Reading University

in 1933, Seaby continued to paint and make prints. Robert Gillmor recalls going out for walks with him and identifying bird calls that were beyond his ageing grandfather's hearing. Gillmor would also sit in his grandfather's studio, painting and watching with fascination as Seaby made wood-cut prints.

At the time of Seaby's death in 1953, Gillmor had had his first illustration work published and was about to follow in his grandfather's footsteps to Reading University Fine Art Department.

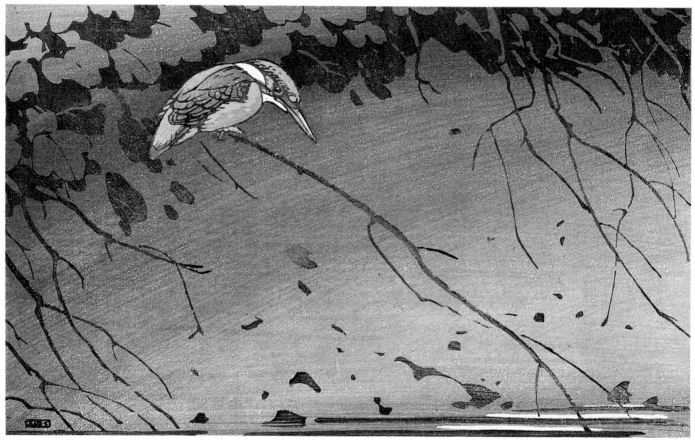

Kingfisher. A.W. Seaby. (Robert Gillmor)

KEITH SHACKLETON

It was as a dinghy sailor that I first became aware of Keith Shackleton. He crewed the winning dinghy four times in the prestigious Prince of Wales Cup in the 1950s. This cup was raced for by International Fourteens, the aristocrats of British sailing dinghies, designed by Uffa Fox and sailed with great success by Peter Scott before the Second World War. I was a teenager with the twin enthusiasms of birds and boats when I saw Shackleton in the Prince of Wales and the handsome blond bird artist became an instant hero for me. Not only could he win dinghy races but his paintings appeared regularly in *Yachting World*.

Several years later, as an editor, I commissioned Shackleton to paint a cover for *Birds*. The subject he chose was gannets. His painting showed two gannets from above, their bodies filling the frame, the wings cut off by the sides. As a cover design it was first-class,

striking and unusual, with a feeling of height as one looked beyond the gannets down to the sea. One of my colleagues pointed out that the gannet whose tail could be clearly seen, had only nine tail feathers and he suggested that no doubt some purist would point out that this was not enough. Sure enough, when we checked, we discovered that the full complement was 12 tail feathers. Tentatively I mentioned the possibility of problems with the pedants. Shackleton's reply was that birds lose feathers and certainly not every gannet one sees has 12 tail feathers. He told me to assure any critics that while he might not have painted 12 feathers, he did paint 12 follicles from which they could grow. He later told me that he looked at photographs which showed gannets with every number of tail feathers between one and 12.

Having learned from this painting that birds need not always be shown in perfect detail I also learned that

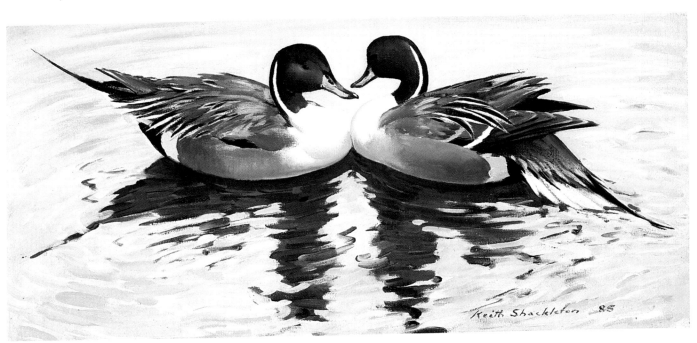

Pintails. Keith Shackleton. (Mill Pond Press)

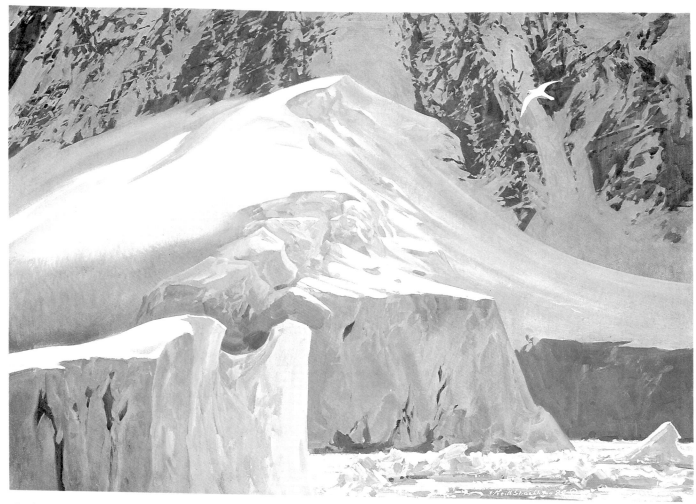

On the Graham Coast: snow petrel. Keith Shackleton. (Mill Pond Press)

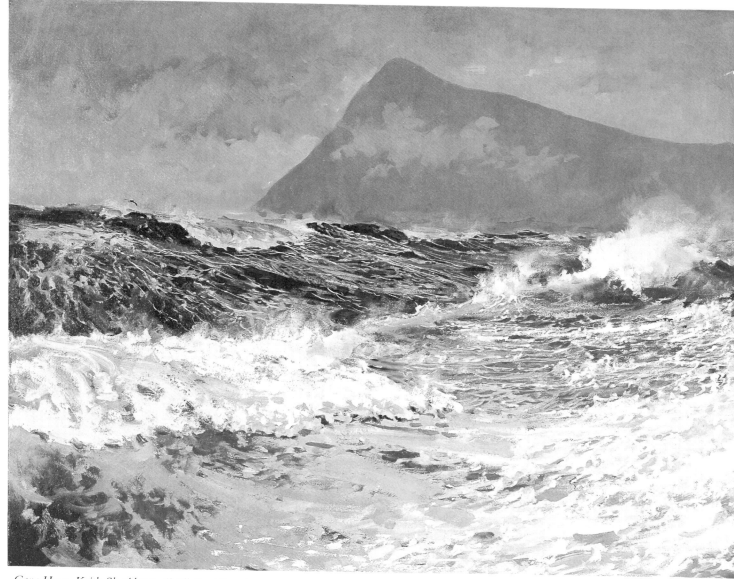

Cape Horn. Keith Shackleton. (Mill Pond Press)

Shackleton was a master of painting the sea. His large oil paintings of towering seas above which flies a tiny petrel are magnificent. As a keen sailor he knows the sea well and is particularly fond of sea birds and marine mammals. The sea can also be a distraction from painting. Although he has a cottage in Sussex at Chichester Harbour, most of his work is painted in his London studio. This studio is the top storey of his house in a smart London square. Here he can live an ordered life free from the distractions of Chichester Harbour with its boats and birds and beachcombing.

Born in Weybridge in 1923, he went to Melbourne, Australia, with his family before returning to school in England. The school chosen for him was Oundle, a public school that had among its old boys, Peter Scott and a headmaster, Kenneth Fisher, who encouraged Shackleton's interest in drawing and natural history. The headmaster's son was James Fisher who became famous in the years after the war as an ornithologist who, through broadcasting, writing and publishing (he was natural history editor of Collins) did a great deal to promote an interest in birds in post-war Britain. In his last years at school Shackleton met Peter Scott, 14 years his senior and already achieving celebrity as a bird artist. Peter Scott encouraged him as both a birdwatcher and a painter.

I have heard Keith Shackleton dismissed as a 'pale shadow of Peter Scott', a gibe that may have been true when Keith Shackleton was first seen by the public in the late 1940s and early 1950s, but which has long been untrue. It is true, of course, that Sir Peter Scott has been a great influence on Shackleton. Both paint in oils, both have sailed, both have shown interest in wildfowl. Even though the plates in Shackleton's book *Tidelines*, published in 1951, do show an imitation of Scott, his handling of the light on the sea emphasised the individuality of his approach.

After service during the latter part of the Second World War in the Royal Air Force (he worked on camouflage and did some painting, although not as an official war-artist) Shackleton joined his father's aviation firm. His elder brother had been killed as a fighter pilot during the Battle of Britain and he seems to have joined the family firm more from loyalty than from a love of aviation. He tried hard and even learned to fly but after 15 years he left aviation to become a full-time artist, specialising mainly in paintings of birds and boats.

Shackleton is remarkably modest about his work. He had no art school training, having entered the RAF on leaving school. He made a desultory attempt at evening classes after the war, but did not persist. He now sees this lack of training as an advantage. 'After a lifetime of painting I keep learning for myself things that I would have been told had I been to art school', he told me. This has meant that painting has been an adventure with his frequently discovering new techniques for himself. He showed me an uncompleted oil painting of a canoeist in a kayak among icebergs in an Arctic Ocean suffused yellow from the Northern Lights. Based on memory, it was an idea that he had been considering for some years. For some reason he never managed to start the painting until he dropped and stood on a tube of oil paint of just the colour he needed. Faced with a mess of expensive oil paint that would be wasted if he did not use it, he had the impetus to start the painting.

The Arctic and the Antarctic are favourite places for Shackleton. On the wall of his studio is a pennant from 45 Commando, Royal Marines. This is a memento of a recent commission for a painting of 45 Commando on manoeuvres in Arctic Norway. He had gone on exercise with the commandoes, living with them in shelters dug in the snow. That a man in his fifties could survive with these young, highly trained Royal Marines says much for his fitness.

This fitness has been useful on his trips as a guest lecturer to Antarctica with *M.V. Lindblad Explorer*. One of the jobs of the guest lecturers is to man the inflatables that transfer the passengers between ship and shore. On one of the ferry trips Shackleton noticed a small school of whales swimming alongside. When he had embarked the passengers and was returning alone the whales began to tease him, swimming beneath the inflatable and bouncing it like a beach ball. He was sure that their attentions were friendly and he was quite unafraid. He thinks they were playing and is convinced that whales and other cetaceans have a sense of humour. With more than 35 *Lindblad Explorer* trips behind him, he has great experience of Antarctica and its wildlife. The seabirds and marine mammals of the southern oceans have provided him with many subjects for paintings. Sometimes he paints flocks of seabirds or shoals of dolphins, using the groups of animals to create abstract patterns, but often his Antarctic paintings have a small animal in the vast landscape of ice and wind.

'For the sheer enjoyment of painting' he wrote in *Tidelines* (1951), 'I would put a composition above a landscape, though a bad landscape is less bad than a bad composition. I would rather paint birds close to and simplified than knitted into a distant horizon, small and fiddling.' Since writing this Shackleton has clearly learned how to paint a small bird in a large

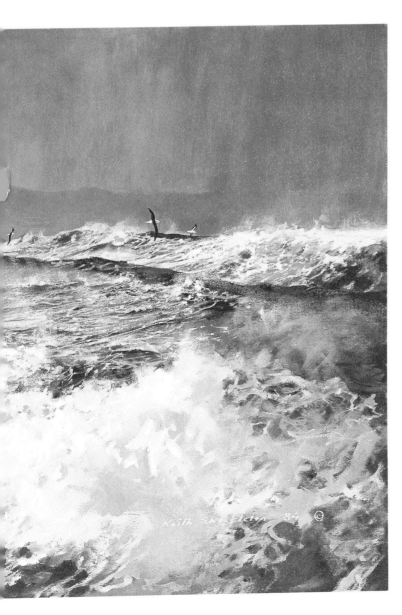

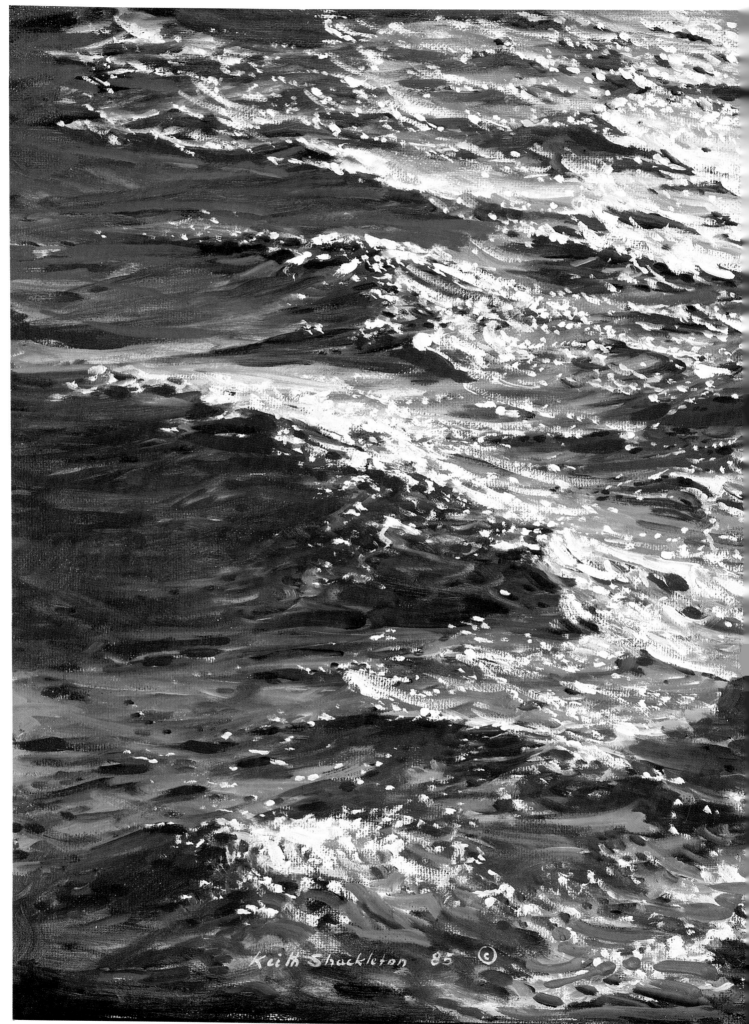

Tristan great shearwater. Keith Shackleton. (Mill Pond Press)

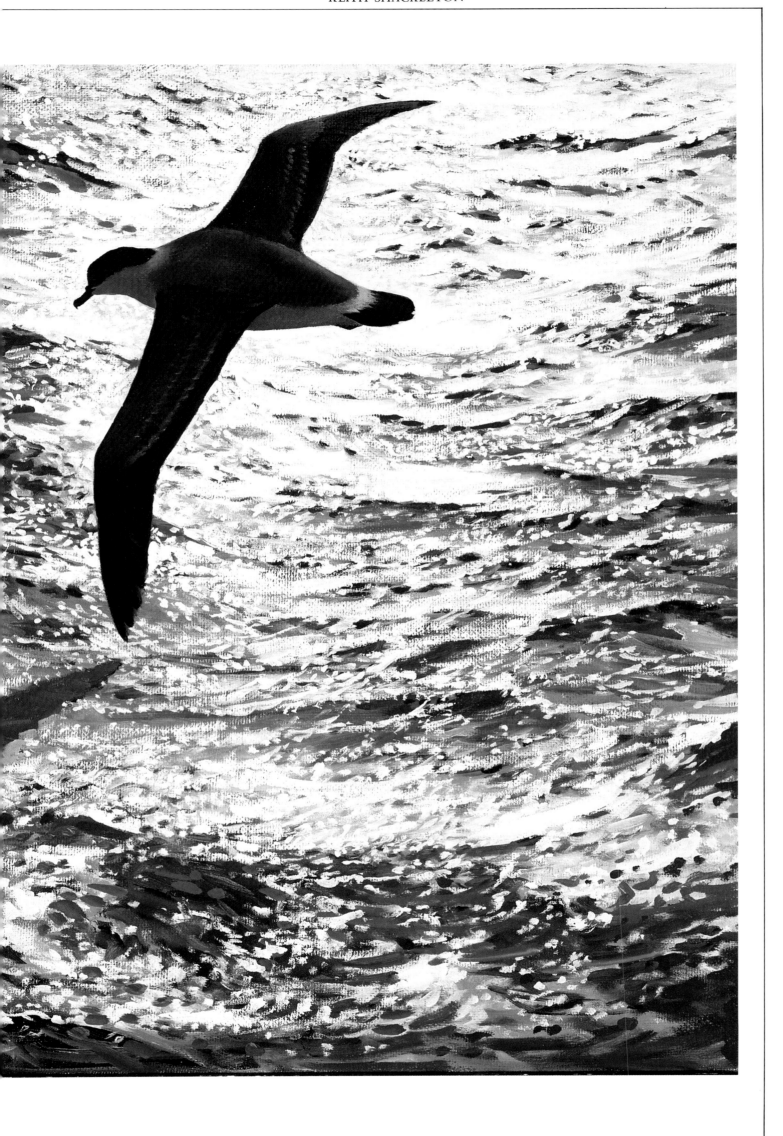

canvas and make it the focal point of the painting.

Shackleton now tends to specialise in seascapes with wildlife or boats but he has painted a range of subjects including landscapes, nudes and still-life. He has found this enthusiasm for painting specialised subjects has its problems as he acknowledged in *Tidelines*:

'A conflict grows between their artistic possibilities, and a half-developed technical knowledge which cries out all the time for recognition. A lot of it is due to the influence of one's friends, who inevitably will see the picture, and, lacking the haphazardness of the painter, will straightaway point out the defects. "But the tarsus of the Garganey teal is shorter than that", they say, "and the vermiculations on the posterior flank more pronounced!" Sailing folk, gripping a pink gin, will put a picture of boats on the easel and ask how on earth one can have both craft on the same course – one nearly close-hauled and the other setting a spinnaker! Turner's classic excuse of "Don't you wish you could" avails nothing.'

When Shackleton faces a conflict between scientific accuracy and artistic necessity, art wins, and he appears to have developed a cheerful tolerance in face of criticism about inaccuracies in detail. 'Because most wildlife painters are primarily naturalists, they need a medium with which they can be precise. But, for me, the detail is the least important thing.'

For this reason he prefers to work in oil, while expressing envy for watercolourists of the skill of Ennion, Gillmor and Tunnicliffe. It is the adaptability of oil that really attracts him. 'Oil suits me because you can just dash away. I like to feel my way with a picture and am very bad at visualising things . . . I like oil painting because there are no rules. If I do not like something, I can wipe it out and start again', he told Sylvia Sullivan in 1984.

Shackleton's oil paintings are not cheap but they sell well in both the United States and the United Kingdom and the limited edition prints published by Mill Pond Press are very popular. His enthusiasm for birds and the places where they live must be communicated to anyone who looks at a Shackleton. Sir Peter Scott recognised this quality more than 30 years ago. Writing the foreword to *Tidelines*, he summed up the chief characteristic of that book as 'the enthusiasm of its painter-author, an enthusiasm which is infectious, light-hearted, ever young and wholly captivating.'

ARTHUR SINGER

The stereotype of the wildlife artist as a countryman whose love and knowledge of wild creatures has found expression in art certainly does not apply to Arthur Singer. He has been a New Yorker from birth. He was born in New York City, raised in mid-Manhattan and still lives in the Long Island suburb of Jericho. By coming from a family of artists he does conform to a pattern followed by several wildlife artists. The family tradition is continued by his two sons both of whom are artists.

New York City, with areas such as Central Park and Jamaica Bay, can boast an impressive list of birds, but it was neither of these places that inspired the young Singer's interest in natural history. It was the Bronx Zoological Gardens, which he first visited at the age of three. Regular visits to the zoo prompted an interest in animals as subjects for his drawings. His family encouraged this interest and the first of his pictures that he sold were zoo drawings made when he was still in high school. Another source of inspiration were illustrations from magazines. In the golden age of magazines before the Second World War the illustrations by Kuhnert, Rungius and Fuertes in *National Geographic, Natural History, Nature* and *Illustrated London News* showed him what might be achieved. During adolescence it was mammals, particularly cats, that were the main subjects of Singer's painting, although latterly he began to draw more and more birds, having seen the original Audubon watercolours at the New York Historical Society.

When he started training in fine art at New York's Cooper Union Art School in Manhattan, he discovered in the school library a full set of Audubon elephant portfolios. His admiration of Audubon's compositional ability shows itself in the design of his own paintings: in his own living room hangs a painting of brown pelicans, of which Audubon might have been proud, especially as it shows a greater understanding of pelicans than Audubon ever showed. At Cooper Union Arthur Singer learned the techniques of drawing and painting. It was also here that he met fellow student, Judy Goulfine, who was to become his wife in 1941.

Having graduated with honours in 1939, Arthur Singer found work with a printer and then with an advertising agency. Three years later he joined the United States Army and saw service in Europe. Once his army service was over he returned to advertising as a designer and illustrator. Having studied fine art at Cooper Union before the war, he returned to take classes in design and illustration. During this period he was painting birds and animals in his own time. This was a fortunate extra-mural activity because in the 1950s the market for illustrations in advertising dried up as photography took over. Happily, an increase in interest in wildlife was also taking place and, despite improvements in cameras and film, there were still many subjects beyond the photographer. Therefore, there was a small boom in wildlife illustration and Arthur Singer, no longer in business as an advertising illustrator, became a full-time wildlife illustrator.

His first big chance came when *Sports Illustrated* commissioned him to paint a feature to be entitled 'A Birdwatcher's Guide'. This was followed shortly by a major 11-page colour series for the *World Book Encyclopedia* and in 1956 eight paintings for the magazine, *American Home*. The Golden Press Division of the Western Publishing Company asked Singer to do several small illustration projects before giving him a major four-year commission to produce 750 paintings for *Birds of the World* (1961) which was written by Oliver L. Austin, Junior. This covers families of birds from all over the world. It is extremely well-designed with examples of each family shown together. As might be expected in illustrations covering such a diversity of species some of them are less successful than others. Once again this seems to demonstrate that familiarity produces the better bird pictures: Singer's wood thrush and American robin are much better illustrations than the European blackbird and European robin within the same spread.

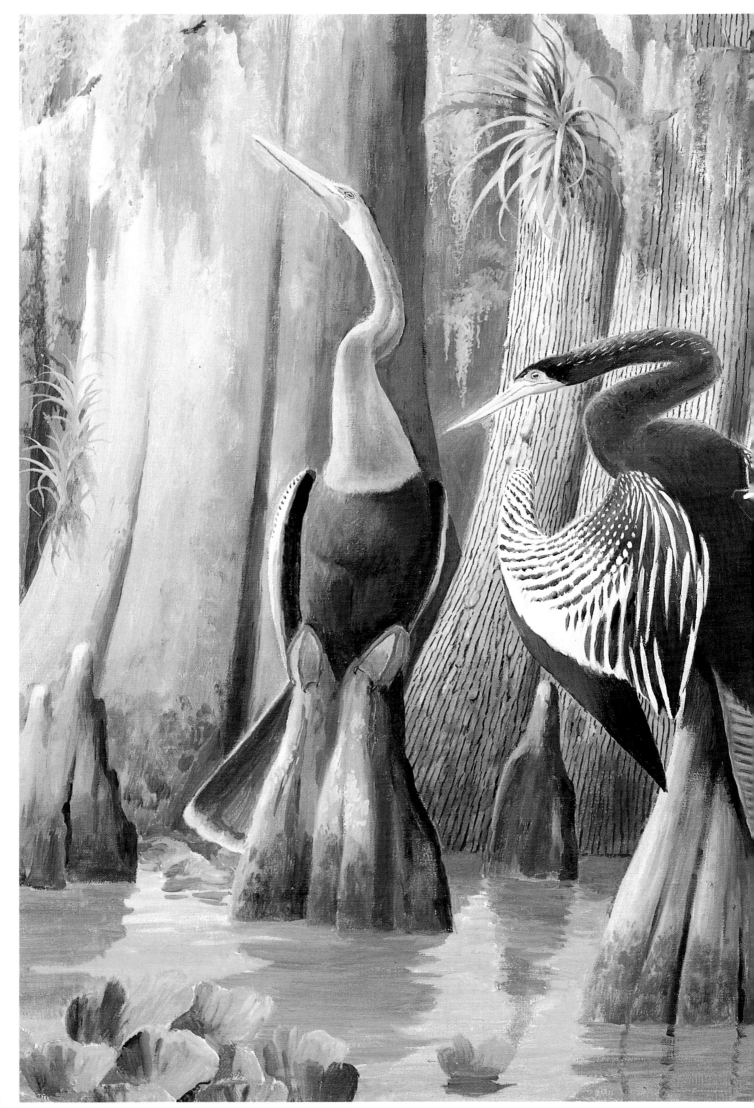

Anhingas. Arthur Singer

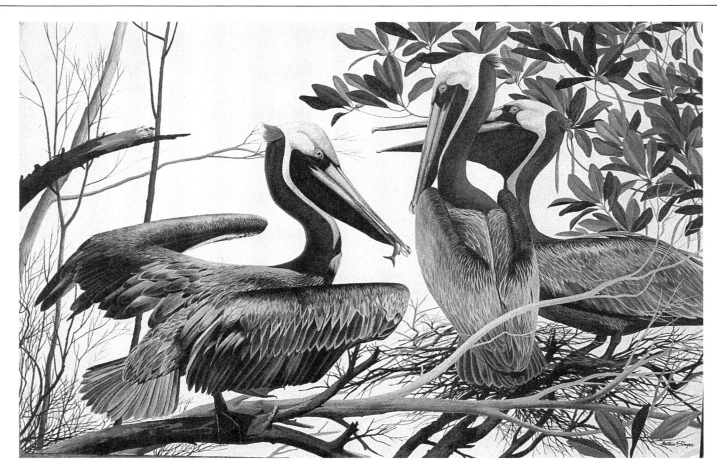

Brown pelicans. Arthur Singer

This massive task was followed by a commission to illustrate *A Guide to Field Identification of Birds of North America* (1966), an awesome task in view of the success of the Peterson Guide, but many people think that for the beginner this guide is better than Peterson. Once again Singer faced a huge task – 142 pages of illustrations showing 300 species, often with five or six species in each illustration.

Roger Tory Peterson, always generous in his estimation of his fellow artists, wrote in 1982 about Arthur Singer: 'Bird artists are drawn to New York because of the galleries, museums and the zoo, but Arthur Singer had the good judgement to be born there. The American Museum of Natural History was a subway ride away and so was the New York Historical Society, where Audubon's original watercolors made a deep impression. He is a skilled delineator with a fine sense of design. Through his art he has made millions of people here and abroad more aware of birds. Although under constant pressure from publishers now he is painting evocative canvases to please himself. In doing so, he also pleases us.'

Translations of *Birds of the World* into seven languages helped to bring the name of Singer before audiences outside the United States. During the 1960s he also worked on a field-guide to European birds. Since Peterson, Mountfort and Hollom's *Field Guide to the Birds of Britain and Europe* had been published in 1953 there had been no real competition. The publication in 1970 of the *Hamlyn Guide to Birds of Britain and Europe* by Bertel Bruun and Arthur Singer put 'Peterson' temporarily in the shade because the illustrations appeared on pages opposite the text making its use in the field easier. It also included birds flying as well as perched in the same illustration.

Singer has travelled widely in search of birds. His field trips have taken him all over the United States, south to the American tropics, the Antilles, Surinam and the Amazon forest; to the Galapagos and Japan; and across the Atlantic to Africa and Europe. He has a collection of sketches made on these trips together with notes and his own photographs. John Bull, of the American Museum of Natural History, said of him: 'It was my good fortune to have had Arthur as field companion on several trips to the American tropics. He was as much in his element in the field with camera as he was with brush and drawing board, for he is a superb photographer as well as a renowned painter.'

Having a grounding in the world of commercial art helped Singer when he became a freelance illustrator. It had taught him the importance of a conscientious approach to commissions and deadlines. He is very well-organised. In his studio there are filing cabinets of looseleaf books of notes and sketches, his own photographs and skins for reference. He works to a background of jazz. He is extremely knowledgeable about jazz and was a close friend of the late Duke Ellington. He works on heavy art board, drawing in pencil and painting in gouache. Backgrounds are important in his paintings so that, unlike many artists, he paints bird and background together.

On the walls of his split level house in suburban Jericho are paintings by fellow Long Island artists, Guy Coheleach and Don Eckelberry, as well as some favourite paintings by himself. He first met Eckelberry in the Museum of Natural History. 'We became fast friends', writes Eckelberry, 'not just because we were plying the same trade, but rather because we found we had a very close aesthetic view beyond our mutual zoological interests. That and our personality compatibility easily overcame the wide difference in our conceptual approach.' Eckelberry patently admires Singer's commercial acumen, but sees more in him than a purely commercial artist. 'Arthur's work has, from the start, shown a design sense that was immediately appreciated and admired. He is a field naturalist in the true sense, but he is also the artist in his ability to abstract from nature and make a personal statement. His work has become

increasingly flexible and has shown that growth to be expected from a truly creative person.'

That growth was made possible by the freedom from illustrative work that success as an illustrator brought. Having achieved sufficient reputation and security from the years as an illustrator, Arthur Singer can now concentrate on painting the pictures he wants to paint for galleries. No longer must he paint the subjects dictated by a commissioning editor. He has a particular fondness for waterbirds, making the most of their shapes and reflections to build memorable compositions.

Occasionally he is tempted by commissions. For instance, in 1981 the United States Postal Service commissioned him and his son, Alan, to paint a set of 50 commemorative stamps, each depicting a state bird and flower. Where a species was shared by several states (the cardinal is the bird of seven states) each was painted differently. Alan Singer painted the flowers.

Although Arthur Singer's work has appeared in several group exhibitions, he has had only six one-man exhibitions. The first was, appropriately, held at the Bronx Zoo in 1942 and the last at New York's Hammer Gallery. His work has been exhibited outside the United States in Toronto, Edinburgh and London. It is also in private collections throughout the world.

Arthur Singer is a quietly spoken man. At times his voice dwindles into such a slow drawl and his eyes become so hooded you could be forgiven for thinking he is about to fall asleep. But this is deceptive. He combines with his courtesy and gentleness, a realistic and businesslike outlook, being well aware of his worth as a painter.

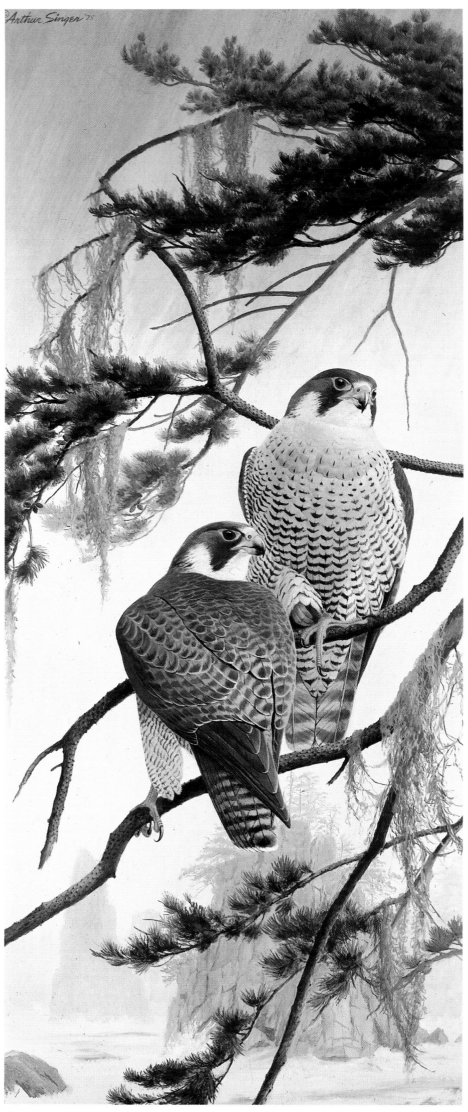

Peregrines. Arthur Singer

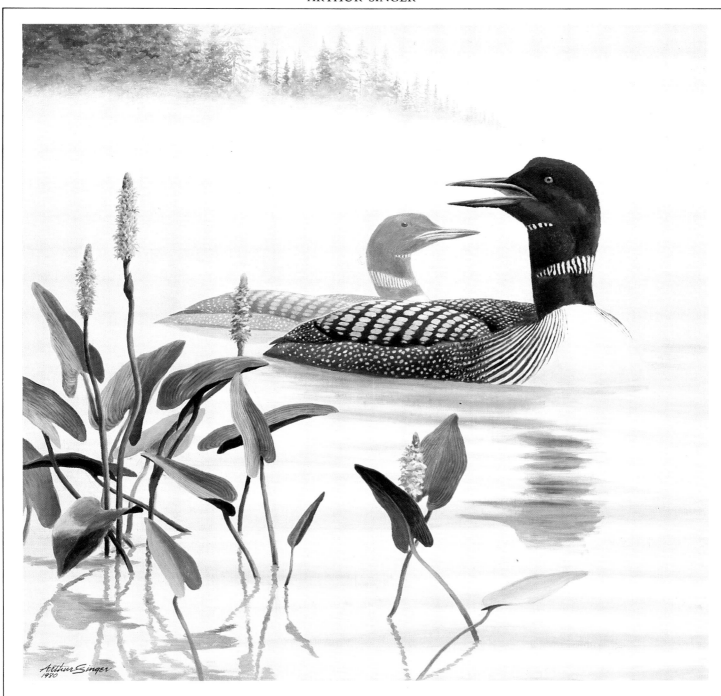

Common loons. Arthur Singer

GEORGE MIKSCH SUTTON

ew artists or ornithologists can have been
held in such high affection as was George
Miksch Sutton by his colleagues, artistic or
ornithological. As an artist he was the link between
Louis Agassiz Fuertes and today's painters of birds and
as an academic biologist he was a legend among the
students he taught. This kind, caring bachelor was an
old-fashioned museum-man whose wanderlust took
him all over the North American continent from
Mexico to the Arctic and made him a fine field man.

His father was a college lecturer and preacher who
moved with his family around the United States of
America. Sutton was born in 1898 in Bethany,
Nebraska. During his boyhood he lived in Minnesota,
Oregon, Nebraska again, Illinois, Texas and West
Virginia. These travels may have stimulated his
wanderlust. Certainly as a boy natural history was
his passion. He, like most boys in the early part of
the century, collected eggs and he was an expert
nest-finder, a talent that was later to be useful on
scientific expeditions. He also kept an array of animals
– rabbits, screech owls, oppossums and even two
roadrunners taken from the nest when he lived in
Texas. When the family moved to West Virginia
he took with him two screech owls and the two
roadrunners. He wrote an article about the
roadrunners and it was published in 1913 in *Bird-Lore*.
Emboldened by this success he made some drawings
of the roadrunners, one of which appeared in the same
magazine in 1915.

Having had a drawing published in the leading
national bird magazine he wrote to Fuertes for advice.
A correspondence was started and lasted until the
great artist's death in 1927. That the man who was
then America's greatest and busiest illustrator of
birds should take the time to enter into a long
correspondence with a teenage artist suggests both
kindness and the recognition of the young man's
talent. In 1916 Fuertes invited this 18-year-old whom
he had never met to his home at Sheldrake Springs,
New York.

Sutton later wrote: 'He was taking an awful chance.
I might, for all he knew, be addicted to smoking
cigarettes, carousing at night, lying abed mornings,
talking incessantly, and whatnot. I was an
unprepossessing young man, just past eighteen. My
sisters and I knew something about manners. I was not
grossly deficient in the field. But I had had very little
worldly experience, and this lack must have been
apparent in all I did and said.'

Fuertes clearly found Sutton an apt pupil and Sutton
was in turn charmed by the artist and his family.
Before he returned to his parents Fuertes gave him one
of his old paintboxes. That box became a talisman:
'. . . a treasure I was to take with me four years later
down the whole of the Labrador coast, seven years
later down the Abitibi River to James Bay, ten years
later down the Missinaibi and the east coast of Hudson
Bay, eventually time after time to the New World
Arctic, repeatedly to Mexico, once to Iceland. Never
since the summer of 1916 have I painted a bird without
having that battered old paintbox close-by.'

Later that year Sutton, back in West Virginia, was
given a female wild turkey shot by a neighbour. This
he skinned, stuffed and offered in a letter to Fuertes,
who accepted the bird gladly. Years later at Cornell,
Sutton discovered that the turkey was among the
collection of Fuertes's birds there: it still had Sutton's
'clumsy' label attached to its leg.

While he was a student at Bethany College in 1918
Sutton accompanied his father on a trip to Pittsburgh
where his father had a supply preaching job. While
there he went to the Carnegie Museum and managed
to go behind the scenes to the laboratory. There he met
and talked with the curator, W.E. Clyde Todd. Todd
took him on to the staff and taught him both museum
and field techniques.

Sutton's first major field trip was an expedition
along the coast of Labrador. Like Clyde Todd, Sutton
was single-minded in the field pursuing his objectives
with determination. In 1923 on an expedition down
the Abitibi River the party went by canoe: it was a

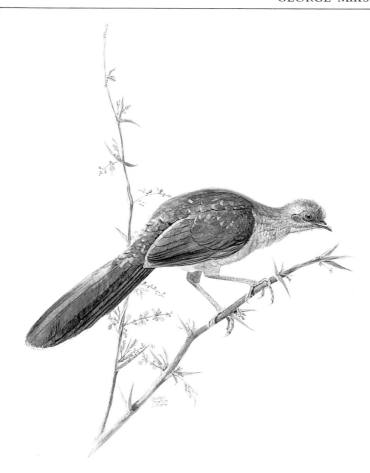

Plain chachalaca. George Miksch Sutton, from Currasows and Related Birds. *(American Museum of Natural History)*

strenuous trip with floods, mud, mosquitoes, miles of portages. Nevertheless Sutton managed to find the blue phase snow geese that were the objective and to draw them. Later, on an expedition to the southern United States, he made sketches of a pair of ivory-billed woodpeckers, a species which may now be extinct.

As a museum-man he had to collect birds and he seemed to have no difficulty or qualms about this killing. 'It's simply a fact of my life, a necessity' he told Verna Mays in 1972. 'Over the years I've argued tirelessly for the protection of wildlife and habitat, and delighted in wilderness. But I have to have models; I must see for myself how a bird is put together, what its muscles are like, what it eats. I can't help but believe that the more we learn from specimens we take from the wild – whether it's to show other people the beauty of the creature in a painting, or to teach students – the more we'll contribute to the well-being of a species on the whole. Understanding must come first.'

He did stress the importance of drawing birds that were alive or very recently dead. In an interview with Frank Graham Jnr in *Audubon* he described his approach:

'On my Mexican trips I made a point of drawing either live birds caught in nets or freshly killed birds. I wanted there to be a scientific record of exactly what the colours of a bird's fleshy parts are – the colour of the legs, the eyes, the linings of the mouth, and around the beak. This is especially important for the rarer

species, where the colours are often altered by age in museum specimens. Even photographs can distort the colours, depending on the quality of the light at the time or the angle from which the picture was taken.'

As a taxidermist he was extremely skilled. On one occasion he skinned and prepared a chickadee in nine minutes. One reason for the immaculate condition of the specimens that he prepared was his habit of taking great care of the bird from the moment of collecting it. It was said that he could preen a bird's feathers as well as the bird itself.

From the Carnegie Museum Sutton became Chief of the Bureau of Research and Information for the Pennsylvania Board of Game Commissioners. He was also given the important-sounding title of State Ornithologist. He did not find the city of Pittsburgh a very pleasant place to walk in and took every opportunity he could to go on trips to the Arctic. He was beginning to make a name for himself as an author and artist when he decided to take a post-graduate degree. He chose to go to Cornell University to study under Arthur A. Allen, who in addition to being an eminent scientific ornithologist was also a pioneer of bird recording and bird photography. Several of Sutton's post-graduate colleagues were to become eminent ornithologists. One of them, Olin Sewall Pettingell, spoke of the way in which Sutton 'generated unbelievable energy'. He had a reputation for being generous in his help for other students and was the life and soul of parties, gravitating towards the piano and singing old songs. In 1932 he was awarded his Ph.D. and was appointed Curator of Birds at Cornell. Shortly after this he became affectionately known to everybody as 'Doc'.

After war service as a technical officer with the US Army Air Force he took a post at the University of Michigan Museum of Zoology, but the atmosphere there was not happy and he began to look elsewhere. In 1952 he became Professor Emeritus of Zoology at the University of Oklahoma and Curator of the University's Stovall Museum. He settled at Norman, Oklahoma, and stayed there until his death at the age of 84 in 1982.

In addition to his paintings, most of which were in watercolour, he was author of 11 books and he illustrated 15 more. His *Iceland Summer* (1962) won the Burroughs Gold Medal in 1962 and his Icelandic paintings earned him an Icelandic knighthood. Many bird artists were encouraged by Doc Sutton who gave practical help by setting up a fund of $25,000 to enable colour plates to be used in the *Wilson Bulletin*.

By the time of his death Sutton had received many awards and honours including being named by the National Wildlife Federation as 'Conservation Teacher of the Year' and his friend, Karl W. Haller, named a new species, discovered in 1937, Sutton's warbler. He nevertheless had a permanently youthful enthusiasm. Verna Mays described him in 1972: 'At 75 he seems more like an intense graduate student than a septugenarian professor.' But then, Sutton was a man of simplicity and said of himself: 'I like to draw birds. I like to study birds. I like to write. That's enough.'

RICHARD BARRETT TALBOT KELLY

R. B. Talbot Kelly left Rugby School in 1914. He had hoped to go up to Oxford, but there was a war on and he joined the army. He entered the Royal Military Academy at Woolwich as an officer cadet. The 'shop', as the RMA was known, was tougher even than a pre-war public school; cleanliness, smartness and alertness were ruthlessly drilled into these future officers. Talbot Kelly did well, particularly in the riding school, and was posted at the end of six months to the Royal Horse Artillery. In May 1915 he went to France and almost immediately found himself taking part in the battle of Festubert. He spent 27 months in France with the 9th (Scottish) Division until, just before his twenty-first birthday, he

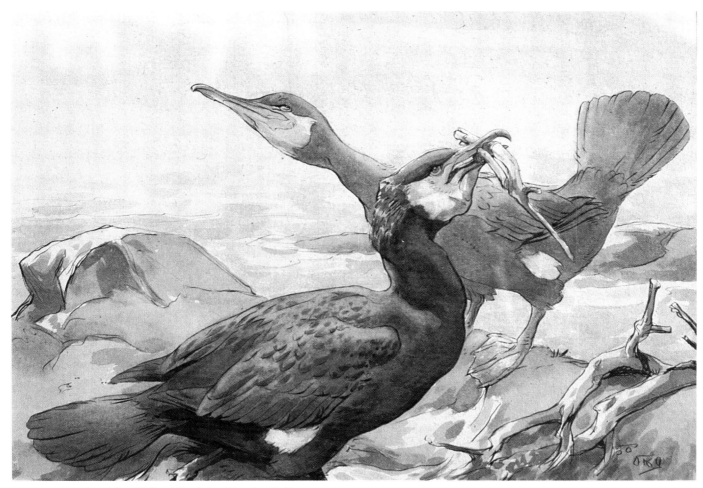

Cormorant. R.B. Talbot Kelly. (Cumbrian Fine Art Galleries)

was badly wounded in the preliminary bombardment before the third battle of Ypres in August 1917. By this time he had already been awarded the Military Cross and mentioned in dispatches.

Throughout the war Kelly had drawn and painted in watercolour the sights and people he had seen. This skill had been very helpful to his fellow officers for whom he produced sketches for artillery purposes. This talent, presumably inherited from his artist father, Robert Talbot Kelly, RBA, FRGS, was extremely useful when, on his recovery, he was posted to a camouflage course. A serious threat was being posed to British gun positions which were being exposed by aerial photography and then subjected to severe bombardment from the enemy. Having become a specialist instructor in camouflage Talbot Kelly constructed on Salisbury Plain a system of trenches to show how gun positions could be hidden from air reconnaisance. He became so interested in flying that he applied and was accepted for training as a pilot, but as he was about to join his training squadron, the war ended and Talbot Kelly found himself back in the Royal Artillery.

The war for Talbot Kelly had been an experience that he did not regret. His son, Giles Talbot Kelly, in a foreword to his father's autobiographical account of experiences during the Great War, wrote: 'My father was a very simple man. His interests were people and people's reactions; and like most of us he found himself the most interesting person. There is nothing derogatory in this: the world could only be seen through his eyes by him, and it was people and living creatures who caused direct reaction and stimulus to him. His realm was not of the mind or of dreams but of a personal reality: what he knew and saw threw shadows. So he went to war with the sure knowledge that it was a vital experience that would cause him to react in a special individual way with people and conditions he would encounter . . . My father took away from combat some values and attitudes that

lasted all his life. This undoubtedly made him the superb teacher he was.'

We have become accustomed to the reminiscences of veterans of the First World War who found it far from enjoyable. The eighteen-year-old Talbot Kelly entered it with a schoolboy's spirit of adventure and enthusiasm. He had been trained as a regular army officer which may have made the experience more palatable and from his own writings about the war it is apparent that much of it he enjoyed. It is ironic that he later expressed great admiration of the nature writing of Henry Williamson, whose subsequent novels gave a very bleak view of the war. Perhaps each learned his fundamental appreciation of nature in the trenches. Talbot Kelly certainly discovered the earth in the war; he wrote in 1955: 'We grew to sense shelter and warmth where no obvious cover existed, were adjusted to heat and cold. Perhaps I was luckier than many in that I was grateful for this glimpse, through impending death, of natural life.'

Nature in the form of birds and other animals became very obvious to him during his post-war army service in India. This was where his interest in birds was ignited and where he began to paint seriously. During this period he exhibited regularly at the Royal Society of Painters in Water Colours, to which he was elected in 1923. By this time he was back in England, posted to an anti-aircraft unit in Aldershot. In 1929 he resigned his commission and returned to Rugby School as Director of Art. He remained at Rugby until his retirement in 1966, an inspiration to generations of boys who remember him with affection and admiration. He had the ability to breathe life into mundane objects and to approach art from a variety of angles.

He was much influenced by the art of the Ancient Egyptians. In *The Way of Birds* (1937), he wrote: 'Emotionally they can teach us everything . . . And technically I have profited from them beyond telling. They taught me the value of line, the truth of

Gemsbok. R.B. Talbot Kelly. (Cumbrian Fine Art Galleries)

silhouette, economy of means, selection of essentials, the drama of undramatic daily life and the pattern of groups.' He admired the Egyptian painters of birds for managing such excellent representations with only a limited palette and the sculptors for portraying nobility in their birds of prey. 'The Egyptian sculptors found the nobility in the animal kingdom as no others have since, and they show us that fine decorative murals can be created out of bird life, as in their fowling and ornamental water garden scenes.'

The Chinese, too, influenced his thinking. He admired the way in which Chinese artists showed birds as living creatures. 'The artists have watched and enjoyed their models as they went about their daily business. They found them as interesting as we do our fellow-men. They were intensely aware that birds feel love and hate and fear, are happy and sad, well-fed and hungry. Moreover they saw birds in scale with their natural surroundings; a little bird amongst small twigs and reeds, an eagle on a great pine branch. Very truly they give us the intimate homes of the birds, their greater or lesser kingdoms. We feel we understand a realm of bushes and a few acres with the finch, or one of the mountains and great rivers with the eagle or goose. How different this from the pictures in many bird books, where a slovenly background is put behind a lifeless, posed bird as a sop to a public that has no feeling for the real live birds.'

This oneness with nature clearly had a strong appeal to the mystical side of the man who knew just what it was like to cling to the earth in fear as shells exploded about him. It encouraged him to use a spare style unencumbered by obsessive detail. Small surprise, then, that he should have admired the work of Bruno Liljefors. To him it seemed that Liljefors painted what he felt. 'I can hear a painting by Liljefors!' he wrote in 1937. He marvelled at the way the great Swede

managed to give as much importance to the animal as to its habitat, so that the viewer is unsure whether to study the environment first or the animal.

Another painter whom Talbot Kelly admired was Joseph Crawhall whom he described as having an 'almost Eastern insight into the life of his models', absorbing all their essentials 'which he stated in the simplest terms, in the broadest and most carefully-considered masses'. Crawhall, some of whose work can be seen at the Burrell Collection in Glasgow, painted domestic fowl rather than wild birds, but his approach was worthy of study by all beginners in bird art. 'It preaches self-discipline as does that of no other artist since the days of ancient Egypt' was Talbot Kelly's assessment.

Familiarity with his subjects, which included both insight and understanding, was the key to Talbot Kelly's work. His ability to exclude what he knew to be the facts and concentrate on what he had seen puts his work into the highest category of bird painting. This conflict between visual accuracy and scientific knowledge was discussed in his book, *Bird Life and the Painter* (1955). 'There are times when the impression of a moving wing-shape is such that it must needs be furnished with double the number of actual feathers possessed. What should the artist do – be accurate to bird anatomy, or true to the impression? Personally I would still choose the latter, it seems to be the only honest course for any painter to pursue.'

Sometimes he was deliberately inaccurate in order to express the personality of a bird through caricature. He believed that the best caricatures were those in which the proportions of the subject, whether it was a person or an animal, were almost correct, the exaggerations being so slight that at first sight they would be almost unnoticeable 'and yet of such quality that they underline the essential personality of the

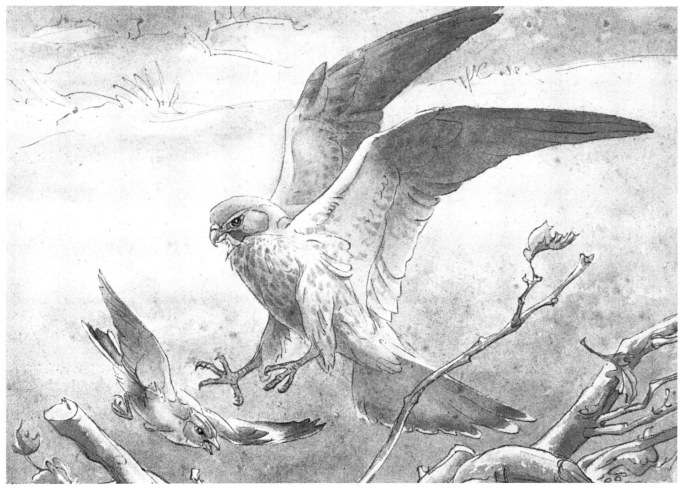

Kestrel. R.B. Talbot Kelly. (Cumbrian Fine Art Galleries)

Turnstones. R.B. Talbot Kelly. (Cumbrian Fine Art Galleries)

subject'. Talbot Kelly also used this technique to emphasise the movement of the birds. One drawing in *The Way of Birds* shows a little grebe pedalling across the surface of a dyke in a prolonged attempt to become airborne. The desperation of its efforts is clear in its expression: the artist described it as gazing up 'pathetically like a frightened avian rabbit'. The resulting picture has some of the qualities of a high-quality animated cartoon.

Like Eric Ennion, his almost exact contemporary, Talbot Kelly lacked formal training as either an artist or a teacher, but brought freshness and originality to each profession. Towards the end of his life, after he had retired he was still teaching courses for adults and children on behalf of the Royal Society for the Protection of Birds and Leicester University. And he also produced dioramas and a mobile of flying birds of prey for the Society's exhibitions. He had always been interested in creating three-dimensional models, using cardboard, paper and wood, producing books of paper birds for both the RSPB and Puffin Books. It is not surprising that he was Design Consultant for the Pavilion of the Natural Scene at the 1951 Festival of Britain: his simple but imaginative approach to life seems to have been entirely consistent with the spirit of post-war revival that was behind the Festival.

Sadly, the lessons of Talbot Kelly's work have been ignored by many of today's so-called wildlife artists: familiarity and understanding of animals takes time, time that might otherwise be used profitably painting. Too often, lack of understanding of the animal subjects of a painting is compounded by an ignorance of the places where they live. Talbot Kelly, on the other hand, even when his paintings have only a suggestion of landscape always demonstrates his understanding of the effects of local environment on birds, especially on their colouring. Painters and publishers can be obsessive about the importance of colour, but Talbot Kelly knew that they were wrong. 'I used to believe that a coloured book-plate of a golden-eye drake said the last word on the subject. Now I know that I myself have seen golden-eye drakes wearing at least three different suits. I used to think that herons were always blue-grey in colour. But I have seen a heron look blue, and pale ash-grey, and purple-grey, and golden-buff in different lights at varying times of day.

'Colour is the least stable clue in the identification of birds. Yet most illustrated bird books have sacrificed all to one colour phase of each bird. Some features absorb light, some reflect it as a mirror, some are utterly changed in colour by it. This miracle of colour of birds could be a source of endless adventure to a painter.'

ARCHIBALD THORBURN

Among the most famous British wildlife artists of this century was Archibald Thorburn. His popularity partly arises from the wide use of his work. His illustrations have influenced several generations of birdwatchers; his plates for Lord Lilford's *Coloured Figures of the Birds of the British Islands*, published at the end of the last century, were later used for the popular *The Birds of the British Isles and Their Eggs* by T.A. Coward, almost continuously

in print for almost 50 years from 1920, and in *The Observer's Book of British Birds* first published in 1937 and the first bird book for most of the post–Second World War generation of birdwatchers. In addition to these there were the prints of Thorburn's watercolours that first appeared on the market in 1900. Small wonder that Thorburn became so well known and so well loved.

Thorburn was the fifth son of Robert Thorburn,

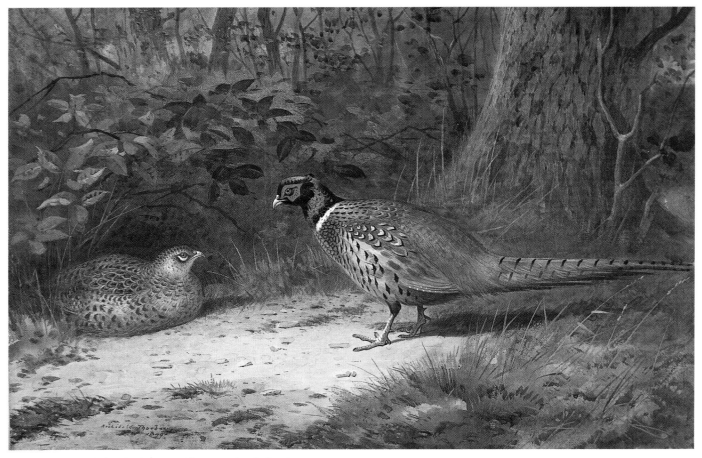

Pheasants. Archibald Thorburn. (William Marler Gallery)

ARA, a Scottish miniaturist who painted three portraits of Queen Victoria. Thorburn was born at Lasswade, near Edinburgh, on 31 May 1860, 17 days after the great Swedish painter, Bruno Liljefors. His interest in nature showed itself early along with a precocious talent for drawing. At six or seven he was taking a particular interest in the flowers of his parents' garden and drew pencil sketches of plants and twigs. By the time he was 12 he was producing pen and ink drawings as well as watercolours. After private education in Dalkeith and Edinburgh he studied under his father before going to London, to the St John's Wood School of Art. The teaching there followed the precepts of the Pre-Raphaelite Brotherhood and was in effect a crammer for the Royal Academy Schools. Later Thorburn admitted that he learned more from his father than ever he did at art school. Thorburn senior was a hard master, insisting on his son's understanding completely the anatomy of his animal subjects. He set his standards high and would tear up drawings that he thought were inadequate.

When Thorburn was only 20, in 1880, he had two large watercolours hung in the Royal Academy. These paintings, entitled 'On the Moor' and 'The Victim', were the first of 21 paintings to be accepted by the Academy over the next 20 years. He stopped submitting to the Academy after the turn of the century because he became discouraged by the 'skying' of his work. By this time, too, he had sufficient reputation not to need the reassurance of Academy approval.

His first published illustrations were two plates for J.E. Harting's *Sketches of Bird Life* (1882). Later he was critical of these, particularly the kestrel. The young man was soon commissioned to paint 144 plates for Walter Swaysland's four-volume *Familiar Wild Birds* (1883–88). Each plate depicted one species with a background.

Then, luck and Lord Lilford stepped into Thorburn's life. Lord Lilford was looking for an illustrator. In his introduction to *Thorburn's Mammals* (1974) David Attenborough likened Thorburn to a young opera singer taking over from an indisposed prima donna and starting on a great career. Lord Lilford was preparing a monumental work about British birds, for whom the chief illustrator was J.G. Keulemans, commissioned after Joseph Wolf had been unable to undertake the work, but Keulemans fell ill. Lilford was most impressed by Thorburn's work for Swaysland and commissioned the young Scot. Thorburn began work in 1887 on *Coloured Figures of the Birds of the British Islands* two years after the first volume had been published. When the final volume was published in 1897 he had completed 268 of the 421 plates in the book. His work for Lord Lilford was incomparably better than that of Keulemans and his reputation as an artist was assured. He also became a frequent visitor to Lilford Hall, where he would paint birds in the aviary. It was there that early in the century Edward Lear had worked when he was making drawings for his famous monograph on parrots.

It was another of Gould's contributors who became a great influence on Thorburn. When the young artist moved to London in 1885 he lived in St John's Wood, close to the Primrose Hill studio of Joseph Wolf. Wolf was kind to Thorburn who learned much from him. Thorburn, however, usually managed to avoid the sentimentality that was found in much of Wolf's work. An exception to this was a Christmas card that Thorburn painted for the RSPB during the First World War, but given the prevailing sentiments of British civilians at the time, this is perhaps forgivable.

Wolf's paintings usually showed animals in some form of suitable background, but Thorburn took this further, giving more prominence to the landscape than any previous British wildlife artist. It is interesting that in Sweden Bruno Liljefors was doing the same, although he was working on an even larger scale and in oils rather than watercolours. Thorburn was aiming at a realism very different from anything that had been done before. Sometimes his animals were not quite accurate, often because he made alterations to help the compositions. His pupil, Philip Rickman, showed me a large watercolour of a peacock spreading its tail with a peacock butterfly in the foreground. As Rickman pointed out the peacock's tail, in life, would have fallen forward obscuring the head of the bird, but that would have ruined the composition; therefore, Thorburn painted the tail standing up and filling the background.

Atmosphere was very important to Thorburn and much of the attraction of his watercolours is the way in which they recreate the atmosphere of a summer's day in a Surrey wood, a snow covered glen in the Highlands or an early morning on an estuary. This would account for his popularity among people who shoot, as well as the conservationists who have a romantic wish to return to a sunny Edwardian countryside before the onset of mechanisation. This ability with atmosphere extended to some of Thorburn's plates of mammals and perhaps showed itself in an anthropomorphism that was lacking in his bird illustrations. This characterisation of mammals marred some of his plates for *British Mammals* (1920), whose weasels look wily and woodmice winsome. The book was published following the success of his *British Birds* (1915–16). This four-volume work had plates that showed several species so that comparison could be made. The limited edition of 105 copies sold before publication and the four-volume set of the ordinary edition sold out very quickly at six guineas: today a set would cost over 100 times the original price.

The publishers, Longmans, suggested a third book featuring plates of butterflies and flowers, but Thorburn, normally an astute businessman, turned down the idea on the grounds that there was not enough interest in butterflies or flowers. This seems an odd judgement when his set of prints of butterflies had been published by Longmans before the First World War. Thorburn was one of the earliest artists to have his work reproduced as prints. The shrewd Scot had understood the potential of the developing reproduction techniques whereby photographic methods were used to make prints of watercolour paintings. The relative cheapness enabled limited editions to be printed, bringing his work to a greater market. His first print 'Partridges in Stubble' was published in 1900 and by his death in 1935 over 100 different prints had been published.

A good businessman, Thorburn was a match for publishers and picture dealers. Although they might attempt to take advantage of him once, they never did so twice. He was, however, a shy, reserved man, who lived quietly. His wife, Constance, whom he married in 1896 described his life as a 'smooth deep river flowing forever serenely on'. In 1902 they moved from London to High Leybourne, a 15-acre estate at Hascombe in the Surrey countryside. Here he lived quietly and worked very hard: only on Sunday did he not paint. He would take a cold bath, breakfast on porridge made from oats sent from Scotland, and then he would walk through Hascombe Woods. Always he would carry binoculars and a sketch-pad. He used to

shoot but gave up when he had wounded a hare and heard its screams of pain.

Foreign travel did not appeal to Thorburn. Apart from a trip to Norway he seems to have confined himself to the British Isles. He made an annual trip to Scotland, where his favourite haunt was the Forest of Gaick in Inverness-shire. It was here that he drew many of the landscapes that appeared in his paintings.

The most productive period of his life was the first 20 years of this century when he worked on both illustrations and commissions. John Southern, a great expert on Thorburn and owner of the Thorburn Museum at Liskeard in Cornwall, has noted how the artist's style changed around 1900. Between the ages of 20 and 40 he painted in a tight, restrained fashion with considerable attention to detail and then between the ages of 40 and 60 he notably gained in confidence, using much more water on his brush and painting in a really masterful way.

During this very busy period he worked closely as an illustrator with J.G. Millais, William Beebe, H.A. Macpherson, Augustus Grimble and W.H. Hudson. Presumably it was through Hudson, who was a leading member of the Society for the Protection of Birds, that he painted roseate terns to be used as a Christmas card by the Society in 1899. This was one of the earliest charity Christmas cards and was followed by 18 more in the next 35 years. Not only did he not charge the RSPB a fee, he also donated the original, which was sold for the Society's funds: the paintings raised between 10 and 30 guineas.

Most Thorburn paintings were in watercolour, but he occasionally used tempera and even more rarely oils, which he found difficult to use and was unable to catch the softness of fur or feathers that was possible with watercolour. He always used Winsor and Newton colours. His preferred paper was cartridge A paper, preferably mellowed with age, and he sometimes used cheaper tinted papers which saved him time in building up colours. Using field sketches for reference he would draw the composition in pencil before beginning to paint when he would tackle all the painting at the same time. The skill with which he flowed on watercolour made him one of the best British watercolourists and he is now being recognised as a fine watercolourist, not merely as a wildlife painter.

Archibald Thorburn influenced a number of his contemporaries. There was George Lodge, an expert painter of birds of prey; Otto Murray-Dixon who died on Vimy Ridge in 1917; J.C. Harrison of Norfolk; and Philip Rickman who at his best equalled his master. Two younger artists working today, Gordon Beningfield and Rodger McPhail, produce very good examples in the Thorburn tradition, and there are others who are rediscovering something which Thorburn learned at the end of the last century – that animals put life into a landscape and vice versa.

When Archibald Thorburn died in 1935 after a long illness, his friend George Lodge wrote the following tribute: 'Thorburn was the greatest ornithological

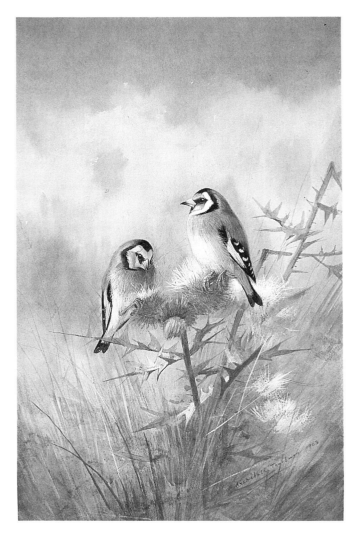

Goldfinches. Archibald Thorburn. (William Marler Gallery)

artist, superior to all contemporaries in the same field, with a wonderful gift for placing his bird subjects in harmonious surroundings. Whether he was painting a large picture of a whole covey or flock of birds or merely a scientific depiction of a single bird for a book illustration, his method and execution were equally admirable. His birds were never flat maps of plumage, but were essentially solid, with the correct amount of light and shade and reflected lights and colours, always extremely well drawn. He was an excellent landscape painter, and painted flowers just as well as birds. His sketches of plant life, foliage, sprays of blossom and such like were extremely clever and beautiful. He appeared to visualize a subject so well before beginning to paint that his work was very rapid, and wonderfully fluent and direct. His technique was dexterous and bold and his colour brilliant and always harmonious whilst his treatment of the plumage of birds themselves was most remarkable. Thorburn was a man of most loveable qualities, very modest about his own work, but never reticent about his own methods of producing it, and always ready to impart his knowledge to others in a most generous way.'

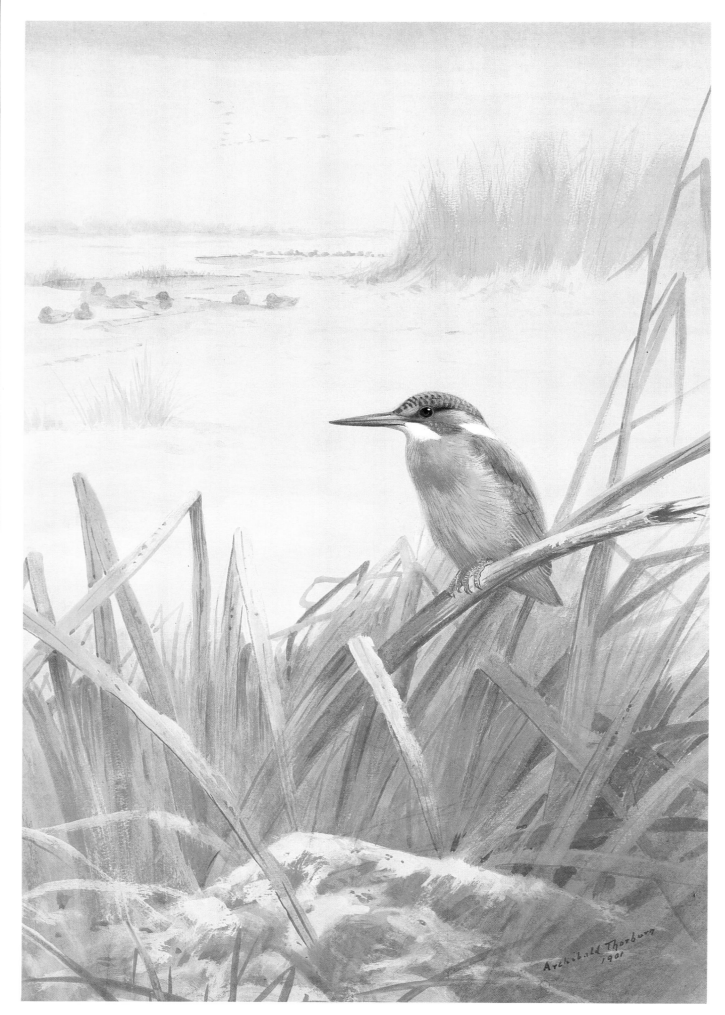

Kingfisher. Archibald Thorburn. (William Marler Gallery)

PETER TRUSLER

A ustralia has some dramatic-looking garden birds, but when Peter Trusler, a native of Yallourn, Victoria came to paint them for a book he was surprised to discover how little he knew about the plumage details of some of the quite common species. He filled in the missing details from a number of sources, among the most important of which were drawings and notes made from birds that had been mist-netted for banding (ringing). By examining birds in the hand he was able to find out crucial information about the colours and structure of the soft parts that are so often overlooked in the field and are so misleading in stuffed specimens. Looking so closely at these birds he was fascinated by the expressiveness of their eyes.

Peter Trusler approaches illustration with a combination of both science and aesthetics. He graduated from Monash University with a zoology degree, but he gained a higher certificate in art at school. Later he received private tuition in oil painting from Jessie Merritt of Ballarat, Victoria.

Born in 1954, he is still in his early thirties and has been a freelance artist and illustrator since 1975. His work appeared on the Gould League of Victoria wall charts of bird habitats and he was one of the illustrators for *Every Australian Bird Illustrated*, published in 1975. However, it was with his 80 plates for *Birds of Australian Gardens* (1980) that he began to receive real public recognition. It was commended 'Best Illustrated Book' by the Royal Zoological Society of New South Wales in 1981 and the plates are in the National Australia Bank Art Collection in Melbourne. His approach to the daunting task of painting these 80 plates was typically thoughtful as his Artist's Notes in the book show.

'In principle, the task of providing illustrations for a book about birds seemed straightforward. I had to be able to produce paintings of birds that were diagnostic in colour and shape, from which readers could identify the birds they saw. The work had to be a "visual shorthand" that would reduce the need for lengthy

Willie wagtail. Peter Trusler. (National Bank)

description, but it could also make an aesthetic and decorative contribution. It soon became apparent that my involvement ran much deeper and that there were many facets that needed to be communicated.

'In addition to my purely illustrative function I have tried to capture something of the "living magic" that

the authors and I find as we watch birds go about their daily activities. It can be just as equally appreciated in the manmade tapestry of the urban environs as in the natural splendour of the wilds.'

As Trusler considered the possibilities for the paintings he found himself very interested in the characteristics, textures and spatial relationship of the plants and objects that were to form part of the illustrations. As can be seen from the plate of the willie wagtail, he has shown the contrast between the hard brass tap and the soft substance of the bird's feathers. The effects of sunlight, with its particular Australian intensity and colour that is so different from the sombre light of cloudy days, has been exploited to give variety to the lighting in the plates. 'Representing something of the seasons as we experience them in Australia,' he wrote, 'the use of light, and the fleeting activity of birds has also encouraged me to try to communicate the impression of time.'

He decided against bringing all the themes together in each plate, because to do so would be to run the risk of the plate becoming cluttered and consequently losing impact. Therefore, he had to find another way of focusing attention on the bird that was to be the subject of the plate. 'For this reason I chose to adopt what superficially appears to be a photographic style.' This meant that the background was blurred and the effect was so similar to that of a photograph that Trusler found himself accused of basing his paintings on photographs. His answer was that he had never used photographs in the context of copying them in whole or in part. Nevertheless he does not deny that they should be consulted, with common sense, because they give insights into movement, behaviour and physical detail, particularly of the soft parts. Trusler is not afraid of admitting that he examines 'the work of other artists in the same way and this frequently crystallises my own ideas.'

As an artist Trusler prefers to work from life. In addition to sketches made in the field and from birds captured for banding, when he was illustrating *Birds of Australian Gardens* he sketched birds in aviaries, particularly parrots and finches. For his final paintings he would work on an idea, either of his own or based on one in the text, by first drawing the posture of the bird. He then worked on the background. Refinements came as the composition developed, sometimes being dictated by the availability of suitable material for the foreground.

The final painting in gouache and transparent watercolour was approached from the background, again with refinements coming as the painting developed. The book's authors, as well as other experts, were consulted as the painting developed.

Trusler appears not to have resented their comments; instead he welcomed their advice and felt that it strengthened both the design and accuracy of the finished work. The artist's imagination is clearly shown by the variety in the plates – three white-throated honeyeaters feed on 'nectar' from a pottery bowl in one; in another a pair of red-rumped parrots drink from water collected in part of a rusty industrial boiler; and in a third there are eastern spinebills attracted by the nectar of a cultivated fuchsia. Trusler's Australian garden birds are a mouthwatering ornithological feast for the birdwatcher from abroad.

Working on these garden bird plates Trusler learned not only about the birds but also about himself. Painting, he claims, has become a tool for analysis of himself, his relationship with people and his surroundings. This has led him towards the portraits, landscapes and still-lifes that were the beginnings of his painting. He feels that there is no important difference between his paintings of wildlife and those of other subjects. He uses them to communicate his thoughts and feelings. He believes that it is necessary to have involvement with the subject, be it a bird or something else.

For Trusler the most important differences exist between those paintings that are commissioned and those he paints for himself. Commissioned illustrations are different because the illustrative function is paramount and brings with it both the discipline of illustrating the text and the constraints of the printing process. An extreme example of this is the paleontological reconstructions in which he has become an expert. All the existing information about the animal must be rigorously adhered to, but considerable artistic creativity is needed to interpret the known facts and fill in those that are unknown. Consequently he has become involved in the gamut of paleontological research from specimen preparation, gathering and evaluating further information and assessing the significance of any variation to making judgements about the comparative anatomy, functional anatomy and ecological adaptation.

He is also building up a collection of paintings and drawings for exhibition. These are predominantly portraits, landscapes and still-life. A wide choice of media – pencil, conte crayon, pastel, watercolour, gouache, oil and ink – mirrors his wide choice of subjects. Trusler is clearly not an artist who can be labelled and his willingness to tackle such a variety of subjects and yet be able to produce acceptably accurate paintings of birds argues against the narrow specialisation of many 'wildlife' artists.

CHARLES FREDERICK TUNNICLIFFE

Although he lived the latter part of his life in Wales, Tunnicliffe was a very English painter. A countryman, the son of a shoemaker who became a small farmer, Tunnicliffe turned his back on the land as a source of income, at least directly. Instead he followed the urge to express himself graphically, an urge that earned boxed ears as a boy. When eventually he achieved success and celebrity, he ignored it and concentrated still on painting, drawing and engraving: in this he was like a master craftsman, sticking to the work he could do really well and eschewing becoming for whatever reason a man of affairs or media personality. His single-mindedness, however, allowed him to develop skills in several techniques.

While Tunnicliffe does not seem to receive as fanatical admiration as Thorburn, he certainly has a loyal and large following. It is interesting, however, that not all his fans admire the same aspects of his work. Etching and wood-engraving were the areas in which he excelled at art school and when he first began as an illustrator. Although he was still wood-engraving until his death, he found more and more opportunity to paint, exploring oil, tempera and watercolour, the last of which he eventually settled for. All his life he chose subjects he knew so that his early etchings were mainly the farming and country scenes he knew as a boy. It was only in the 1930s that he began to tackle wildlife and then he began to prepare very carefully to learn about his subject. He started to build up field sketches and the now renowned measured drawings which have been given an importance quite out of proportion to his other work.

The measured drawings are meticulous maps of dead birds and mammals, drawn to scale and containing fascinating detailed descriptions. The first of these drawings was of a pochard purchased by his wife in the Shambles in Chester in 1939. Before plucking and dressing and putting it in the oven, Tunnicliffe measured it, sketched the wing, head and feet. Soon more species followed and whenever a second or third corpse of a species already drawn came into Tunnicliffe's possession he would measure it and check it carefully against the existing drawing, lest there be a difference worth recording. A good source of material was the late Reginald Wagstaffe, one time curator of the Stockport Museum and the man who did more than anyone to guide Tunnicliffe, the bird artist. Small boys, fishermen, sportsmen and neighbours were also among the suppliers of corpses. Considering the macabre nature of the subjects these measured drawings are quite beautiful because of the skilful way in which they are painted and their composition: the artist has so arranged the drawings that they almost become pictures in themselves.

Few people had been lucky enough to see the post-mortem drawings until some were exhibited at the Diploma Galleries of the Royal Academy of Arts in 1974. To Tunnicliffe they were no more than a source of reference when he was illustrating or executing a commission. When I visited his studio in 1972, he casually showed me a folder containing drawings of red fox, badger, otter, polecat, weasel and stoat. Obviously he prized them greatly as reference material – 'feather-maps' he called them – but it appeared that to him this was the extent of their value. When ornithologists saw the measured drawings on exhibition they drooled and made the kind of extravagant remark towards which the self-consciously scientific incline. Overwhelmed by the large drawings on the walls, they missed the open sketch-books in the show cases. There we saw the most important reference material – the field sketches of the living birds, the hunting barn owl or the resting wigeon. In the sketch-book illustration showing the waterfowl on the Cob Lake, Malltraeth, Anglesey, each species is full of life, its position in the water acutely observed – not for Tunnicliffe the overblown ducks of Thorburn, looking like Elizabethan galleons with three-quarters of the hull beneath the surface.

At the end of his life Tunnicliffe had completed over 50 sketch-books of a wide range of subjects. In

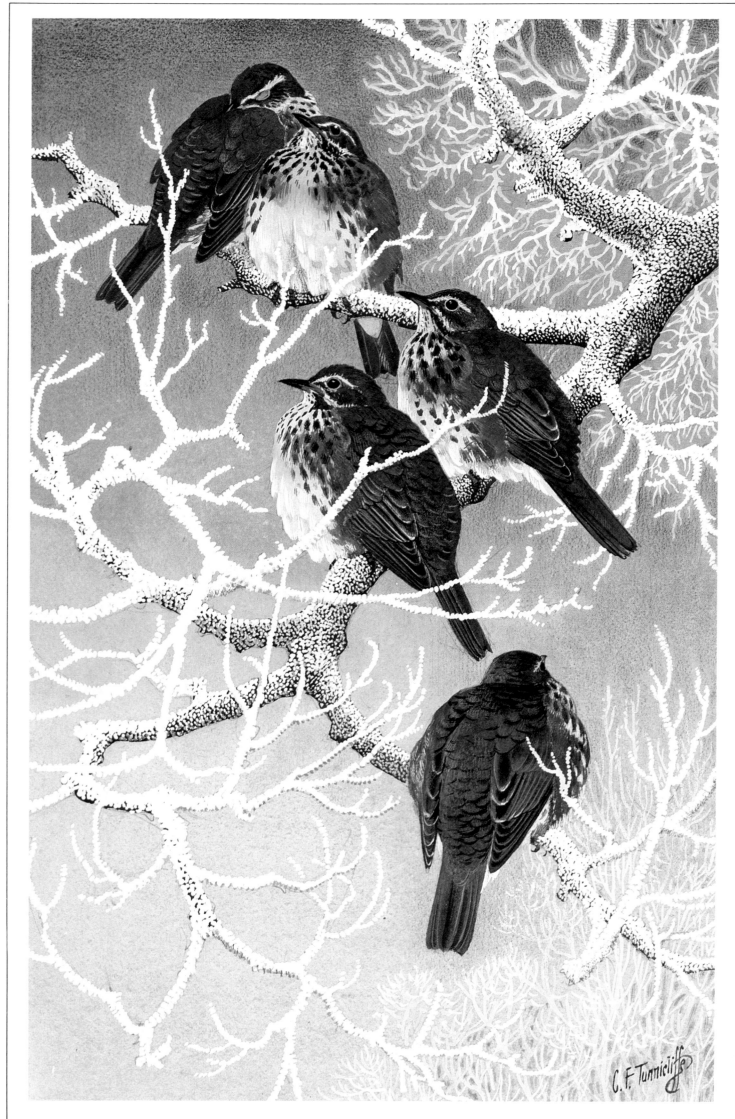

Redwings. C.F. Tunnicliffe. (Royal Society for the Protection of Birds)

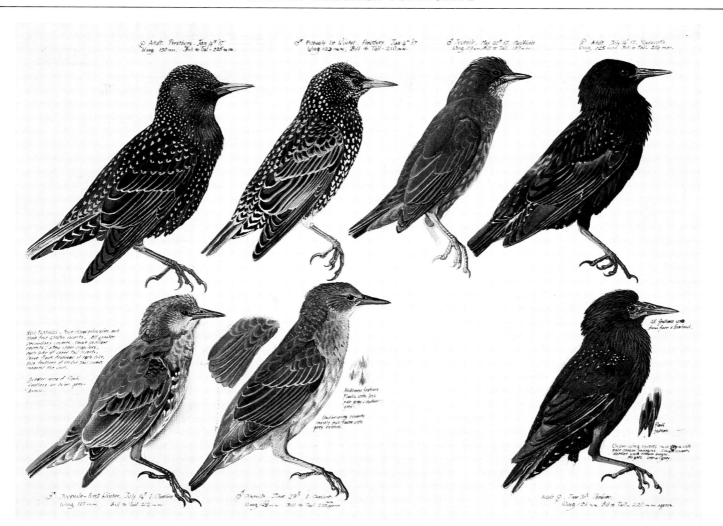

Starling. C.F. Tunnicliffe. (Victor Gollancz)

Moorhen. C.F. Tunnicliffe. (Victor Gollancz)

addition to birds there were boats, trees, buildings and people – the raw material of so many of his illustrations. Like a concert pianist, Charles Tunnicliffe always kept in practise, even on holiday he would sketch what he saw – another example of the dedication of this man whose life was built on the peasant ethic of achievement through hard work.

The world into which Charles Tunnicliffe was born in December 1901 was much quieter than today's. His father, William, was the shoemaker in the village of Langley on the outskirts of Macclesfield. He lived and worked in a small cottage and his wife, Margaret, had given birth to three girls and two boys, both of whom died in infancy, before the arrival of Charles. The cramped conditions must have been hard and William was not well. The doctor advised that for the sake of his health he should look for different work instead of working in a bad light, hunched over a last. Margaret came from a farming family and the couple grabbed the chance of taking on Lane Ends Farm, a 20-acre holding in the tiny village of Sutton Lane Ends. If the farm did not prosper, they always had William's trade as a shoemaker to fall back on.

Charles, therefore, was a farmer's boy from the age of 18 months. Indeed, he could not remember when he had not lived on the farm. He grew up in the hard atmosphere of a small mixed farm; picturesque and full of incident it may have been but far from the romantic image that many of us have of farming before the Common Agricultural Policy. His talent in

Otter and herring gulls. C.F. Tunnicliffe, from Tarka the Otter

drawing soon became apparent with his attempts to draw cows and horses on the whitewashed walls of a byre. He was encouraged to develop this talent by Christmas presents of sketch-blocks and paints: from his father's viewpoint it must have saved the walls of farm buildings and, perhaps, his mother realised that

here was a way in which her Charles might have a different life from the boys on other small Cheshire farms. 'I shall never forget my first sketch-block', he wrote in *My Country Book* in 1942, 'I thought it was a great invention: so flat and rigid, and with a beautiful clean sheet under each one I tore off. Alas, the sketch-block did not last for ever, and after I had drawn portraits of the cows that gave the most milk, the big sow and the glowing Rhode Island Red cock, not to mention various dogs, cats and a neighbour's bull which persistently broke through into our pastures, I came at last to the cardboard end of the block.' Already he was sketching compulsively using living animals.

At the village school, the drawing lessons on Mondays, Wednesdays and Fridays were the highlights of the week. Of these he loved the Friday lesson best because it was memory drawing and the pupils were permitted to draw what they liked. 'So the drawing books became filled with all sorts of things: savage beasts, cowboys and Indians, and, of course, the inevitable farm animals.' The life of a ten-year-old son of a small farmer in 1912 did not leave much leisure time away from school. There was farmwork to be done – cows to be milked, horses to be fed, watered, cleaned and worked. Somehow, though, young Charles managed to find time to draw and his talent was not overlooked by his schoolmaster, Mr Buckley Moffat. When the time approached for Charles to leave school at 14, Mr Moffat visited his parents to explain that their son had exceptional talent and to suggest that this should be encouraged by a course at art school. William's reaction seems to have been that the place for a 14-year-old farmer's son was on a farm, not wasting time drawing pictures, but Margaret wanted her son to have a chance to make something of himself. Thanks, therefore, to a schoolmaster's intervention with the accepted course of events and a mother's ambition, Tunnicliffe found himself at Macclesfield School of Art with a scholarship.

Art school taught the young man about the various media available and in those days gave a disciplined approach to his drawings. In his last term at Macclesfield, Charles sat the Royal College of Art entrance examination and passed with a scholarship. To the farmer's boy from the Cheshire plains, the prospect of the RCA and London was daunting. In *My Country Book*, the most self-revealing of his writing, he admits to homesickness for his family, the farm animals and the Cheshire countryside. After a month or so this began to wear off as he discovered that London was not just a dusty, dingy, unfriendly place that smelled of petrol and tar. There was the zoo and the Natural History Museum, where he filled his sketch-book with studies of both live and stuffed birds and other animals. It was at the museum that he discovered how unsatisfactory stuffed specimens can be as models and decided to concentrate on sketching living animals, using the museum specimens for reference to detail.

It was fashionable amongst RCA students to admire the modern artists, post-Impressionists and Cubists, but Tunnicliffe with his passion for the countryside animals preferred the then less fashionable Rembrandt, Millet, Pieter Breughel, Dürer, Constable, Girtin and Cotman. One quality, he learned, that all the Masters had was their ability to work hard, an ability that by then he must have shared with them.

The RCA had an engraving school, which Tunnicliffe joined in his fourth year and through which he became absorbed in etching. It was then a fashionable form of art, with investors buying the

work of young and yet unknown artists. With the encouragement of Malcolm Salaman he arranged a contract with a publisher to supply etchings of any subjects. Tunnicliffe's subjects were all agricultural, but he made no concessions to any romantic views that potential buyers might have: he showed ploughmen and horses plodding wearily, pigs straining against the prods and pulls towards the slaughtering bench, or the anxiety of the farmer and his wife tending a sick cow.

By combining etching, illustration and teaching Tunnicliffe calculated that he could survive in London when he finished at the RCA in 1925. His time there had been well-spent, he learned a great deal, but socially he seems to have had little contact with other students. He did, however, share digs with Eric Ravilious, who was to become a well known wood-engraver and an official war-artist. And, more important, Tunnicliffe met Winifred Woonacott, a student at the college. She came from Belfast and was a very able artist. In 1929, shortly after Tunnicliffe returned to Cheshire, they married and she taught art while he worked on illustrations for advertisements for cattle food, fertilisers, veterinary products and other items of the fast-developing agricultural service industry. He worked in line and wash, in wood-engraving and in colour.

His entry into book illustration was at the suggestion of Winifred, who really was the woman behind the great man (and whom he described as his best and most honest critic). She thought he should send some aquatints to illustrate *Tarka The Otter* by Henry Williamson. Publisher and author were impressed and it was decided that Tunnicliffe would illustrate the book, but his wood-engravings would be preferable to aquatints and that the three other Williamson nature books should be illustrated in a uniform edition. Beautiful as Williamson's nature writing was, the images that I retain of *Tarka* are the wood-engravings by Tunnicliffe. The illustrations in the other books are not always so successful, especially the birds, which were engraved before the artist became so knowledgeable about the subject. The relationship between artist and author was not the happiest. The plain straight-forwardness of Tunnicliffe did not combine easily with the neurotic, self-absorption of Williamson. The chapter in Ian Niall's *Portrait of a Country Artist* (1980) dealing with this period of Tunnicliffe's life is fascinating and even to a student of Williamson's life is scarcely credible. When I asked Tunnicliffe about Williamson, he commented no further than, 'He was a queer chap.' Williamson in reply to a similar question about Tunnicliffe told me that he had made Tunnicliffe as an illustrator and that he became 'Too big for his boots.'

There is no doubt that the Williamson books helped Tunnicliffe's reputation. Equally, it might be argued the other nature books by Williamson sold better because of the illustrations. Some of the best of Tunnicliffe's illustrations appeared in *Salar The Salmon* in 1935, the last book of Williamson's which Tunnicliffe illustrated, and when I visited his studio in 1972, he was painting a commission of a salmon using field sketches made when working on *Salar*.

I can find no evidence that Tunnicliffe put any high-minded motive on his work. He was illustrating, painting or print-making because these were his skills and he was giving people what they paid for. And yet his work has made a considerable contribution to public awareness of nature. Many of us were captivated by his illustrations to the Williamson books or to his own books such as *Shorelands Summer Diary*

(1952), *My Country Book* and *Bird Portraiture* (1945), or by his RSPB Christmas cards in the 1950s and 1960s, or even those delicate pictures for Cussons Imperial Leather advertisements and Brooke Bond tea cards. For some 18 years he was almost the official artist to the RSPB, painting the covers to the magazine *Bird*

Avocet. C.F. Tunnicliffe. (Royal Society for the Protection of Birds)

Notes, as well as Christmas cards, posters and illustrations in other publications. His approach was thoroughly professional – a well-executed job, following the brief and delivering on time – craftsman's stuff rather than great art, but like all good craft work well worth the money. People who look closely at the originals of his work often remark at its unexpected coarseness and brightness, but Tunnicliffe knew his medium. The colour work was all painted one and a half times the size at which it was to be reproduced; he knew that on reduction it would tighten. He also painted more brightly to compensate for loss of colour in reproduction.

The peak of Tunnicliffe's work was his Royal Academy submissions. Each year he submitted six large watercolours, which are vastly better than his more widely known commercial work. It was in these that the years of training, the sketches, the measured drawings and his feelings about wildlife and countryside came together. But his early black and white work should not be overlooked. In these he showed an ability which matches Thomas Bewick's both in skill and in his understanding of the countryside. It could even be argued that his wood-engravings showing wild animals are even better than Bewick's because they have a quality of life that Bewick, using mounted specimens, never achieved. Tunnicliffe, like Bewick, had his feet firmly planted on the earth and might well in an increasingly urbanised, sophisticated society be the last English wildlife artist with real country roots.

STAFFAN ULLSTRÖM

lthough it was thanks to a taxidermist that Staffan Ullström was discovered as a 14-year-old, he is today very cautious about using stuffed birds or mammals for anything more than reference to detail. 'I am aware' he says, 'that stuffed birds, in most cases, have defects that I don't want to reproduce.' Nevertheless he remains a friend of the taxidermist and visits his studio to look at details on dead and stuffed specimens.

Ullström still lives and works in the village of Knivsta, three kilometres from the farm where he was born in 1949. Now he owns his own house where he lives with his wife and teenage son. From his desk he can look into a garden and see birds, squirrels, hares and roe deer. Although he started drawing as soon as he could hold a pencil, it was not until he discovered a bird book in the local library that he began to become interested in wildlife. The illustrations were an inspiration. 'I had never seen anything like this. Although I wasn't aware of it at the time, since that moment my life became entirely devoted to wildlife painting.'

When he was 14 he was 'discovered' by Hjalmar Fleischer, a taxidermist who allowed the boy the run of his studio. Fleischer helped to develop his talent and allowed him to spend all his spare time and summer holidays drawing in the studio. When Ullström was 16 Fleischer arranged an exhibition of his work in Uppsala. In those days he used a black ballpoint for drawing and he only began using watercolour in 1970.

When he left school Ullström did not go to art school. He became a professional artist straight away. The basis of his work is field sketches. He spends a great deal of time in the field and has travelled throughout Europe. 'I travel a great deal to see both new places and birds and mammals' he says. 'The Swedish mountains are one of my favourite environments – I feel that I need to go there at least once a year. From April to the end of June I spend most of my time outdoors watching birds, going to different parts of the country. I take my tent so that I

can spend the night wherever I want. This is one of the main advantages of being a professional artist. There is a freedom that not many other people enjoy. This doesn't mean that I am a lazy person. I often work ten to twelve hours a day, so one has to have a lot of self-discipline. I really enjoy my work. It is so wonderful to be able to make a living out of my hobby – not many people get the chance to do that.'

He also takes his own photographs which he uses for reference, but he is careful not to use other people's photographs or to plagiarise other artists' work. He also maintains a library of books about natural history and is a keen book-collector.

'I paint in a naturalistic style' he says, 'I will always try new techniques and mediums and I will probably vary the way I design pictures. I intend to spend more time studying birds and animals to improve the way I

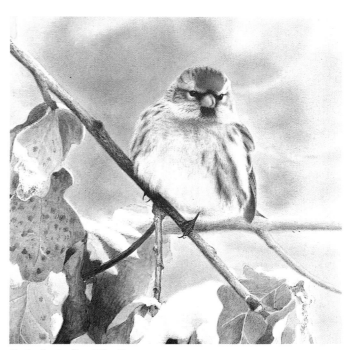

Redpoll. Staffan Ullström

211

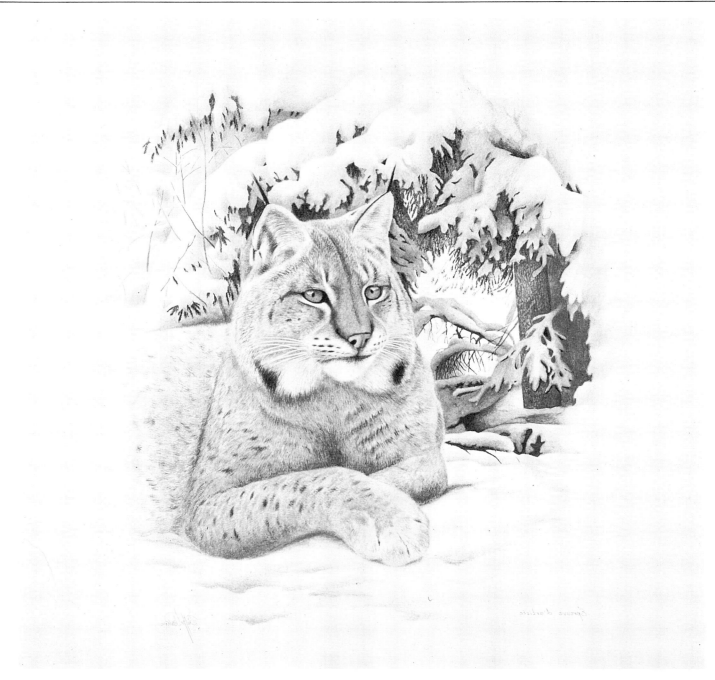

Lynx. Staffan Ullström

illustrate their behaviour.' He clearly has plenty of ambition to improve and even change his paintings. For example, although he states that he does not paint in oils or acrylics, he adds that important word 'yet'. Another ambition is to have an exhibition of his work in London. He already has had shows throughout Sweden and in Oslo.

The Swedish public has seen his work in a number of different forms. During the 1970s he painted a number of pictures of dogs and had several covers for *Hundsport*, the magazine of the Swedish Kennel Club. He has designed four Swedish postage stamps featuring waxwing, great spotted woodpecker, hawfinch and nuthatch. And he has illustrated two books, one of which, *Däggdjur*, by Anders Bjärvall, was one of Sweden's ten best-sellers during 1985. The other illustrative work has included Christmas cards and charts for Svenska Naturskyddsforeningen (Swedish Society for the Protection of Nature) and covers for *Var Fågelvarld*, the magazine of the Sveriges Ornithologiska (Swedish Ornithological Society).

It is encouraging to see such a successful wildlife artist so determined not to lose touch with the birds and mammals that he paints. He has visited many of the famous European wildlife sites. Fair Isle between Shetland and Orkney, the Varanger Peninsula and Runde in Norway, the Abruzzo Mountains and Gran Paradiso National Park in Italy and Spain's Coto Donana are among them. His travel is not the luxurious kind. He enjoys being out in the field and deliberately keeps fit in order to do so. He lifts weights a few times each week and is a cross-country and road runner. In spring and summer he goes canoeing, adding that this is good for both exercise and birdwatching. Keeping fit, he says, is very necesary because at the start of a mountaineering expedition his rucksack may weigh as much as 40 kilogrammes.

Ullström is an artist who has firm ideas about his work. Having taught himself to paint, he could have become overly influenced by the work of another artist, but he has tried to avoid being too influenced by others. He does, however, admit to being inspired by some others and cites Robert Bateman, Archibald Thorburn and, like so many others, Bruno Liljefors.

MICHAEL WARREN

In some ways Michael Warren's work makes him a birdwatcher's painter; his paintings feature what might be described as 'good birds in good places', but the decorative quality of many of them attracts the attention of bird-lovers who have never watched birds beyond their garden walls. That same decorative style does infuriate some birdwatchers who see Warren's backgrounds as trivialisation. In fact, his style has changed considerably since his paintings, influenced by Art Nouveau, first came to be seen by the public in the early 1970s. Then his style was unmistakable, quite unlike that of any other bird artist. His style is still unmistakable, but the birds are less stylised while the backgrounds have strong abstract elements. Paradoxically in the early days his apparent obsession with feather detail led to birds in somewhat distorted postures.

It was a cover on the magazine *Birds* that first focused public attention on Warren's work. It was one of the few speculatively submitted illustrations to be used on the magazine cover during the 1970s. The subject was pink-footed geese amid swirling plants and with a carmine wash. His talent was spotted and a one-man exhibition at the Tryon Gallery followed. Enough members of the picture-purchasing public liked his work to enable Warren to devote all his time to painting.

Born in 1938, Warren studied at Wolverhampton College of Art and specialised in illustration, but when he left it was to become an interior designer. For nine years he worked for a well known paint and wallpaper manufacturer as an interior designer. His spare time was given to painting and birdwatching. At first he tried to express his enthusiasm for the birds that he saw through abstract paintings. While these provided him with some personal satisfaction, they were not very attractive to buyers of paintings. If he was to sell paintings, he decided, he must restrain his abstract ideas of birds. Instead he concentrated the abstraction on the landscape elements in his paintings. Today the

Water rail. Michael Warren, from Shorelines

Green-backed heron and red-winged blackbird. Michael Warren, from Shorelines

birds, although drawn in less detail than they were in the 1970s, are more accurate and the backgrounds vary from the realistic to the abstract.

The wondrous shapes of rocks, trees and other natural features attract his interest. He has a collection of rocks, bleached driftwood and other *objets trouvés* to be used as models for his paintings. This collection has to be ever changing less the same rock appear in too many pictures. Warren is a birdwatcher to whom the places where he sees birds are almost as important as the birds themselves. His book *Shorelines* (1984) has some excellent examples of this enthusiasm. It deals with birds he has seen in Europe and the United States of America. They are all water birds or birds at the edge of water. The abstract qualities of water are particularly suitable for Warren's brush: the jacket painting of black-necked grebes on a shimmering lake compels the reader to open the book. I saw proofs of the book soon after I had returned from a trip to the eastern United States and was immediately transported back across the Atlantic by Warren's paintings of red-winged blackbirds and black-bellied plovers (grey plovers).

A commission in the mid-1980s from an American manufacturing company has kept him very busy and given him an enviable chance to visit each of the 50

Ringed plover. Michael Warren

Turtle doves. Michael Warren, from Shorelines

states. He has to choose an identifiable place in each state and a bird that might be found there. These paintings have all the constraints of book illustrations, because they have to follow predetermined shapes and sizes. Naturally Warren prefers painting for commission or exhibition when the subject dictates size and shape.

Warren's work has been exhibited in New York and Toronto in addition to his five one-man shows in London. In 1979 he was chosen to design four stamps to celebrate the European Wetlands Campaign in 1980. The species chosen were kingfisher, dipper, grey wagtail and moorhen. The British Post Office has only ever issued two sets of four bird stamps, which suggests how great an honour this was. He followed his first *Birds* cover with six more, two of which were from twelve calendar plates issued by the RSPB. He has also been commissioned to paint a set of conservation stamps for the Audubon Society and has painted several prints in limited editions.

Warren is a busy artist, who lives with his wife, Kate, and two children in a spacious Victorian villa in a Nottinghamshire village not far from Newark. Field sketches are vital to Warren's work. He uses felt-tips or crayons for these. For composition he makes thumbnail sketches. This planning stage is most important. Warren uses a wide variety of shapes

and each composition has a freshness. Once the composition is fixed, he begins the finished painting. Initially he painted in waterproof Chinese inks, but in 1978 the supply suddenly stopped, a near-traumatic event for an artist who relied on his ability to build up layers of transparent colour. He found a suitable substitute in acrylics, which he uses with water. The board on which he presently works is Barcham Green's Pasteless Board. First he draws the bird and then paints in detail so that there is a stage when there is nothing on the board but the bird. Some people have suggested that he should stop painting at this stage: presumably they do not share Warren's fascination with a bird's environment. That the landscape should be completed after the bird is difficult to understand, especially where he has made the most of aspects of camouflage or where the bird is obscured by foliage.

Very much a birdwatcher himself, Warren is, as we have seen, in many ways a birdwatcher's artist. Ironically, however, many of the keenest birders who appreciate his work cannot afford them or would prefer to spend their money on birding trips. Despite his success as a painter Warren is determined to spend as much time in the field as he can. And that is the secret of the success of his work. All his landscapes are real whether they are in Connecticut or Caithness and each of the birds he paints is a bird he has seen.

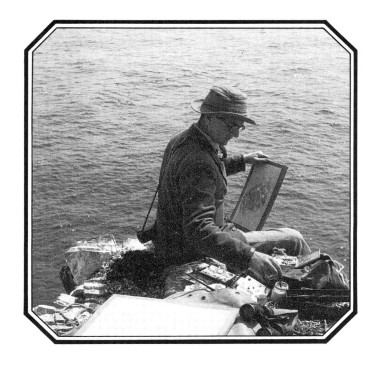

DONALD WATSON

<p>atercolours of hen harriers displaying above a Dumfries-shire hillside or a greenshank calling from a stump in the Caithness flow country are typical of the work of Donald Watson. A pair of grey wagtails on a fast-flowing stream or a merlin in the heather are subjects that few artists can handle with the skill of this quiet, modest Scot. Readers of many of the monographs published by T. & A. D. Poyser will be familiar with his decorative line and wash drawings. In exhibitions it is very easy to overlook the gentle work of Watson.</p>

Although his father was a Scot, Watson was born at Cranleigh in the Surrey Hills, in 1918. From an early age (he thinks that he was about four) he began to take an interest in birds. As a small boy he also met Archibald Thorburn and has vivid memories of having tea with him and seeing his studio. After tea he recalls he would have been happy to have looked around Thorburn's studio again, but the artist, whom he remembers as a 'sweet old boy' made it clear that young Donald and his brother should go home and leave him to return to his work.

When Donald was 12, in 1932, the Watson family moved to Edinburgh. At that time exciting developments were taking place in Scottish ornithology. One of the forces behind this was a young man called George Waterston, who was later to become Scottish Director of the RSPB. He was a founder of the Midlothian Bird Club and it was he who allowed Donald Watson to become a member when he was a mere 13-year-old.

As a schoolboy Donald Watson drew birds. At first he copied other people's work, but by the age of nine he had begun to draw from life, illustrating his diaries with the birds that he had seen, but he had no thought of becoming a wildlife artist. He left school for Oxford where he read modern history with a special interest in Renaissance art. Coming down from Oxford in 1940, he joined the army and served until 1946 in India and Burma. In his spare time he painted and drew the birds that he saw and even entertained a grandiose scheme to

produce a handbook of the birds of the sub-continent. The scheme was abandoned when he was demobbed.

On his return to civilian life he was fortunate enough to be commissioned by Sir Arthur Duncan, a landowner and very keen ornithologist, to paint a series of large watercolours of the birds of Galloway. Helped by this commission he became what he described as a 'wandering artist' arranging exhibitions of his work wherever he could. In the late 1940s and early 1950s he held one-man exhibitions across Scotland and England from Edinburgh to Bristol. In 1950 he shared an exhibition at the Rowland Ward Gallery with Oliver Heywood, David Reid-Henry and James McEwan.

Watson married in 1951 and settled in Galloway with his wife, Joan, and they have lived there ever since. The Galloway countryside and that of neighbouring Dumfries-shire figure prominently in Watson's paintings. Many of his pictures show birds in landscapes. The landscapes are all real, usually painted *in situ*. 'For years,' he told me, 'I worked on the spot because I felt that was the only way to capture atmosphere.' This has been an important aspect of his work. He had been struck by the work of Bruno Liljefors when he had seen a book about him just after the war. 'I had not been aware of him before that and I had never seen anyone paint the environment in such a broad way.' He also admires the way in which Liljefors concentrated on the subjects he knew. It gave Watson something to aim for, but he was quick to assure me that he was not putting himself in the same category as the great Swede.

Another admired artist was Archibald Thorburn. 'At his best,' says Watson, 'he was a very good illustrator and he did some charming small birds.' There is something of Thorburn in Watson's own work, but very often his bird paintings are as good as, if not better than, Thorburn. He has a technique that really shows the moulding of a bird's body. His birds are solid and rounded, never painted as two-dimensional profiles.

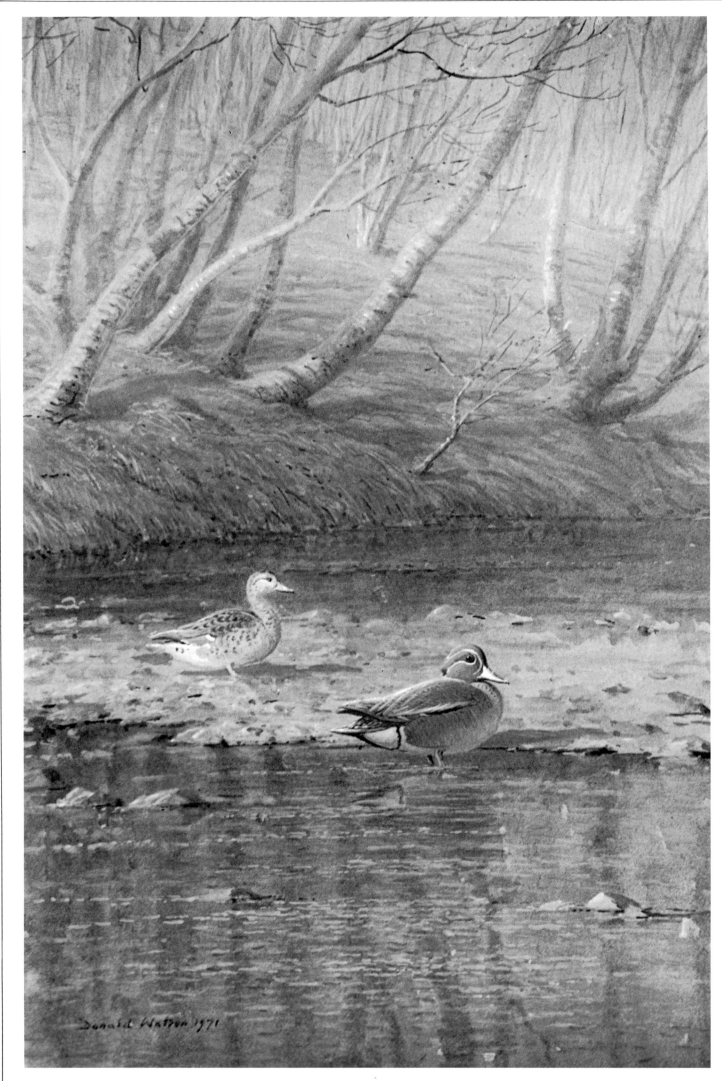

Pair of teal in spring: Galloway. Donald Watson

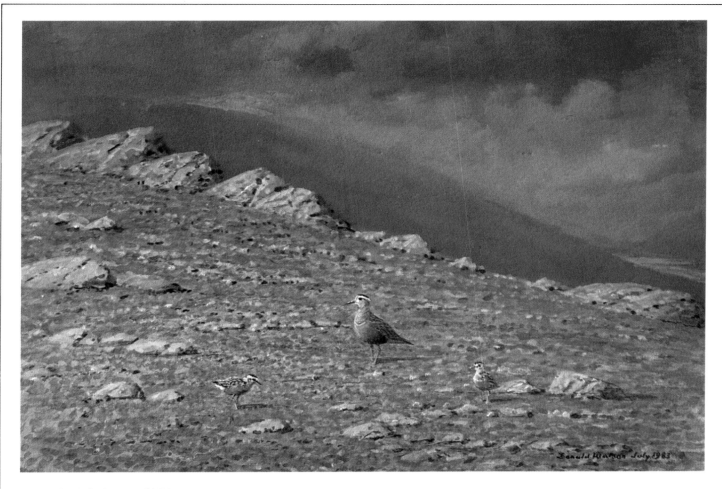

Dotterel and chicks. Donald Watson

Unlike many of the artists in this book, Donald Watson came to illustrating relatively late in his career, having started by painting for exhibitions. His first commission to illustrate a book was for *The Oxford Book of Birds* (1964). This was followed by *Birds of Mountain and Moorland* (1972) for which he painted delightful full-page plates. These were followed by illustrative work for other books and magazines.

Much of Watson's birdwatching has taken place in Scotland and he served a three-year term as President of the Scottish Ornithologists' Club, but his birdwatching and painting has not been confined to Scotland. He has visited Egypt and several Mediterranean countries and illustrated Bannerman's *Birds of the Balearics* (1983). A recent trip was to

California where his daughter lives. Although he did not have much chance to see birds, he enthused about the chance to see and identify new waders along the seashore at San Diego. Another of his four children, his son Geoffrey, worked for a spell in the Seychelles which gave Donald and Joan Watson the opportunity to see the amazing birds and other animals of those islands.

Despite these forays abroad, Donald Watson remains primarily an artist of the Scottish countryside and its birds. In his paintings he manages the very difficult task of capturing the atmosphere of seeing the birds in their environment and at the same time painting them in a way that will satisfy the most critical stickler for ornithological accuracy.

BIBLIOGRAPHY

Adams, C. and Knight, A. *Wild Lives: The Art of Charles Tunnicliffe R.A. 1901–1979* (Mostyn Art Gallery, 1980)

Amadon, D. and Brown, L. *Eagles, Hawks and Falcons of the World* (Country Life, London, 1968)

Arnold, E.N., Burton, J.A. and Ovenden, D. *A Field Guide to the Reptiles and Amphibians of Britain and Europe* (Collins, London, 1978)

Arnold, N., Ovenden, D. and Corbet, G. *Collins Handguide to the Wild Animals of Britain and Europe* (Collins, London, 1979)

Austin, O.L. Junior and Singer, A. *Birds of the World* (Golden Press Inc., New York, 1961)

Bain, I. *Thomas Bewick: An Illustrated Record of His Life and Work* (Tyne and Wear County Council Museums, Newcastle-upon-Tyne, 1979)

Barber, L. *The Heyday of Natural History 1820–1870* (Cape, London, 1980)

Bateman, R. *The Art of Robert Bateman* (Allen Lane Penguin Books, Harmondsworth, 1981)

Bennett, Linda 'Paige Impressions', *Birds*, vol. 6, no. 7 (Summer 1977)

Bond, J. *Birds of the West Indies* (London, 1963)

Bruun, B. and Singer, A. *The Hamlyn Guide to Birds of Britain and Europe* (London, 1970)

Burt, W.H. and Grossenheider, R.P. *A Field Guide to the Mammals* (Houghton Mifflin, Boston, 1952)

Busby, J. *The Living Birds of Eric Ennion* (Gollancz, London, 1982)

—— *Drawing Birds* (RSPB, Sandy, 1986)

Chalmers, P.R. *Birds Ashore and A-foreshore* (Collins, London, 1935)

Chapman, F.M. 'A Great Portrait Painter of Birds', *American Museum Journal*, vol. 15, no. 5 (May 1915)

Ching, R. *Studies and Sketches of a Bird Painter* (Landsdowne Editions, Melbourne, 1981)

Clark, K. *Animals and Man* (Thames & Hudson, London, 1977)

Cramp, S. (ed.) *Handbook of the Birds of Europe, The Middle East and North Africa: The Birds of the Western Palearctic* Vols I–IV (Oxford University Press, 1977–84)

Cumings, E.D. *The Bodley Head Natural History* (John Lane, The Bodley Head, London, 1913)

Cusa, N.W. (ed.) *Tunnicliffe's Birds: Measured Drawings by C.F. Tunnicliffe*, R.A. (Gollancz, London, 1984)

Dal, B. *The Butterflies of Northern Europe* (Croom Helm, London, 1982)

Danziker, Jo-Anne Birnie J. *Fenwick Lansdowne* (Vancouver Art Gallery, Vancouver, 1981)

Delacour, J. and Amadon, D. *Currasows and Related Birds* (American Museum of Natural History, NY, 1973)

Devlin, J.C. and Naismith, G. *The World of Roger Tory Peterson* (Times Books, New York, 1977 and David & Charles, Newton Abbot, 1978)

Dunne, P. 'A North American Lifer for Roger', *Bird Watcher's Digest*, March/April 1985

Eckelberry, D.R. 'Birds in Art and Illustration', *The Living Bird* (Cornell University Press, Ithaca, 1963)

—— 'Bird Painting in a Tropical Valley', *Audubon*, vol. 66, no. 5 (September/October 1964)

—— *Upland Game Bird Sketchbook* (Frame House Gallery, Louisville, 1976)

—— 'Of Animals and Art', *Audubon*, vol. 80, no. 5 (September 1978)

Ellenius, A. *Bruno Liljefors* (Carmina, Uppsala, 1981)

Fishbeck, L.E. 'Finding the Fun in Nature', *The Plate Collector* (May 1985) p. 63

Fisher, J. *The Shell Bird Book* (Ebury Press, London, 1966)

Fisher, J. and Peterson, R.T. *Wild America* (Houghton Mifflin, Boston, 1955)

Gloaguen, A. 'Robert Hainard, Le Primitif', *Penn Ar Bed*, no. 114 (Brest, 1983)

Graham, F. Jnr. 'Roger Peterson Builds a Blockbuster', *Audubon*, vol. 82, no. 5 (July 1980)

—— 'Signals from the Wild: The Art and Science of George Miksch Sutton', *Audubon*, vol. 83, no. 4 (July 1981)

Hainard, R. 'Discours d'ouverture du premier Callogue National de Mammalogie', *Le Courier de la Nature*, no. 54 (1978)

—— *Mammifères Sauvages d'Europe* Ed. Delachaux et Niestlé, Lausanne

Hammond, N. 'Tunnicliffe R.A.', *Birds*, vol. 3, no. 10 (1971)

—— 'Lars Jonsson', *Birds*, vol. 7, no. 4 (1978)

—— 'Craft or Credibility?', *Birds*, vol. 7, no. 8 (1979)

—— 'Bird Illustration', *A Dictionary of Birds* (British Ornithologists' Union and T. & A.D. Poyser, Calton, 1985)

Hancock, J. and Elliott, H. *The Herons of the World* (London Editions, London, 1978)

Harper, C. *Charles Harper's Birds and Words* (France House Gallery, Louisville, 1975)

Harris, H. 'Examples of Recent American Bird Art', *The*

Condor, vol. XXVIII, no. 5 (September/October 1926), (Berkeley, California)

Harrison, G.H. 'Robert Bateman', *Birds*, vol. 7, no. 6 (Summer 1979), pp. 41–2

Hayman, P. and Burton, P. *The Birdlife of Britain* (Mitchell Beazley, London, 1976)

Hayman, P. *The Mitchell Beazley Birdwatcher's Pocket Guide* (Mitchell Beazley, London, 1979)

Hayman, P. and Everett, M. *What's That Bird?* (RSPB, Sandy, 1979)

Hill, M. 'Liljefors of Sweden: The Peerless Eye', *Audubon*, vol. 80, no. 5 (September 1978)

Jackman, B. *The Countryside in Winter* (Century Hutchinson, London, 1985)

Jackson, C.E. *Bird Illustrators: Some Artists in Early Lithography* (H.F. & G. Witherby, London, 1975)

—— *Bird Etchings: The Illustrators and their Books 1655–1855* (Cornell University Press, Ithaca, 1985)

Jaques, F.P. *Francis Lee Jaques: Artist of the Wilderness World* (Doubleday & Co. Inc., New York, 1973)

Johnson, D.A. 'The Shape of Things', *Audubon*, vol. 85, no. 1 (January 1983)

Jonsson, L. *Fåglar i Naturen* (Wahlström & Widstrand, Stockholm, 1976–80)

—— *Bird Island: Pictures from a Shoal of Sand* (Croom Helm, London, 1983)

Kirkman, F.B. and Jourdain, F.C.R. *British Birds* (Thomas Nelson, London, 1930)

Kirkpatrick, R.B. 'National Wildlife Visits Arthur Singer', *National Wildlife*, vol. 8, no. 1 (December/January 1970)

—— 'National Wildlife Visits Roger Tory Peterson', *National Wildlife*, vol. 6, no. 4 (June/July 1968)

Kloot, T., McCulloch, E.M. and Trusler, P. *Birds of Australian Gardens* (Rigby, Adelaide, 1980)

Knight, D. *Zoological Illustration: an essay towards a history of printed zoological pictures* (Dawson, Folkestone, 1977 and Archon, 1977)

Kuhn, B. *The Animal Art of Bob Kuhn* (Watson-Guptill Publications, New York, 1973)

Lambourne, L. 'Birds in Art', *A Dictionary of Birds* (British Ornithologists' Union and T. & A.D. Poyser, Calton, 1985)

Leigh Yawkey Woodson Art Museum, Bird Art Exhibition Catalogues (Wausau, Wis., 1981/5)

Lewis, F. *A Dictionary of British Bird Painters* (F. Lewis, Leigh-on-Sea, 1974)

Lodge, G.E. *Memoirs of an Artist Naturalist* (Gurney & Jackson, London, 1946)

L'Orange, H.P. and Nordhagen, P.J. *Mosaics* (Dreyers Forlag, Oslo, 1958)

Luce, D.T. and Andrews, L. *Francis Lee Jaques: Artist-Naturalist* (University of Minnesota Press, 1982)

Lysaght, A.M. *The Book of Birds: Five Centuries of Bird Illustration* (Phaidon, London, 1975)

Marcham, F.G. 'Louis Fuertes Revisited', *The Living Bird* (Cornell University Press, Ithaca, 1963)

—— *Louis Agassiz Fuertes and the Singular Beauty of Birds* (Harper & Row, New York, 1971)

Marler, W. Tenth Anniversary Exhibition (William Marler Gallery, Cirencester, 1984)

Mays, V. 'A Determined Innocence', *National Wildlife*, vol. 4, no. 2 (March/April 1972)

Mengel, R.M. 'Beauty and the Beast: Natural History of Art', *The Living Bird* (Cornell University Press, Ithaca, 1980)

Morris, F.O. *A History of British Birds* (6 vols), (John C. Nimmo, London, 1857)

Mudie, R. *The Feathered Tribes of the British Islands* (2 vols), 2nd edn (Whitaker, London, 1835)

Mullins, E. 'On Safari with Robert Hainard', (*Daily Telegraph Magazine*, 15 May 1970)

Murray, P. and L. *The Penguin Dictionary of Art and Artists* (London, 1959)

Niall, I. *Portrait of a Country Artist: C.F. Tunnicliffe, R.A.* (Gollancz, London, 1980)

—— *Tunnicliffe's Countryside* (Clive Holloway Books, London, 1983)

Nicholls, R.E. 'A Painter who had no Peer in Capturing the Character of Birds' (*The Philadelphia Inquirer*, 24 October 1982)

Norelli, M.R. *American Wildlife Painting* (Galahad Books, New York, 1982)

Peck, R.M. *A Celebration of Birds: The Life and Art of Louis Agassiz Fuertes* (Walker, New York, 1982)

—— 'Louis Agassiz Fuertes (1874–1927)' (*Southwest Art*, November 1983)

Peterson, R.T. *A Field Guide to the Birds* (Houghton Mifflin, Boston, 1934)

—— *Audubon Birds* (Abbeville Press, New York, 1980)

—— 'Books of a Feather', *National Wildlife* (December/January 1984)

Peterson, R.T. and Chalif, E.L. *A Field Guide to Mexican Birds* (Houghton Mifflin, Boston, 1973)

Peterson, R.T., Mountfort, G. and Hollum, P.A.D. *A Field Guide to the Birds of Britain and Europe* (Collins, London, 1954)

Pough, R.H. *Audubon Bird Guide: Eastern Land Birds* (Doubleday & Co. Inc., New York, 1946)

Rayfield, S. *Wildlife Painting: Techniques of Modern Masters* (Watson-Guptill, New York, 1985)

Robbins, Chandler S., Bruun, B., Zim, H. and Singer, A. *A Guide to Field Identification of Birds of North America* (Golden Press Inc., New York, 1966)

Rogerson, S. *Both Sides of the Road* (Collins, London, 1951)

Rogerson, S. and Tunnicliffe, C. *Our Bird Book* (Collins, London, 1947)

Sauer, G.C. *John Gould: The Bird Man* (Landsdowne Editions, Melbourne, 1982)

Scott, P. *Morning Flight: A Book of Wildfowl* (Country Life, London, 1936)

—— *Wild Chorus* (Country Life, London, 1939)

—— *A Coloured Key to the Wildfowl of the World* (Wildfowl Trust, Slimbridge, 1957)

—— *The Eye of the Wind: an Autobiography* (Hodder & Stoughton, London, 1961)

—— *Observations of Wildlife* (Phaidon, Oxford, 1980)

—— *Travel Diaries of a Naturalist* (Collins, 1983)

Scott, S.L. (ed.) *Field Guide to the Birds of North America* (National Geographic Society, Washington, 1983)

Searle, G. 'Portrait of the Master', *Birds*, vol. 5, no. 11 (1975)

Shackleton, K. *Tidelines* (Lutterworth, London, 1951)

Skipworth, P. *The Great Bird Illustrators and Their Art 1730–1930* (Hamlyn, Feltham, 1979)

Southern, J. *Thorburn's Landscape: The Major Natural History Paintings* (Elm Tree Books, London, 1981)

—— 'Thorburn: Master of a New Tradition', *Birds*, vol. 9, no. 6 (Summer 1983)

Sullivan, S. 'Of Birds and Boats', *Birds*, vol. 10, no. 3 (Autumn 1984)

Sutton, G.M. 'Fuertes Remembered', *Audubon* (November/December 1974)

—— *Bird Student* (University of Texas, Austin and London, 1981)

Talbot Kelly, R.B. *The Way of Birds* (Collins, London, 1937)

—— *Bird Life and the Painter* (The Studio Publications, London, 1955)

—— *A Subaltern's Odyssey: A Memoir of the Great War 1915–1917* (William Kimber, London, 1980)

Tate, P. *A Century of Bird Books* (Witherby, London, 1979)

Thorburn, A. *British Birds* (4 volumes), (Longmans, London, 1915–16)

—— *Thorburn's Mammals* (Michael Joseph, London, 1974)

Tryon Gallery *Bird Artists of the World* (Exhibition Catalogue, London, 1963)

Tunnicliffe, C.F. *My Country Book* (The Studio, London, 1942)

—— *Bird Portraiture* (The Studio, London and New York, 1945)

—— *Mereside Chronicle* (Country Life, London, 1948)

—— *Shorelands Summer Diary* (Collins, London, 1952)

—— *Bird Drawings* (Royal Academy, London, 1974)

—— *A Sketchbook of Birds* (Gollancz, London, 1979)

—— *Sketches of Bird Life* (Gollancz, London, 1981)

Van Gelder, P. *Wildlife Artists at Work* (Watson-Guptill,

New York, 1982)

Vere Benson, S. *The Observer's Book of British Birds* (Frederick Warne, London, 1937)

Walker Leslie, C. *Nature Drawing* (Prentice Hall, Englewood Cliffs, 1980)

—— *The Art of Field Sketching* (Prentice Hall, Englewood Cliffs, 1984)

Warren, M. *Shorelines: Birds at the Water's Edge* (Hodder & Stoughton, London, 1984)

Wexler, M. 'The Moving Art of Manfred Schatz' (*International Wildlife*)

Whalley, P. *The Mitchell Beazley Pocket Guide to Butterflies* (Mitchell Beazley, London, 1981)

Willcox, A.R. *The Rock Art of Africa* (Croom Helm, Beckenham, 1984)

Williams, Kyffin and Campbell, B. *Bird Drawings by C.F. Tunnicliffe R.A.* (Royal Academy of Arts, 1974)

Yapp, B. *Birds in Medieval Manuscripts* (British Library, London, 1981)

INDEX